Images of Adventure

University of Pennsylvania Press
MIDDLE AGES SERIES
Edited by
Ruth Mazo Karras,
Temple University

Edward Peters,
University of Pennsylvania

A listing of the available books
in the series appears at the
back of this volume

Images of Adventure

Ywain in the Visual Arts

James A. Rushing, Jr.

University of Pennsylvania Press

Philadelphia

FOR BETH

Library of Congress Cataloging-in-Publication Data
Rushing, James A., Jr.
Images of adventure : Ywain in the visual arts / James A. Rushing, Jr.
p. cm. — (University of Pennsylvania Press middle ages series)
ISBN 0-8122-3293-3
1. Ywain (Legendary character)—Art. 2. Arthurian romances—Illustrations.
3. Art, Medieval. I. Title. II. Series: Middle Ages series.
N7763.Y94R87 1995
704.9′47′094—dc20 95-8878
 CIP

Cover: Search for the invisible Ywain. From an early thirteenth-century cycle of wall paintings in Rodenegg Castle in South Tyrol. Photo courtesy Leonhard Graf von Wolkenstein-Rodenegg.

Contents

Figures and Tables

FIGURES

TABLES

Acknowledgments

This book has been a part of my life for longer than I care to think, and I have incurred a variety of debts of gratitude along the way. The greatest debt of all is the one that I will say the least about in this public and professional forum: this book is dedicated to my wife, and that dedication may stand for all that is here unsaid.

My profoundest professional debt is to my teacher and mentor, Michael Curschmann. He has been a pioneer in the kind of image-and-text studies I am attempting, and I have properly cited almost countless references to his publications. But I want to make much more general acknowledgment here of the way in which he and his ideas, communicated in letters, conversations, and seminars over what is now quite a few years, have influenced my development not only as a writer on image-and-text issues, but also as a scholar and medievalist in general.

To the custodians of the Ywain images I owe special gratitude: to Maria Baroness Call at Rodenegg; to Museum Director Harm at Schmalkalden for granting me permission to visit the Hessenhof, to Herr and Frau P. Handy for showing me the paintings there, back in the days of the GDR, and to Helgard Rutte and other more recent staff members at Schmalkalden for photographs and information; to Jean Preston at the Princeton University Library and the staff of the Bibliothèque Nationale; to the staff of the Royal Commission on the Historical Monuments of England and others who have provided photographs of misericords; to Dr. Detlef Zinke at the Augustinermuseum; to Dr. Helmut Stampfer, the Landeskonservator in Bozen.

My forays into art history and iconography have been greatly assisted over the years by the friendly scholars of the Index of Christian Art, especially Adelaide Bennet, Nigel Morgan, and Brendan Cassidy. Various kinds of advice, counsel, support, and assistance, over the years of this project have been provided by Norris Lacy, Keith Busby, Patricia Marks, James Schultz, Norbert Ott, Eckehard Simon, and Allison Stones.

My study of the Ywain images was made possible in the first place by two generous travel grants from the Department of Germanic Languages

and Literatures at Princeton University. My work has also been supported by two grants from the Research Council of Rutgers University, including a generous grant to subvene publication, for which I am truly grateful.

That the project has finally found its way to completion in book form is due in large part to the advice and counsel of the readers for the University of Pennsylvania Press and to the support and patience of Jerome Singerman.

Introduction: Exploring the Realms Beyond the Text

The Story of Ywain

The story of Ywain[1] as told by Chrétien de Troyes and Hartmann von Aue begins at the court of King Arthur, where Calogrenant tells Guinevere and a group of knights the story of his defeat ten years earlier at the hands of a powerful knight who appeared when Calogrenant poured water from a magic fountain onto a block of emerald. When Arthur hears the story, he vows to go in two weeks with all his knights to the fountain and avenge Calogrenant's defeat. But Ywain wants the adventure for himself, so he sneaks away that very day, makes his way to the fountain, pours the water on the rock, and mortally wounds the fountain knight, Ascalon. Pursuing the dying knight into his castle, Ywain becomes trapped between two portcullises, one of which slices his horse in half as it falls. Here he is aided by the maiden Lunete, who remembers that Ywain was the only knight at Arthur's court who would speak to her when she went there as a messenger; she now gives him a magic ring that makes him invisible and thus enables him to hide from Ascalon's angry men. Ascalon dies, and his widow Laudine tears at her hair and her clothes in lamentation while Ywain, watching her, falls in love. Again Lunete comes to his assistance, persuading Laudine that she really must remarry, because someone must protect the fountain—and who could be better for the job than the man who defeated the previous guardian? So Ywain and Laudine marry, and Ascalon is forgotten.

A few days later, the Arthurian knights arrive, and Ywain, in his new role as fountain defender, unhorses Key. Arthur and his men spend several days at Ywain's court, celebrating his good fortune. Before they leave, Gawain persuades Ywain that he should not let marriage make him soft and idle, but should come with them to jousts and tournaments. Laudine grants Ywain permission to leave, but specifies that he must return within

a year. When he forgets the deadline, Lunete shows up at Arthur's court to denounce him and take back a ring Laudine had given him. Ywain goes mad with shame and grief, and lives naked in the forest until a group of ladies from Noroison find him asleep and cure him with a magic ointment.

Ywain now embarks on a new series of adventures. After defending Noroison against an attacking enemy, he rides into the forest, where he finds a lion and a dragon fighting. He kills the dragon, and the grateful lion becomes his companion, often coming to his aid at crucial moments in combat. Ywain defeats the giant Harpin, who has been terrorizing Gawain's brother-in-law and niece; on the same day, incognito except to Lunete, he defeats Laudine's seneschal and his two brothers, thus saving Lunete from being executed for treason for having persuaded Laudine to marry Ywain. At the Castle of Pesme Avanture, Ywain frees three hundred noblewomen who have been enslaved by two "sons of the devil." Finally, he fights on behalf of the younger daughter of the lord of the Black Thorn against a knight representing her sister. After a long and difficult battle, in which neither can get the upper hand, Ywain's foe is revealed to be Gawain, and the two friends refuse to fight each other any more. Arthur resolves the dispute between the sisters, and Ywain is welcomed back to Arthur's court.

But he is still unhappy without Laudine. He returns to the fountain and causes a continuous storm of such intensity that the people despair; Lunete is able to convince Laudine that the fountain must have a protector, and the man for the job is the "knight with the lion." Unfortunately, Lunete tells her mistress, this knight is so distraught over the loss of his lady's favor that he will not aid anyone who does not promise to help him win her back. Laudine swears to do everything in her power to help the "knight with the lion" regain his lover's favor, and Lunete again leads Ywain before his lady. Laudine is angry when the knight turns out to be Ywain, but he begs for forgiveness, and she grants him his "peace."

The Images of Ywain

Today we generally encounter Ywain, like most medieval characters, in texts. We read Chrétien de Troyes's *Yvain* or Hartmann von Aue's *Iwein*, or, more rarely, the Middle English or Old Norse version of the story, and develop the conviction, whether we think about it or not, that Ywain existed only in those now canonical texts.[2] In the Middle Ages, on the other

hand, Ywain was not a prisoner of the texts, in which relatively few people encountered him. He experienced many more adventures in the lands beyond them, in the realm of orality and in the realm of images. Many times the number of people who heard or read Chrétien or Hartmann must have known the story through all the varieties of second-hand narration, hearsay, and conversation that we may call secondary orality. Many other people, from South Tyrolian ministerials to East Anglian clerics, encountered Ywain and his story in the various visual manifestations that form the subject of this book: the wall paintings at Rodenegg and Runkelstein in South Tyrol and at Schmalkalden in Thuringia, the illustrations in two manuscripts of Chrétien's *Yvain*, the Malterer tapestry in Freiburg, and the misericords in five English churches.

The statement that these are all the Ywain images requires some qualification. Ywain appears as a member of the standard Arthurian cast of characters in a wide variety of prose and verse romances in Old French and several other languages. Most notably, he appears many times in the prose *Lancelot* or Vulgate Cycle. This work is preserved in numerous manuscripts, many of which are profusely illustrated, and Ywain appears in a number of these illustrations, as well as in illuminated manuscripts of some other Arthurian texts.[3] Nonetheless, it seems clear that these images need not be included in my catalogue of Ywain pictures, any more than these texts would be included with Chrétien, Hartmann, and the others in a list of Ywain texts. Ywain in these other works is not the "knight with the lion," the hero of the fountain adventure, or the husband of Laudine; he is little more than a name, a featureless member of the featureless cast of Arthurian supporting characters.[4] The seven pictures and groups of pictures that I treat, on the other hand, all represent the same Ywain, the lion-knight, the hero of the adventures with Ascalon, Lunete, and Laudine.[5]

Two books have attempted to catalog and discuss all pictorial versions of Arthurian material. After more than half a century, the grand effort of Roger Sherman Loomis and Laura Hibbard Loomis—*Arthurian Legends in Medieval Art* (1938)—remains the standard reference and starting point for studies of Arthurian iconography.[6] But the enormous scope of the Loomises' work necessarily limits its discussion of each item, and it is now outdated, due not only to more recent discoveries, such as the Rodenegg murals and the Princeton manuscript, but also to advances in our knowledge of many of the artworks it discusses. Muriel Whitaker's recent *Legends of King Arthur in Art* (1990) will supplement, but not replace, the Loomises' work as a reference on Arthurian images. It covers not only

medieval art, but all pictorial Arthuriana through the 1980s. All the Ywain pictures are included, but, not surprisingly in a work of this scope, the treatment of each work is brief, highly derivative, and superficial. In the absence of an up-to-date, systematic catalog of the Ywain images, my first purpose must be to evaluate carefully the available knowledge about artists, dates, patrons, and places of origin, and to offer fairly detailed descriptions of each work.[7]

An Introductory Survey of Image-and-Text Studies

My main purpose, however, is not to catalog the Ywain images, but to analyze them, to attempt to "read" them. Most of this introduction will be devoted to explaining what I mean by this. Despite the recent proliferation of scholarship in image-and-text studies, the field remains so vaguely defined, so poorly mapped, that I cannot clearly explain my own interests except by offering an introduction to the image-and-text field. This requires both a broad survey of more than a century of scholarly approaches to the field, and a return to the Middle Ages, to see how the field may be defined in and on medieval terms.

The region to be surveyed reaches from conventional philology on the one extreme to conventional art history on the other. Within each of these traditional disciplines, we find scholars who seek assistance in the other field, calling on pictorial evidence to explain texts, or written evidence to explain pictures. The most obvious example of an art history that uses texts to explain pictures is Panofskian iconology, in which the focus remains squarely on the images, even though massive and erudite studies of texts are undertaken to explain them.[8] At the other boundary of the field, although no school of literary interpretation relies so heavily and systematically on images as Panofskians do on words, a variety of scholars have turned to pictures to help with the interpretation of texts. D. W. Robertson, Jr., for example, notes that the shocking gesture with which Nicholas woos Alison in the *Miller's Tale*—"prively he caughte her by the queynte" (I [A] 3276)— conjures up an image that would have been familiar to medieval readers as an iconographic emblem of lechery. This becomes part of Robertson's evidence for finding a didactic, religious meaning in the tale. The image, Robertson argues, whether depicted in words or in pictures, signifies the sin of lechery; the medieval reader familiar with the pictures would read the words the same way.[9]

If I do not discuss these categories of image-text research any further, it is certainly not because they are not important. Obviously a great many mythological, religious, and other images cannot be understood at all by modern scholars without reference to texts, even though the original artists and audiences may in many cases have accquired the necessary knowledge through some sort of secondary orality. Just as obviously, Chaucer and many other medieval authors did make allusions to pictorial traditions, in ways sometimes obvious and sometimes subtle, and scholars of such literature must make reference to the pictures to fully understand these texts. These endeavors, however, do not really go beyond the bounds of the traditional academic disciplines, nor really move into the middle ground between the two.[10]

I intend to explore this middle ground: the space between academic disciplines, between the conventional study of images and the traditional study of texts. Let me say first that my primary concerns are more practical than theoretical—or, at least, theory is to serve practice here, and not the other way around. Several types of explorations that are sometimes undertaken in this field are thus not my main concern. These include a long tradition of philosophical discussion of the relationships among the various arts that runs from Plato to Schopenhauer and Nietzsche and beyond. Discussions of which artistic medium comes closest to expressing ultimate reality, and of similar questions, may eventually have to be brought back into the discussion of texts and images. But, for the present, metaphysics would only complicate matters. I am also excluding all that discussion of *ut pictura poesis* which runs from Horace to Lessing and onward, because that tradition appears to be concerned more exclusively with literature than with images.

Likewise, I will not reopen the old debate about "reciprocal illumination of the arts." This discussion, which began at about the beginning of the twentieth century, marked, in an important sense, the beginning of modern scholarly (as opposed to philosophical) interest in the relationship between words and images. The discussion is of little relevance to investigations of concrete relationships between specific images and texts or stories, but it is mentioned so often in introductory essays and bibliographic surveys of image-text studies, that it is worth discussing briefly here.[11] The debate about the "wechselseitige Erhellung der Künste" was carried out primarily in the realm of comparative aesthetics or stylistics and remained at a relatively theoretical level, with writers like Oskar Walzel asking to what extent scholarly concepts are transferable from one art to

another.[12] Walzel's answer was that art history had developed terms and methods that were more scientific than those of philology, and the literary historian could therefore learn much from the art historian. In particular, Walzel wanted to learn from Wölfflin, who had recently developed five pairs of "basic concepts for art history" ("kunstgeschichtliche Grundbegriffe"), based primarily on an understanding of the High Renaissance and the Baroque as diametrically opposed poles of art. Walzel was convinced that the study of literature needed a similar set of categories, and he proceeded to adopt, with some limitations and modifications, Wölfflin's system. Such efforts to apply art historical concepts to literature were not without consequence: German literary history owes its concept of a "Baroque" period to the "wechselseitige Erhellung" practiced by Fritz Strich, Walzel, and others, who transferred Wölfflin's definition of the Baroque from the visual to the verbal arts.[13]

Yet numerous essays on "reciprocal illumination" published in the early part of this century suffer from a problem that plagues many more recent introductions to image-text studies as well: they tend to assert that a connection between the verbal and visual arts exists and that medievalists ought to study it, and to trot out of a few good examples of themes and motives or stylistic tendencies that appear in both arts, without making much effort to explain their significance. Moreover, the general aesthetic arguments that Walzel and the others made so passionately now seem, on the one hand, obvious and on the other hand unhelpful.[14] We see no difficulty in referring to a certain period of literature as Baroque, nor in discussing the structure of a poem, whereas Walzel had to argue for "the right" to see the serial structure of a poem as analogous to the spatial structure of a building ("Wechselseitige Erhellung" 68).[15] And if the word "Zeitgeist" is no longer in favor, surely few would argue against the notion that the various arts of an era reflect certain deeply held beliefs and thought-structures.[16] On the other hand, this sort of "wechselseitige Erhellung" cannot tell us anything about the relationships between specific pictures and specific texts or stories, nor can it help us to understand the narrative and thematic significance of individual images.

The last thing this study is not is this: I am not primarily concerned with purely semiotic issues—whether images are signs are not, or what kind of signs they are (in either modern or medieval theory).[17] To be sure, I will draw upon both medieval and modern theories of signs and communications to provide a framework for my investigations, but semiotic theory in itself will not be my main concern.

The Literature of the Laity?

My purpose is not to develop an overall theory of image-text relations, but to explore a specific group of pictures based on a story, in the hope of contributing to an understanding of how the pictures relate to the story, and how medieval viewers might have understood the pictures. The theoretical framework for such an understanding is best created not by the application of modern conceptions of the role of images, but by reference to the theory of images developed both explicitly and implicitly in a variety of sources throughout the Middle Ages.

In 1215–16, just a decade after the completion of Hartmann's *Iwein* and only a decade or so before the creation of the wall paintings at Rodenegg, the Aquilean cleric Thomasin of Zirclaria wrote a long, didactic poem and sent it as a "foreign guest"—*Der welsche Gast*—into Germany (most likely South Tyrol) to teach morals and manners.[18] Thomasin recommends that children hear courtly romances, in order that the girls may learn from the example of Enite, Blanschefor, and others and the boys may learn from the likes of Gawein, Clies, Erec, and Iwein, including Calogrenant (but not Key, who is held up as an example of what not to become). Thomasin insists at some length that "romances are good, because they develop the character of the child" ("die âventiure die sint guot, / wan si bereitent kindes muot" [1089–90]). He refuses to condemn the romances as lies—the lies, he says, are mere decorations, beneath which important truths are to be found: "the truth is clothed in lies" ("daz wâr man mit lüge kleit" [1126]). In such lines, Thomasin clearly alludes to the medieval exegetical doctrine of *integumentum* or *cortex*, and a lively controversy has developed in recent years about whether or not he actually applies the doctrine to secular texts.[19] The answer ultimately depends on how narrowly we define *integumentum*. Thomasin does not suggest that the truths of Christian salvation lie hidden beneath the surface of Arthurian romance, but he does adapt the doctrine in order to say that important truths are contained beneath the surface of courtly tales.[20] This extension of the *integumentum* doctrine is in essence metaphorical: Thomasin does not claim that the romances are Christian allegories, but that they function like salvific allegory, in so far as the surface story conceals a deeper truth.

Having thus begun his justification of secular romance by metaphorically invoking a doctrine originally developed to allow allegorical readings of Bible passages in which the higher meaning is not the literal meaning, Thomasin immediately attempts to strengthen his argument by invoking

another ancient and respected church doctrine. In a move that must appear considerably more startling than the first one from the modern point of view, Thomasin continues his defense of vernacular storytelling by saying that it is analogous to pictures. After explaining that romances are worthwhile because they educate the young, he continues:

> swer niht vürbaz kan vernemen,
> der sol dâ bî ouch bilde nemen.
> swer schrîben kan, der sol schrîben;
> swer mâlen kan, der sol belîben
> ouch dâ mit; ein ieglîcher sol
> tuon daz er kan tuon wol.
> von dem gemâlten bilde sint
> der gebûre und daz kint
> gevreuwet oft: swer niht enkan
> verstên swaz ein biderb man
> an der schrift verstên sol,
> dem sî mit den bilden wol.
> der pfaffe sehe die schrift an,
> sô sol der ungelêrte man
> diu bilde sehen, sît im niht
> diu schrift zerkennen geschiht. (1091–1106)

> Whoever cannot comprehend higher things
> ought to follow the example [lit. image] [of the romances].
> He who can write ought to write;
> he who can paint ought to stick
> with that; everyone ought
> to do what he can do well.
> From the painted image
> the illiterate man[21] and the child
> have often taken pleasure: he who cannot
> understand what a respectable man
> ought to understand in writing,
> let him make good use of pictures.
> As the priest looks at writing,
> so should the untaught man
> look at the pictures, since he
> recognizes nothing in the writing.[22]

The idea invoked here—that pictures are the "literature of the laity"—is usually traced to Pope Gregory the Great, who wrote, in October of the year 600, urging the iconoclastic bishop Serenus of Marseilles not to destroy the images in his churches:[23]

> Aliud est enim picturam adorare, aliud picturae historia, quid sit adorandum, addiscere. Nam quod legentibus scriptura, hoc idiotis praestat pictura cernentibus, quia in ignorantes vident, quod sequi debeant, in ipsa legunt qui litteras nesciunt; unde praecipue gentibus pro lectione pictura est. (Gregory 270)

> For it is one thing to adore a picture, and another thing to learn from the story in the picture what is to be adored. For what writing offers to those who read, the picture offers to the illiterate who look at it, since in it the ignorant see what they ought to follow, in it they read, who do not know letters; whence especially for the common people, the picture stands in place of the reading.

Gregory was not the first churchman to defend pictures against iconoclasts, nor did his pro-image stance settle the question permanently.[24] But it was Gregory's formulation of the justification for images that became canonized in the decretals of Burchardt of Worms and was quoted again and again throughout the Middle Ages.[25]

To what extent, or in what sense, lay people actually could "read" or understand iconographic representations of religious materials has long been a subject of debate. For many years, some scholars have scoffed at the idea that ignorant medieval churchgoers could have understood complex images that modern medievalists can only explicate with the aid of extensive reference to the *Patrologia Latina*.[26] Such objections certainly have some validity, and some complex imagery, especially that accompanying learned texts, can hardly have been intended for the edification of the masses. But many pragmatist objections to the idea of lay people reading pictures, such as Avril Henry's argument that "two self-consciously naked people picking fruit" are likely to be taken as "apple-gathering nature-worshippers" unless viewers know in advance that they represent Adam and Eve (17–18), ignore the basic fact of semiotics that *no* signifier has meaning unless its recipients share a code with its sender.[27] Like the images, the graphemes ⟨Adam⟩ and ⟨Eve⟩ or the phonemes thereby represented have only limited meaning unless those who hear or read them already know the essential facts about the story and the symbolism of the Fall. Readers who recognize ⟨Adam⟩ and ⟨Eve⟩ as proper names will still fail to see the full significance of a statement that "Adam and Eve ate the apple" unless they already know certain basic Christian doctrine. To say that the image

of the Fall can only serve to remind viewers of what they already know is thus merely to state a basic principle of semiotics. Likewise, Duggan is wrong to quote in this context Gombrich's assertion that "Language can form propositions, pictures cannot" (Gombrich 97, quoted in Duggan 243). "The naked man eats the fruit" is a proposition, and images can express it. Indeed given the existence of an iconographic tradition in a Judeo-Christian culture, pictures have no difficulty at all communicating the statement that "Adam ate the fruit of the Tree of Knowledge."[28] What is true is that language can convey certain kinds of information much more efficiently than pictures (while pictures can convey other kinds of information more efficiently than words), and certain kinds of information can probably not be communicated, certain types of propositions not expressed in pictures at all. This is Gombrich's real point when he says that images cannot communicate philosophical propositions like *Universalia sunt ante rem* (97). But to take any of this as proving the flat statement that Gregory was "wrong" is not only to exaggerate the limitations of images, but to reduce the Gregorian dictum quite willfully *ad absurdum*.

Gregory does not say that pictures are semiotically identical to texts, but that, for those who cannot read, pictures *function like* texts—"the picture stands in place of the reading."[29] What reading is for the literate, picture-viewing is for the illiterate. Reading and writing are two parallel modes of communication that are not identical, but functionally equivalent. Gregory shows no doubt that writing is superior, the preferred means of communication for those who know how to use it; but images may serve more or less the same function for those who do not.

By writing, Gregory means writing in Latin. But later in the Middle Ages, as vernacular literacy emerged as an increasingly viable alternate mode of communication, the use of the vernacular was often defended in much the same terms as have been used to defend the use of pictures. This is true first of all in a general sense. Dante, for example, defends his use of Italian rather than Latin for the commentary sections of the *Convivo* by saying that he wants to reach the great number of noble people who can understand only the vernacular (*Convivo* 1.9.4–5, *The Banquet* p. 30). More specifically—and more important for the present discussion—a number of writers, like Thomasin, make direct reference to the Gregorian doctrine in order to justify the use of the vernacular. In the St. Albans Psalter, the so-called Alexius-master (1120s) narrates the life of Christ in pictures, then the life of St. Alexis in Old French, and then the story of Christ in Emmaus in pictures. The afterword to the *Alexius* quotes Gregory from the decretals,

first in Latin and then in Norman French (Pächt, Dodwell, and Wormald 4, plate 37). Pächt suggested some time ago that the maker of the Psalter was "aware of the revolutionary character of his venture"—namely, the independent narration of complete stories in pictures—and "felt it necessary to defend himself" by inserting the Gregorian citation (Pächt 21–22). But as Curschmann has more recently pointed out, the quotation from Gregory clearly applies to the whole multi-media work, thus placing the vernacular text squarely in the same category as the pictures: both are literature of the laity ("Pictura" 218). Similarly, in the mid-thirteenth century, Matthew of Paris comments in his *Life of Edward the Confessor* that he has translated the Latin *vita* into French for those who cannot read Latin, and provided a set of pictures for those who cannot read French (Luard vv. 3957–66).[30] The Gregorian topos appears in a variety of contexts to justify the use of both images and vernacular texts. Both are seen as ultimately inferior or subordinate to Latin literature.[31] But both are suitable means of communication—and, what is most important for us, more or less equivalent means of communication—for those not capable of reading and writing in Latin.

All this means two things: first, that images were intimately, and perhaps primarily connected with vernacular culture; second, that in vernacular culture word and image were independent and equally privileged media. A number of vernacular authors were conscious of this. For example, Richard of Haldingham and Laford, the maker of the English "Hereford Map," itself a complex blend of word and image depicting the world as symbolically understood at the end of the thirteenth century, addresses a preface to "all who possess, hear, read, or see this story."[32] The last word, Anglo-Norman *estoire*, means not just story, but also something like pictorial narrative.[33] Clearly, the map maker sees his work as a mixed-media product that may be perceived through reading the written words, hearing the words spoken, or looking at the images (Curschmann, "Hören-Lesen-Sehen" 218–19). For him, image, word, and text are all more or less equal modes of communication. Another example of this attitude is the oft-quoted prologue to Richard of Fournival's *Bestiaire d'Amour*, in which the author presents his lady with a richly illustrated manuscript of the work, noting that the human mind has two doors, the eye and the ear, to which lead the two paths *peinture* and *parole*—the image and the (spoken) word.[34] Such passages indicate that medieval intellectuals were well aware of the equal importance of word and image as media for the transmission of ideas, information, and truth. It is the later centuries that begin to ascribe a unique importance to the written word, and we must consciously

set aside these centuries of graphocentricism in order to begin to understand the role of images in the production, transmission, and reception of medieval narrative and other literary material.

Scholarly recognition of the independent role of images has developed in part out of the exploration of the relationship between orality and literacy in medieval culture, an issue that has concerned medievalists for some time.[35] Against the older view that stressed the absolute orality of the early Middle Ages and the totally literary nature of later medieval culture (leaving aside the question of whether either extreme view is accurate in itself), much newer work has stressed the intermediate nature of the High Middle Ages as a "symbiotic culture," in which both orality and literacy, both listening and reading are important modes for the reception and transmission of literary and intellectual materials.[36] Two important and related studies of medieval culture that emerge from this general recognition of the intermediate position are those of Brian Stock, who develops the idea of "textual communities," and Mary Carruthers, who considers medieval culture to be neither oral nor literate but "memorative." From these two works, though they are in many ways different, emerges a general line of thought that supports, in an overall way, the idea that images could function in essential independence from texts, although certain aspects of both studies appear to ascribe an overly central importance to them.

Stock views medieval culture as essentially oral up until about the year 1000, but argues that during the eleventh and twelfth centuries, as writing became more and more important, literacy did not simply replace orality, but a "new type of interdependence . . . arose between the two. In other words, oral discourse effectively began to function within a universe of communications governed by texts" (Stock 3). Texts were not always present, but people acted as if they were. They became a "reference system both for everyday activities and for giving shape to many larger vehicles of explanation" (Stock 3). Medieval culture was neither oral nor literate, but rather "textual": it consisted of a variety of "textual communities," and at the highest level was a single such community, centered on texts that governed the culture of the entire community, even though only a minority could and did read them. Knowledge of the essential texts and their interpretations was disseminated through the community in part through writing, but also through oral and—although Stock does not discuss the pictorial arts—visual means.

Courtly culture, no doubt, was a textual community, centered on the texts of courtly literature, even though few members of the community

had direct access to the texts themselves. The majority knew them through formal and informal listening, and through looking at images. The problem with using Stock's theory to describe high medieval society is that it appears to assume willful manipulation of the interpretation of the central texts by the leaders of the community. While this may be an appropriate assumption for the heretic groups Stock discusses, in the larger community of courtly society, systematic control over the texts was virtually nonexistent. As literary scholars are well aware, the ethical core of courtly culture is not so much a fixed set of values as a group of essential questions: How can a man live to please God and attain honor in this world? What is love? What is honor? What is *aventiure*? In this culture, the "texts"—that is, not the literal texts, but the materials, the *sujets*—are freely available for reinterpretation and remaking.

Carruthers builds on Stock's idea of textual communities by stressing that the "texts" of medieval culture may exist in nonwritten forms. "The Latin word *textus*," she writes, "comes from the verb meaning 'to weave' and it is in the institutionalizing of a story through *memoria* that textualizing occurs" (12). In a textual or memorative culture as Carruthers describes it, literary works are not hermetic art objects, but "institutions" that "weave a community together" (12). "Their meaning is thought to be implicit, hidden, polysemous and complex, requiring continuing interpretation and adaptation" (Carruthers 12). Memory is the essential element in medieval culture—texts are not so much read and re-read, as remembered. But this memory is primarily *ad res* and not *ad verbum* (as anyone familiar with medieval habits of quotation has long known): written texts are not memorized word for word; their substance is committed to memory. Clearly, there is much to be said for this description of medieval culture, as long as we remember that pictorial works like the Ywain images are a part of the weave and play a major role in the constant "interpretation and adaptation" that Carruthers's model envisions.

Indeed, some of Carruthers's conclusions strongly support the argument for the independence of the picture from the writing. First, she recognizes the essential truth of the Gregorian dictum that "Looking at pictures is an act exactly like reading . . . *because it is a rhetorical activity*" (222, Carruthers's emphasis). In the end, in arguing that memorative (and not oral or literate) is the best description for the "modality" of medieval culture, she stresses that, since this memory is *ad res*, "Indeterminacy of meaning is the very character of recollective gathering," and "Adaptation, the essential conduct of *memoria ad res*, lies at the very basis of medieval literary activity"

(259). Thus it should not be surprising when adaptors, whether in the same or another medium as the "original," use a material in their own way and for their own purposes.

In dealing with concrete images, however, Carruthers ignores her own emphasis on adaptation and ascribes the images a position distinctly secondary to the texts. The problem arises, in part, from the fact that Carruthers's book attempts to bring together three bodies of material that, though clearly related, do not form a conceptual unity. Under the broad assertion that memory was more important in medieval than in modern culture, she discusses, first, the general importance of memory in holding textual communities together; second, the classical tradition of the "arts of memory," which was revived in learned circles in the High Middle Ages; and, finally, the philosophical or theological value of memory in the clerical culture of the Middle Ages.[37] Images—though usually mental images rather than real ones—are important throughout Carruthers's work, since classical and medieval theorists of memory invariably described it in terms of images, and the artificial memory systems nearly always involved them.

In discussing actual images in books, Carruthers concentrates on the *ars memoriae*, arguing that illumination serves to aid memorization and/ or recall: "the basic function of all page decoration [is] to make each page memorable" (247). Marginalia in the decretals, for example, often appear to have nothing to do with the text they accompany; their purpose is to aid in the memorization of the text (246). This may well be true of marginalia in the decretals, but it is absurd to imagine anyone memorizing *Yvain*.[38] In general, Carruthers's book is pervaded by the assumption that texts and images in medieval culture serve primarily as aids to memory—either to assist in memorization or to remind viewers and readers of truths they already know. How they know these things in the first place is a question never satisfactorily addressed.

The idea that images can only remind, but not really communicate new contents, is a variant of the common argument that pictorial narrative only works when viewers already know the story. This is an issue that will be addressed repeatedly throughout this study. But let me anticipate a later argument by pointing out that, even when viewers did have advance knowledge of the subjects of pictorial narrative, they did not read the images strictly in terms of that knowledge. Marilyn Aronberg Lavin deals with biblical and hagiographic materials that are so well known she can hardly imagine viewers who are unfamiliar with them. But she does not envision these viewers imposing preconceived understandings of the

stories on the pictorial narratives. On the contrary, she assumes "that most spectators/worshippers knew the story and interacted with the narrative. When viewers saw that the story was 'out of order,' they looked for new relationships and juxtapositions of scenes, knowing that they would constitute new meanings" (Lavin 6). Such viewers did not use the images as aids to remembering stories they had previously learned, but responded to them as new works of art with new meanings.

The separate but equal status of word and image in medieval vernacular culture has one practical consequence of immense importance for the study of medieval secular images. It means that we can and must assume that medieval viewers read the pictures in much the same way as they read or listened to the texts—that the pictures were not mere illustrative appendages to the texts, but independent works of art. This principle applies both to the production and the consumption of medieval images. It means that we must not assume, as scholars often appear to do, that the artist at Rodenegg, for example, worked with a paintbrush in one hand and a book in the other with the goal of recreating the text in pictures. Likewise, we must also not assume that the viewers studied the paintings with text in hand like modern museum-goers, endeavoring to establish one-to-one correspondences between scenes in the paintings and scenes in the text. In short, we must not assume the primacy of the text. If the painter at Rodenegg or Schmalkalden has told a somewhat different story from Hartmann, we must read the story that is on the walls, not the story that is not there. We must treat the pictures as autonomous works of narrative art, not as illustrations to be read solely in reference to the now-canonical texts.

Modern scholars have not traditionally looked at pictures in the way I am proposing. The problem is not that they have inevitably assumed a specific, direct connection between picture and text—although very often they have, even when it seems utterly unjustified—but that scholarship examining connections between pictures and texts has been, until very recently, so strongly determined by the logocentricity, or graphocentricity, of modern culture that it has overprivileged the text, assuming the priority and authority of the written word in a way that is thoroughly inappropriate for the Middle Ages. This pervasive and sometimes subtle graphocentric bias has prevented most modern scholarship from treating paintings based on literary materials as autonomous works of art in their own right, and thus from looking at such paintings as medieval viewers looked at them.[39]

Earlier Efforts

The argument for the autonomy of the pictures is not entirely new. Although much analysis of images based on literary materials continues to assume a direct, subordinate relationship of pictures to text, and much that does not is pervaded by a subtler graphocentrism, various scholars have contributed to an increasing trend toward recognizing the autonomy of pictures. Much of this work, however, has been done in the areas of classical and Christian art. In medieval studies, especially in studies of vernacular culture, such attempts remain sporadic and scattered. A variety of starts in the right direction have not yet added up to a new and widely recognized method of inquiry.

On a theoretical level, two important explorers of the realm between traditional art history and traditional literary history have been the art historian Michael Camille and the Germanist Michael Curschmann, who have independently discussed much of the same evidence. Curschmann's works have been cited several times already: among those approaching the middle ground from the literary side, he has been a pioneer in recognizing the independent role of images in medieval culture, and the importance of the visual in the development of vernacular culture in the High Middle Ages.[40]

Camille has been a similar pioneer among art historians, and has done much to make medievalist art historians aware of the possibility of reading images to ascertain their meanings, rather than concentrating on issues of style and iconography. In the two 1985 articles that represent an initial statement of his theoretical position, Camille is, I think, too much influenced by Gilbert Crispin's statement that letters are signs of speech and pictures are signs of writing (quoted in "Book" 134), and by the Derridean concept of marginality. Thus Camille describes image-text studies as the attempt to examine the "space between what can be written as language and represented to picture it" ("Book" 134), a formulation which assumes that pictures are marginal to the written word as the written word is marginal to the spoken word, and regards pictures as signs of or responses to the text rather than to the substance underlying the text.[41] Despite this theoretical obeisance to the hegemony of the text, in Camille's interpretive work, he is rightly serious about reading images more or less as he would read texts, concerning himself with the meaning in various senses, and with the essential question of what impact images actually had on medieval readers and viewers.[42] The immediate usefulness of Camille's work as a model for

my present endeavor, however, is limited by his lack of attention to visual narrative as narrative: his interest is more in exegesis than diegesis.

Pictorial narrative, of course, has been the object of both theoretical and practical studies by art historians for a century or more, although far more attention has been devoted to classical and biblical narratives than to secular medieval narratives like the story of Ywain. Much of this scholarship has either overemphasized the connection to canonical literary versions of the material or concentrated on identifying iconographic traditions, and thus failed to confront directly pictorial narrative as narrative rather than as picture. The works of Franz Wickhoff and Kurt Weitzmann, for example, which build on earlier efforts by Carl Robert, establish a useful and influential typology of visual narrative modes. The three theoretical possibilities for portraying action in pictures are the *monoscenic*, in which an entire story is depicted in one scene, without any of the characters being shown more than once; the *continuous*, in which the story is told in one frame, but characters may appear more than once; and the *polyscenic* or *cyclical*, in which a series of images depicts a series of narrative moments.[43] In practice, the three methods do not always appear in pure form—we will encounter Ywain pictures, for example, in which individual frames of cyclical narratives contain multiple moments in the manner of the continuous method.[44] Nonetheless, the Wickhoff-Weitzmann terminology provides, at the very least, a useful way of describing how many narrative moments are depicted in one image (Lavin 2 and 294), and the work of these scholars makes an important start toward thinking about pictorial narrative. Weitzmann's implicit assumption, however, that the goal of the artist is always to narrate the entire story as the texts tell it, and his related (explicit) assumption that all narrative images of antiquity and the early Middle Ages derive from massive cycles of manuscript illuminations (see 37–46) reduce the value of his typology as an explanation for narratorial choices. Moreover, Weitzmann's seminal *Illustrations in Roll and Codex*, like Wickhoff's work before it, focuses almost exclusively on the production of images, and hardly at all on either the dynamics of pictorial narrative or on its meaning, interpretation, or reception.

A much more serious attempt to understand storytelling images as autonomous narratives independent of textual versions can be found in the works of three recent historians of classical art—Tonio Hölscher, Anne-Marie Leander-Touati, and Richard Brilliant. The reception of the images these scholars discuss appears to have been rather different from the medi-

eval one—on the one hand, literacy was more widespread, while on the other hand the stories narrated were not so exclusively associated with specific texts. Nonetheless, though their emphases vary, the works of all three scholars provide important general precedents for the methodology I develop in this book. All three treat pictorial narratives in a relatively text-independent manner; they attempt to analyze the structure of visual narrative as narrative; and they confront issues of meaning in pictorial narrative —of meaning that goes beyond the story, created by visual "intertextuality" and the juxtaposition of images within the narrative work.[45]

Attempts to pursue similar inquiries with regard to pictorial narrative of the central Middle Ages remain sporadic. Otto Pächt, in his book on visual narrative in twelfth-century England, is primarily interested in the development of styles and the iconographic sources of images, rather than the internal dynamics and structures of pictorial narration. Nonetheless, he does take pictorial narrative seriously as narrative—as the attempt "to smuggle the time factor into a medium which by definition lacks the dimension of time" (1), and he recognizes the "revolutionary" independence of image from text in some of the works he studies, especially the St. Albans Psalter (see above) and the *Life of St. Edmund* (New York, Pierpont Morgan MS 736). Most important, he admits the possibility that pictorial narrative can move beyond "the literal transcription of words to the visual realization of scenes and actions" (59).

More recently, a few scholars studying medieval church art have undertaken ambitious studies of visual narrative as narrative. Lavin, in dealing with a large number of religious narratives from medieval and later Italian art, treats picture cycles as fully independent works and considers their structure in purely visual terms. She begins by observing that some scholars take the Gregorian position fairly literally and imagine illiterate viewers learning from pictures, while others assume a semi-literate public reading tituli as part of their reception of paintings, but that, in either case, the assumption "that pictorial art illustrates and is inextricably bound to written sources," as a subsitute book, or as an image-text composite, "has tacitly guided much of the thinking about visual narrative up to the present time" (1). In other words, even those who have taken the Gregorian dictum at face value have still regarded pictures as secondary and subordinate to texts. Against this prevailing attitude, Lavin's goal is to study the picture cycles not as "narrative illustrations" but as "narratives that communicate in direct visual terms," to consider "visual narrative as distinct from any

literary form, and its place—both its role and its physical location—in the architectural framework that supports it" (3).

Wolfgang Kemp, in an important and fascinating study of a group of stained glass windows painted in the twelfth and early thirteenth centuries, argues, against the common conception that window design is primarily a matter of light, color, and geometry, that windows do narrate "in large and complex patterns," and, in fact, take the lead, during the period he covers, in the development of pictorial narrative (14–17). Kemp repeatedly stresses the independence of images from texts (esp. 119–24), showing, through an examination of several versions of the prodigal son story, how pictorial narratives develop their own structures and their own thematic centers, even when they are physically connected to the text, as on the Marburg *prodigus*-tapestry (121–22). Kemp also stresses the connection between the development of such highly independent visual narrative and the rise of vernacular narrative: in France, he points out, the years from roughly 1160 to 1220, which see the great expansion of French poetry, are also the most creative period of narrative in stained glass (146).

Finally, and of most immediate relevance to my own project, Cursch-mann and his fellow Germanist Norbert Ott have begun to explore the role of images in vernacular culture and to examine the images inspired by vernacular narrative within a theoretical framework provided by the recognition of the independence of image from text. As an early cataloger of Tristan images and as chief author of the *Katalog der deutschsprachigen illustrierten Handschriften des Mittelalters* (begun by Frühmorgen-Voss), Ott has written widely on images that relate to vernacular texts or vernacular culture. Perhaps his most important statement of the independence of images is in his contribution to Haug's book on the wall paintings at Runkelstein, where he takes direct aim at literary historians who see in Tristan images "documents of the reception history of texts" ("'Tristan' auf Runkelstein" 194–95).[46] Through the discussion of a variety of pictorializations of the Tristan material, Ott demonstrates that the purpose of pictorial versions of literary materials is not to produce an "abridged version of the text" (212), but to create a new work of art in a new medium. In an excellent concise statement of this position, he writes that, even in illustrating manuscripts, artists generally do not work with texts, so much as with the material on which the texts are based (227).[47]

Reading the Images

Little or nothing written about the Ywain pictures shares in this new approach. Even Ott, writing several years ago on Rodenegg with Wolfgang Walliczek, remains disappointingly text-oriented. Anne-Marie Bonnet, in the largest study of Ywain pictures yet undertaken, grants the pictures little real autonomy and generally ascribes them a clearly secondary status. My purpose is to focus on the Ywain pictures neither as moments in the history of style or iconography, as art historians have conventionally done, nor as substitute texts, as image-text scholars have so often done, but as *narratives* (or, sometimes, as allusions to narrative); for that, I will argue, is how their makers and their intended audiences saw them. I will employ a variety of modern methodologies, but the goal, ultimately, is to understand how medieval artists and viewers understood these pictures.[48]

Understanding how medieval viewers understood pictures often appears to involve speculation about how well they might have known the stories in advance.[49] In the case of the Ywain pictures, as I will argue in more detail later, we cannot be sure how well the Chrétien-Hartmann version of the story was known in a given time and place. Theoretically, we must assume a wide range of viewers, from those who had read or heard a text themselves to those who were completely ignorant of the Ywain story, with the majority of viewers probably falling somewhere between these extremes.[50] But for my purposes the real question is not whether or not artists and viewers were acquainted with textual versions of the story, but whether the pictorial narrative was intended to be understood primarily by reference to standard texts. It is a question, in theoretical terms, of visual diegesis. Diegesis, as explained by Robert Scholes, designates the story as opposed to the récit or narrative or text—not as a fictively real history underlying the narrative but as a product generated by the reading process. "In reading a narrative," Scholes writes, "we translate a text into a diegesis according to codes we have internalized" (113). In these terms, the central question of image-text studies is how—according to which codes—viewers translate images into diegeses. It will be my argument that the implied viewers of these images employed a variety of visual, cultural, rhetorical, and narrative codes—but not a textual one. The implied viewer of an Ywain picture cycle, like the implied reader of an Ywain text, is one who is generally familiar with courtly literature, but does not know the Ywain story in advance.

My goal, therefore, is not to determine how a specific group of his-

torical viewers would have understood this or that set of images—an impossible goal in any case—but to consider how the implied viewer of each picture cycle was expected to understand it. This involves exploring the iconographic sources for various images, in order to understand how the pictorial vocabulary is developed and what visual codes are involved in the narrative, but it also involves careful analysis of the structure of the pictorial works. The result should be a series of close readings that treats each visual manifestation of Ywain as a work of art that is as independent as any of the Ywain texts. That is not to say that such works exist in a vacuum, but only that their interpretation is not determined by reference to some pre-existing version of the material.

In the course of this analysis it will be necessary to distinguish between two basic categories of images—the *narrative* and the *representative*.[51] The narrative work tells a story; the second type of picture represents or alludes to a story, by displaying a scene or character that the viewing public may associate with the story. For example, the famous Bayeux tapestry *narrates* the story of the Norman conquest of England. In a long series of pictures, William's men build their ships, sail to England, fight, and win. In contrast, the statues of Roland in Bremen and other cities narrate nothing, even though they are ultimately based on the same story as the narrative *Chanson de Roland*; they *represent* the hero's deeds and stature. The Ywain pictures may easily be sorted into the same two types: the mural cycles at Rodenegg and Schmalkalden and the miniatures of Garret 125 and BN fr. 1433 narrate the story, while the English misericords, the Malterer tapestry, and the Runkelstein frescos represent the story or character.

Images in the Process of Literarization

In addition to having practical consequences for the understanding and interpretation of images, the idea that both image and vernacular text can be regarded as *pictura* in the terms of the Gregorian dictum also means that pictures are inextricably involved in the literarization process that is one of the great driving forces of medieval culture. In the simplest sense, the process of literarization is the writing down in texts of previously oral story materials, which were often derived from very old Germanic or Celtic narrative traditions. In a broader sense, this process is a part of the cultural synthesis that produced the Western Middle Ages: the merging of the Judeo-Christian-Roman cultural tradition, transmitted in written

Latin by the clerical institutions of the church, with the Germanic and Celtic cultural traditions transmitted orally in the vernaculars by the tribal institutions of those transalpine peoples. The ongoing, dynamic process by which these cultures merged began at least as early as the writing of the first extant vernacular poems and continued throughout the Middle Ages. The process governs medieval literature to a large extent from beginning to end: elements of the Latinate culture are adapted into vernacular literature, which expands and enriches itself in the process; materials from the vernacular traditions are adapted into Latin and Latinate literature, which is also expanded and enriched by the process; and finally new literatures emerge, written in the vernacular, based on vernacular materials, but deeply influenced by classical-Christian learning.

On a concrete level, the creation of a new vernacular literature involves the adoption of rhetorical formulae from the literate Latinate sphere for the narration of vernacular stories, as well as allusions to classical literature and mythology in the narration of vernacular tales (one thinks of Gottfried's invocation of the classical muses in *Tristan* [4860–4927]). This aspect of literarization affects pictures in a number of ways, as iconographic and rhetorical motives from the classical and Christian spheres are adapted for the narration of secular tales, and vernacular materials are adapted into topoic structures of classical and Christian origin. We will often find evidence of this sort of cultural merging as we examine the Ywain pictures.

But it is a more abstract aspect of the literarization process that concerns us most, as we consider the role of images in the creation of a literature for the laity. In essence, the concept of literarization depends upon the assumption that narration in oral culture is fundamentally different from narration in scribal or textual culture. This assumption does not depend on the validity of the much debated theory of oral-formulaic composition so much as on the notion that, in oral society, storytelling is an unselfconscious social activity.[52] In the primal scene of oral narrative that opens the *Nibelungenlied*, the narrator announces: "I have heard in old stories . . . now you may hear."[53] The individual storyteller is simply one more link in a long chain of narrators telling old stories. In the purely oral society, moreover, both poet and audience probably assumed that the story was true: that, at least, is the image conjured up by, for example, Tacitus's report that the Germanic peoples sang songs about Arminius (*Annals* 2.88).[54] When storytelling becomes written, it acquires an inevitable self-consciousness and a new structural dimension: only in written narrative can the story be meaningfully distinguished from the narrative, or the poet from the nar-

rator.[55] It may well be that fiction in the usual sense is only possible in a culture after the development of written narrative—that the story can only be fiction when the narrator is a fiction, that it is only with a fictionalized narrator that the whole act of storytelling can become a game for both narrator and audience.

This suggests that the transition from oral to written literature is immediate and absolute—that transitional texts, as Lord argues, do not exist (Lord 128–29). Nonetheless, written narratives display a wide variety of attitudes toward both their own literariness and the orality they replace. Some, like the *Nibelungenlied*, pretend to be oral narratives, others, like the *Klage*, stress their own bookishness.[56] Hartmann von Aue, in his *Iwein*, displays a somewhat ambiguous attitude. He is at pains to locate his narrator and audience in the (fictional) tradition of oral narration at Arthur's court. The scene of storytelling that begins *Iwein* (and Chrétien's *Yvain*) invites the reader or listener to think "just as Arthur's knights once sat listening to Calogrenant, so we sit listening to our narrator." And yet Hartmann's narrator appears rather scornful of the oral tradition of the British, who tell stories of Arthur and "claim he still lives today" (*Iwein* 14). On one level, this storytelling scene actually motivates the entire action of the text, for Ywain is inspired by Calogrenant's story to seek out the fountain for himself, and all his adventures thus arise from Calogrenant's narration. *Aventiure* in the sense of "adventure" follows directly from *aventiure* in the sense of "story," and so the wild herdsman's question—"aventiure: waz ist daz?" (*Iwein* 527)—becomes a major theme of the narration itself. This self-reflexive contemplation of the text's own subject appears all the more remarkable when we consider that *Iwein* and similar texts stand near the very beginning of the literary genre of courtly romance. In making literature out of the old stories they tell, these texts reflect self-consciously on the kind of literature they are making.

The ways in which written narratives of the Middle Ages thematize and dramatize their own literariness are myriad and fascinating. But what is more important for present purposes is that if pictures, in the medieval scheme, are functionally equivalent to vernacular texts, images as well as words must be involved in the literarization process. Thus it will not be surprising if pictorial, as well as verbal, narratives thematize and dramatize their own participation in the process of literarization—if they too struggle to answer the herdsman's question—"aventiure: waz ist daz?" *Aventiure*, of course, means both "knightly adventure" and "tale of knighthood," so the question addresses both the subject and the narration of

romance. What does it mean to be a knight, and what does it mean to be a story of knighthood? Just as each Ywain text offers its own answer to these questions, so does each set of images. The pictures are thus not only images of Ywain, but also images of adventure.

Notes

1. Since the name is spelled differently in each language—*Yvain* in Chrétien's Old French, *Iwein* in Hartmann's Middle High German—and there seems to be no standard modern English spelling, I have adopted the Middle English *Ywain* for all general discussion of the story and character, and use Yvain, Iwein, and other forms only when speaking of specific texts. For other Arthurian names, I have somewhat arbitrarily chosen standards—Calogrenant, Laudine, Lunete, Ascalon, Key—and use the variants only when referring to specific texts.

2. Chrétien's *Yvain* dates from the late 1170s or very early 1180s (Frappier, *Chrétien de Troyes* 6 and 183; Uitti, "Le Chevalier au Lion" 185), Hartmann's *Iwein* from about 1203 (see Cormeau and Störmer 30–32). *Ywain and Gawain* dates from 1325–50 (*Ywain and Gawain* lvii–lviii); the Old Norse version from around 1226 (*Ívens Saga* xvii). Other versions are the Welsh *Owein* and the Old Swedish *Herr Ivan Lejonriddaren*.

3. At least one *Queste* manuscript contains miniatures depicting Ywain, as do at least five manuscripts of *Lancelot*, and at least four of the *Mort*. But if the former Yates Thompson manuscript (now Pierpont Morgan Library MS 805–6; miniatures reproduced in Thompson 6: 12–20), is typical, Ywain in most of these images may be scarcely distinguishable from other knights. Ywain also appears in miniatures in at least two manuscripts of the prose *Tristan*. (On the "prose *Yvain*," see the following note.) Ywain, or at least his name, appears in a great many other texts (at least thirty Old French verse romances [West 163–64]), in both French and other languages, but it appears unlikely that he is pictorially depicted in any of the manuscripts (Rushing, "Adventures," Appendix C). My survey of these materials has been aided immensely by letters from Patricia Stirnemann at the Bibliothèque Nationale and C. Pantens-Van den Bergen at the Bibliothèque Royale in Brussels; the published catalogs vary widely in completeness. The most complete survey of the illumination of the Vulgate Cycle is Stones's unpublished dissertation, but she does not provide a complete list of miniatures.

4. The so-called "prose *Yvain*" (Aberystwyth, National Library of Wales MS 444-D), which contains three or four pictures of Ywain, deserves special mention. The text is a series of seven Arthurian episodes based on the *Compilation de Rusticien de Pise* (Muir 361–64). Ywain is the protagonist only in the first episode, a short story version of his rescue of the lion, completely detached from its Chrétiennian context. The lion adventure, the only point of even remote contact between the Wales *Yvain* and the Chrétiennian tradition, is not illustrated; in none of the illuminations depicting Ywain is he recognizable as the knight with the lion. It therefore seems pointless to add the Wales manuscript to the canon of Ywain pictures. (For

more detail, see Rushing, "Adventures," Appendix C.3, and the works cited there, especially Perriccioli-Saggese. I am grateful to the National Library of Wales for a detailed description of the miniatures.) The two miniatures in Pierre Sala's *Chevalier au lion*, of about 1518–19 (BN fr. 1638), have also not been included, both because they do not depict Ywain, and because they are, by all conventional reckonings, no longer medieval (see Burin).

5. A small number of images have been mentioned as representing Ywain and do not, or may have represented Ywain but are no longer extant. Most of these are discussed in Rushing ("Adventures," Appendix B). One that is not discussed there is the wood carving on a church door from Valthjofstad in eastern Iceland (now in the National Museum, Reykjavík; for photographs, see Paulsen, plates 1, 29, 51; Kristjánsson 325). The carving, which dates from about 1200, depicts in the lower half of a roundel a knight killing a dragon, and thereby freeing a lion. In the upper half, the lion follows the knight as he rides toward a church, then lies, apparently dying, on a grave. The narrative reads from bottom to top and tells the story of a knight who rescued a lion, who was so grateful that he chose to follow his master even into death. The grave bears a runic inscription, deciphered by Bæksted as "ríkja konung hér grafinu er vá dreka þenna" ("[see the] mighty king, here buried, who killed this dragon") (192, translated into German by Paulsen 36–37). Due to the "rescue of the lion" episode, the carving has sometimes been taken as a manifestation of the Ywain story (e.g., by Bernström [172] and Kristjánsson [325–26]). But, as Paulsen (179–96, esp. 180–81) and Hoppe (31–32) have demonstrated, the motive of the lion's death on the knight's grave links the carving conclusively to the saga of Henry the Lion (for agreement, see also Wells 43).

6. Often cited simply as "Loomis." Roger alone wrote "Part I: The Decorative Arts"; Laura collaborated with him on "Part II: Book Illustration." Stones's "Arthurian Art Since Loomis" reaffirms the value of the Loomises' work, while pointing out some of the ways in which our knowledge of Arthurian images has advanced since the 1930s.

7. Efforts to catalogue the pictorial manifestations of a major theme remain rare: one of the most ambitious efforts to date is Lejeune and Stiennon. In the Arthurian realm, only the Tristan images have been comprehensively cataloged (see Ott, "Katalog der Tristan-Bildzeugnisse"). On the difficulty and rarity of such undertakings, see Walliczek (155–56); on the lack of iconographic indices for secular art, see Stones ("Arthurian Art" 39).

8. See, for example, Panofsky's *Studies in Iconology*.

9. The image is discussed in *A Preface to Chaucer* (22, 385). Fleming discusses the same image in less dogmatic fashion (131).

10. Pickering sees this kind of activity as the only legitimate contribution of literary historians and art historians to one another's fields (3–71). Stammler, in introducing his essay on "Schrifttum und Bildkunst im deutschen Mittelalter," outlines three main ways in which the two disciplines can contribute to one another—the use of texts to explain pictures, the use of pictures to explain texts, and "wechselseitige Erhellung" of a common "Zeitstil" (789).

11. See Ott ("Text und Illustration" ix–xvii); Meier and Ruberg (10–11).

12. ". . . ob der Erforscher einer Kunst fähig ist, von dem Erforscher einer

anderen, einer Nachbarkunst die Augen zu leihen, um gewisse künstlerische Züge besser zu fassen, die ihm seine eigene Beobachtungsweisen nicht hinreichend enthüllen" (Walzel, "Wechselseitige Erhellung" 9). On "wechselseitige Erhellung," in addition to the primary sources cited here, see Schweikle, Ott ("Text und Illustration" ix–xvii), Meier and Ruberg (10–11); the whole movement is traced in some detail by Hermand.

13. Strich (esp. 21). See also Walzel ("Wechselseitige Erhellung" esp. 41–56, 84–85, "Shakespeare" 24–27); Hermand (17–18).

14. But see Pickering's extreme skepticism about all "reciprocal illumination" (9–15).

15. "Das Recht, das Nacheinander einer Dichtung ganz wie das ruhende Nebeneinander eines Baus zu betrachten" ("Wechselseitige Erhellung" 68).

16. As Schweikle notes, objections to a "Zeitgeist" are generally more to the word than to the idea (48).

17. Probably the most frequently mentioned semiotic study of word-image relationships is Schapiro's book, which appears to be cited out of all proportion to its actual influence. Camille discusses both modern and medieval semiotic theory and devotes particular attention to the status of the visual, as opposed to the verbal sign (especially in "The Book of Signs"). An excellent general survey of possible semiotic approaches to art history is Bal and Bryson; for a more cursory overview of the possibilities, with much bibliography, see Nöth (446–459).

18. On the date, see Kuhn ("Thomasin" cols. 467–80) and Neumann (vii–ix).

19. For the argument that Thomasin applies the doctrine to romance, see Brinkmann (*Hermeneutik* 179, "Verhüllung" 322–23) and Huber (esp. 96–100; with further bibliography, 79–80). For the opposing view, see Haug (*Literaturtheorie* 232) and Knapp (623–24). For more conciliatory positions, see Curschmann ("Hören-Lesen-Sehen" 246, "Der aventiure" 225–26); also Bäuml ("Varieties and Consequences" 255–57). For a good introduction to the *integumentum* theory, see Robertson ("Terminology").

20. Cf. Curschmann's judgment that, for Thomasin, "*Wârheit* ist nicht (wenigstens nicht nur) (heils-)geschichtliche Wahrheit, sondern alle Art von Sitten- und Tugendlehre ("Hören-Lesen-Sehen" 246; also "Der aventiure" 226).

21. Literally "farmer," but in the sense of *rusticus*, meaning one who understands no Latin (on this usage, see Stock 27–28). This is not the usual meaning of MHG *gebûre*, but compare Haug's translation, "das ungebildete Volk" (*Literaturtheorie* 230), and cf. Green ("Primary Reception" 290).

22. Except as noted, translations throughout are my own, and strive for a fairly literal word for word and line by line translation that preserves the syntax of the original, rather than for elegant English style.

23. Thomasin's indebtedness to Gregory was cursorily noted by Rückert (in Thomasin 533, note to v. 1097), but first discussed at length by Curschmann ("Hören-Lesen-Sehen" 245; see also "Der aventiure" 226–27; "Pictura" 216–19).

24. Iconoclasm flourished in the Eastern Church in the eighth and ninth centuries, until the second council of Nicaea, in 787, ordered the restoration of the pictures. Early arguments in favor of pictures as some sort of substitute writing for the illiterate include those of Paulin of Nola, St. Nilus, Gregory of Nyssa, and Basilius the Great. See Duggan (228–29) and Jones (79).

25. See Duggan (passim) and Curschmann ("Pictura" 214); also Jones.

26. See especially Duggan (passim, but especially 228, 242–44, 248, 250, 251) and Camille ("Seeing and Reading" 36 et al.).

27. Henry is quoted approvingly by Duggan (242–43). In the same paragraph, Henry scoffs at the idea that pictures could be understood without texts. His specific point, that the elaborate typologies of the *Biblia Pauperum* cannot be understood without prior knowledge (17–18), may perhaps be granted, but that does not prove anything about the general ability of pictures to narrate.

28. Hypothetical viewers from outside the culture would have no more trouble with the image of the Fall of Man than they would with the primer verse "In Adam's fall / We sinned all."

29. See Curschmann ("Pictura" 213), who argues that the significance of the "literatura laicorum" formula—both for the Middle Ages and for us—is not practical, but metaphorical.

30. See Curschmann ("Pictura" 212; "Hören-Lesen-Sehen" 255–56); Camille ("Seeing and Reading" 41–42).

31. Monks were urged to read in books, not on the walls, for example by Hugh of Fouilloy: "Legatur Genesis in libro, non in pariete" (1053B; cf. Curschmann, "Pictura" 215).

32. "Tuz ki cest estoire ont. ou oyront ou lirront ou ueront" (quoted, with discussion and further bibliography in Curschmann, "Hören—Lesen—Sehen" 218, from Konrad Miller, ed., *Die ältesten Weltkarten*, vol. 4).

33. See Tobler and Lommatzsch (4: col. 1403): "bildliche Darstellung eines Vorgangs." See also Curschmann ("Hören-Lesen-Sehen" 218).

34. Segre 4. The passage has been much discussed lately, first by Curschmann ("Hören—Lesen—Sehen" 244), more extensively by Huot (135–73) and Solterer (passim).

35. One essay in which the emergence of image-text theory from orality-literacy studies is particularly obvious is Curschmann's "Hören-Lesen-Sehen."

36. "Symbiotic culture" is Green's term ("Über Mündlichkeit" 1; see "Primary Reception," "The Reception of Hartmann's Works"). Early work on the orality-literacy issue was heavily influenced—in often unhelpful ways—by the Parry/Lord "theory of oral-formulaic composition"; on this see Curschmann ("Oral Poetry"); Bäuml ("Oral Tradition"). An influential early study of the general subject is Grundmann ("Litteratus-illiteratus").

37. Especially in the study of the classical rhetorical tradition of the arts of memory, Carruthers's work has an important predecessor in Yates's *The Art of Memory*.

38. Yates's position regarding the connection between images and memory is more carefully hedged. She thinks that the growth in the use of images in the thirteenth and fourteenth centuries may be related in a general way to the scholastics' rediscovery of the classical *ars memoriae*, but she never claims that all images were meant as aids to memory—only that some clearly emblematic or allegorical images were used in this way (92–104).

39. Cf. Kessler: "Historians and scholars of literature still generally assume that images were secondary to the written word and filled only incidental roles in ancient and medieval society. . ." ("Reading" 1).

40. See, most importantly, "Hören-Lesen-Sehen," "Images of Tristan," "Imagined Exegesis," "Pictura," and "Der aventiure."

41. Camille explicitly stresses the secondary status of the image in several passages. See "Book" (140, 142); "Seeing and Reading" (37).

42. See, for example, "Visual Signs" and, with a somewhat different emphasis, "Labouring for the Lord."

43. Wickhoff's original terms were *continuierend* (several moments in one scene), *distinguierend* (a series of essential moments), and *completierend* (the whole story in one scene without any figure more than once) (Wickhoff 7–9). Weitzmann rejected these terms while retaining the same basic typology, and proposed *simultaneous, monoscenic,* and *cyclical* (*Roll and Codex* 33–36).

44. The distinctions are problematic from the start. The Vienna Genesis, which Wickhoff's terminology was developed to explain, presents a series of images, each one of which of is "continuous," but which add up to a polyscenic narrative. Likewise, Trajan's column, which Wickhoff (59) considers to be "continuous," is arguably a long series of separate scenes and thus polyscenic (Brilliant, following earlier scholars, identifies 155 separate scenes [90–91 and 183, with further references]).

45. See Hölscher (*Römische Bildsprache als semantisches System* and "Die Geschichtsauffassung in der römischen Repräsentationskunst"), Leander-Touati, and Brilliant.

46. See also Ott's "Epische Stoffe" (esp. 448–49; 455–59 on Tristan).

47. "Daß der Künstler weniger die spezifische Textfassung rezipiert als vielmehr den Stoff, der ihr zugrunde liegt, gilt vielfach bereits für die Handschriftenillustration" (227).

48. This is, in general terms, the same sort of endeavor outlined by Stones ("Arthurian Art" 25), although her emphasis is more on production that on reception, and her orientation is more diachronic than synchronic.

49. See Kessler's argument that, in the congregations Gregory had in mind, the hagiographic stories painted on the walls of the church would have been well known to all viewers ("Pictorial Narrative").

50. These three categories of viewers are similar to the three types of relationship to texts postulated by Camille, following Bäuml: "the fully literate," the "individual who must rely on the literacy of another for access to written information," and the "illiterate without means or needs of such reliance" ("Seeing and Reading" 32, with reference to Bäuml, "Varieties").

51. Van D'Elden has questioned the value of this distinction in proposing her own classification of narrative scenes into "generic" and "specific." But her objections appear to be based on a misunderstanding, for I do not speak of "representative and narrative *scenes*" (Van D'Elden 269, my emphasis), but of representative and narrative works. Thus there is no need for our classifications to be considered competitors; they serve entirely different heuristic purposes. The "division of representative and narrative," however, most certainly does "tell us about the structure of the . . . literary or visual text" (Van D'Elden 269)—it tells us whether a work is narrative or not.

52. The concept of an oral and a literate consciousness, or of oral and literate

societies, has spawned a tremendous amount of discussion since the early 1960s; for an overview and a discussion of Greek orality and literacy, see Havelock.

53. "Uns ist in alten mæren wunders vil geseit . . . muget ir nu wunder hœren sagen" (*Nibelungenlied* 1, 1 and 4; cf. Curschmann, "Nibelungenlied" 94–95).

54. Cf. Haug (*Literaturtheorie* 26).

55. On these points, see especially Ong (*Interface*); on the poet-narrator distinction as unique to written narrative, see Bäuml ("Unmaking of the Hero" 90).

56. See Curschmann, "Nibelungenlied und Nibelungenklage"; see his "Abenteuer des Erzählens" for a discussion of the way in which Wolfram creates a speaking narrator within the written text of *Parzifal*.

1. The Ambiguity of Adventure: The Rodenegg Mural Cycle

Our study of the Ywain images begins at Rodenegg in South Tyrol at a castle that might almost have been created by the fervent imagination of a medievalist reading Arthurian stories too late into the night.[1] The twelfth-century building, perched dramatically atop a narrow spine of rock far above the Rienz valley, accessible only by a drawbridge over a deep chasm, seems in many ways to be the quintessential *burg* of Middle High German romance. Within the castle is a small room that also might have been created by a medievalist's dream, for it contains a spectacular, early thirteenth-century cycle of wall paintings of the story of Ywain—the oldest wall paintings in Europe based on a motif from vernacular literature. These most sensational Ywain images are by far the most recently discovered. Until the early 1970s, the Rodenegg murals[2] were almost entirely obscured by whitewash and dirt and by a vaulted ceiling added after their creation; the few visible fragments had long led art historians to assign a religious theme to the cycle, and to identify the room as the palace chapel.[3] Then, in 1972–73, Nicolò Rasmo removed the vaulting and the whitewash, and discovered not the expected religious cycle but the stunning pictorial narrative of the story of Ywain.[4]

The large, brilliantly colored, well-preserved paintings, for which Rasmo proposed a date nearly contemporary with—or, perhaps, even earlier than—Hartmann's *Iwein*, attracted the immediate attention of Germanists who claimed them as an almost magical new source for understanding Hartmann's text and its original reception. More has been written about the Rodenegg murals in the twenty years since their discovery than about all the other Ywain pictures in over a century of scholarly activity. Rodenegg, therefore, is a logical starting point for a study of all the pictorial Ywain material: most, if not all, of the crucial issues in such a study present themselves in the Rodenegg cycle and in the scholarship that has accumulated around it.

The paintings are located in a rectangular, ground-level room of about 7 × 4 meters, under the main hall of the castle. Viewers enter through a door in the east wall near the northeast corner of the room. The narrative begins with a badly damaged scene on the entry wall, south of the door, and continues from right to left around all four walls.[5] Only the southmost portion of the east wall—where a heating stove may have stood—is empty of paintings. The cycle unfolds in a series of eleven scenes, as follows.[6]

1. Ywain's departure.
2. Ywain with the wild man (figs. 1-1, 1-2, and 1-3).
3. Ywain at the magic fountain (figs. 1-1 and 1-3).
4. Ywain's battle with Ascalon, lance phase (fig. 1-4).
5. Ywain's battle with Ascalon, sword phase (fig. 1-5).
6. Ywain trapped by the falling gate (fig. 1-6).
7. Death of Ascalon (figs. 1-6 and 1-7).
8. Lunete giving Ywain the ring (figs. 1-6 and 1-8).
9. Ascalon on his bier (fig. 1-9).
10. Search for the invisible Ywain (fig. 1-10).
11. Lunete presenting Ywain to Laudine (fig. 1-11).

Since the cycle ends with a scene that occurs less than halfway through the canonical text of *Iwein*, it might be tempting to wonder whether the narrative was originally longer. Such temptation must be decisively rejected. The paintings cover the upper walls to the ceiling; no traces of paint appear in the wall area below the murals. The original ceiling appears to have been flat and wooden not unlike the present one; the vaulting that obscured portions of the paintings until Rasmo's restoration was a seventeenth-century addition.[7] Since the Ywain room is somewhat isolated and its only door leads outside to the courtyard, it is not easy to imagine that the narrative was continued in another room. Moreover, the medieval tradition to which the Rodenegg murals belong (as the earliest surviving example) is one of "epic rooms"—single rooms decorated with pictorial narratives. At Runkelstein, for example, separate rooms are devoted to Wigalois, Tristan, and Garel, and the narration in no case continues beyond the walls of a single chamber. The same is true, of course, of the Schmalkalden Ywain cycle. As Ott and Walliczek put it, "an 'epic room' is to be understood as a closed narrative unit."[8] No more space for pictures was available in the Ywain room at Rodenegg, no neighboring room offered

space to continue the story, and the medieval tradition does not encourage us to seek a continuation in another room. We can assume with near certainty that the cycle as it now exists is complete.[9]

Historical Background

The extensive scholarship on the Rodenegg Ywain contains a rather bewildering mass of speculation and commentary on the date, artist, patron, and style—much of it groundless and misleading—which must be sorted through and evaluated before we turn to the analysis of iconography, structure, and meaning. The confusion arises from three main sources: the effort—mainly on the part of Nicolò Rasmo—to attach the Ywain paintings to the name of a documented but unknown "Hugo the painter," the very early date proposed by Rasmo, which conflicted with the generally accepted date of Hartmann's *Iwein*, and the attempt—again mainly by Rasmo—to assign a number of Brixen paintings to the same artist and date.

DOCUMENTARY EVIDENCE—"HUGO THE PAINTER"
Documentary evidence allows us to establish only a broad time frame for the construction of the castle and the creation of the murals. The lords of Rodank first appear as ministerials of the bishop of Brixen in 1126 (Ackermann 392), and Friederich von Rodank had built a castle at Rodenegg by about 1147.[10] The chapel is mentioned in a document of 1289 (Garber 109), proving that the castle had been furnished as a dwelling place by that time, but this is of no real assistance in dating the Ywain cycle, which is clearly of a much earlier period.

It was another document that led Rasmo down a scholarly blind alley (where most other early writers on Rodenegg followed him), by providing the name of a "painter Hugo" and connecting him with Konrad von Rodank, Bishop of Brixen. The bishop is often assumed to have been responsible for the paintings in the Brixen churches of the Blessed Virgin (Frauenkirche) and St. John the Baptist, and Rasmo sees him as the patron of the Rodenegg murals, as well.[11] The evidence about both Hugo and Konrad, however, is of extremely questionable value. Hugo's existence is attested by only one document, dating from 1214–15, in which Bishop Konrad visits Wolfger von Erla, patriarch of Aquileia, and a ministerial is transferred, and a "Hugo pictor" appears as the last in a series of 22 wit-

nesses (Redlich no. 541, p. 193).[12] Starting with the assumption that this painter was a member of Konrad's entourage, which is by no means certain, Rasmo and other scholars have promoted him to "court painter," and ultimately created an artist with personality, style, and oeuvre to fit this name.[13] Trinkhauser, in 1855, was the first to attribute the paintings in the Church of the Blessed Virgin to Hugo (cited in Bonnet, "Überlegungen" 26), but the confidence with which many early writers on Rodenegg speak of the painter stems primarily from Rasmo, who writes of Hugo as if his biography were known with certainty. In 1971, for example, he asserts without qualification, "bishop Konrad had a court painter, Hugo, who, in about 1204, accompanied him on a trip to Aquileia which resulted in a document" (*Affreschi* 64).[14] This court painter is said by Rasmo to have come from southern Germany and to have had connections to the Benedictine church at Frauenchiemsee, but to have been strongly influenced by Aquileian painting (*Pitture Murali* 11–13);[15] he is credited with a "surprising clarity and precision of thought," and a "lively interest in contemporary profane culture" ("Überaschende Funde" 100).

In much of the early scholarship dealing with Rodenegg, the existence of Rasmo's "court painter Hugo" is taken as fact (e.g. Ackermann 417; Szklenar 179). The entire biography, however, is based on one name in a document. We do not know whether this Hugo was a member of Konrad's court or lived at Aquileia; no clear evidence connects him with Konrad. The document does not identify Hugo as a "court painter"; no documentary evidence proves that he was ever in Brixen. Given this dearth of evidence, a number of art historians have expressed considerable skepticism about the attribution of any paintings to Hugo. Even as early as 1928, Garber admitted that associating such early works with a known painter was a tantalizing prospect, but found the attribution of the Frauenkirche paintings to Hugo "quite uncertain" (96–97). More recently, Bonnet, Heinz Mackowitz, and Peter and Dorothea Diemer have all more or less strongly rejected Rasmo's theories about Hugo.[16] The still widely accepted picture of Hugo the painter must be regarded as a figment of the scholarly imagination.

Konrad von Rodank, on the other hand, Bishop of Brixen from 1200 to 1216, is not so shadowy a figure. Still, although church documents record that he ordered improvements to the Church of the Blessed Virgin, it is not so certain that he was responsible for the paintings in that church, or in the Church of St. John the Baptist, as Rasmo and others assume.[17] Moreover, Konrad was not the lord of Rodenegg, and even if he were responsible for the Brixen paintings, a wide leap remains from this assumption to the

theory that he also ordered those at Rodenegg. In fact, the patron of the Rodenegg paintings was most likely the lord of Rodenegg himself[18]— either Bishop Konrad's cousin, Arnold II, who died on July 1, 1221, or this lord's son, Arnold IV, who died in 1256.[19] The lords of Rodenegg were among the most important ministerials of the bishopric of Brixen—certainly of sufficient rank and power to decorate their own castle. Elimination of Konrad as the patron also, of course, eliminates the validity of his death year, 1216, as a terminus ante quem for the paintings.

THE DATE OF RODENEGG AND THE DATE OF *IWEIN*

Based in part on the assumption that Konrad's death in 1216 did mark the latest possible date for the paintings, and in part on the hypothetical chronology of Hugo's works, Rasmo initially proposed a date of "about 1200" for the Rodenegg paintings (Szklenar 179). This, of course, conflicted with the date of Hartmann's *Iwein*—1203—which was required by the elaborately worked out and firmly established, if ultimately hypothetical, chronology of Middle High German literature.[20] And yet, for scholars who sought direct textual sources for paintings like these, the source was clearly Hartmann, and not Chrétien, because the fountain knight is labeled "Aschelon," as in Hartmann's text, and not "Esclados," as in Chrétien's.[21] The discovery of a set of paintings three years older than the text they were supposedly based on seemed to call for the modification of some existing hypotheses.

Nonetheless, only one Germanist has suggested redating the text based on the supposed date of the paintings (Cormeau, "Hartmann" col. 502). The majority of scholars have attempted to find a compromise theory that leaves both the traditional dating of *Iwein* and Rasmo's dating of the frescos intact. Volker Mertens and Achim Masser independently explain both the very early date of the paintings and their "incompleteness" compared to the text by assuming that the painter had heard only the first part of *Iwein*. Furthermore, they reason, an unfinished work would be presented only by its author; therefore, the painter must have heard Hartmann von Aue himself read the first part of *Iwein* (Mertens 82; Masser, "Wege" 395–97).[22] Mertens attempts to support this speculation with the information that the Zähringer Berthold V, Hartmann's assumed patron, and Bishop Konrad of Rodank were both at Speyer on May 28, 1199, probably accompanied by ministerials (82). Alternatively, Mertens proposes that transmission could have occurred through Konrad's supposed superior in the ecclesiastical hierarchy, Bishop Wolfger von Erla of Aquileia, a patron of Walther von

der Vogelweide, Albrecht von Johannsdorf, Thomasin von Zirclaria, and possibly the Nibelungen poet (82)—an argument that is seriously weakened by the fact that the bishops of Brixen were suffragans not of Aquileia but of Salzburg (Sparber, "Brixen" col. 699). In general, such speculation is impossible to prove but equally impossible to disprove.[23] It becomes irrelevant, however, if we assume a greater independence of picture from text. Other scholars writing on Rodenegg assumed a little flexibility in Rasmo's dating, and saw the Rodenegg paintings as evidence not of an earlier dating for *Iwein* or of a partial hearing of that text but of the rapid spread of the romance's popularity.[24] Schupp, for example, sees no reason not to assume a knowledge of the novel in Tyrol as early as 1200 ("Anmerkungen" 431).[25] Of course, once "Hugo the painter" has been revealed as a scholarly illusion, a date based on the hypothetical chronology of this painter's works presents considerably less of a problem and is hardly sufficient grounds for redating Hartmann or assuming partial knowledge of the text. In any case, the debate about the date of Rodenegg and the date of *Iwein* has been made virtually irrelevant by more recent, more careful art historical analyses of the style of the paintings in the context of early thirteenth-century Brixen art.

STYLISTIC EVIDENCE

The stylistic evaluation of the Rodenegg paintings is complicated by Brixen's geographical and art historical location between North and South —between Salzburg and Italy—and by the stylistic position of these works between Romanesque and Gothic.[26] The broad issues of stylistic history, however, need not concern us here. We may focus on the two Brixen works of immediate relevance for the stylistic evaluation of the Rodenegg murals —the thirteenth-century wall paintings in the churches of the Blessed Virgin and St. John the Baptist.

According to the Konrad and Hugo theory, the Church of the Blessed Virgin frescos dated from no later than 1216, the year of Bishop Konrad's death.[27] The murals in St. John's, where the originals were covered by a later overpainting, were long ascribed to the second half of the thirteenth century. But more or less contemporaneously with the discovery of the Rodenegg paintings, a restoration removed the later work, revealing that the St. John's paintings belong to the early thirteenth century and bear a striking stylistic resemblance to the Rodenegg murals.[28] Rasmo, therefore, oversimplifying the stylistic connections and relying on his Hugo/Konrad theory, ascribed all three sets of paintings to the same painter and

to the very early part of the century ("Überraschende Funde" 48 and 100).[29] Other art historians, however, have not adopted such a simplistic interpretation of the Brixen material. Despite the complexity of the situation, an approximate consensus seems to be developing on the stylistic chronology of the major Brixen paintings.

The paintings in the Church of the Blessed Virgin, it is agreed, display a more advanced style than those in St. John's (Bonnet, "Überlegungen" 29–30; Diemer and Diemer 57). Both Bonnet and Garber find that two painters were at work more or less simultaneously in the Frauenkirche. The more advanced of the two—Bonnet's painter "A"—creates "large, three-dimensional figures, whose bodies fully exploit the space provided by the architecture."[30] The style of Bonnet's painter "B" appears less advanced and is more similar to that of the St. John's painter. He produces "more delicate figures, whose drapery is indeed adapted to that created by A, but not graphically developed in the same way."[31] Bonnet thus identifies two generations of painters in the Romanesque works at Brixen—the earlier in St. John's, the later in the "A" paintings in the Church of the Blessed Virgin, with Frauenkirche painter "B" representing a transitional phase ("Überlegungen" 30).[32]

The Rodenegg paintings, Bonnet finds, are stylistically much closer to those of St. John's than to those in the Frauenkirche. Indeed, in Bonnet's analysis, the style of the Rodenegg cycle is derived from that of the Baptistry paintings ("Überlegungen" 36). In St. John's church, she finds, the typical characteristics of the portrait style appear in their original form; at Rodenegg they have become stylized (36). In other details as well—for example, in the use of architectural props as framing for scenes—and in general, Bonnet finds that the Rodenegg painter has taken the St. John's painter's style as his starting point (36–37). If, she concludes, the Rodenegg painter did not come from the atelier of the Baptistry painter, he was at least thoroughly familiar with its works (37). Although Diemer and Diemer discuss the Brixen paintings in less detail than Bonnet and do not insist on the derivation of the Rodenegg style from that of the Baptistry, they agree in seeing the St. John's paintings as more or less contemporary with Rodenegg, and slightly more archaic in style (57).

Bonnet's comparison of the paintings at Rodenegg with those in the Church of the Blessed Virgin reveals more differences than similarities. On the one hand, the murals in the church are technically and stylistically more advanced; on the other, the Ywain paintings show an expressiveness

and a dynamism that the Blessed Virgin murals do not ("Überlegungen" 37–38). In Bonnet's analysis, then, both the Ywain cycle and the Blessed Virgin frescos are stylistic descendants of the Baptistry paintings. But they are cousins, not siblings: the two cycles belong to the same generation, but their styles are distinct ("Überlegungen" 37–38).[33] Both sets of paintings, Bonnet concludes, should be dated in the twenties or thirties of the thirteenth century ("Überlegungen" 38)—a date considerably later than Rasmo's proposal and one that eliminates Bishop Konrad as a possible patron and avoids all conflict with the generally accepted date of *Iwein*.[34]

The Date of the Rodenegg Cycle

Unfortunately, it is easier to discredit theories about the date, artist, and patron of the Rodenegg frescos than to prove the validity of alternate theories. Some tentative conclusions, however, are possible. We cannot with any degree of certainty name the artist of the Ywain cycle. We can say with some certainty that the Rodenegg cycle, the Blessed Virgin paintings, and the St. John's frescos are stylistically similar and were all painted in the first three or four decades of the thirteenth century, and that the Ywain murals are probably somewhat later than the Baptistry paintings. Until the complex stylistic history of late Romanesque Brixen area painting has been studied more thoroughly, some such formulation as "1220–30s" or "around 1230" should probably be adopted as the best estimate of the date of the Rodenegg Ywain. If the stylistic differences can be taken as suggesting the actual chronology, the Rodenegg frescos may predate the paintings in the Church of the Blessed Virgin by a few years, and the 1220s may be more likely than the 1230s.[35]

Of course, even if the Rodenegg frescos are pushed forward to the 1220s or 1230s, they remain a remarkably early pictorialization of the Ywain story. Redating the paintings by a decade or two hardly makes it any less tempting to assume, as have most medievalists writing on Rodenegg, that we have here, at last, evidence of the way Hartmann's original audience responded to his work. But as I have already argued, we cannot assume that the paintings represent a direct response to the text, or that the goal of the painter was to translate Hartmann's text into pictures. Instead, we must carefully consider the story the pictures tell in terms of iconography, plot, and structure.

Iconography

The first question is one of iconography. In particular, we must explore the complex interrelationship of the story, the various pictorial traditions, and the demands of the visual medium. Scholars studying Christian art have long recognized that artists creating pictorial versions of Biblical, apocryphal, and hagiographic narratives do not usually create images based on individual readings of the text, but rely on standard images from an extensive iconographic vocabulary. An artist illustrating the first psalm, for example, is not expected to read the psalm and invent an illustration for it, but to draw on a set of images conventionally associated with that psalm—the image of David as "King and Psalmist," for example.[36] Likewise, Roman artists narrating historical events relied heavily on a set of stock images, such as the *profectio*, or departure scene, and a variety of battle topoi.[37]

Nonetheless, despite occasional acknowledgment of the importance of iconographic traditions, the Rodenegg scholarship has been unable to free itself from the assumption that pictures based on a literary motive are directly derived from a text. Even Anne Marie Bonnet's *Rodenegg und Schmalkalden*, the most elaborate investigation of the Rodenegg paintings and the only major study by an art historian, remains typical of those works that have made virtually no progress in this respect. Bonnet's analysis of the paintings is as dependent on Hartmann's text as she assumes the paintings were. Here the painter follows the "wording of the text" (41), there the painter "deviates from the text" (40); "deviations" from the text are explained as "contamination by fixed picture types" (35), as if the goal of the painter were always the pure, direct translation of words into images.

Schupp, on the other hand, in his 1975 article, acknowledges in a general way the "independence of the iconographic code" (428) and describes the painters at Rodenegg and Schmalkalden as "genuine narrators in their medium" (428). Nonetheless, in his analysis of the paintings, Schupp remains bound to the idea that the paintings document the reception of Hartmann's *Iwein*, and his interpretation of the paintings is subservient to his primary goal of text interpretation.[38] By 1982, Schupp's theoretical stance has progressed to the recognition that the paintings attempt to narrate the Ywain story "as independently as possible of Hartmann" ("Ywain-Erzählung" 3). But his interpretation of the images remains essentially text bound. He refuses to admit that the pictorial narrative does not end in Ywain's reconciliation with Laudine: since the episode ends happily in the text, it must end happily here, too, even if the viewer must imagine the

ending based on prior knowledge of the story. As we will see, this is not necessarily the case.

Ott and Walliczek point the discussion more clearly in the right direction, recognizing that the reception of a literary work by a mural painter is not equivalent to the work's reception by its usual audience (esp. 476–77), and arguing that the Rodenegg painter is influenced more by iconographic traditions and the pictorial medium's own demands than by allegiance to the text (esp. 482, 499). Nonetheless, Ott and Walliczek do not go far enough. Despite recognizing the importance of nontextual influences on the pictorial narrative, they still assume a direct relationship between the picture and the text. They write, for example, that the "tituli . . . allude to Hartmann's version of the material, *on which the fresco master apparently based his work* (476, emphasis added); they refer to the text as the "literary basis [Vorlage]" (482), and "literary source" (499). This is not just a matter of language, but appears to reflect the assumption that the production of the frescos depends upon immediate and direct reference to the text, even though the painter is free to alter the material he finds there.

Moreover, in regarding "functional context" (*Gebrauchszusammenhang*) as the most important determinant of meaning, Ott and Walliczek reduce the picture cycle to a simple function of its purpose: if the purpose of the frescos is to represent courtliness, then the adventures depicted must exemplify courtliness (esp. 499–500). I will return to this issue below; for now I would only point out that literary scholars do not usually treat medieval texts that way. An important purpose of *Iwein* was surely to entertain and to show the courtliness of its patron, but that does not prevent interpreters from identifying the ways in which the text questions the norms of courtly adventure. Ott and Walliczek thus fail, despite coming much closer than other early writers on Rodenegg, to recognize fully the autonomy of the pictorial narrative—to analyze either the production or the reception entirely in terms of the visual medium itself.

Yet it is precisely on the visual narrative itself as an autonomous pictorial text that we must focus, if we want to understand the production and reception of these images. My point is not to insist that the painter or the audience did not know the text. For all we know, Arnold von Rodank may have owned a manuscript in Hartmann's own handwriting. But regardless of how much knowledge the artist had, the goal was not to translate the text into images, but to use the story to create an independent work of art in the new medium. And regardless of the knowledge viewers may have had, they were not expected to read the images by comparing them to the

text, but by regarding them as an independent narrative in their own right. The first question is one of iconography or production. We must examine each scene carefully, in order to determine which factors govern the creation of the pictorial narrative. At the same time, we can begin to develop a preliminary impression of the story the pictures tell.

Scene 1. Ywain's Departure

The fragmentarily preserved first scene raises the question clearly: is the image based on the text, or on a more general understanding of the story? The painting has suffered considerable damage, so that any reconstruction of the scene is partly hypothetical. What is preserved is this: a man dressed in brown stands in front of a castle gate, with a bird perched on his left wrist. Above the gate the heads of three women are visible. All the figures gaze toward a large blank area to their right.

It seems most logical to identify this scene as Ywain's departure from a castle to seek adventure.[39] If we assume a direct connection to Hartmann's text, as do Szklenar and Ackermann, we will identify the bird as the molted hawk mentioned in *Iwein* (284), and the man as the vavasour who grants Calogrenant and Ywain hospitality; one of the women watching from above the gate might be his daughter.[40] Bonnet, assuming that lines 281–284 of *Iwein* are depicted here, reconstructs a mounted knight and sees the scene as Ywain's arrival at the vavasour's castle.[41] A much more coherent narrative, however, is produced by reconstructing the knight's departure from the castle, for the cycle's protagonist then rides out from a castle in the first scene, and "around the corner" to meet the wild man in the second. Indeed, if we consider the image without reference to texts, the man with the hawk has no particular identity, and the scene, assuming that the hypothetical Ywain was indeed present, must be understood simply as "Ywain's departure": a knight rides out from a castle, where a man and a few ladies bid him farewell, and into the woods. Such a scene is not only logical; it is also the usual beginning of an Arthurian story. The departure from a castle into a wood typically initiates a chain of adventures.[42] A man with a hawk, however, is hardly an inevitable part of a departure scene, and his appearance here does suggest that the painter knew at least some details of the specific version of the story told by Chrétien and Hartmann. This does not necessarily mean that the painter knew the text directly: a version of the story including the detail of the "good host with a hawk" could have been circulating in a secondary oral tradition. But even if the artist did know the text, the appearance of the hawk indicates that his goal

was something other than a direct translation of word into image, for the man with the hawk is described in *Iwein* when Calogrenant arrives at the vavasour's castle (281–284) and not when Ywain arrives or leaves (*Iwein* 976–979). Whatever the precise nature of his source materials, the artist rearranged them to suit his purposes as an independent narrator.

The departure of the knight appears to have been a standard part of romance iconography—as one would expect, given its importance in romance narrative.[43] As an image, the departure scene may have roots in Christian or classical imagery. The importance of the departure scene in the Prodigal Son narratives discussed by Kemp suggests that the iconography of setting forth to seek adventure might be derived from the illustration of that parable; indeed, Kemp appears to suggest that the structure of courtly romance is itself influenced by the parable (esp. 151–60).[44] The hero's departure (*profectio*) was also an important topos in Roman narrative art, which could be a distant source of the medieval image.[45] But the motive of leaving home is an important part of so many narratives that it is probably pointless to seek a particular source.

Above the door leading into the room, a small fragment of painting is preserved. Nothing is recognizable except a number of treetops. Any attempt at identifying this scene is pure speculation, but if the first scene is Iwein's departure from the castle, the next scene might have shown him riding through the woods toward his meeting with the wild man. Probably it is more likely that the mounted knight was shown between the first preserved scene and the door, and the space over the door was merely filled with scenery.[46]

SCENE 2. YWAIN WITH THE WILD HERDSMAN

The story and the knight turn the corner onto the north wall. The knight is now labeled YWAIN—the first indication that the painter is telling the story in his own way rather than closely following Hartmann's text. In the Chrétien/Hartmann version, this part of Ywain's adventure is not narrated at all. The only descriptions of the wild man and the fountain are found in Calogrenant's narration of *his* adventure; when Ywain sets out to avenge Calogrenant's defeat, the narrator merely says that he stayed with the good host, saw the wild man, and found the fountain (Hartmann 975–998). The narrator does not need to retell in detail the story Calogrenant has already told. The painter, however, has no such option. He cannot tell the story of Calogrenant and then tell the viewer that Ywain does the same things Calogrenant did, so he—like the creators of the Schmalkalden paintings

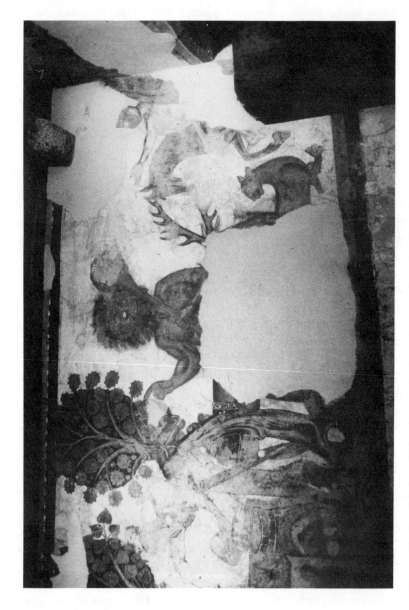

Fig. 1-1. Ywain with the wild herdsman; Ywain at the magic fountain. Photo by author.

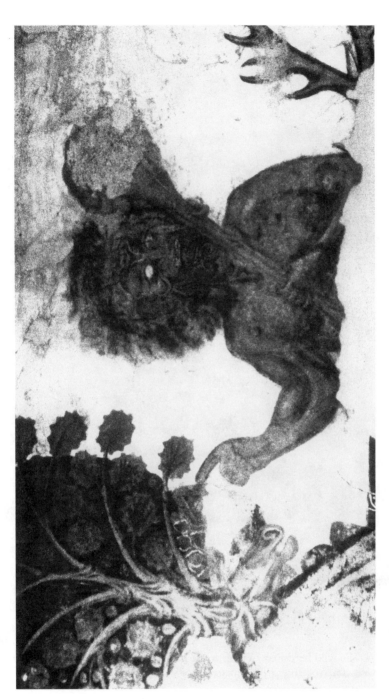

Fig. 1-2. The wild herdsman. Photo by author.

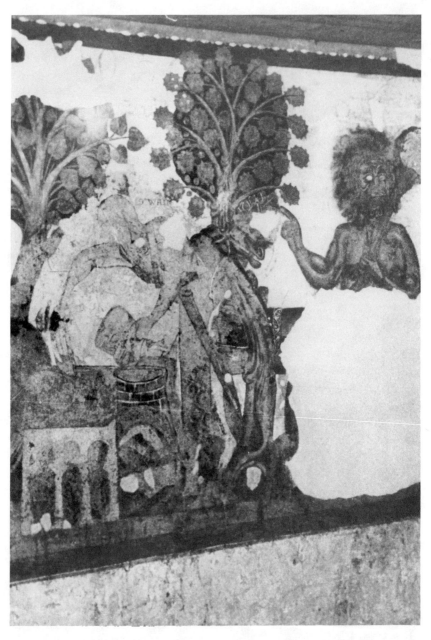

Fig. 1-3. The wild herdsman; Ywain at the magic fountain. Photo courtesy Leonhard Graf von Wolkenstein-Rodenegg.

and the Princeton miniatures—chooses to tell the story only once. The logical choice is to tell it of Ywain, since the painter's interest is not in reproducing Chrétien's or Hartmann's text but in telling the story of Ywain in a way appropriate to the pictorial medium.

And so it is Ywain, not Calogrenant, who here rides out of the woods, his arm extended in a gesture of greeting or inquiring for directions. He points toward the herdsman, who, in turn, points with his right index finger toward the fountain and Ywain's adventure. The scene is damaged: Ywain is fairly well preserved, as are the head and torso of the wild man, but the area below the herdsman's chest is missing. Parts of two of the wild beasts are visible.[47] One has elk-like antlers, the other seems to be a lion. The figure of the wild man again raises the central question of the Ywain cycle's iconography: is the artist illustrating the text or drawing on existing visual traditions? The question has two parts: how closely does the image correspond to Hartmann's description and what pictorial traditions existed for portraying such creatures?

The herdsman described by Hartmann has a truly bizarre set of features (*Iwein* 425–470). He is large and black, with a huge head and tangled, matted, rust-colored hair. His flat but deeply-lined face is an ell wide. He has enormous hairy ears as big as tubs, long tangled beard and brows, a nose like that of an ox, and red eyes. His mouth is immensely wide, and his teeth are like a boar's tusks. His chin grows far down onto his chest, and he is hunchbacked. He wears two fresh animal skins and carries a club.[48] The Rodenegg figure is large—about as tall as the mounted knight next to him, which is a common size for giants in medieval paintings. He is dark. His head is large but not disproportionately so. His face is flat and deeply wrinkled. His hair and beard are long and tangled. His ears are large. He carries a club. But his torso is not hairy, and as far as can be seen he wears no skins, although he may have worn something around his waist.[49] He is not hunchbacked, he does not have boar's tusks, his eyes are not red, and his ears are not covered with hair.[50] The herdsman of the painting shares the general attributes with the creature of Hartmann's description, but not the more unusual details.

The Ywain herdsman has generally been associated with the tradition of the wild man—the hairy woods-dweller who appears frequently in medieval literature, and even more often in the visual arts.[51] From the later Middle Ages, and even into more recent times, a plethora of images portray wild men, and only somewhat less often wild women. A glance at Bernheimer's *Wild Men in the Middle Ages*, the most quoted study of

the subject, or the more recent exhibition catalog by Timothy Husband quickly reveals the number of late medieval "wild men," and the variety of contexts in which they appear.[52] The pictorial tradition survived well beyond the Middle Ages, through the Renaissance and into the Romantic period;[53] even today, such figures appear as inn signs and heraldic supporters. These wild people are generally quite "normal" in appearance, except that they have long, flowing hair and beards and their bodies are covered with dense hair or fur. They are not otherwise deformed, and they do not have animal-like facial features. Chronology suggests that these traditions cannot be very helpful for explaining the sources of the Ywain herdsman. Although folk beliefs about wild men—and women—were common in many mountainous regions of Europe, including the South Tyrol, from as early as the tenth century, and apparently well into the nineteenth-century age of folklore collecting,[54] the passage in *Yvain* appears to be the earliest appearance of such a figure in literature, while the Rodenegg painting predates all previously known pictorial presentations of the theme.[55] The Ywain figure has often been identified, therefore, as the starting point of the literary and artistic wild man traditions.[56]

A look back at the description of the herdsman, as he appears in either the texts or the Rodenegg painting, suggests, however, that he should never have been associated with the hairy wild man tradition at all.[57] With his bizzare mixture of human and animal features, and his lack of overall hairiness, the herdsman belongs, instead, to another, more diverse tradition, which we might label the "hideous human."[58] Probably the earliest manifestation of this tradition in vernacular literature is the description of Charon, the ferryman of Hades, in the Old French *Roman d'Eneas*. While Virgil's "portitor horrendus" (6.298) merely has an unkempt beard, firey eyes, and dirty clothes, the anonymous French poet describes a Charon who is old, ugly, wrinkled, and gray; his head is covered with boils, his face is emaciated and flat, his brows are broad and mossy, his eyes are red as coals, and his ears are large and hairy (*Eneas* 2441–2454). In Heinrich von Veldecke's *Eneide*, he is even more hideous. His head is now like a leopard's, his brows are like thorns, his eyes like fire. His mouth is fierce, his teeth are red and long; he has claws on his hands and feet, and a tail like a dog (3012–3076). Veldecke also adds a description of Sibille, Eneas's guide in the underworld, as a monstrous woman with tangled hair, long eyebrows that hang to her nose, mossy ears, long yellow teeth, deepset eyes, and horrible clothes (2687–2744).[59] Charon and Sibille are depicted visually in the miniatures of the Berlin *Eneid* manuscript, which are probably more or less

contemporary with the Rodenegg paintings.[60] He is shown with matted hair, a mouth that does not close properly, and a deformed nose and ears; in one of two miniatures he has claws for fingers (Boeckler pl. 27). She has wild hair and strange ears, but otherwise appears fairly normal (Boeckler pls. 25, 26, 28).

The next major character belonging to this tradition is the Chrétien/Hartmann herdsman, who is followed in literature by the roughly similar Kundrie in Chrétien's and Wolfram's grail romances, and by the appearance of Merlin as a hideous giant in the *Livre d'Artus*.[61] This is not the place for a complete analysis of these figures and the possible relationships between them, but the general outlines of the tradition are clear. The details vary considerably, but these hideous persons are generally large and black, with long and horrible hair, brows, and beards; wide, beastlike mouths; and long teeth, frequently described as boar's tusks. Large, hairy ears are among the most common features, and eyes and noses are generally compared to those of one beast or another. Due to the constant interaction of text and image, the literary and the iconographic traditions of the hideous human cannot be meaningfully separated. Both have their roots in a bewilderingly diverse mass of medieval lore about monstrous races of man, which in turn arises from three types of sources—rhetorical, quasi-biblical, and classical.

The rhetorical tradition involves a well-established technique for describing ugly persons, which can be traced to Apollinaris Sidonius's fifth-century description of Gnatho. Among many other horrible features, Gnatho has elephantine ears surrounded by ulcers and "warts oozing with pus" (Sidonius 3.13, pp. 51–53, trans. Anderson). He has a large nose, a huge mouth full of rotting and yellow teeth, a disgustingly wrinkled forehead, and a beard that is both white with age and black with disease; he is immensely fat; and his head has more scars than hairs. Gnatho's entire body is described in revolting detail until it is summed up as a "hideous mass of misshapen features" (3.13, p. 55).[62] The importance of Sidonius as a model for medieval descriptions has been described by Curtius and others,[63] and the possible importance of the Gnatho description as a source for Chrétien's and Hartmann's herdsman has been explored by Salmon ("Wild Man" esp. 525–26). The Ywain figure shows more animal-like features than Gnatho, and those features, clearly rhetorical in Sidonius, appear more real in Chrétien and Hartmann.[64] Yet despite the differences, it does appear that the Sidonius passage might have influenced Chrétien and/or Hartmann, as well as contributed to the general medieval idea of the hideous human.

A quasi-biblical tradition represented by the *Wiener Genesis* may have been more important than the rhetorical tradition. The early Middle High German *Genesis* describes Cain's children as monsters, born because their mothers ignored Adam's advice not to eat herbs during pregnancy. Some had the heads of dogs; others had their heads in their chests, so that the mouth was in the breast and the eyes in the armpits; others had ears so large that they could cover themselves with them; and some walked on all fours like cattle (Smits 646–60). Schönbach suggested long ago that the *Iwein* herdsman might be derived from these children of Cain (214), and even longer ago, the poet of *Ywain and Gawain* referred to the herdsman as "þe karl of Kaymes kyn" (559, parallel to Hartmann's "den vil ungetânen man" [934] and Chrétien's "grant vilain" [709]).

Cain's children as described in the *Wiener Genesis* combine the features of several of the exotic races described by Pliny in his *Natural History*. Pliny, ultimately, is the origin of most of the classical traditions, which constitute the third type of source for the medieval variety of bizarre and monstrous humans. Many of the Plinian "races," such as the often depicted sciapods, who use their enormous feet for parasols, have little to do with our ugly people. Other Plinian races, however, are characterized by various features that provide a basic vocabulary of images from which the medieval poet or artist can create a hideous human. For example, the Pandae and the Panoti have the enormous ears that are a common feature of medieval monstrosities (see Friedman 18). The Cynocephali are described and pictured in the pseudo-Fermes text as having the heads of dogs, the manes of horses, and the teeth of boars; they are also said to breathe fire. The same tradition, represented in three English manuscripts from as early as about the year 1000, depicts a variety of strange creatures, including a race of women "with hair to their heels, boars' teeth, tails of oxen, and camels' feet" (James 55–59).[65]

Ultimately, it is impossible to determine which of these various and varied traditions was most important for the creation of a given figure. What is clear is that the medieval artist—visual or verbal—had an immense palette of monstrosities from which to choose, and probably selected details almost at random to create a hideous creature. Thus Hartmann's herdsman varies from Chrétien's, and the Rodenegg painting differs from both. The painter, in all probability, had no single pictorial source, nor did he base his creation directly on the text. Instead, he drew on a rich pictorial vocabulary to create his own hideous herdsman.[66]

SCENE 3. YWAIN AT THE MAGIC FOUNTAIN

The painting here does not follow the text in every detail, but follows the story in a general way. The spring, fountain, or well has been interpreted as a low, round well.[67] Instead of one wondrous linden tree, the Rodenegg cycle shows a linden and an oak. Hartmann's porous stone supported by four marble animals is something very like an altar. Ywain, holding his helmet in his left hand, pours water from a shallow basin onto the altar with his right. The essential elements for the advancement of the story are all here, but rather than the precise, somewhat fantastic descriptions found in Hartmann's text, the artist has depicted the scene in more familiar, everyday images.

SCENES 4–5. YWAIN'S BATTLE WITH ASCALON

Immediately thereafter, apparently because of having poured the water, Ywain fights against a knight labeled ASCHELON. They fight first with lances, then with swords, and Ywain seriously wounds Ascalon in the head.

The depiction of single combat in the pictorial arts, as in the verbal, was governed by well-established tradition. The typical combat consisted of two phases: a battle with lances, on horseback; a duel with swords, on foot.[68] The Rodenegg frescos alter the traditional scheme in a way that parallels Hartmann's text—the knights remain mounted for the sword fight (cf. Ott and Walliczek 483–84). But the alteration of the traditional presentation depends not so much on knowledge of a specific version of the story as on the demands of the picture cycle's own narrative structure. If, in the next scene, Iwein is to ride in pursuit of his defeated opponent, the sword fight must take place on horseback. Bonnet (40) notes that the painter "diverges from the text" by showing both knights with shields even at the climactic moment of the fight—by which point, according to Hartmann, both shields had been destroyed. This detail is best explained not as a "divergence" from the text, but as a case in which each medium draws on a different stock of storytelling formulas. It was a common topos of verbal narrative that the shields were hacked to pieces.[69] In pictorial narrative, the shield is simply part of the image of the knight and is never missing or destroyed.[70]

The differences between Hartmann's handling of the Ywain-Ascalon combat and the presentation of the fight at Rodenegg also reflect the special needs of the pictorial medium. While the poet declines to describe the battle in any detail, saying he was not a witness, the painter devotes a

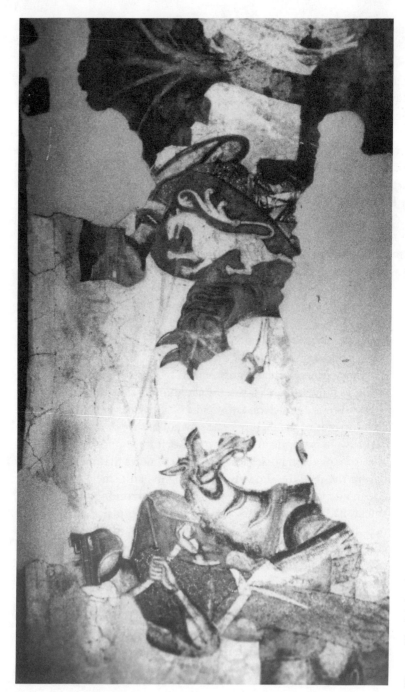

Fig. 1-4. Ywain's battle with Ascalon, lance phase. Photo by author.

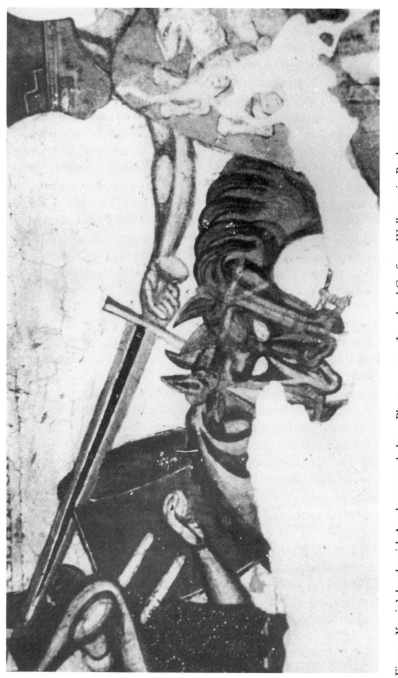

Fig. 1-5. Ywain's battle with Ascalon, sword phase. Photo courtesy Leonhard Graf von Wolkenstein-Rodenegg.

large portion of the available space to the battle. The extensive scene is no doubt influenced not only by the iconographic tradition but also by the special requirements of the visual medium. If the artist is to tell in images a story involving a fight between two knights, he is practically forced to show the battle. The painter cannot adopt the ironic stance of the verbal narrator and tell about the fight without describing it—for him, to narrate is to describe. He is not required, however, to devote so much space to the fight. He could have condensed the battle as did the Schmalkalden painter, who combines the narrative moments "sword fight" and "chase" into one scene (cf. Ott and Walliczek 484). But the overall structure of the Rodenegg cycle—the binary opposition we shall soon discover between exterior scenes of combat and interior scenes of grief, hiding, and surrender—demands the large, elaborate depiction of the battle between Ascalon and Ywain. The creation of these scenes depends on iconographic tradition, the inner logic of the pictorial narrative, the media-specific demands of visual as opposed to verbal art, and ultimately on the specific themes and structures of the Rodenegg cycle.

SCENE 6. YWAIN TRAPPED

After being wounded, Ascalon flees through a gate into a castle with Ywain pursuing closely. Ascalon, it appears, is in the process of falling from his horse, while Ywain raises his sword for another blow.[71] As Ywain leans forward, a portcullis falls on his horse's hindquarters. Most pictorial versions of this scene depict a conventional, realistic portcullis—a lattice-work with spikes—rather than the monstrous instrument required by the story—a sort of falling blade that can not merely impale a horse but actually slice it in half. The Rodenegg painting is damaged, but appears to depict the slicing portcullis demanded by the plot.[72] If this is the case, the painter did not simply use a stock image but devoted some thought to the specific requirements of the tale to be narrated.

SCENE 7. DEATH OF ASCALON

While Ywain is trapped, Ascalon lies dead or dying in the arms of Laudine.[73] Though the death of Ascalon is certainly a key element in the story of Ywain, it is not actually described by Chrétien or Hartmann, and its depiction is not necessary in a pictorial narrative if the fatal blow, the "Bahrprobe," the burial, or some combination of these moments are narrated. The inclusion of the death scene at Rodenegg results, on the one hand, from the independent thematic emphasis desired by the artist; and,

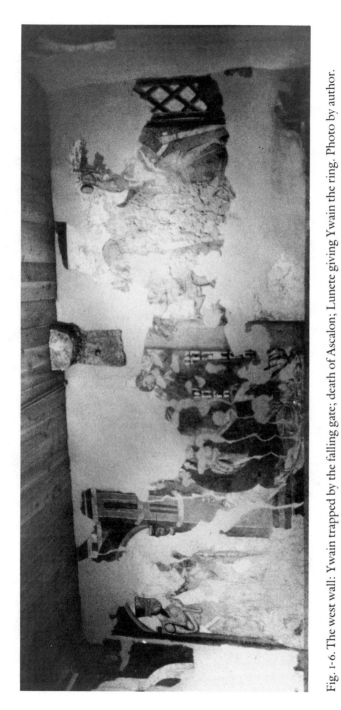

Fig. 1-6. The west wall: Ywain trapped by the falling gate; death of Ascalon; Lunete giving Ywain the ring. Photo by author.

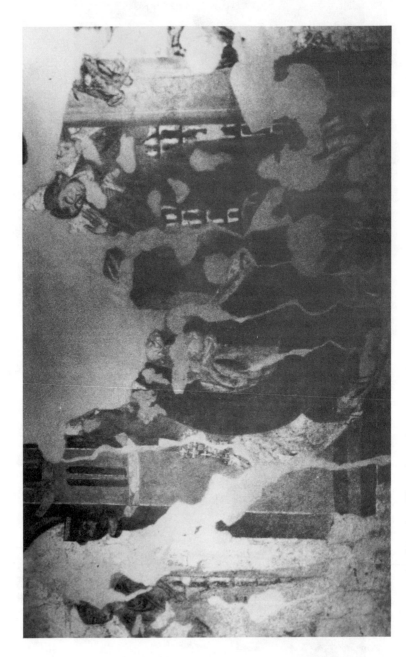

Fig. 1-7. Death of Ascalon. Photo by author.

on the other hand, from the influence of the "Lamentation of Christ" tradition in religious art.

The Lamentation (or Bewailing, or Threnos) developed, as Weitzmann has shown, from the Entombment, when one narrative moment was isolated and made into a "self-contained composition" with a devotional character ("Threnos" 476–79). The topos was fully developed by the eleventh century and was relatively widespread in Byzantine and Italian art in the late twelfth and early thirteenth centuries.[74] Due to their geographical and chronological proximity to Rodenegg, two paintings deserve particular notice. One that was probably made just a few years before the Ywain-frescos is a tempera painting on the stem of a cross from the San Matteo monastery in Pisa, depicting Mary holding the dead Christ on her lap.[75] Though almost certainly not a direct source for the Ascalon scene, the Pisa painting shows that the Rodenegg "lamentation" is no isolated invention, but a motive known to painters of the time.

Much closer to Rodenegg is the Lamentation fresco in the crypt of the cathedral in Aquileia. There, Jesus lies on the ground; Mary lifts the head of the prone Christ with her right hand and embraces him, holding his right hand in her left. Their heads are close together, as if she were kissing him.[76] The fresco almost certainly predates the Rodenegg paintings, though it may have been new when the Ywain cycle was made.[77] Rasmo (esp. *Affreschi* 68) perceives an Aquileian influence on the style of the Rodenegg paintings, and though Bonnet rejects Rasmo's arguments, she herself finds a similarity between the faces at Rodenegg and those in the crypt at Aquileia; and she specifically mentions the Deposition (Taking down from the Cross), though not the Lamentation. Nonetheless, she insists that no parallels can be found for the Death of Ascalon: it is, she claims, a newly created image based directly on the text of *Iwein* and perhaps inspired by thirteenth-century literary "Marienklagen" ("Überlegungen" 34). The Pietà, she notes, is a "lamentation formula that is actually developed much later" (*Rodenegg und Schmalkalden* 42).[78] This commentary overlooks the obvious. Granted, the Death of Ascalon is not a copy of the Aquileia Lamentation. But given that the Lamentation scene was fairly widespread in the art of the region and the era, and given that a prominent manifestation of the topos was located less than a hundred miles from Rodenegg, it seems obvious that the Lamentation tradition—if not specifically the Aquileia fresco—is the source for the Death of Ascalon.[79]

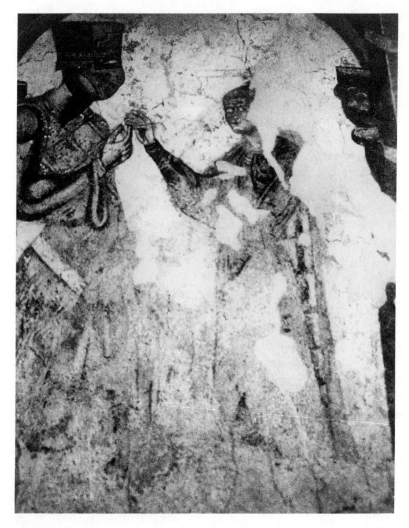

Fig. 1-8. Lunete giving Ywain the ring. Photo courtesy Leonhard Graf von Wolken-stein-Rodenegg.

SCENE 8. LUNETE GIVING YWAIN A RING
Ywain and the maiden stand in a small room indicated by walls and vault-ing. Still fully armed, Ywain raises his right hand, and the maiden places a ring on his index finger.[80] Bonnet describes the painting as "text-treu" (*Ro-denegg and Schmalkalden* 44), but it does not actually follow the details of Hartmann's text. In *Iwein* (1202–10), Lunete says to Iwein "take this ring"

("nemet diz vingerlîn") and explains, not that the *wearer* of the ring will be invisible, but that the ring will make anyone invisible who holds the ring in his bare hand. The narrator then remarks "And so she gave it to him" ("Alsus gap sîz im hin" [1211]). The text does not say that she places the ring on his finger; indeed, the words of the text would rather suggest that she does not. Far from being precisely true to the text, the painter creates a generalized scene of ring-giving.

SCENE 9. ASCALON ON HIS BIER/ASCALON'S FUNERAL
As Ywain watches from a window, the grieving Laudine stands with folded hands, apparently (the painting is damaged) looking down at her husband's coffin. A number of people look on in grief, and a cleric stands by. Although most of the portion of the painting that showed what Laudine is looking at has been destroyed, enough remains to suggest strongly that what the mourners are looking at is a draped or ornately decorated coffin with a "hip roof." Most of one end is visible directly in front of Laudine, in the left-hand part of the scene. In the same area, two carrying poles or handles project to the left. The scene must, therefore, be identified as either Ascalon lying in state, or, as the closed casket and the presence of a priest with a cross suggest, Ascalon's funeral.

Any speculation that this is the "Bahrprobe," the scene in which the dead Ascalon's wounds bleed afresh, indicating the presence of his killer and inspiring the search for Ywain depicted in the next section of painting, is surely groundless. Bonnet argues that the astonished expression of the central figure who appears to point at something, together with the "widow's rigid gaze" and the fact that all the figures appear to stare at the corpse, strongly suggest that the moment of Ascalon's bleeding was depicted (*Rodenegg and Schmalkalden* 45–46). In fact, the expressions of grief and the fact that everyone appears to stare at the body are entirely reconcilable with a generalized scene of mourning similar to the one in the Paris *Yvain* manuscript (fol. 72v; see below, p. 165). The startled expression of the one figure who appears to be talking might, indeed, suggest that something unusual is happening, although it might simply indicate the court's amazement at Ascalon's death. But if the object in the foreground was a closed and draped casket, the scene can hardly be identified as the "Bahrprobe."[81]

Ywain's observation of the proceedings from a small window might suggest a specific acquaintanceship with the Chrétien/Hartmann version, even though the detail is misplaced in relationship to the texts.[82] But the detail also might be simply the painter's way of reminding the viewer that

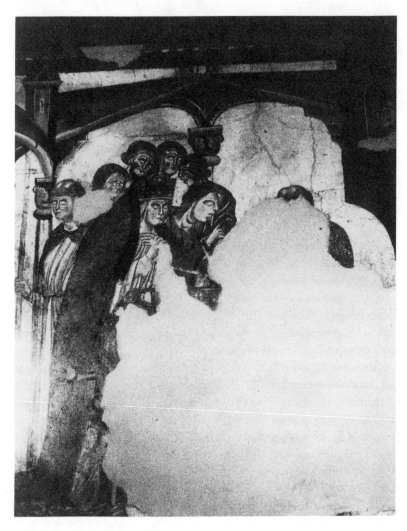

Fig. 1-9. Ascalon on his bier. Photo by author.

Ywain is hiding in the next room while Laudine mourns for Ascalon. And even without a "Bahrprobe," that detail serves to set up the next scene, in which Ascalon's men, convinced that their lord's killer must be present, search frantically for Ywain.

SCENE 10. SEARCH FOR THE INVISIBLE YWAIN

Several men slash and thrust wildly about with swords and a lance, while an older man gestures and points to his eyes, as if explaining that they cannot see the object of their search. In the lower left-hand corner of the scene, a curtain hides Ywain. That portion of the painting is almost completely destroyed, but Ywain's hand and the top of his head are visible above the blank area, and fragments of his surcoat appear below.[83]

If the version of the Ywain story the painter knew related that the knight was not discovered because the ring had made him invisible, the depiction of Ywain behind a curtain represents the artist's effort to solve the difficult problem of depicting invisibility in a visual medium. The painter cannot show an invisible figure, and he has no way of telling the viewer that a figure is present but not shown. By depicting Ywain behind the curtain, the artist indicates that he is in the room but cannot be seen by the searchers. Exactly how viewers understand this probably depends on how much they already know of the story. While pre-informed viewers might easily recognize that the curtain symbolizes Ywain's invisibility, as Bonnet claims (*Rodenegg und Schmalkalden* 48), it seems likely that viewers who did not know the story already would simply see that Ywain was hiding behind a curtain. Such viewers would have no way of knowing that the ring made Ywain invisible, and would probably think that Lunete gave Ywain a ring as a symbol of her promise to help him, and then hid him so securely that he could not be found. On the other hand, even uninformed viewers might guess that Ywain is invisible by analogy to the conventional method of depicting the contents of dreams, visions, and speeches by setting them apart from the rest of a picture by means of a cloud frill or a halo—the technique Ringbom labels "differentiation" (52–55). The lesson here is that knowing whether Ywain is invisible or merely well hidden is not essential to the plot. Either way, he is secure, and his searchers are frustrated. Since the next scene depicts Ywain's surrender, however, the viewer not familiar with the story might well assume that Ywain has been captured.[84] The importance of this will be discussed more fully below.

Bonnet (48–49) dutifully notes that while Hartmann's text contains two searches for Ywain (vv.1257–1304, 1370–80), the paintings condense

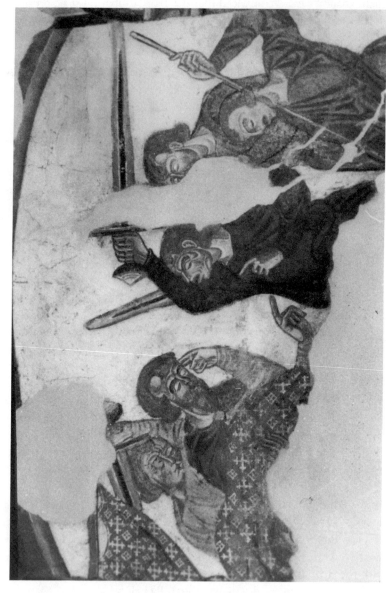

Fig. 1-10. Search for the invisible Ywain. Photo courtesy Leonhard Graf von Wolkenstein-Rodenegg.

the two into one scene. The condensation—assuming that the story as the painter knew it did include two search scenes—allows a more economical narrative. Crowding two search scenes into the available space would have destroyed the logical flow of the narrative from Ywain's entrapment, to the mourning for Ascalon, to the search.

SCENE 11. LUNETE'S PRESENTATION OF YWAIN TO LAUDINE
Laudine sits, grieving, with her head in her left hand. The pose, which is not described in the text, is a conventional pictorial depiction of grief, based on a topos common in Christian iconography, but with deep roots in classical art as well.[85] Indeed, the gesture of holding the head in one hand had long been the most common nonviolent gesture of sorrow in classical, Byzantine, and medieval art (Maguire 132).[86] All sorts of grief, misery, depression, pain, and remorse were expressed by the pose. Mourners appear seated, with head in hands, on an Attic grave relief and on a Roman sarcophagus in Ostia (Maguire 134, fig. 16), and the two Marys sit in the same posture by Christ's tomb in a series of Byzantine images from as early as the fifth century.[87] The pose was used in early Christian and Byzantine art for the regretful Adam, the remorseful Peter, the suffering Job, the sorrowful disciples in Gesthemane, the weeping Hebrews by the waters of Babylon, and the mournful Joseph in Nativity scenes (Maguire 132–40).

In later art, the pose occurs most frequently in the iconography of David and Jeremiah.[88] The scene "David Weeps for Saul" is commonly used as a frontispiece or opening initial for 2 Samuel, and though David is most frequently depicted rending his garment in his grief, he is shown seated, resting his head in his hand, in at least five eleventh- or twelfth-century manuscripts.[89] David's grief at the death of Absalom is likewise expressed by the head in hands pose in at least five other manuscripts.[90] Images of Jeremiah with his head resting in his hand as he mourns for the fate of Jerusalem are even more common, appearing at least six times before 1200, and twenty more times in the thirteenth century, usually at the beginning of the book of Jeremiah.[91]

By the early thirteenth century, the head in hand pose was clearly among the most obvious choices for an artist who needed to depict grief. The Rodenegg painter was not the only secular artist to employ the pose as a sign of sorrow. The gesture is used twice in the Berlin illuminations of Heinrich von Veldecke's *Eneid*—to indicate a mourner's grief at the burial of Kamille (fol. 52), and to show Dido's sorrow at Aeneas's departure (fol. 17).[92] Arthur is shown with head in hand, mourning the "supposed death

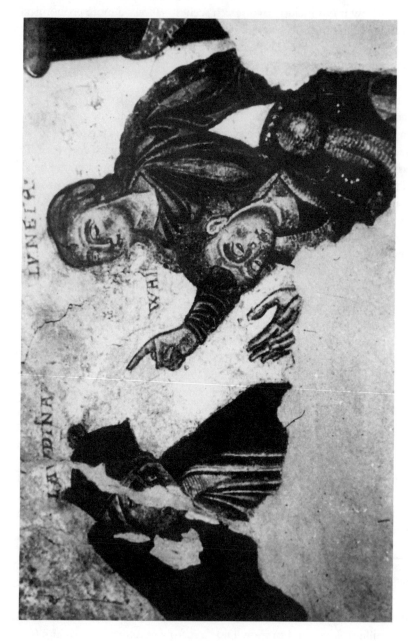

Fig. 1-11. Lunete presenting Ywain to Laudine. Photo courtesy Leonhard Graf von Wolkenstein-Rodenegg.

of Lancelot," in an initial in the Yates Thompson manuscript of the prose
Lancelot.[93] Perhaps most relevant for Rodenegg is that the gesture appears
in the Aquilea Deposition scene. But there is clearly no need to trace Lau-
dine's gesture to a specific source—the pose was an important part of an
early thirteenth-century artist's iconographic vocabulary.

Before Laudine are Lunete and Ywain. Lunete stands, her right hand
raised as if to make a point, her left hand resting on Ywain's shoulder in
the gesture of a patron saint.[94] Ywain kneels, his folded hands raised in
the supplicatory gesture that is today associated with prayer. It is a very
old conventional gesture of submission, originally associated with the cere-
mony of enfeoffment, but also signifying the submission of the lover to
his lady.[95] These poses and gestures do not add up, as text-oriented in-
terpreters have claimed, to the "reconciliation of Ywain with Laudine."[96]
As Bonnet correctly points out, Laudine displays nothing but grief, and
Ywain nothing but submission (*Rodenegg and Schmalkalden* 51). The the-
matic significance of this scene, and of the fact that the narrative ends here,
will be discussed in the next section.

But before moving on to a discussion of the possible interpretations
of the story the pictures tell, I must pause to summarize what my analysis
of each picture has shown about the iconographic factors governing the
production of the Rodenegg cycle. Most important, the Rodenegg painter
has created very few scenes from scratch, based purely on the inherited
plot. He has, of course, created new pictorial solutions to some of the
problems his plot presents—most notably, perhaps, in the search for the
invisible Ywain. But the painter has devoted the majority of the available
space, including the thematically vital space that is both the midpoint of
the narrative and the first section of painting seen by those entering the
room, to scenes drawing more heavily from iconographic traditions than
from the story of Ywain.

Clearly, the Rodenegg artist's goal was not to translate a text into pic-
tures, but to use an existing story as the basis for an independent pictorial
narrative. The inherited plot has been cut more or less in half and radically
restructured. Our next task is to determine exactly what story the pictures
tell.

The Rodenegg Ywain as Pictorial Narrative

A work so influenced by iconographic traditions, so clearly structured ac-
cording to its own thematic intent rather than the canonical text, is a work

that is obviously quite independent of the text and deserving of independent analysis. It is not, as many scholars have assumed, a derivative "illustration" that shows how Hartmann's near contemporaries understood *Iwein*,[97] but an independent pictorial manifestation of the Ywain material.

The weakness of the text-oriented approach is, perhaps, most obvious in the interpretation of the cycle's final scene, in which Ywain kneels before Laudine. Visually, the scene suggests not reconciliation but surrender. The knight's pose is one of total submission, and Laudine's expression and posture indicate unrelenting grief. Moreover, considering that the preceding scene shows the search for Ywain, viewers interpreting the images independently of Hartmann's text are likely to understand the final scene as indicating that the search has been successful, and Ywain has been captured. Scholarly interpreters of the Rodenegg cycle, however, have consistently ignored the visual evidence, assuming that Hartmann's text was the basis for both the production and the reception of the murals. The scene is thus seen as "Ywain wins Laudine," as if the image were nothing more than shorthand, a metonymic representation of the entire textual episode.[98] Schupp, for example, in a passage I have already mentioned, insists that "the logic of the story promises a happy ending, and the romance reader substitutes it" ("Ywain-Erzählung" 5). Such a statement confuses the text with the story. The *logic* of the *story* in no way requires a happy ending: what Schupp means is that the story told by Hartmann's text ends happily and the viewer who knows the text will, Schupp assumes, substitute the Hartmannian ending for the ending on the walls.

But could the typical Rodenegg viewer have done that? How much knowledge of the story did the typical early visitor bring to the Ywain room? We know in a recent count 32 manuscripts and fragments of *Iwein*, only about ten from the thirteenth century, and only one (B) from the early part of the century (Cormeau and Störmer 19).[99] That is a fairly large number of manuscripts for a German medieval romance (only of *Parzival* are significantly more preserved)[100], but even if many manuscripts have been lost, it is a very small number compared to the number of minor noblemen and ministerials in medieval Germany. It must have been a relatively rare household that had direct access to a manuscript of *Iwein*, especially in the early thirteenth century. Many more people, of course, may have heard a performance of Hartmann's text, perhaps during a visit to a larger court, perhaps during a visit by a traveling jongleur, in the beginning potentially even by the author. But how many? We do not know.

Clearly, the commissioning of the murals by the Rodank family suggests that they had some knowledge of the Ywain story. But again, we do

not know how much and what kind. Considering the rarity of manuscripts and the probability that the early depiction of Arthurian motives in the monumental arts was associated with ministerials at least in part because they did not have sufficient socio-economic stature to participate in the patronage of poets and thus in either the old oral tradition or the developing textual tradition,[101] it would appear most likely that the Rodanks and their visitors did not have first-hand access to Hartmann's text. It is more likely that some of them had heard performances of *Iwein*, and perhaps most likely that they had heard about the story of Ywain through informal narration and other forms of secondary orality. Most of them, surely, would have been familiar with the name Ywain and could have applied it to the lion-knight, especially with a little prompting from someone who could read the tituli. But in the absence of any real information about the knowledge of Ywain at Rodenegg in the 1220s or 1230s, we are left to consider the theoretical possibilities, as I have suggested in the introduction.

At the one extreme, viewers could have had no knowledge at all of the story, or no knowledge beyond the notion that "there was a knight called Ywain, the knight with the lion." At the other extreme, viewers could have come to the paintings fresh from reading *Iwein* or hearing it read. Most medieval viewers of the murals may well have fallen somewhere in between—having had varying amounts of knowledge of the story, without ever having heard or read a text. Scholars trying to understand how the Gregorian notion of pictures as the books of the illiterate actually worked in practice have often asked which sort of viewer was most common.[102] But what my analysis of the structure of the pictorial narrative will show is that it did not matter how much prior knowledge viewers of the Ywain paintings had, because the visual text did not ask them to activate it. The implied viewer of the paintings, like the implied reader of Hartmann's *Iwein*, is familiar with the genre of courtly romance, but does not yet know the story of Ywain. Where the paintings do not tell the same story as the text, viewers who know the written text are expected to base their understanding of the visual narrative on the images, not rely on their prior knowledge to correct or augment the pictorial narrative. In other words, the experience and understanding of the picture cycle will be much the same for viewers who know the story well and viewers who do not know it at all.

THE RODENEGG PAINTINGS: A STRUCTURAL ANALYSIS

In exploring the iconography of the Rodenegg paintings, I have discussed primarily production, attempting to determine what traditional images the painter relied upon to create the pictorial narrative. To a large extent the

process of reception mirrors that of production. If, for example, the painter draws upon his knowledge of traditional hideous human images to create his wild herdsman, viewers draw on their knowledge of similar traditions to interpret the images. If, in semiotic terms, the process of production is governed by iconographic and other codes, then the process of reception—by which the ideal or implied viewer creates diegesis out of the visual narrative—is presumably governed by the same or similar codes.

Literary scholars, of course, have been engaged in careful, sophisticated analysis of the diegetic process for a number of years.[103] Yet despite the influence of structuralist methods on some recent writers on visual narrative, no one, to my knowledge, has attempted the kind of detailed structural analysis with medieval pictures that literary critics like Roland Barthes have attempted with texts.[104] It is not my intent to set up an elaborate terminology or adopt Barthes's methods directly just for the sake of being theoretical. But I believe the structuralist approach to narrative exemplified by Barthes's work can help us to understand what happens when viewers confront visual narratives.[105]

In "Introduction to the Structural Analysis of Narratives," Barthes describes one of the primary units of narrative as the "function"—a unit, such as a segment of plot, which has its correlates "on the same level." (An "index," as we will see in a moment, has correlates on other levels.) A "cardinal function," or "nucleus" is one that refers to an action that opens, continues, or closes "an alternative that is of direct consequence for the subsequent development of the story, in short that . . . inaugurate[s] or conclude[s] an uncertainty" (265). A series of nuclei become a "sequence" when the first opens an uncertainty and the last resolves it; "sequence" is a flexible term that can designate a very small segment of narrative as well as a very large one (272–73). If James Bond is in his office at night and the telephone rings, that ringing is a cardinal function that opens an alternative—"it is equally possible to answer or not answer, two acts which will unfailingly carry the narrative along different paths" (265). The ringing thus inaugurates a sequence, which will end when the phone has either been answered or stopped ringing without being answered. If Bond is said to move towards his desk, light a cigarette, reach slowly for the receiver, and so on, these actions are not cardinal functions, but "catalyzers"—they advance the narrative in a purely chronological way; they do not open alternatives (266). And finally, if Bond is said to have "picked up one of the four receivers," the signifier /four/ may become an "index," relating the act of picking up the phone to other levels of meaning—indicating the size and

"power of the administrative machine behind Bond," and thereby suggesting that "Bond is on the side of order" (264). Some elements of narrative are neither functions nor indices, but only "informants," which serve "to identify, to locate in time and space" (267).

In the later *S/Z*, Barthes breaks a text into small units called "lexies," and analyzes each one in terms of five "codes"—the proairetic, the code of action; the semic, the code of setting; the hermeneutic, the code of knowledge, the creation and solution of enigmas; the referential, the code of culture; and the symbolic, the code that indexes units of narrative to deeper (or higher) meanings on other planes.[106] Again, I have no wish to make the theoretical apparatus more important than the narrative under analysis, but I believe that by combining the methodology suggested by the "Structural Analysis of Narratives" with that developed in *S/Z* we can significantly advance our understanding of what goes on when viewers confront the Rodenegg Ywain or similar narratives.

Lexie 1: A Knight Departs

In the first scene, if we have reconstructed it correctly, a knight departs from a castle. In the world of medieval romance, of course, a knight departs from a castle for only one reason—to seek adventure. The act is thus a "cardinal function" or "nucleus"; it opens a major sequence "to seek adventure," and it opens an alternative: the knight must either succeed and achieve glory, or fail and be dishonored. The expectation is very strong that the hero of a romance will achieve glory, and that the story will end with his triumphant return to a court (not necessarily the one from which he left). Symbolically, the knight's departure from a castle into the woods sets up the opposition castle/forest, inside/outside, society/world (J. Schultz 47). The hero ventures out from the safety of the court into the unknown potentialities of the forest.

That we identify the knight in this scene as the protagonist of our narrative is a function of the semic code—viewers automatically follow the rule that, if a knight departs from a castle in the first segment of a romance narrative, he must be the hero of the story. In all likelihood, the knight in this scene was identified either by a lion on his shield, or by a titulus, or both. Naming the knight "Ywain" or identifying him as "the lion-knight" probably had considerable meaning for some viewers and little or none for others. At a minimum, it probably identified him as belonging to the Arthurian cast of characters—as being one of the exemplary knights of the exemplary Arthurian court.[107] But regardless of how much or how little

knowledge a viewer may have had of Ywain from other sources, the figure in the painting is named and designated as the main character of the narrative just beginning. A viewer who previously knew nothing at all of the lion-knight or Ywain now knows that he is the protagonist of a story about to be told. In the proairetic code, then, the knight rides out, initiating the grand sequence of "adventure." In the semic code, the protagonist is introduced, and in the symbolic code, the opposition court/forest is invoked.

Lexie 2: Getting Directions from a Wild Herdsman

In the second scene, the knight gets directions from a wild herdsman. That is a sequence in its own right, and it is educational to note how economically the visual narrative depicts a series of nuclei. Visually, it is one scene: the knight sits on his horse, his arm extended; the wild man stands among his animals, pointing toward his right. Narratively, it is at least three nuclei: the knight approaches the herdsman, which opens an alternative in that the encounter could either lead to combat or not; the knight speaks to the wild man (that is the meaning of his extended arm), and the wild man could answer or not; and finally the herdsman points, closing the segment peacefully and allowing us to understand the sequence as "getting directions." The wild man's gesture is also very powerful visually, pointing the viewer on toward the next scene.

As established at length above, the herdsman refers, via the referential code, to a variety of traditions both learned and folkloric. It is impossible to know which of these references were activated for thirteenth-century viewers at Rodenegg, but, symbolically, the figure clearly connotes "wildness," which is obviously opposed to the "courtliness" embodied by the knight, just as "forest" was opposed to "castle" in the first scene. The knight has left the court and entered the wild realms: the conventions of romance lead viewers to expect that he will overcome this wildness and return to the court. As we will see, the outcome of this knight's encounter with the wild will not be exactly what the romance conventions lead one to expect, and his return to court will be of a highly ambiguous nature.

A number of elements in the scene—the trees, the wild animals— are "informants," which serve "to identify, to locate in time and space" (Barthes, "Introduction" 267). Setting the scene in a clearing in the woods with wild animals has a verismilitudinous function, helping to establish an illusion of reality. But the animals and trees are indices as well, functioning in the symbolic code to evoke "wildness" and "forest." Whether or not uninformed viewers can recognize that, as the text of *Iwein* tells us,

the wild man is "herding" these beasts, the association of the wild beasts with the strange figure who dominates the scene certainly strengthens the association of the scene with wildness. In the proairetic code, then, the second scene depicts the hero "getting directions." In the referential code, it refers to various traditions of wild men or hideous humans. Symbolically, it develops the "courtly vs. wild" or "society vs. world" opposition already articulated in the first scene.

Lexie 3: Pouring Water

Ywain takes water from a well and pours it onto a low altar-like structure. The fact that he does so without dismounting suggests that he has just arrived at the well, following the directions given by the wild man. The scene is framed by two trees, which again serve as informants to set the scene in the forest, and as indices, to remind us that this is the realm of adventure.

The reader or hearer of *Iwein* is told that this is what a knight must do in order to initiate a certain adventure. But what would the uninformed or poorly informed viewer make of this scene? Was the notion that knights can provoke adventures by performing apparently senseless acts in the forest sufficiently well known in courtly society that a viewer who knew something about the romance genre but little or nothing about Ywain could understand what the knight is doing here? The answer seems, clearly, to be yes. A viewer who had never heard of initiating an adventure by pouring out water from a well could still have recognized this as the sort of thing that knights do to get adventures started. This is true in part because, "intertextually," Ywain's action alludes to a variety of similar actions in other stories—Erec's entering the garden of Joie de la Court, Gawain's breaking the branch off Gramoflanz's tree, and so on. The adventure here is thus equated, in the referential code, the code of cultural knowledge, with other set adventures, like Joie de la Court or Schastel Marveille. The implied viewer is evidently expected to possess this cultural knowledge— not to know the story of Ywain in advance, but to know that in stories of the sort narrated here, knights often undertake pre-arranged adventures, which they provoke by various actions, like pouring water onto an altar. This is exactly what is expected, I would add, of the implied reader or hearer of an *Yvain* or *Iwein* text—not advance knowledge of the story, but a general familiarity with romance conventions. For such viewers, the act of pouring the water is clearly a nucleus—"starting an adventure"—that marks the beginning of a major sequence, which might be thought of as

"the adventure of the well." An obvious alternative is opened: the knight may succeed, or he may fail.

Lexie 4: Single Combat

Here, for the first time, the visual division of the mural cycle into scenes does not correspond to my division of the narrative into lexies or reading units. The scenes correspond, more or less, to nuclei, and the two scenes together make up the sequence "Ywain fights Ascalon" or "protagonist fights opponent," which I am treating as one unit here. The first nucleus of the sequence is the fight with lances.[108] The fight with lances has two possible outcomes: it may be decided or undecided. If one knight is unhorsed and the other is not, the combat is at an end. But if both knights break their lances without either being unhorsed, the fight continues to the next phase, the next nucleus here, the fight with swords. Since it is the presence of the sword phase that indicates the outcome of the lance phase, the second fight scene is a nucleus belonging to two sequences: it is the resolution of the sequence "fight with lances" and the opening of the sequence "fight with swords." The fight with swords also has two possible outcomes—like the lance phase, it can end with a decision or undecided. (Fights in literature sometimes go on to a third phase, that of wrestling.) Here, the sword fight ends when Ywain strikes Ascalon a serious wound in the head. The one image thus serves to narrate three nuclei—the resolution of the lance phase, and both the opening and the resolution of the sequence "fight with swords." In Hartmann's verbal narrative, of course, no set of words serves such a multiple function. We are told that the lance phase has begun, and then that it has ended without a victor. We are then told that the sword phase has begun, and then that Ywain has defeated Ascalon. A verbal narrative, however, *could* be made as economical as the visual narrative is here: "they fought with lances, and then they fought with swords, and Ywain struck Ascalon a terrible wound." A visual narrative *could* easily devote one scene to each nucleus: two pictures for the lance phase, and two (or even more) for the sword phase. The narrative economy of the two scenes is thus not determined by the limitations of the visual medium, but by the painter's decision to fill his space with a small number of large pictures rather than a large number of smaller pictures.

The economy, however, is not as severe as it could have been: the artist could have represented the whole fight sequence with one scene, dispensing with the lance phase altogether, as is done in the Paris miniature. The decision to depict the fight sequence with two large images must, there-

fore, reflect thematic or symbolic concerns, and the reading of these images must involve other codes than the proairetic. For one thing, the existence of a strong iconographic tradition for depicting knightly combat in this way means that the depiction here is inevitably connected, through the referential code, to every other courtly combat. Ywain's battle with Ascalon therefore stands, symbolically, for knightly glory and honor. Since courtly combats normally end in the surrender, not the death, of the defeated knight, the seriousness of the wound that Ywain strikes Ascalon may suggest, however, that something is not quite courtly here, that something is not quite right about the progress of the adventure, which otherwise seems to be bringing Ywain all the glory that could be expected for a romance hero.

Lexie 5: Becoming Prisoner

I have described the preceding two scenes as a battle sequence that ends in the wounding of one knight by the other, and the iconographic and narrative traditions of two-phase knightly combat certainly must have encouraged the viewers to see the two scenes as a unit. As the narrative continues around the corner onto the west wall, however, it becomes apparent that the wounding of Ascalon did not quite end the combat sequence. When viewers consider the next scene, they recognize that the wounding in fact opened up another alternative: the wounded knight might live or die. The alternative is not immediately resolved.

The sixth scene is complex, in that several nuclei are narrated by one image. The first is "pursuit"—Ywain chases Ascalon through a gate or doorway, raising his sword for another blow. The next is apparently "Ascalon's collapse," as far as can be determined from the poorly preserved images—Ascalon falls from his horse, to die or to recover. And the next is Ywain's narrow escape from the falling portcullis, which leaves him alive but a prisoner. In a verbal text, the three events would necessarily represent a narrative diachronicity: even if they were said to have occurred simultaneously, they would have to be narrated successively. In real time, of course, they could and might all take place at once, Ywain raising his sword for another blow just as Ascalon falls from the saddle and the portcullis comes down. The conflation of the events into one image is thus not a weakness of the visual medium, a failure to match the precise structure of the verbal narrative, but a strength, an ability to do what the verbal narrative cannot. On the other hand, it is questionable whether the viewer can actually comprehend all these events simultaneously. And if viewers are reading right to

left, following the narrative around the walls, they will perceive the events in the opposite of their order in the verbal narrative: the portcullis falls, then Ywain raises his sword, then Ascalon falls from his horse. But the occurrence of all these things in such a small space makes the precise order of the events irrelevant. The general impression is that they all happen more or less at once. Proairetically, Ywain pursues his wounded opponent into his castle, where Ascalon collapses, as the portcullis falls, trapping Ywain. The nucleus "becoming trapped" also opens a new alternative. The protagonist may escape or otherwise become master of the situation, or he may remain captive and the capture may mean his defeat. The alternative must be held open during the next scene, which does not bear directly on the hero's immediate fate.

Symbolically, the scene is dominated by the doorway, which sets up the opposition inside/outside and represents, ironically, Ywain's return to a castle, the adventurer's return to the court. The move back from the wild outside to the courtly inside has been expected since the knight-protagonist's departure in the first scene, but it has been expected to have a positive value. Instead, it has a clearly negative one: the knight returns to court not as a conquering hero, but as a trapped intruder.

Lexie 6: Death of Ascalon

Proairetically, this scene is simple: it depicts the nucleus, "death," that conclusively ends the combat sequence. But through the allusion to Christ's death and Mary's sorrow (a function of the referential code, calling upon viewers to activate their iconographic knowledge), the scene acquires considerable symbolic value. It is important to understand that this value is symbolic, not allegorical. Viewers are not expected to equate Ascalon with Christ; they are expected to recognize the profundity of the sorrow and mourning brought on by Ascalon's death.

I will say more, below, about the importance of this scene's location in the overall layout of the Rodenegg cycle. But in terms of the narrative structure we can note that the lavish depiction of Ascalon's death interrupts the sequence that began with Ywain's departure in the opening scene. That initial nucleus opened the alternative "return in disgrace" or "return in glory." Now that the sequence has been concluded, provisionally at least, with the return of the knight to court, the narrative has turned away from him altogether to focus on the death of his opponent. That means, on one level, that the overarching sequence "Ywain's adventures" is not yet at an end, and the alternative that his departure opened has not yet been closed. On another level, it clearly means that the result of the hero's adven-

tures has been not glory or honor, but death and the profoundest possible sorrow.

Lexie 7: Ywain Gets a Ring

The narrative now returns to the protagonist, whom we last saw in a dire situation, being trapped and almost killed by the falling portcullis. That action opened, as noted above, a new alternative, which the nucleus narrated here holds open. The hero stands in a small room—which suggests that he is still trapped—where a maiden gives him a ring. The pictures, unlike a verbal text, cannot explain why the maiden is giving the hero the ring. But for viewers following the visual narrative and waiting at this point for resolution of the alternative opened by the hero's entrapment, it is surely evident that he is receiving assistance. The act of ring-giving in itself works through the referential or symbolic code (alluding to other acts of ring-giving in the culture if not in the literature) to signify "assistance" or "pledge of assistance." [109] But in any event, it is clearly not a hostile act, and in the hero's precarious situation, anyone who interacts with him is necessarily either a friend or an enemy.

Lexie 8: Ascalon on His Bier

Proairetically, the fact that the hero's victim is lying in his coffin while his widow and other courtiers look on in grief does not advance the action at all. The knight's death has not opened any new alternatives for him (since this is not a story of the fate of his soul), and so the scene would appear to function reiteratively in the proairetic code, restating the fact of the knight's death and his court's grief, and, more importantly in the symbolic code, signifying not so much an action, "mourning," as an emotion, "grief." In Barthes's terms, the images here are not so much functions as indices, linking the level of plot to symbolic or emotional levels—in part through the visual allusion to other scenes of mourning and funerals, and in part by reference to viewers' real-life experience. The fact, however, that Ywain watches the proceedings from a small window (presumably from the room where the maiden gave him a ring), involves the scene in the arc of plot that began with the hero's entrapment by the falling portcullis. Will he be discovered by the agitated mourners? His presence so near, yet apparently unseen, keeps that question very much alive.

Lexie 9: Search for Ywain

The alternative is kept open, and the suspense it creates is increased in the next scene. Ywain appears to be in hiding behind a curtain, while

Ascalon's furious men stab and slash wildly about in search of him. Viewers who know the Hartmann version may see Ywain's pose as representing invisibility, while less informed viewers may simply think Ywain is hiding, but the plot only requires viewers to recognize that Ywain is in an extremely precarious position, surrounded by angry enemies, trapped in his dead opponent's castle.

Lexie 10: The Final Scene

The two main arcs of plot involving Ywain are both brought to an end in this final scene. One began in the first scene, with the knight's departure to seek adventure, which raised the expectation that the knight would eventually return to a court, and opened the alternative: return in glory, or return in shame? The other began when Ywain was trapped by the falling portcullis, a moment that opened a similar alternative of positive or negative outcome. Both alternatives are resolved here. But how?

Let us set aside, for the moment, the question of whether viewers are likely to have known the story in advance and relied on that knowledge to read the pictures. Even in purely visual terms, the image is somewhat ambiguous. Ywain's pose, as noted, works through the codes of both iconography and ritual to signify submission. But there are various sorts of submission. The pose here evokes, potentially, the submission of a vassal to his lord, the ceremony of manumission, through which the vassal pledges his service, but receives feudal holdings in return. From this feudal ritual is derived the idea of the lover pledging service to his lady, and so Ywain's submission to Laudine could suggest not so much surrender as the beginning of a courtly love relationship. The lady does not appear, however, to be receiving a lover's homage. Her pose and her facial expression connote nothing but grief, sorrow, and agony.[110] Any tendency that a viewer may have to look at Ywain's pose and read this as a courtly love scene is immediately undermined by Laudine's pose and expression. Moreover, although the scene appears to be in a position to resolve the major proairetic alternatives still open, if we think about it in concrete terms, we find that it actually raises further questions. Assuming that Ywain has surrendered to Laudine, what is she going to do with him? Have him executed? Proairetically, the scene is ambiguous, whether or not viewers bring in outside knowledge of the story. Is it "hero surrenders" or "hero pledges fealty to lady"?

But in the symbolic code the significances are clearer. They are "grief," "sorrow," and "submission." Although submission in itself is not neces-

sarily a bad thing, even at this level, the symbolic value of the scene as a whole is overwhelmingly negative. For viewers who read the proairetic content of the scene as a happy ending, that reading is strongly undercut by the image's negative value in the symbolic code. It is important to note that viewers might have expected a happy ending for one or both of two reasons. They might have known directly or indirectly the Hartmann version of the Ywain story. But even if they did not, the structure of courtly romance sets up powerful genre-based expectations. When the romance knight rides out to seek adventure, although the alternative success or failure is opened, the expectation is strong that the final result will be a successful return to the court. In the final scene at Rodenegg, these expectations are jarringly frustrated, if not by the images' ambiguity on the proairetic level, then certainly by the scene's unambiguous negativity on the symbolic level.

The point is not that viewers will therefore conclude that Ywain is about to be executed or banished. At the level of plot—I repeat—the scene is ambiguous. Some viewers may assume that the hero is pledging fealty to the lady and entering into a love relationship with her. Some viewers may recall their knowledge of the story of *Iwein* and identify the scene as the betrothal of Ywain and Laudine. But since any positive reading is immediately undercut by the pervasive sorrow in the scene, the understanding of the image is dominated by its thoroughly negative symbolic value.[111]

Disposition

Structure, a term that is ultimately metaphorical when applied to texts, is a literal, physical aspect of a cycle of wall paintings. The arcs of plot and the symbolic oppositions that I have discussed belong to diegesis and are products of the viewing process. But the physical layout of the paintings on the walls supports their effects in significant ways. The arrangement of images—what Lavin, borrowing a term from rhetoric, calls "disposition" (10)—has traditionally received surprisingly little notice in studies of monumental narratives. But Lavin's recent work on Italian church murals and Kemp's study of narration in stained glass call new attention to the ways in which visual structure contributes to meaning. Again and again, Lavin and Kemp show how "relationships and juxtapositions of scenes" work to create meaning of "greater than narrational value" (Lavin 6).

At Rodenegg, the most obvious element of the disposition is the central location of the "Death of Ascalon" in the center of the west wall at the midpoint of the cycle. As the first image to strike the eye of the viewer

entering through the door in the east wall, the scene sets a funereal tone and suggests death as the dominant theme of the entire cycle. As the midpoint of the narrative, the scene serves to divide the scenes of knightly glory on the north wall from the scenes of mourning, chaos, and despair on the south wall. This general opposition of the positive aspect of *aventiure* on the north wall against the negative results of *aventiure* on the south wall is also evident in important details. "Ywain at the Fountain" on the north wall is directly across from the final scene, in which Ywain kneels before the grieving Laudine. The stereotypically courtly beginning of the adventure is thus dispositionally opposed to its end in grief and submission. Likewise, the wounding of Ascalon appears directly across from his burial, the cause directly across from the effect. Finally, on the east-west axis of the room, Ywain's initial departure from a castle, the beginning of the entire adventure sequence, is directly juxtaposed to the "Death of Ascalon"—if not as cause to effect, then as the positive side of *aventiure* to the negative. The overall effect of these juxtapositions is to reinforce the opposition developed in the narrative between the positive and the negative sides of romance adventure. The glory and the beauty are opposed to the grief and the despair—to some extent as cause and effect, but more importantly as two aspects of the same phenomenon, like the two sides of *Frau Welt*.

The most basic aspect of disposition remains to be discussed. Given the wall space at his disposal, the artist could have chosen to employ two or more registers, as is done at Schmalkalden, and as is frequently done in the wall paintings discussed by Lavin. By painting in multiple registers and dividing the space into more but smaller segments, the painter could have depicted the entire inherited plot in considerable detail. The choice to paint one register of large, vivid images, and to dispose the scenes in just this way, was made with specific thematic and narrative goals in mind. What motivates the artist's decisions is not the desire to narrate the whole story in pictures or translate the text into a new medium. The artist—or "programmer," "ideologist," or "conceptualizer"[112]—chose this layout because he (or she) wanted to achieve precisely these thematic and symbolic goals, through precisely these juxtapositions, through precisely these images. The goal is not to turn the story into a clear defeat for Ywain and an absolute condemnation of his knightly endeavors. It is to depict courtly *aventiure* as having two sides—a glorious one and a tragic one—and thus to question, not necessarily to condemn, the ethics of the Ywain story and the romance genre.[113]

THE SOCIAL CONTEXT OF THE RODENEGG YWAIN

It has been argued, by Masser and Schupp among others, that thirteenth-century viewers of the Rodenegg paintings cannot possibly have read the pictorial narrative as having anything but a happy ending or anything but a positive message because these viewers—and the painter's patrons—were all knights who must have identified with the knights depicted.[114] This sort of argument fits in with the tendency among some image-and-text researchers (in particular Ott and Walliczek) to insist on the crucial importance of the social or functional context in the interpretation of images.[115] The importance of the social context is in many cases unquestionable. An image of Tristan and Isolde on a courtly lady's ivory comb is certainly more likely to have inspired thoughts of love than meditations on the sin of lechery. But to exclude all negative interpretations of the Rodenegg cycle simply because it was commissioned and viewed by knights overlooks the very real difference between the work's social function and its literary function. The question of social function is actually two questions—one of production and one of reception. What motivated the lords of Rodenegg to decorate their walls with these images? And how did the guests at Rodenegg respond to them?

In order to understand the motivations of the Rodenegg patrons, we must recall that the lords were ministerials. Members of this social class derived a quasi-feudal status from administrative service to a lord—in this case, the Bishop of Brixen—but remained "unfree"; that is, they did not, in the beginning at least, possess their own allodial estates and, therefore, did not attain a social rank equal to that of the older nobility.[116] Despite this inherently inferior status—they were not "noble"—these "Dienstleute" were, by the early thirteenth century, increasingly rich and powerful, and increasingly concerned with identifying themselves through clothing, heraldry, language, and attitudes as knights, or *miles* (Cormeau and Störmer 65). By commissioning "courtly" works of art, such "social climbers" enhanced their claims to being a part of the upper classes. The role of social class in the creation of German Arthurian romance needs a fuller investigation than can be undertaken here; it may be that the commissioning of visual works by upwardly mobile patrons like the Rodeneggs (and the Malterers in Freiburg) was influenced by the fact that literary patronage was still the province of the old nobility—Hermann of Thuringia, for example.[117] It might be that the power and wealth of the ministerials was not sufficient to keep a poet at court, but that commissioning a set of paintings

was relatively more affordable. In any case, it is clear that the most important function of the paintings from the point of view of their patrons must have been primarily to impress—not so much to imply that the lords of Rodenegg were knights of the same stature as Ywain as to establish their membership in the class of people who commission such art works.

Presumably, the guests at Rodenegg who saw the paintings were indeed impressed. But in order to understand more fully their possible responses to the cycle, we must also consider the social context for the reception of the paintings. Under what circumstances were the paintings viewed? That social context is implicit in the designation of the room as a *"Trinkstube."* [118] With a heating stove in one corner, the room was apparently used for drinking and perhaps dining by relatively small groups. From the point of view of these users of the room, the social function of the paintings must have been primarily to entertain. At least some of the men who drank in the room must have derived satisfaction from imagining themselves to be as heroic as Ywain; conversations may have arisen about the interpretation of the Ywain story, or about the relative merits of this version as compared to others. The paintings served as an entertaining backdrop for social gatherings.

But do these twin social functions of status symbol and entertainment necessarily exclude all other literary functions? Certainly not—no more than the fact that Hartmann's *Iwein* was performed to entertain the nobility means that we must read it as an unproblematic series of knightly adventures. We know that *Iwein* raises, and must have been intended to raise, various questions about knightly behavior. We may disagree about precisely which questions are raised, and we may disagree violently about how we are to answer them. But we know that the early part of Ywain's life is problematic, because the story tells us so: Ywain is rejected by Laudine, goes mad for a time, and must laboriously regain all that he seemed to have won. The structure of the text raises questions about certain of Ywain's deeds—and it does so despite the fact that the text was written for an audience of knights. In the same way, the structure of the pictorial narrative at Rodenegg raises questions, despite the fact that the murals were no doubt intended, on the surface, as a status symbol and a decoration or entertainment.

THE RODENEGG YWAIN IN THE PROCESS OF LITERARIZATION
This questioning of the values inherent in the story and its genre clearly marks the Rodenegg cycle as an independent participant in the process

of literarization of vernacular narrative. The artist is not merely retelling an old story in a new medium, he is reflecting on the significance of that story and creating a new thematic emphasis based on that reflection. The making of a new narrative out of an old story by the Rodenegg painter is exactly parallel to the making of new narratives out of old stories by the vernacular poets—the process described by Chrétien's oft-quoted statement in the *Erec*-prologue that he will make from a "conte d'avanture" a "molt bele conjointure" (13–14). Whatever the source and the precise meaning of "conjointure," in opposition to "avanture" it clearly suggests "literature," or "fictional narrative," in contrast to preliterary (oral) storytelling.[119] In these lines, Chrétien draws attention to the fact that he is not simply recording an oral tale in writing—he is creating a new work of art, with its own plot, structure, and themes. Likewise, Hartmann does not simply translate Chrétien's French text into German: he also creates a new work of art, with its own narratorial voice and its own emphases. Finally, the Rodenegg artist does not simply translate either of these texts into pictures. He also creates his own independent work of narrative art, using techniques and structures appropriate to his medium, relying on existing topoi and traditional motives of his medium to create a new "conjointure" out of the existing stories of "avanture."

Just like the texts of *Yvain* and *Iwein*, the paintings represent a self-reflexive attempt to answer the wild herdsman's question: "âventiure: waz ist daz?" (Hartmann 527). The structure and iconography of the mural cycle create a profound ambiguity and raise, but do not answer, serious questions about the nature of knightly adventure. Standing among the very first visual narratives of vernacular tales, and not far from the beginning of the romance genre in literature, the Rodenegg Ywain cycle, like the texts but entirely independent of them, reflects self-consciously on the kind of genre it is creating, thus participating fully, and independently, in the process of literarization.

Notes

1. A note on the spelling: the castle Rodenegg is located in the village of Rodeneck (Italian Rodengo) near Brixen.

2. Although often referred to as "frescos," the paintings are not frescos in the technical sense, but were executed *al secco* (Bonnet, *Rodenegg und Schmalkalden* 31).

3. In 1928, Garber described the fragments then visible, suggesting that the

painting on the south wall (the largest visible fragment) was probably a cruci-
fixion (128). He assessed the style as "spätromanisch" and dated the paintings in the
second half of the thirteenth century (109–10). Cf. Weingartner (*Kunstdenkmäler*
1:268). For other descriptions of the pre-restoration appearance of the paintings,
see Schupp ("Anmerkungen" 424), Szklenar (175), and Rasmo (*Affreschi* 66).

4. On the discovery, see Ackermann (391); Szklenar (174), Rasmo's "Über-
raschende Funde" describes the paintings but not the discovery. Rasmo's first de-
scription of the paintings appeared in a 1974 wall calendar published by the Spar-
kasse der Provinz Bozen, which has proved impossible to locate.

5. The exact dimensions: north wall, 7.1 m; east wall, 4.3 m; south wall,
6.8 m; west wall, 4 m (for floor plans, see Ackermann 399; Bonnet, *Rodenegg und
Schmalkalden* fig. 1). The paintings begin about 1.5 meters above the floor and ex-
tend more or less to the ceiling, covering a height of about 1.9 meters (Ackermann
398).

6. For detailed descriptions see Szklenar (175); Schupp ("Anmerkungen"
424); Ackermann (398); Bonnet (*Rodenegg und Schmalkalden*).

7. Ackermann (398); Szklenar (178); Schupp ("Anmerkungen" 424).

8. "Ein 'Epenraum' ist als geschlossene darstellerische Einheit aufzufassen"
(481).

9. For agreement, see Szklenar (178); Ott and Walliczek (476 and 481);
Masser ("Wege" 395); Schupp ("Die Ywain-Erzählung" 5).

10. In a document dating from 1140–47, probably 1144–45, Bishop Hart-
mann gives to Friederich the *mansus* Rodenegg, "in quo edificaverunt sibi castrum"
(Redlich no. 457, pp. 16–61; cf. Garber 109; Ackermann 392; Weingartner, *Burgen-
kunde* 13; Töchterle 19). The Rodank family sold the castle to Meinhard II in 1269
(Weingartner, *Burgenkunde* 45) or 1271 (Ackermann 392). The castle passed through
various hands until, in 1491, Maximilian I gave it to Veit I von Wolkenstein, a grand-
son of the poet Oswald. Rodenegg remained in the Wolkenstein family until its
male line died out in 1849, then again passed through several owners until 1897,
when it was acquired by Graf Arthur von Wolkenstein, who then called himself
Wolkenstein-Rodenegg; this family still owns the castle today (Ackermann 392).

11. For example, "Überraschende Funde" (48). A note of clarification on the
names of the Brixen churches is necessary. The Chiesa della Beata Vergine or Nos-
tra Signora in ambitu, known in German as the Frauenkirche, which I will call the
Church of the Blessed Virgin, is located on the west side of the cathedral cloister.
On the south side is the Chiesa di S. Giovanni Battista, or Bapistery, known in
German as the Johanneskapelle or Johanneskirche, which I will call the Church of
St. John the Baptist, or simply St. John's.

12. See also Ackermann (417), Bonnet ("Überlegungen" 26).

13. See Bonnet ("Überlegungen" 26) for a skeptical account.

14. See Rasmo's *Pitture Murali* (11–13) for a more cautious assertion that
Konrad's court painter is perhaps identifiable with the Hugo of the document.

15. See also Ackermann (417), and Szklenar (179)—both referring to various
works by Rasmo.

16. See, most recently, Diemer and Diemer's succinct rejection of Rasmo's
theories, which includes a review of the scholarship. Bonnet had earlier reached

the same conclusion: the existence of a court painter Hugo cannot be proven, and the works which are ascribed to him are not the works of a single artist ("Überlegungen" 23, 26–27; *Rodenegg und Schmalkalden* 147–48). Much earlier, Morassi (149) had also rejected the Hugo hypothesis. Even Ackermann, who takes Rasmo's biography of Hugo at face value, says only that it is "nicht auszuschließen" that Hugo painted the Rodenegg frescos (20). Schupp ("Die Ywain-Erzählung" 9) does not question the existence of Hugo, but attributes only the Frauenkirche murals to him, attributing the Rodenegg and St. John's paintings to another, nameless artist.

17. "Überraschende Funde" (48). A document of 1221 describes a chapel in the Church of the Blessed Virgin, "die er schön und anständig erneuert hatte" (Bonnet, "Überlegungen" 25). None of this, however, specifies the nature of the improvements he ordered to the Frauenkirche or directly connects him with St. John's. Cf. Bonnet ("Überlegungen" 26; *Rodenegg und Schmalkalden* 28).

18. For agreement, see Schupp ("Anmerkungen" 433): "als Auftraggeber . . . kommt nur der Herr von Rodeneck selber in Frage." The bishop, Schupp speculates, might have "loaned" the painter to the secular lord. Cf. Ackermann (417).

19. On the Rodank family, see especially Töchterle (23, 26, 28); also Schupp ("Anmerkungen" 433).

20. For a clear discussion of the date of *Iwein*, see Cormeau and Störmer (30–32).

21. Szklenar (178); Ott and Walliczek (476); Ackermann (416); Bonnet (*Rodenegg und Schmalkalden* 16). *Ascalôn* is the reading of the standardized text (*Iwein* v. 2274). But the *Aschelon* of the frescos, which reflects the Bavarian shift of *k* to *ch*, is paralleled by the *aschalon* of the Upper German MS. D (*Iwein*, ed. Benecke et al., note to line 2274).

22. This speculation is revived by Van D'Elden (264).

23. Ott and Walliczek protest that the lion on Ywain's shield proves a knowledge of the second part of the story, in which Ywain becomes the "knight with the lion" (476–77). But an awareness of Ywain as the lion-knight might easily have preceded knowledge of the complete story in the area. Moreover, since the lion was the most common heraldic device in the Middle Ages (Pastoureau, *Traité* 136), it is difficult to attribute too much importance to the appearance of a lion on a fictional shield. Masser ("Ritterhelm" 183) also argues that the lion alone cannot prove the patron knew the entire text.

24. Ackermann, on the basis of Rasmo's speculations and his own stylistic analysis, suggests the 1210s and notes that the early date implies a very rapid spread of the romance's popularity (420).

25. Ott and Walliczek accept 1200–1210 as the date with no further comment (476).

26. Art historians have long debated whether early thirteenth-century art in South Tyrol and specifically in Brixen represents a continuation of the Salzburg school—itself a product of a strong Byzantine influence—or a new Byzantinism based on Italian models. The best answer seems to be the synthesizing view of Frodl-Kraft ("Margaretenfenster" especially 28 and 29) and Demus (92–94 and 311), who find that Brixen art reflects both a continuation of the Salzburg tradi-

tion and new Italo-Byzantine impulses. Rasmo (*Affreschi* 66–68) denies any Salzburg influence, while Bonnet stresses the Salzburg influence but finds that the Brixen style is difficult to locate between the "poles" of Salzburg and northern Italy ("Überlegungen" 30–33, here 33).

27. An early adherent to this theory was dell'Antonio (320).

28. Garber (103) and Morassi (160) represent the earlier scholarship on St. John's. On the recent redating, see Rasmo, ("Überraschende Funde" 48), Bonnet ("Überlegungen" 24), and Diemer and Diemer (57).

29. These views are consistently repeated throughout Rasmo's numerous publications on the art of the South Tyrol. See *Kunstschätze Südtirols* (30–31), "Aspects of Art" (168–74), *Pitture Murali* (11–13). Bonnet's judgment of Rasmo's one-artist theory is that it was developed "ohne Analyse und Begründung" ("Überlegungen" 24).

30. ". . . sehr plastische, voluminöse Figuren, die in ihrer Körperlichkeit den Raum nützen, den die Architektur bereitstellt" ("Überlegungen" 29).

31. ". . . etwas feinergliedrige, zartere Figuren, deren Gewandung zwar der von A gestalteten angepaßt, aber nicht in derselben Weise plastisch durchgebildet ist" ("Überlegungen" 29).

32. Garber (98) anticipates Bonnet in his identification of two stylistic generations in the two painters of the Frauenkirche.

33. The differences between the Rodenegg paintings and those in the Church of the Blessed Virgin are not so much a matter of date, Bonnet thinks, as function: "Der Maler der Frauenkirche hat ein religiöses Thema monumental zu gestalten, das keinerlei erzählerische Momente hat; entsprechend hieratisch und großangelegt sind seine Bilder. Der Rodenegger Maler hingegen muß eine fortlaufende Geschichte wiedergeben, die von heftigen Gefühlsbewegungen und Handlungen geprägt ist; so entstehen bewegte, expressive Bilder" ("Überlegungen" 38).

34. Bonnet repeats the findings of her article in *Rodenegg und Schmalkalden*, concluding "zeitlich sind die Fresken in den 20er Jahren des 13. Jh. anzusiedeln" (61–62). The Diemers generally agree with this chronology, seeing the Frauenkirche paintings as clearly later than those at Rodenegg or St. John's, and the St. John's paintings as slightly older than Rodenegg, in style if not necessarily in date (57–58). Achim Masser's study of the armor depicted at Rodenegg produces a date of "um 1205" ("Ritterhelm" 198) for the paintings, but is ultimately unpersuasive because it relies too heavily on the assumption that relatively minor changes in helmet design will be directly and immediately reflected in art, and Masser's considerations must give way to Bonnet's stylistic analysis (see Diemer and Diemer [57] for agreement).

35. Cf. Diemer and Diemer (58). On the date of the Ywain frescos, they conclude that it should be possible "eine Hypothese aufzustellen, welche auch den Kriterien von Literaturchronologie und Rezeptionsbedingungen in der höfischen Gesellschaft angemessen Rechnung trägt, ohne das erste Viertel des 13. Jahrhunderts zu überschreiten" (57). See Curschmann ("Der *aventiure*" 220, also "Images of Tristan" 5) for agreement; in the latter work he prefers the 1220s to the 1230s, largely because of the presumed connection to Thomasin of Zirclaria.

36. On the *beatus*-David, see Pickering (103–5 and 124–25, with further references; pl. 10a and b).

37. On the *profectio* and other such stereotyped scenes, see Hölscher ("Geschichtsauffassung," esp. 291–92); on battle topoi, see Leander-Touati (28).

38. Cf. Ott and Walliczek's critique of Schupp (478).

39. As does Szklenar (175), referring to the "Logik der Erzählfolge," and Ackermann (400–401). Cf. Schupp ("Anmerkungen" 424).

40. Szklenar (175) and Ackermann (400–401) both identify the hawk and the castle's lord. Both also note that a direct association of the image with the text would lead to the identification of this scene as Ywain's arrival (*Iwein* 976–78), a scene that may be assumed to be identical with Calogrenant's arrival (*Iwein* 282–85), where the hawk and the lord are actually described.

41. See her reconstruction drawing (*Rodenegg und Schmalkalden* fig. 4). Bonnet elsewhere contradicts her own reconstruction, referring to the scene as "Abschied und Ausritt" (33).

42. Cf. James Schultz's description of the archetypal Arthurian episode: "the hero, at home in society . . ., hears of an opponent" and leaves society, traveling through a woods to an encounter with the opponent (66–75). And: "an Arthurian hero can be sure, on entering the woods, of finding *aventiure*; every Arthurian woods is the Walt Aventuros" (14; see also 71–73).

43. It appears in two of the four Ywain cycles (here and at Schmalkalden), and in about a third of the Tristan cycles cataloged by Ott ("'Tristan' auf Runkelstein" 202; "Katalog" 141–56).

44. Bonnet's suggestion (*Rodenegg und Schmalkalden* 58, 153) that this scene is iconographically related to Christ's entry into Jerusalem seems far-fetched—since that is an arrival and this is a departure—and her proposed example, the mosaic at Monreale, does not resemble a knight's departure at all (see Kitzinger pl. 50).

45. On the *profectio*, see Hölscher ("Geschichtsauffassung" 291–92).

46. As in Bonnet's reconstruction (fig. 4). The fact that the women peering from above the gate in the first scene gaze to the right, into the empty space, supports this theory, since they may well have been gazing after the departing Iwein (cf. Ackermann 401; Szklenar 175).

47. Szklenar says three (176).

48. Hartmann's description (*Iwein* 425–70) varies from Chrétien's (*Yvain*, ed. Roques 286–311) in some details. In *Yvain* the wild man's nose is like a cat's, in *Iwein* an ox's. In the French text the herdsman has eyes like an owl; in the German they are simply red. Chrétien's creature merely has sharp teeth; Hartmann's has tusks like a boar.

49. Bonnet's reconstruction suggests that the herdsman wears skins around his waist (fig. 6).

50. Ackermann (403), Schupp ("Anmerkungen" 428), and Bonnet (*Rodenegg und Schmalkalden* 35) point out these ways in which the Rodenegg wild man varies from the herdsman described by Hartmann. But Bonnet also claims that his dark skin "illustriert aber genau" the line "er was einem Môre gelîch" (*Iwein* 427) (*Rodenegg und Schmalkalden* 35).

51. He is discussed as a "wild man" by Salmon ("Wild Man") and Bonnet (*Rodenegg und Schmalkalden* 35), among others.

52. See also, but less helpfully, Möller, and Scheine.

53. On the later "triumph" of the wild man as the "noble savage" in the seventeenth and eighteenth centuries, see Hayden White.

54. On the wild man as a mythological figure, see Bernheimer, Husband, Möller, and Scheine; for more detail, see Mannhardt, and "Wilde." The oldest records of folk beliefs in wild men seem to be a tenth-century decretal of Burchard of Worms referring to the South Tirolese belief in the "Salvang" (Mannhardt 113) and a Hessian document of "vor dem 11. Jahrhundert" naming a place in the Bernahrdswald "wilderô wîbô hûs" (Mannhardt 87).

55. According to Bernheimer, the "first indubitable representations in art" appear in the mid-thirteenth century, and the real popularity of the image begins in the second half of the fourteenth (21–22). See also van Marle (*Iconographie* 183).

56. Bernheimer (30) wonders whether the widespread notion of the wild man in medieval literature—e.g. *Aucassin et Nicolette* 24,2; *Roman de la Rose* 3155, 3755, 15304; *Orendel* 1235–60—is a native inheritance or a dispersion of Arthurian prototypes. Mulertt is more nearly certain that the *Yvain* passage stands "[a]m Anfange der Wildmanns-Abbildungen (83).

57. Chrétien calls the herdsman a "vilain" (292 etc.); Hartmann calls him a "waltman" (598) and says that his ears are as hairy as those of a "walttôren" (440).

58. Studies of the wild man often include some of the hideous humans without distinguishing them from the much different wild men. Some of the most helpful work on the hideous people has been done by scholars studying medieval ugliness in general, or specific hideous characters. See especially Brandt, Dallapiazza, and Wisbey's two essays.

59. For a discussion of Sibille and Charon, as well as Cundrie/Kundry and the Ywain herdsman, see Brandt.

60. The manuscript is Berlin, Staatsbibliothek Preußischer Kulturbesitz, Mgf 282. Schneider's dating on paleographic grounds to 1220–30 (99) is reinforced by Diemer and Diemer's discussion of the miniatures ("Die Bilder" 928–32). These findings supersede Boeckler's older suggestion of 1210–20, which was accepted by Schieb and Frings (in Heinrich von Veldecke liv).

61. Kundrie is described in *Perceval* (4608–39) and *Parzival* (313,1–314,10 and 780,18–27); compare also her brother Malcrêatiure (*Parzival* 517, 11–30). For Merlin's appearance as a monster in the *Livre d'Artus*, see Sommer (*Vulgate Version* 7: 124). Freymond discusses this hideous Merlin, calling him a "*mixtum compositum* verschiedenartiger Monstren" (54–55).

62. It must be noted that Gnatho is not a real person but a character from Terrence's *Euripides*; the description is really an extended figure for the character's vile personality and develops in the context of a lengthy *vituperatio*. Cf. Curtius 188n3; Brandt 257; Salmon ("Wild Man" 525).

63. Curtius (188n3); Brandt (257), both with further references.

64. Sidonius compares Gnatho's ears to those of an elephant, but does not say that Gnatho has an elephant's ears; Hartmann says that the herdsman was "starke gezan, /als ein eber, niht als ein man" ("strongly toothed,/ like a boar not like a man," *Iwein* 455–56). But is Hartmann's language a simile describing a man with large, protruding teeth, or a literal statement that the man has boar's tusks? Compare Wolfram's description of Cundrie as having "zwên ebers zene" (*Parzival*

313,22), and the miniaturist's depiction of her with long curving tusks in cgm 19, fol. 50 (Loomis and Loomis, fig. 357). Is it possible that the boar's tusks are still metaphor in Wolfram's text and become literalized only in illuminations? Could it be that the Rodenegg painter omits the boar's tusks because he understands what the Parzival illuminator does not—that the verbal description is not to be taken literally?

65. This "pseudo-Fermes" tradition seems to derive from a fourth-century Latin treatise purporting to be a letter from a certain Fermes to the emperor Hadrian; it is preserved in at least three English manuscripts: Cotton Vitellius A.xv of about 1000 (in an Anglo-Saxon translation), Cotton Tiberius B.v. of the eleventh century (in Latin), and Bodley 614 of the early twelfth century (in Latin). All are lavishly illustrated and have been published by James; see also Wittkower 172–73).

66. All this, of course, sharply contradicts Bonnet's judgment that, given the lack of contemporary evidence, the importance of pictorial topoi is virtually impossible to assess (*Rodenegg und Schmalkalden* 35 and 153).

67. Bonnet remarks that the artist has "replaced" the "'Quelle'" of the text with the "Topos 'Brunnen'" (38). But actually, Hartmann's word is "brunne" (553, 569, et al.), which can mean either "well" or "spring."

68. See Lejeune and Stiennon's summary statement (1: 73) and a large number of the images they reproduce. Some early examples are the bas-relief at St. Zenon, Verona, ca. 1138 (figs. 47–48); the facade of the ducal palace at Grenada, 1150–65 (fig. 62, 63, 64); and the deambulatory window at Chartres cathedral, early thirteenth century (plates xii–xiii). In the Berlin mansucript of Veldecke's *Eneide*, ca. 1210, the elaborate presentation of the combat between Pallas and Turnus follows the two-phase model (fols. 48v, 50r, 50v; see Boeckler); likewise the fight between Tristan and Morolt in the Munich *Tristan* of about 1240 (fol. 46r; see the facsimile edition). On the motive in literature, see also Alwin Schultz (2: 172–73).

69. For example, Tristan and Morold shatter each other's shields into a thousand pieces (Gottfried, *Tristan* 6680–81); Parzival's and Clamide's shields are cut to pieces so fast they look like feathers tossed up in the wind (*Parzival* 211,29–212,1); Erec and Guivreis quickly reduce one another's shields to worthless fragments (*Erec* 9140–46).

70. This statement is based on a survey of the images in Lejeune and Stiennon, and Loomis and Loomis. Bonnet notes that the iconographic tradition of always portraying fighting knights with shields may have "contaminated" the pictorialization of the text (*Rodenegg und Schmalkalden* 151).

71. Ascalon's pose is clear enough, even though the scene is damaged; see Bonnet's reconstruction (*Rodenegg und Schmalkalden* fig. 12).

72. See Bonnet's reconstruction (*Rodenegg und Schmalkalden* fig. 12).

73. I am assuming that Laudine was identified with a titulus; in the area above her head, the painting is destroyed. She is in any case labeled LAUDINA in Scene 9. Ascalon was perhaps labeled as well; he is identifiable, in any case, by his surcoat, as Ackermann points out (408).

74. Weitzmann ("Threnos" 485, figs. 13, 14, 16). For other early examples, see Millet (493–498).

75. The painting has been dated "about 1200" by Lazarev ("New Light" 67);

Simson's less specific dating places the painting in the first quarter of the thirteenth century (367).

76. Reproduced in Magnani (pl. 6, p. 38).

77. The Aquileia frescos were once dated in the patriarchate of Pellegrinus I (1132–62) (Swoboda 91–92), but Demus—and what he calls the current consensus—assigns the paintings to the patriarchate of Pellegrinus II (1195–1204), "or even later" (308).

78. This may be a case in which terminology inhibits understanding. The Pietà, as narrowly defined, does indeed develop later: it becomes particularly common in later medieval German sculpture, and is characterized—in its handbook definition—by "ein gefestigtes Sitzen Mariä, die nun auf ihren Knien den Leichnam trägt (oder jedenfalls ohne Hilfe tragen könnte), und die sich nicht mehr zum Haupte des Sohnes beugt, sondern aufrecht über dessen Körper erhebt" (von der Osten cols. 460–61). The Lamentation is a broader term and an older tradition.

79. It has been suggested in passing by Ott and Walliczek (484) and in some detail by Ackermann (409), that the iconographic source for the Death of Ascalon is the "Kreuzabnahme" or Deposition. Ackermann points to the Deposition scene at Aquileia, as illustrated by Demus (77, 99), as an example of the motiv. To label the Death of Ascalon "Kreuzabnahme" is iconographically inaccurate. In the Deposition, Mary, Nicodemus, and John lift the dead Christ down from the cross, supporting the weight of the corpse; the body of Christ is often held above the shoulders of the mourners (at Aquileia, chest-high). Admittedly, Ascalon's body is somewhat more upright than the body of Christ in most early Lamentations, but he does lie on a bed, across the lap of the seated lady. The Death of Ascalon is far closer to a Lamentation than to a Deposition.

80. Bonnet's suggestion (43 and fig. 16) that Ywain's dead horse may have been depicted at his feet is speculative given the the present condition of the paintings.

81. Ackermann (411) thinks that the partly visible head and arm in the right-hand portion of the scene belong to the dead Ascalon, depicted in a half-sitting position. But the mostly obliterated figure here surely represents one of the mourners.

82. In *Iwein*, the hero watches Laudine from a window only after Ascalon has been carried to his grave (v.1450f).

83. Riedl appears to have been the first to realize that the head and hand belong to Ywain (19, cited in Ackermann 413). Ackermann discerned fragments of an identifying titulus above Ywain's head (413). See also Bonnet (*Rodenegg und Schmalkalden* 48 and 152, and her reconstruction, fig. 20). Szklenar overlooked the fragmentary head and assigned the hand to one of the searchers (177–78).

84. In one manuscript of the Old Norse *Ivens Saga*, Iven is captured immediately after the portcullis falls, and later freed from his fetters by Lunete (*Ivens Saga* 31–37, 165–69).

85. The same pose could also be used to represent "contemplation," as in the long tradition of meditating poets that encompasses both Walther von der Vogelweide and Rodin's "Thinker." Walther's poetic description of himself in the pose

probably derives from the late classical and medieval pictorial tradition; the pose is repictorialized in the well-known miniature from the Mannesische manuscript (on the relationship of the poem to the pictures, see Frühmorgen-Voss, "Bildtypen" 57).

86. See also Barasch (9–10).

87. Maguire (134) discusses the following examples: a fifth-century ivory in the British Museum (Maguire fig. 17); miniatures in the ninth-century Chladov Psalter (Moscow Historical Museum add.gr. 129, fol. 44r); a tenth-century lectionary (Leningrad, Public Library, ms. 21, fol 8v, fig. 18); a thirteenth-century Gospel (Berlin, Staatsbibliothek, gr.qu. 66, fol.96r, fig. 19).

88. Pickering discusses many of these scenes under the rubric "seated figure" (92–114). To him, the seated position, not the head in hands gesture, is the key to the meaning. But Laudine seated in another position would not have anything like the same effect here.

89. David appears with head in hand in the Vatican Book of Kings, Rome, Vatican Library gr. 333, fol. 40r (eleventh-twelfth centuries), the Lobbes Bible of 1084 (Tournais, Bibliothèque Séminaire 1, fol. 132v), the twelfth-century "Dover Bible" (Cambridge, Corpus Christi College Library 3–4, I, fol. 133r), and a twelfth-century bible in Durham (Cathedral Library A.II.1, I, fol. 173r). All are listed in the Index of Christian Art.

90. The Index of Christian Art lists the following under "David: weeping for Absalom": León, Church of San Isidro 2, Bible, fol. 139r (960); León, Church of San Isidro 3, Pamplona Bible, I, fol. 138r (1162); Maihingen, Wallenstein Library I.2.q.15, Bible, fol. 116r (ca. 1200); Oxford, Bodleian 270b, Bible moralisée, fol. 159v; New York, Pierpont Morgan 619 (single leaf, verso, twelfth century).

91. These counts are based on the listings of the Index of Christian Art under the headings "Jeremiah: Addressing Jerusalem" and "Jeremiah: Weeping over Jerusalem." Those images dated before or around 1200 include Paris, BN gr. 923, the "Sacra Parallela," fol. 258v (ninth century), Dijon, Bibliothèque Communale 2, fol. 192v (eleventh-twelfth centuries), León, Church of San Isidoro 2, fol. 293r (960), León, Church of San Isidoro 3, fol. 123v (1162), Tournais, Lobbes Bible, Collection Séminaire 1, fol. 196v (1084), London, British Library, Stavelot Bible, Additional 28106, fol. 163v (1097).

92. See Boeckler, fols. 17 and 52, p. 37.

93. Thompson (6: pl. XLV).

94. "Wie eine Schutzheilige" (Bonnet 58).

95. The gesture was a required part of the legal ceremony of enfeoffment as described and illustrated in the *Sachsenspiegel* (Schmidt-Wiegand 27; see also Amira 233–34). On the gesture in general, see Amira (233–34) and Peil (198–200). On the gesture in courtly love and Minnesang: Amira (244); A. Schultz (1:648–49, figs. 173, 174); Kluckhohn (67). The gesture was also already associated with prayer in the Middle Ages (Amira 244; Oechelhäuser pl. 5; Bäuml and Bäuml 159–60).

96. For this reading, see Schupp, Mertens (81), Ackermann (414), and Szklenar (178). Typical is Schupp's identification of the final scene as "Versöhnung Iweins mit Laudine ("Anmerkungen" 425), followed by his comment that "Laudine, die trauernd ihre Wange in die Hand schmiegt, muß erst noch gewonnen werden"

(426). Cf. Ott's interpretation of the cycle as a "gefährliche, doch glücklich endende, positiv akzentuierte Minne-Aventiure" ("Geglückte" 7).

97. Masser, for example, invokes the paintings as "ein Zeugnis schlechthin einmaliger Art für den tiefen Eindruck, den der Vortrag epischer Dichtung bei ritterlichen Hörern zu hinterlassen in der Lage war" ("Wege" 394–95). Schupp sees the picture cycles as "eine Gattung von Zeugnissen, die zwar gesammelt, aber nur selten für die Interpretation fruchtbar gemacht worden sind" ("Anmerkungen" 422), and devotes a section to the "Bedeutung der Bilderzyklen für das Textverständnis" (434).

98. See note 88 above.

99. See Wolff.

100. For comparison (totals of complete manuscripts and fragments): *Parzival*, 86; Gottfried's *Tristan*, 27; Wirnt's *Wigalois*, 40; Hartmann's *Erec*, 1 (Cormeau and Störmer 19).

101. On this point, see Curschmann ("Der aventiure" 221–23), and below, pp. 77–78.

102. Kessler, for example, considers a life of St. Martin painted in the cathedral at Tours just before 590 and thus nearly contemporaneous with Gregory the Great's defense of images. He concludes that at Tours, in the kind of situation Gregory had in mind, viewers would have known the stories and would have relied on that knowledge to understand the pictures. The audience would have been "stratified," however: some viewers would have known the texts better than others, some would have been more skilled in reading images. See Kessler, "Pictorial Narrative" (passim).

103. For a short and cogent example, see Scholes.

104. For analyses of visual narrative influenced by recent literary theory, see, e.g., Brilliant, Kemp, Lavin. For the Barthesian methodology I discuss in the following section, see Barthes ("Structural Analysis"; *S/Z*).

105. I am aware, of course, that Barthes's works are no longer the last word in the structural analysis of narrative. But the methodology and terminology I adopt from Barthes appear appropriate for the present endeavor. I have no need, for example, to adopt the Todorovian, deep structural approach developed by James Schultz for the analysis of Arthurian texts: I am not trying to explain the generative grammar of a genre, but to elucidate the structure of certain works.

106. The codes are introduced in *S/Z* (17–20).

107. The lion does not appear to have any particular symbolic value here, but simply suggests power and knighthood.

108. Sequences relate to each other in a manner that might be visualized as a tree diagram. There are supersequences and subsequences. The sequence "adventure of the well" is made up of at least two subsequences—"pouring water" and "fighting Ascalon"—but it is itself part of the meta-sequence "seeking adventure" that began in the first scene.

109. The ring is an obvious sign of friendship or alliance. More specifically, rings that give some sort of magic power are not uncommon in medieval literature. For example, Medea gives Jason a ring that can make him invisible in both the Old French and the Middle High German versions of the *Aenied* (Benoît 1691–

94; Herbort 1026–36). As Woledge notes, the motive is widespread (1:99); see also "Ring."

110. Pickering associates the seated figure of David, Job, et al. typologically with the image of Christ as Man of Sorrows (110–14). The meaning here, however, is symbolic, not allegorical: the viewer is to recognize Laudine's profound grief, not to associate her with Christ.

111. It may well be more "satisfying," in a sense, to postulate an additional scene and an unambiguous happy ending (Van D'Elden 263). But the evidence does not allow it.

112. The first two terms are suggested by Lavin (5), the last by Brenk (esp. 31–32) to designate the person responsible for deciding which scenes to include and how to present them. Since it is generally impossible to know whether such decisions were made by patron, painter, or someone else, I usually speak simply of the "artist," or "painter." To be precise, I am really talking about what Wayne Booth might have called the "implied artist"—the creating consciousness that is implied by the miniature cycle, and that is not necessarily identical with that of any individual. It is always possible, for example, that the actual artist or planner might have personally understood the story differently, or not known the story at all, and might have been ordered by his patron to produce this reading. For Booth's notion of the "implied author," see *The Rhetoric of Fiction* (71–76).

113. Bonnet, though her interpretation is flawed by its graphocentricism, is the first critic to recognize the negative emphasis of the Rodenegg narrative. She contends that the presentation of only the first part of the story focuses attention on Ywain's guilty act and his submission to his victim's widow. While Hartmann's hero reaches courtly perfection in the novel's second part, the hero of Rodenegg is given no opportunity to redeem himself. Instead of ending in triumph, his adventures end with his submission to the widow of his "victim" (69). The murals thus call into question the " 'Condottiere-Ethik der Eingangsaventiure' " (*Rodenegg und Schmalkalden* 68–71). Most earlier interpreters of Rodenegg argued that no criticism of Ywain could be intended, since the murals present Iwein as a model knight and his story as a model of knightly behavior. See next note, below.

114. Schupp, in particular, assumes that the lords of Rodenegg and their guests identified themselves with Ywain and saw his behavior as exemplary; therefore, no criticism of Ywain can be intended ("Anmerkungen" 434–35; likewise Masser, review of Bonnet 96–97). Instead, Schupp ("Anmerkungen" 434–437; "Ywain-Erzählung" 3–4) and Mertens (83) agree in proposing a positive reading, and in regarding the Rodenegg pictures as a refutation of the *Iwein*-interpretation that sees Iwein's pursuit of the mortally wounded Ascalon as an infringement of the rules of courtly combat, and the hero's subsequent problems as a purgatorial punishment leading to Iwein's final redemption. For a recent reconsideration of this charge against Iwein, with references to earlier discussions, see Le Sage; in favor of finding Iwein guilty in this regard, see most importantly Wapnewski (66–73, esp. 69); on Iwein's behalf, Gellinek. Ott and Walliczek move Ywain's exemplariness into the literary sphere, seeing the Rodenegg Ywain as the quintessential courtly knight and the Rodenegg narrative as the quintessential courtly plot structure (488–89).

115. See Ott and Walliczek on the importance of considering the functional

context, the "produktive Umsetzung in einen anderen Gebrauchszusammenhang," when pictorial material is interpreted as evidence of the reception of a text (480; also 473–75).

116. For a good introductory discussion of the complex meanings of the term ministerial, see Cormeau and Störmer (40–46 and 63–67).

117. This is similar to, and to some extent derived from, the view expressed by Curschmann ("Der aventiure" 221–23).

118. Ott and Walliczek (480); Rasmo (*Wandmalereien in Südtirol*, quoted by Ackermann [397]): "Wohn- und Gesellschaftsraum." Ackermann rather rhapsodically suggests that the room may have had some quasi-religious function for "esoterische Kreise" (397).

119. For an interpretation along these lines, see Haug (*Literaturtheorie* 91–106).

2. The Game of Adventure: The Ywain Wall Paintings at Schmalkalden

Even though the Ywain murals in the small Thuringian city of Schmalkal-
den have been known far longer than the Rodenegg paintings, they have
attracted much less scholarly attention. This neglect no doubt results in
part from their location on the eastern side of the now-lifted Iron Curtain,
which made access difficult for Western scholars, and in part from their
poor condition. They are not, and probably never were, as spectacular as
the Rodenegg murals. Yet they narrate a much greater portion of the Ywain
story and represent a remarkably different attitude toward the material.

Although more recent scholarship has tended to neglect the Schmal-
kalden paintings, their discovery was a fine drama of nineteenth-century
antiquarianism. It began in 1893, when the Landrath Dr. Hagen, who lived
in the medieval building known as the "Hessenhof" in Schmalkalden, read
in an architectural guidebook that his cellar contained "fragments of crude
figure painting."[1] Intrigued, no doubt, by the possibility of discovering
something in his own residence, Hagen summoned Oberbaurat Carl Hase
of Hannover, and together with "the whole church leadership" of Schmal-
kalden, the men descended into the cellars of the Hessenhof (Hase col. 121).
But before they did so, one member of the group, an amateur historian and
the head of a local history society, read aloud a description of Ludwig IV
of Thuringia's departure from Schmalkalden for the fifth crusade (from
which he did not return) in 1227. Ludwig's wife, the future St. Elisabeth,
was said to have commemorated the parting by building in Schmalkalden
a chapel, the whereabouts of which were unknown. Descending into the
cellars with the story of Ludwig's departure and St. Elizabeth's lost chapel
fresh in their minds, the group soon discovered the room with the paint-
ings. The walls were dirty, the light was poor, and only a part of the mural
cycle could be seen. The men saw first "a slender woman, resting her head
on the chest of a knight and saying farewell" (Hase cols. 122–23)—and they
immediately believed they had found a depiction of the farewell scene they

had just heard described. Further investigation revealed nothing that absolutely contradicted the theory that the paintings depicted scenes from the life of St. Elisabeth, and Landrath Hagen reportedly exclaimed, "we must have found the chapel of Saint Elisabeth!" (Hase col. 125) But Hase, in his published account of the paintings, offered a slightly different interpretation: he believed the gentlemen had found the crypt underneath the original chapel, and speculated that the paintings had been hastily done soon after Elisabeth's death in 1231, when the city of Schmalkalden hoped to be chosen as her burial place.

Three years later, in 1896, Otto Gerland published photographs of the murals and demonstrated for the first time that they represented scenes from the Ywain story (Gerland 27).[2] After their publication by Gerland and a detailed description and analysis by Weber in 1901, the Schmalkalden cycle attracted virtually no further scholarly attention until the discovery of the Rodenegg cycle, when it began to receive distinctly secondary attention in studies of the more recently discovered paintings.[3] Bonnet's *Rodenegg und Schmalkalden* is the first investigation to grant the Thuringian cycle more or less equal time.

Located in a roughly rectangular room of highly irregular dimensions,[4] the paintings are arranged in 6 rows, one on the west wall, the other five on the vaulted ceiling. The lunette of the north wall is covered by a large painting of a festive meal, which, together with the figure of the cupbearer on the west wall, suggests that the room was a place for eating and drinking. Since the room is small—Weber ("Iweinbilder" 85) assumes that no more than ten or twelve people could gather there—it was evidently not intended for major festivals, but was a room in which the inhabitants of the Hessenhof might meet every day for meals or other social occasions.[5]

The Ywain story is narrated from the beginning of the Chrétien/Hartmann version up to the killing of the dragon. Only those scenes that are logically indoors are separated by architectural features, but the others may be divided by their narrative content into a total of 23 scenes, as follows (for a visual overview, see figs. 2-1 and 2-2).

Register 1

Scene 1. Arthur's Nap.
Scene 2. The Dispute Between Ywain and Key (?)
Scene 3. Ywain's Departure to Seek Adventure.
Scene 4. Ywain and the Wild Herdsman.

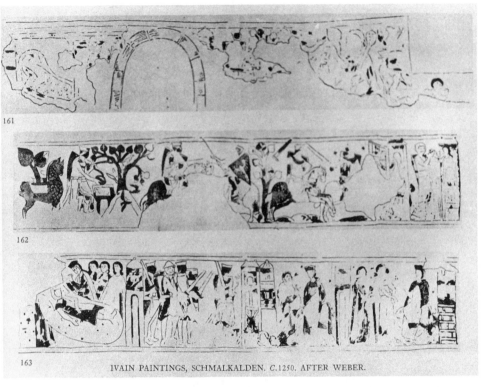

Fig. 2-1. Registers 1–3. Reprinted by permission of the Modern Language Association of America from Roger Sherman Loomis and Laura Hibbard Loomis, *Arthurian Legends in Medieval Art*.

Register 2

Scene 5. Ywain at the Magic Well.
Scene 6. Ywain's Fight with Ascalon (lance phase).
Scene 7. Ywain's Fight with Ascalon (sword phase and pursuit).
Scene 8. Lunete Giving Ywain the Magic Ring.

Register 3

Scene 9. Ascalon's Death (fig. 2-4).
Scene 10. The Search for Ywain (?).
Scene 11. Lunete's Conference with Laudine.
Scene 12. Ywain and Lunete Before Laudine.

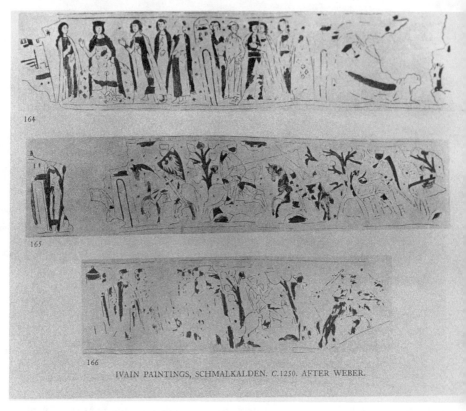

IVAIN PAINTINGS, SCHMALKALDEN. C.1250. AFTER WEBER.

Fig. 2-2. Registers 4–6. Reprinted by permission of the Modern Language Association of Amer
from Roger Sherman Loomis and Laura Hibbard Loomis, *Arthurian Legends in Medieval Art*.

Register 4

Scene 13. Laudine's Announcement to Her Advisers.
Scene 14. The Marriage Ceremony.
Scene 15. Wedding Night of Ywain and Laudine.

Register 5

Scene 16. Arthur at the Magic Well.
Scene 17. Ywain's Defeat of Key (fig. 2-5).
Scene 18. Ywain with Key's Horse.
Scene 19. Ywain's Return to His Castle.

Register 6

Scene 20. A Castle Scene.
Scene 21. A Castle Scene.
Scene 22. Ywain's Second Departure to Seek Adventure.
Scene 23. Ywain and a Lion Fighting a Dragon.

In contrast to the bright and colorful Ywain chamber at Rodenegg, the room at Schmalkalden is small, dark, and damp. Although the room was originally not in the cellar but on the ground floor, the one original window was probably smaller then, so the room can never have been really well-lighted.[6] And even if the colors of the Schmalkalden paintings were originally much brighter than they are today, the impact of the murals on a viewer entering the room for the first time is entirely different from that at Rodenegg. The Tyrolean paintings strike the viewer as a set of large, colorful images to be absorbed all at once; the Schmalkalden murals strike one as a pictorial narrative that awaits careful perusal.[7]

Thanks to a recent restoration (see Zießler 17–19), the paintings are probably in better condition today than at any time since their discovery, although some details were apparently clearer in Weber's time. The outlines are dim, however, and the colors have faded virtually into oblivion. The dominant colors today are a reddish brown, which was apparently originally much redder, and a yellow; in the fifth register, Ywain's shield displays traces of a light blue that has otherwise disappeared.

Historical Background

In the absence of tantalizing documentary references to contemporary local painters and art patrons, the Schmalkalden paintings have been largely spared the sort of speculation that has created so much confusion around the Rodenegg murals. Unfortunately, this lack of controversy has not led to the development of any real consensus of opinion on the date or style of the paintings. The general assumption has been that they date from the first half of the thirteenth century, but are newer than the Rodenegg murals. Recent publications by art historians of the former German Democratic Republic, however, have repeatedly suggested dates in the 1220s and 1230s, which, together with the now accepted later dating of the Rodenegg cycle, would make the Schmalkalden paintings more or less contemporary with, or perhaps even earlier than the Tyrolean cycle.[8]

These proposals are based in part on the assumption that Landgrave Ludwig IV of Thuringia, whose stay in Schmalkalden in 1227 has already been mentioned, was the patron responsible for the Ywain paintings, and that his death in 1227 thus provides an approximate terminus ante quem for the paintings (*Restaurierte Kunstwerke* 226).[9] The argument is circular, however, since Patze, who was the first to suggest that the Hessenhof might have been not only the seat of a government official, but a part-time residence of the landgrave himself, based this suggestion on the presence of the paintings in the building (*Entstehung* 412).[10] The present Hessenhof, it must be noted, is a sixteenth-century building built atop the ground floor of an older, medieval building, which dates from no earlier than 1203, when the Neumarkt was laid out. The assumption that this original building was something like the "governor's residence of the Thuringian landgraves" (Zießler et al. 61) is widespread and plausible,[11] but there is no evidence other than the paintings themselves that the landgrave resided in the building. Even if he did stop there briefly, on his way to the crusade, in 1227, it seems unlikely that he would have commissioned such extensive decorations during such a brief stay. Moreover, the idea that the Landgrave himself, the son of the great patron of the Middle High German poets, commissioned the paintings does not fit with what we know about the usual patronage of visual arts based on vernacular literature. As the examples of Rodenegg, Runkelstein, and the Malterer embroidery show, the patrons of such art were usually not the members of the old nobility—who were more likely to sponsor the poetry itself—but new arrivals in the class of the rich and powerful. The nobleman who could afford to commission first-class literary works was not likely, it appears, also to commission paintings based on the same sort of literature.[12]

A more reliable indication of the date must be sought in the style of the paintings and in the realia depicted. Weber ascribes to the armor, weapons, and costumes a style generally similar to that depicted in the illustrated Munich manuscripts of *Parzival* and *Tristan* (cgm 19 and 51), both products of the first half of the thirteenth century ("Iweinbilder" 119).[13] Bonnet finds the analysis of clothing and armor unproductive, since styles changed so little in the course of the thirteenth century; she does suggest, however, that "especially the two-colored clothes, the many ornamental borders, and Laudine's chin-band" indicate a date slightly later than Rodenegg and perhaps in the 1230s or 1240s (*Rodenegg und Schmalkalden* 92). The evidence of the armor is somewhat contradictory. The helmets, although more crudely depicted, resemble those at Rodenegg, with concave fronts and cylindrical

upperparts noticeably wider at the top than the bottom. This is more or less the shape that Masser identified on a seal from 1204 ("Ritterhelm" 193 and fig. 1), and it is not radically different from some of the helmets in the Berlin *Eneide* manuscript of 1210–1220.[14] This is a type of helmet, moreover, that is clearly older than the so-called "pot helmet," or *Topfhelm* depicted in the Munich *Parzival*. But if the helmets suggest an earlier date, the apparent presence of plate armor protecting the knees suggests a later date, since *genouillières* or knee-caps were apparently not in general use until after 1250, as Loomis notes (78).[15]

No attempt has been made to identify the paintings with any known painter. Based on the Franconian form of the name "Iwan," the use of arms corresponding to those on the Thuringian seal (eagle), and the depiction of leading characters on *Apfelschimmel* (a type of horse for which the region was famous), Gerland suggests that the murals were the creation of a local painter (29). The catalog of *Restaurierte Kunstwerke*, starting with the vague comment that the "fabric patterns and architectural ornaments have parallels in late twelfth- and early thirteenth-century painting, especially that of the alpine region," then notes similarities with the Rodenegg paintings and suggests that the Schmalkalden painter might have been trained in the "southern German-alpine" area (226). Otherwise, no attempt has been made to identify the stylistic affinities of the Schmalkalden painter.

Stylistic analysis is made difficult by the poor condition of the paintings. Gerland and Weber agree in the application of the label "late Romanesque" (Gerland 22; Weber, "Iweinbilder" 116).[16] The Hessenhof murals, Weber says, show only the slightest hint of the new joy in depicting material things that arrives at the end of the thirteenth century ("Iweinbilder" 116–18). Thus Weber establishes the probable date of the paintings as after 1204 (composition of *Iwein*) but not later than the mid-thirteenth century ("Iweinbilder" 118).[17] Bonnet, acknowledging the difficulties created by the poor state of preservation, finds in particular that the folds of Laudine's robe in scene 13 show more affinity with the fourth or fifth decade of the thirteenth century ("Zackenstil") than with an earlier date (*Rodenegg und Schmalkalden* 94). Her final suggestion, then, is "about 1240" (94). Given the poor condition of the paintings and the inherent uncertainty of relying on small differences in clothing and armor, the best we can do is settle on a general formulation such as "later part of the first half of the thirteenth century." The paintings are most likely newer than those at Rodenegg, but probably not by more than ten or twenty years.

Iconography

Since so much less has been written about the Schmalkalden paintings than about Rodenegg, a much smaller accretion of speculation about the source must be swept aside before we begin our analysis of the production of the murals. One bit of speculation that does need to be decisively rejected is Masser's theory that the Schmalkalden paintings were inspired by those at Rodenegg. Starting with the knowledge that Thuringian knights fairly often passed near Rodenegg on the Brenner route into Italy, Masser envisions a scenario in which a Thuringian ministerial enjoys the hospitality of the lord of Rodenegg and is so impressed by the paintings that he has a sketch made and his own *Trinkstube* painted in the same way when he returns home ("Wege" 397). Masser arrives at the idea because he believes the "incompleteness" of the Schmalkalden cycle can best be explained by an incomplete source. Once we recognize, however, that a picture cycle is not necessarily intended to reproduce directly a text in pictures, we can no longer assume that the only reason for the failure of a pictorial narrative to include the entire plot of the literary source is incomplete knowledge. Even the documentary evidence that, on at least one occasion, Heinrich of Thuringia met the "Herr von Rodank" in Brixen in August, 1236, (Masser, "Wege" 397) does little to remove Masser's idea from the realm of pure speculation, since there is no guarantee that the ministerial from Schmalkalden accompanied his lord on this trip.

The Schmalkalden paintings, like those at Rodenegg, must be analyzed as an independent pictorial narrative. I shall proceed in the same manner as I did in the Rodenegg chapter, first examining the paintings segment by segment, discussing iconography where appropriate, and briefly describing each scene. While these descriptions should provide a rough outline of the story the pictures tell, structural and thematic analyses of the cycle will be reserved for a second section, in which I consider the murals lexie by lexie, using the Barthes-influenced methodology developed in the previous chapter.

THE CUPBEARER

Entering through the small door in the northwest corner of the room, which may have been the only original entrance,[18] the viewer is welcomed by the painting, on the west wall, of a man raising his glass in a toast—an obvious allusion to the room's function as a place of festive dining and drinking.[19]

THE FEAST (FIG. 2-3)

The dominant image in the Schmalkalden Ywain room is the large painting of a courtly feast in the lunette of the north wall. Six figures, arranged in pairs, stand behind a long table: at left, two noblemen, one raising a cup to the other; in the center a man and a woman, both wearing crowns, she raising a goblet to him; at right a married woman in conversation with a man. In front of the table, at each end, two servants enter with uplifted dishes or drinking vessels. Weber perceived a drummer in the right-hand corner, a fiddler in the center under Ywain, and the head of a flute player at the left end of the table ("Iweinbilder" 82).

Since Gerland, the opinion that this scene depicts the wedding feast of Ywain and Laudine has gone more or less unquestioned.[20] As Weber sees it, the feast scene is to be included in the narrative at the end of the fourth register after the wedding of Ywain and Laudine ("Iweinbilder" 82). While there is a certain logic to including the painting on the end wall in the story at the end of the register which is directly overhead, there is also a certain lack of logic in inserting the wedding feast just *after* the wedding night.[21] Thus Nickel has suggested that the feast may be seen as the end of story (Nickel et al. 282), and an equally good case might be made for understanding the scene as the Arthurian Pentecost festival that begins the Chrétien/Hartmann version of the Ywain tale. Given the difficulty that arises with any attempt to explain the feast scene as a part of the narrative, however, it is probably best, as I will argue below, to see the connection between the large feast scene and the six or seven registers of storytelling as thematic rather than narrative.

The scene, like virtually all dinner table scenes of the thirteenth century, is clearly derived from Last Supper iconography, which, by this period, had become standardized as showing a long, rectangular table with a row of figures behind it. The central figure often raises his hands in blessing of the first communion or in accusation of the betrayer, Judas, who is often shown kneeling alone in front of the table. The table is usually set simply, with a few chalices and plates, often with fish.[22] Not only were Last Suppers and other biblical meals depicted in this way—virtually all images of secular feasts employed identical imagery (Laura Hibbard Loomis 74).[23] The Schmalkalden scene obviously fits the pattern, although Laudine, in the center of the picture, lifts her cup rather than merely raising her hand. If, as Weber claims (82), a fiddler originally stood in the center, in front of the table, "under Ywain," this detail surely reflects the tradition of placing Judas in front of the table. Secular feast images often included a server in

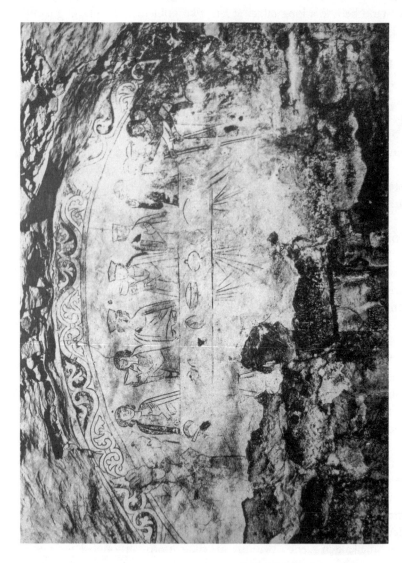

Fig. 2-3. The Feast. Photo from Otto Gerland, *Die spätromanischen Wandmalereien im Hessenhof zu Schmalkalden*. Leipzig, 1896.

this position (Laura Hibbard Loomis 76). None of this means that the religious allusion incorporated in the feast image gives the Schmalkalden cycle an allegorical significance. It simply means that, for the artist of the time, to paint a feast was to paint a Last Supper. The appearance of a table scene on the wall may also reflect the function of the room as *Trinkstube*: cloister refectories were often decorated with Last Supper paintings, Leonardo da Vinci's Milan painting being a famous example (Schiller 47).

SCENE 1 (REG. 1, SEC. 1). ARTHUR'S NAP [24]

A man and a woman lie in bed. The scene is poorly preserved: while Weber could make out the queen's diadem ("Iweinbilder" 80), Bonnet finds only "Farbspuren" to indicate Guinevere's presence (*Rodenegg und Schmalkalden* 78, 161). In the Chrétien/Hartmann version of the story, this scene leads to Calogrenant's telling of the tale, which inspires Ywain to seek out Ascalon's fountain. Whether the uninformed viewer would understand the connection between this scene and the rest of the cycle depends greatly on the contents of the next scene.

SCENE 2 (REG. 1, SEC. 2). THE DISPUTE BETWEEN YWAIN AND KEY (?)

Unfortunately, this scene is too poorly preserved to tell us much. As Bonnet puts it, there are "traces of paint, . . . that resemble two torsos" between scene 1 and the door in the west wall. These, she suggests, are the remains of a depiction of Ywain's argument with Key, or of Guinevere's intervention in the dispute (*Rodenegg and Schmalkalden* 79).[25] Iconographically, the scene is probably a fairly standard depiction of conversation, similar to the first miniature in the Princeton *Yvain*, or to several of the illuminations in the Munich *Parzival*. Nothing about it would seem to indicate "storytelling" as opposed to ordinary courtly conversation. Nonetheless, a viewer who knew the text could easily have identified this image with the storytelling scene that begins *Yvain/Iwein*. What the more ignorant viewer might have made of this sequence will be discussed below.

SCENE 3 (REG. 1, SEC. 3). YWAIN'S DEPARTURE TO SEEK ADVENTURE

A knight, later identified by tituli as Ywain,[26] rides out from a castle into the woods. The departure of the knight appears to have been a standard part of romance iconography,[27] and the image here is not unlike the first scene at Rodenegg, although it draws fewer details from Hartmann's version of the story—the host with the hawk is not depicted. A tower borders the scene on the left, indicating the castle Ywain is leaving, and trees at the right suggest the forest into which he rides.

SCENE 4 (REG. 1, SEC. 4). YWAIN AND THE WILD HERDSMAN

Ywain rides into the scene from the left, gesturing to the herdsman, or wild man, who raises his left hand in greeting or to point the way, and holds his monstrous club in the other. The herdsman is monstrously large, standing almost as tall as the mounted Ywain. He has a full head of long, bushy hair. Given the poor condition of the paintings, it is difficult to tell precisely how hideous he is, or how closely he resembles Hartmann's description of the figure.

In general, the creation of this figure may have been influenced by the same iconographic traditions as the Rodenegg herdsman. One detail, however, suggests a link between the Schmalkalden wild man and another tradition. As a cloak, he wears an animal skin, the two paws of which are clasped around his neck. The pelt might be seen as representing a link to the textual tradition, for Hartmann's text notes "zwô hiute het er an geleit" (466); the painting, however, shows not two skins but one, and the way it is draped over the wild man's shoulders with the two paws intertwined suggests a connection not to Hartmann but to a traditional portrayal of Hercules. Indeed, the Schmalkalden herdsman shows a strong overall similarity to the standard classical image of Hercules as a large, powerful man with a curly beard and curly hair, wearing skins and carrying a club, but not hairy or deformed. More specifically, the Schmalkalden figure resembles one of the common portrayals of Hercules, in which the hero stands resting his club on his left shoulder and holding apples, a wreath, or a vial in his outstreched right hand.[28] This portrayal of Hercules survives into and through the Middle Ages, appearing, for example, on a silver casket of Rhenish origin preserved in the cathedral treasury at Anagni (see Goldschmidt and Weitzmann 2: 84–85, pl. LXXIX [242b]).[29] Potentially more important for Schmalkalden is a miniature in a Schulpforta manuscript of Augustine's *Civitatis Dei*, written and decorated about 1180 in the Leipzig area.[30] This Hercules is clothed and holds the lion's skin, but otherwise stands in the pose shared by the antique images and the Schmalkalden wild man. Since he is apparently neither particularly hairy nor particularly hideous, the Schmalkalden herdsman may be iconographically not so much wild man or hideous human as Hercules.[31]

SCENE 5 (REG. 2, SEC. 1). YWAIN AT THE MAGIC WELL

At far left, Ywain's horse waits in front of a tree.[32] The "stone" is again an altar, as at Rodenegg; it stands on two column-like legs. The source of the water, whether well or spring, is not shown, but Ywain, dismounted but fully armed, pours water onto the stone from a bucket.

SCENE 6 (REG. 2, SEC. 2). YWAIN'S FIGHT
WITH ASCALON (LANCE PHASE)
Ywain, having remounted, rides to meet Ascalon, who attacks from the
right. Ascalon's shield bears an eagle, a conventional attribute of a ruler.[33]
Ywain clearly wins the first round of action: he sits upright, his lance level,
while Ascalon falls backward slightly and his lance points upward at an in-
effectual angle. In Bonnet's interpretation, Ascalon "holds his lance more
upright than Iwein, as if he were giving up the fight" (*Rodenegg und Schmal-
kalden* 80), but the point of the image is that Ascalon is being defeated,
not that he is surrendering. Weber describes the scene as the moment when
the lances break, but this is an imposition of the written narrative on the
images. Hartmann's text describes a fight that is not decided in the lance
phase, and the breaking of both lances is a typical feature of such nonde-
cisive jousts. Here Ywain apparently strikes a decisive blow in the lance
phase, though he does not unseat Ascalon.

SCENE 7 (REG. 2, SEC. 3). YWAIN'S FIGHT WITH ASCALON
(SWORD PHASE AND PURSUIT)
Effectively defeated in the preceding scene, Ascalon flees, turning in the
saddle to fend off the attack of the pursuing Ywain. Reading the images
strictly by comparison to Hartmann's text, Bonnet assumes that the second
phase of the combat, the sword fight, has just ended, and Ywain has struck
Ascalon the fatal sword wound (*Rodenegg und Schmalkalden* 80). If the pic-
torial narrative is considered without reference to Hartmann, however, it
appears that Ywain has fatally wounded Ascalon with his lance, and the
sword phase consists simply of Ascalon's hasty retreat. At the right-hand
border of the scene is the castle gate with the portcullis, toward which the
knights ride. The pictorial narrative of the combat thus flows smoothly and
economically from decisive lance blow to flight and pursuit, and through
the castle gate into the next scene.

SCENE 8 (REG. 2, SEC. 4). LUNETE GIVING YWAIN THE MAGIC RING
Bonnet's reconstruction suggests that Ywain's dead horse may lie under
the portcullis at left. Whether or not that is the case, it is clear that Ywain
has pursued his opponent through a gate and become trapped. He stands,
still in armor, between the gate with the portcullis and another building
to the right. Lunete appears in a window and hands Ywain a ring. This
is not the way Hartmann tells the story, as Weber ("Iweinbilder" 81) and
Bonnet (*Rodenegg und Schmalkalden* 80) are quick to point out. It is, how-
ever, a logical technique of pictorial narrative: placing Lunete in a window

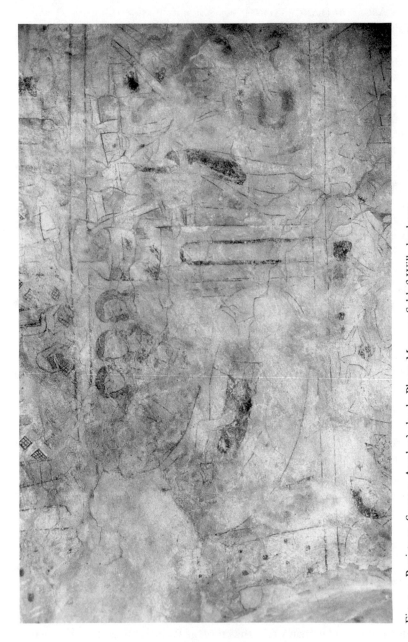

Fig. 2-4. Register 3, Scene 9. Ascalon's death. Photo Museum Schloß Wilhelmsburg.

emphasizes the idea that there is no entrance to or exit from the space where Ywain is trapped.[34] Clearly, the artist has neither employed an existing topos nor closely followed the canonical text; he has, rather, given independent thought to solving the narrative problem posed by his story.

SCENE 9 (REG. 3, SEC. 1). ASCALON'S DEATH (FIG. 2-4)

The dead or dying Ascalon lies on a bed; Laudine, accompanied by three other figures, stands behind him, wringing her hands. The creation of this scene may have been guided, in a general way, by the iconography of the death of the Virgin Mary, the so-called *dormitio*, in which Mary lies dying with the apostles gathered around her bed as mourners and Christ standing behind her to receive her soul, which is depicted as a small child.[35] Here, Laudine stands more or less in Christ's usual place, and the twelve mourners have been reduced to three. The existence of the iconographic tradition probably provided not only a general model for the creation of the scene, but also an incentive for including the death scene—not narrated at all in the Chrétien/Hartmann version—rather than the "Bahrprobe" or some other moment from the death, lamentation, and burial of Ascalon.

SCENE 10 (REG. 3, SEC. 2). THE SEARCH FOR YWAIN (?)

In an interior space bordered by architectural structures, three armed men move left to right, swords drawn. At far right stands Ywain, his back to them, holding his sword but making no effort to defend himself and apparently contemplating the ring, which he holds in his left hand.

In the story as Hartmann tells it, Ywain cannot be seen by the searchers. Weber and Bonnet both see this scene as a clever solution to the problem of depicting his invisibility. Weber, assuming the viewer will know the story well, sees Ywain's visibility as a humorous touch ("Iweinbilder" 81–82). Bonnet finds that Ywain's indifference to the immediate threat of capture or death signifies his invisibility (*Rodenegg und Schmalkalden* 81), and the presence of the ring probably strengthens this view. Nonetheless, the images alone do not make clear that Ywain cannot be seen. How they might be read without reference to the text will be discussed in the next section.

SCENE 11 (REG. 3, SEC. 3). LUNETE'S CONFERENCE WITH LAUDINE

In another interior scene, Laudine sits holding her right hand in front of her breast with the palm open, in a gesture which appears to be the equivalent of a shrug. Lunete, standing to the left of Laudine, gestures with uplifted right hand and index finger, as if to make a point. Even to

the uniformed viewer, this is clearly a scene of persuasion, and the following events will make clear what the informed viewer knows already: that Lunete is persuading Laudine to marry Ywain.

SCENE 12 (REG. 3, SEC. 4). YWAIN AND LUNETE BEFORE LAUDINE

Laudine remains seated on her throne as Lunete and Ywain approach from the left. Unlike the corresponding scene at Rodenegg, this is not an image of grief and submission, but a conventional scene of conversation. Laudine raises her right hand in greeting, a gesture which can only signify good intentions,[36] and the knight steps forward as if to greet an equal, rather than kneeling in submission. Instead of standing behind Ywain as if to protect him, Lunete stands in the background, her hands folded in front of her waist, a passive observer.

SCENE 13 (REG. 4, SEC. 1). LAUDINE'S ANNOUNCEMENT TO HER ADVISERS

Laudine sits near the left border of the scene; three advisers stand to the right. To the left of her stands a figure who is presumably Ywain (Weber, "Iweinbilder" 82). Laudine gestures toward him with her right hand, as if introducing him to her court. Once again, the artist employs a relatively standard image of conversation, using stereotyped gestures suggesting that the figures standing around together are conversing, but not giving a hint of the subject.

SCENE 14 (REG. 4, SEC. 2). THE MARRIAGE CEREMONY

In the center of the scene, Ywain and Laudine embrace in a gesture indicating that the ceremony is complete.[37] A tonsured cleric stands just to the right of the pair; other witnesses surround them. All the figures face the viewer more or less directly. This scene is particularly good evidence of the pictorial narrative's independence from texts. Hartmann reports the wedding ceremony with a cursory three lines:

> dâ wâren pfaffe gnuoge:
> die tâten in die ê zehant.
> sî gâbn im vrouwen unde lant. (2418–2420)

> There were plenty of priests there:
> They married them immediately.
> They gave him the woman and the land.

But the Schmalkalden painter devotes more space to the wedding than to any other single episode and makes it the structural center of the visual narrative. The extensive presentation of the wedding results in part from the lack of a narrator in the pictorial medium, which means that the painter cannot tell about the wedding without showing it, in part from the influence of a strong iconographic tradition for depicting weddings, and in part from a certain thematic emphasis that I will discuss below.

The depiction of the marriage ceremony itself is clearly derived from the highly standardized wedding iconography of thirteenth- and early fourteenth-century art, in which the frontal view of a priest joining the hands of the bride and groom is nearly universal. Miniatures following this pattern appear in bibles, decretals, and diverse secular manuscripts.[38] Most frequently, the priest stands between the man and woman, but variations like the one found here also occur.[39]

SCENE 15 (REG. 4, SEC. 3). WEDDING NIGHT OF YWAIN AND LAUDINE
In a scene that, somewhat oddly, seems to be outdoors (a tree appears at right), Ywain and Laudine embrace on a bed. The consummation of the marriage is not described in Hartmann's text,[40] but it is an obvious part of the story of a wedding, and the artist may have been inspired by a developing iconographic tradition of couples in bed. At the time of the Schmalkalden murals, almost all such scenes appear to have been in secular art.[41] A noteworthy early example is the bronze mirror from Bussen (Swabia), which shows a couple in bed, covered by the bedclothes but clearly engaged in the sex act, while a third person sits by the bed playing a harp. The image has been associated with Tristan and Isolde, Aeneas and Dido, and the Song of Songs, but probably does not need to be forced into any particular narrative context.[42] Another early bed scene that has been associated, somewhat questionably, with Tristan and Isolde, is on the "Forrer casket," an ivory box from eastern France or the Rhineland from about 1200–1220.[43] Finally, two miniatures in the Berlin manuscript of Heinrich von Veldecke's *Eneide* depict Aeneas and Dido in intimate embraces, first under a tree, with horses standing by (Boeckler, pl. 14), then again, in a bed, after their wedding feast (pl. 15).[44] In the Schmalkalden Ywain narrative, the consummation completes the presentation of the wedding, adding the *Beilager*, the act that was customarily considered, in lay culture, to validate the marriage, to the clerical ceremony with the priest.[45] By devoting the entire fourth register, the visual midpoint of the narrative, to the wedding of Ywain and Laudine, the Schmalkalden paintings give much more

prominence to the marriage ceremony than either the texts or any other picture cycle.[46] The thematic effects of this will be discussed below.

Scene 16 (reg. 5, sec. 1). Arthur at the Magic Well

Because the apex of the vault has now been passed, the fifth register reads right to left, so that the depiction of Arthur at the well is essentially a mirror image of the portrayal of Ywain at the well (Scene 5).[47] His horse waiting by a tree at far right, Arthur pours water from a bucket onto the altar-like structure. Unless the figure was originally named in one or more tituli (none are visible today), the recognition of this knight as Arthur depends entirely on the viewer's knowledge of the canonical Ywain story. The pictures offer no visual clue to the identity of the new knight; he is not even identifiable as a king. But in terms of visual diegesis the identification of the intruder is not at all essential. All that matters is that the well is again attacked, and Ywain must defend it.

Scene 17 (reg. 5, sec. 2). Ywain's Defeat of Key (fig. 2-5)

Ywain rides in from the left, his lance lowered, while Key tumbles from his horse, his lance breaking in half. Birds from the tree by the well fly about. The joust scene itself is standard and predictable, and is more a product of iconographic tradition than of any specific knowledge of the Ywain story. The birds, however, may suggest a fairly specific knowledge of the Chrétien/Hartmann version of the tale.

Scene 18 (reg. 5, sec. 3). Ywain with Key's Horse

Ywain rides back in the direction from which he came in the previous scene, leading the riderless horse of his vanquished opponent beside him. With Ywain riding in this direction, the front of his shield is turned toward the viewer, who sees that Ywain now bears the eagle arms of the land's ruler.[48]

Scene 19 (reg. 5, sec. 4). Ywain's Return to His Castle

In a very poorly preserved scene, apparently an interior, two female figures, most likely Lunete and Laudine, stand at left, and at least one male figure with a sword, probably Ywain, stands at right. As Weber ("Iweinbilder" 83) sees it, in reference to *Iwein*, the scene depicts the arrival of Ywain and the Arthurian group at the castle, where the ladies greet them.[49] The fact is, however, that the scene cannot be understood in this way unless it is read strictly in terms of the canonical text. Viewers who rely on the pic-

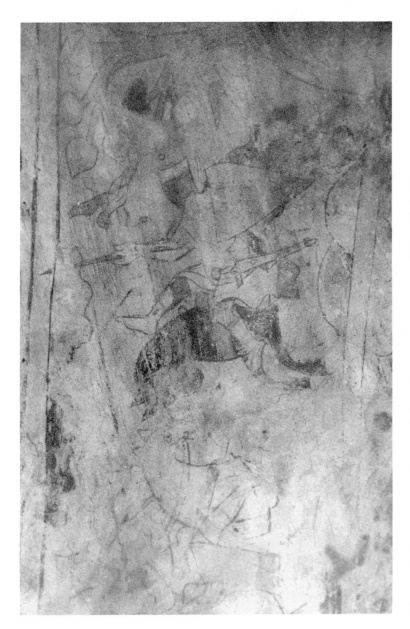

Fig. 2-5. Register 5, Scene 17. Ywain's defeat of Key. Photo Museum Schloß Wilhelmsburg.

tures themselves will not only not recognize Arthur, they will not preceive a group of knights at all. The only thing that can be seen or reconstructed with any certainty is that two ladies speak to a knight, who appears to have just entered an interior space.

SCENE 20 (REG. 6, SEC. 1). A CASTLE SCENE

Bonnet finds fragments of a scene here which she labels "Auf der Burg (?)" (*Rodenegg und Schmalkalden* 203). The action cannot be determined, and it is not certain that this and Scene 21 are not parts of one section (Bonnet, *Rodenegg und Schmalkalden* 85).

SCENE 21 (REG. 6, SEC. 2). A CASTLE SCENE

In another poorly preserved segment, a group of figures stand in an interior scene. Weber assumes that Arthur and Ywain take leave of Laudine ("Iweinbilder" 84); Bonnet suggests that either Ywain takes leave of his wife or Ywain embraces Gawain (*Rodenegg und Schmalkalden* 85). Weber ("Iweinbilder" 84) could still read a *W* in the border above the scene and assumed that it was part of a titulus reading "YWAIN," but Bonnet suggests that "GAWAIN" is equally possible (*Rodenegg und Schmalkalden* 85).

SCENE 22 (REG. 6, SEC. 3). YWAIN'S SECOND DEPARTURE TO SEEK ADVENTURE

To the right of the castle wall or tower bordering the preceding scene, Ywain rides out into the woods. Weber's text-bound interpretation is "Iwein departs with Arthur and his knights" ("Iweinbilder" 84), which ignores the fact that Arthur and the other knights are not shown. Bonnet, in her equally text-centered approach, wonders which departure is depicted here—Ywain's departure with Gawain, which begins the year of jousting that ends in disgrace when he forgets to return at the time appointed and is therefore banished by Laudine, or his departure from Noroison after he has been cured of his madness. She answers that since the lion and dragon scene is next, this must be the departure from Noroison (*Rodenegg und Schmalkalden* 85).[50] But though her answer is logical, her question ignores the fact that in the story told by the paintings, these two departures do not exist—nor do the year of jousting, the banishment, the madness, and the recovery. Ywain simply rides out again, thus beginning a new series of adventures, only the first of which is shown.

SCENE 23 (REG. 6, SEC. 4). YWAIN AND A LION FIGHTING A DRAGON
Standing in a forest clearing (indicated by a tree at left), Ywain strikes a
blow to the head of a large, winged dragon. A dark lion attacks the dragon
as well, springing forward to sink its teeth into the monster's throat. In
the Chrétien/Hartmann story, the lion is losing the battle with the dragon
when Ywain comes to his aid. The Schmalkalden painting, however, in
no way indicates that the lion has been in danger. It appears, rather, that
Ywain and the lion are already fighting as a team. Viewers who knew the
textual version well could understand this scene as Ywain's rescue of the
lion, but uninformed viewers could have followed the pictorial narrative
without recognizing that a rescue was involved. They would simply have
seen that Ywain had somehow accquired a lion as a companion, and that
he and the lion were fighting together against a dragon.

LOST SCENES?
Ywain's second departure (Scene 22) may have initiated another series of
knightly adventures roughly parallel to those narrated in the second part of
Yvain/Iwein, but no more are preserved after the dragon fight. A narrow
window has apparently destroyed one additional scene at the end of the
sixth register, and a few traces of paint suggest that a seventh register may
originally have been present below the vaulting on the east wall, parallel
to the first register on the opposite wall (Bonnet, *Rodenegg und Schmal-
kalden* 86).[51] On the other hand, these traces appear to be remnants of a
fairly large area of solid color of a size that does not exist in the six extant
registers of narrative. This may suggest that these paint traces were part
of a large decorative frieze, rather than another narrative register. But if a
seventh register similar to the other six did exist, it would probably have
contained three or four segments. All together then, four or five scenes
may have been lost—enough to depict all or most of Ywain's adventures as
related by Chrétien and Hartmann and perhaps bring the hero home again
to his wife and castle. Another possibility, recently suggested by Zießler,
is that the narrative might have continued on the walls of another room,
which his archaeological investigations indicate once existed beyond the
present south wall (8–9 and 15). However, it is hard to imagine the painter
continuing the narrative into a second room when space remained to com-
plete the story in the first room, and other vernacular picture cycles, such
as the ones at Runkelstein, are apparently always confined to one room. If
additional pictures existed at Schmalkalden, a seventh register below the
sixth appears more likely than a second room.

In a sense, the urge to postulate additional scenes arises only from the traditional assumption that pictorial narratives set out to translate entire texts into images. But even when we recognize the independence of the picture cycle from the text and acknowledge that the painter's goals may not have required the presentation of any more scenes, the Schmalkalden cycle still appears to break off abruptly, in mid-adventure. Nonetheless, as we will see below, analysis of the existing narrative can provide a good understanding of the structure and theme of the picture cycle—even if we cannot be certain whether the narrative originally continued beyond the last extant scene.

Iconographically, the Schmalkalden painter, like his counterpart at Rodenegg, is frequently influenced by pictorial traditions. The presentation of Key's defeat by Ywain follows the standard pattern for depicting single combat. The marriage scene also relies on standard iconography, as does the depiction of the wedding night. In other cases, the limitations and demands of the pictorial medium cause a plot segment to be narrated differently in pictures than it would be narrated in words. For example, the desire for a smooth, logical, economical narrative flow probably led the artist to show Ywain defeating Ascalon in the lance phase, even though both the inherited plot and the available iconographic tradition called for a two-phase combat decided with swords. But a relatively large number of scenes at Schmalkalden were invented more or less from scratch, in response to the demands of the story being narrated. This story, however, is not Chrétien's or Hartmann's. Like the Rodenegg murals, the Schmalkalden paintings remain, ultimately, an independent rethinking of the story of Ywain and the issues it raises, and an independent work of art. A fuller understanding of this narrative may be approached through the same kind of structural analysis attempted in the Rodenegg chapter.

The Schmalkalden Cycle: A Structural Analysis

By analyzing the narrative, lexie by lexie, we may hope to approach an understanding of the narrative that approximates that of the work's implied viewer—that ideal viewer who creates diegesis through reference to the same codes by which the implied author (or painter) creates visual text.

LEXIE 1: THE COURTLY FEAST; LEXIE 2: THE CUPBEARER
These two scenes work together to provide a thematic frame for the pictorial narrative. The large painting of the courtly feast is both the dominant

single image in the room and the first image to strike the eye of the viewer. As noted above, modern interpreters have generally tried to read this scene as the wedding feast of Ywain and Laudine.[52] Any attempt, however, to explain the feast scene as a part of the narrative runs aground on a simple question: how are viewers to know when to look at the end wall? Medieval users of the room did not walk through the door with the text in their hands and immediately begin to trace the story. Noticing the large painting on the end wall and following the pictorial narrative are not, under most circumstances, part of the same process of perception. The user of the room becomes aware of the contents of the large painting immediately upon entering, without effort, and almost unconsciously; following a plot through a series of small scenes, many of which are directly overhead, requires deliberate concentration. While the painting on the end wall certainly *can* be fitted into the narrative, it is much less artificial to see a thematic connection between the feast scene (and the cupbearer) and the several bands of narrative. Courtly storytelling, after all, was commonly associated with the sort of festivities that the feast scene depicts. The large feast painting and the much smaller cupbearer are not part of the pictorial narrative; they are, rather, the scene in which the narration (not the story) takes place.

Symbolically, the feast and the cupbearer connote not only courtliness but also *muoze*, a Middle High German term translatable as "free time" or "leisure." Courtly narration belongs to *muoze*: the events depicted here do not, but the narrating of them does.[53] This thematic framing of the story focusses the viewer's attention on the surface—on the artwork, not the subject; the narrative, not the story. In other words, the Schmalkalden narrative is self-reflexive: its subject, in a certain sense at least, is not the story of Ywain so much as the telling of the story.

This self-reflexiveness appears all the more appropriate when we consider the social purpose of these and similar wall paintings. As noted in the preceding chapter, the purpose was not so much to identify the patrons and viewers as belonging to the class of heros who experience such adventures, as to identify them as belonging to the class that tells itself these stories. Both the large painting and the pictorial narrative serve to suggest that this room was devoted to courtly pursuits, and that those who gathered in it were of sufficiently high social status to participate in such rituals. Courtliness is thus thematized in the basic structure of the wall decoration, which may suggest that the narrative is presented more for the sake of its courtliness than for any other reason.

LEXIE 3: ARTHUR'S NAP; LEXIE 4: YWAIN AND KEY

The feast scene and the cupbearer work together with the first two fragmentarily preserved scenes of the Schmalkalden narrative to dramatize and thematize the act of narration, although the precise thematic impact of these scenes depends on what exactly they depicted and how they were understood by viewers. The pictorial narrative apparently begins with "Arthur's nap," and continues with a scene of storytelling or conversation at court. For viewers familiar with the Chrétien/Hartmann text, this beginning is an obvious allusion to the scene of storytelling that begins that version of the Ywain story. For viewers who recognized the allusion, the opening of the Schmalkalden narrative must have been functionally equivalent to the beginning of *Iwein*. If the pictorial narrative indeed begins with a scene of storytelling, then the fictive scene of narration at Arthur's court frames the actual narration taking place on the vaulting at Schmalkalden and equates the courtly narration of the picture cycle with the exemplary storytelling in the Arthurian world. This framing identifies the Hessenhof world with the Arthurian world, and locates the viewers of the paintings in the same courtly tradition with Arthur, Calogrenant, and Ywain. This is the identification of the audience with the knights of the Arthurian realm that the courtly genre implies when it is taking itself seriously. The Schmalkalden narrative is thus a straightforward manifestation of the genre that the Rodenegg cycle undermines.

It is impossible, however, to be certain how clear it was that the second scene depicted storytelling, and it is difficult to imagine what the uninformed viewer might have made of the first two or three scenes, in which a man and woman lie in bed, some knights talk, and a knight leaves a castle. What sort of story is that? It is, clearly, a story of courtly people and their activities at court. Even if the second scene is not clearly identified as one of storytelling, the opening sequence, together with the large feast painting, does locate the story at court, and thereby encourage the identification of the Hessenhof world with the Arthurian world. The scene is set, it must be stressed, at court, where narration and other courtly entertainments occur, and not in the forest, where *aventiure* is found. The protagonist's adventures are framed by scenes of feasting, drinking, resting in bed, and conversing at court: they belong to the realm of the courtier, not the warrior. Ywain's adventures represent "the kind of deeds we knights tell stories about at the dinner table," rather than "the kind of deeds we knights perform." The setting, again, is one of *muoze*, not of danger and combat. *Aventiure*, that notoriously amphibolous concept, thus appears as a major

theme in the Schmalkalden cycle, not so much in the sense of "adventure" as in the sense of "story." The lion knight's adventures are unquestioningly exemplary—the "model of knightly activity in the world," as Ott and Walliczek have put it;[54] however, this exemplarity refers not to the real world, but to the world of literature. This is not a real knight doing battle against his neighbors or the infidel, but a clearly literary knight experiencing clearly literary adventures.

Lexie 5: The Knight's Departure

These adventures get under way in the conventional manner with the knight's departure from a castle into the woods. Here, we are in territory familiar to us from the Rodenegg cycle. Proairetically, the scene opens a major sequence—a sequence of knightly adventure—and opens the alternative "return in glory" or "return in failure." Symbolically, the scene sets up the opposition "court" vs. "forest" or "courtly" vs. "wild." The knight's departure from the safety of the castle thrusts him into a confrontation with the wildness of the forest, adding a symbolic dimension to the proairetic alternative: to return in glory is to overcome the wildness; to return in failure (or not return at all) is to be defeated by the wildness.

Lexie 6: The Wild Herdsman

As at Rodenegg, Ywain's venture into the forest quickly brings him into contact with an embodiment or personification of the forest's wildness—the hideous herdsman. Proairetically, this lexie is not the sequence "getting directions from a wild man," but the simpler sequence "encountering a wild man." The knight rides out of the forest and approaches the herdsman, which opens an alternative in that the encounter could be peaceful or violent. The knight speaks to the wild man (indicated by his gesture), and the wild man speaks to the knight (indicated by his gesture). But it is not clear, as it is at Rodenegg, that the herdsman gives Ywain directions. The wild man points, if at all, back in the direction whence Ywain approaches, and the gesture, with outstretched palm, appears not to be one of pointing, but simply one of conversation. Ywain goes on, in any case, to the magic fountain. But without the link between scenes provided by the wild man's pointing gesture, it is not so strongly suggested that Ywain is seeking one particular adventure. The knight is thus not so much Ywain setting forth on his well-known path as the generic knight of romance setting forth to seek whatever adventure he can find (like Calogrenant in the texts). It is dangerous to conclude too much from this one detail, but the

Schmalkalden cycle's failure to provide the link between these scenes that the Rodenegg paintings do may suggest an important difference between the two narratives. Unlike the Tyrolean cycle, the Schmalkalden murals are not a consideration of the issues raised by the story of Ywain, but a much more general depiction of the romance knight in search of *aventiure*.

LEXIE 7: YWAIN AT THE MAGIC WELL

Proairetically, though not visually, this scene is nearly identical to the corresponding segment at Rodenegg. The implied viewer is expected to recognize the pouring of water onto the stone as the sort of thing knights do to set adventures in motion; the recognition relies on the association, through the referential code, of this act with similar acts in other romances. The scene thus begins a sequence and opens an alternative: the knight can succeed or fail.

LEXIE 8: THE FIGHT WITH ASCALON

As at Rodenegg, this lexie encompasses two visual segments. The difference, as I have already suggested, is that here the battle is decided in the first segment—the lance phase—and the sword phase has been combined with Ywain's pursuit of the wounded Ascalon. The sequence thus departs from the norms of courtly narrative. As noted in the Rodenegg chapter, the function "fight with lances" normally has two possible outcomes—the battle may be decided or undecided. But for the fight to be decided in the lance phase normally means that the loser has been unhorsed. Fatal wounds are almost never struck with lances in courtly literature (where death is in any case rare), although they are not unheard of in heroic narrative.[55] By having the outcome decided in the lance phase and combining the sword phase with the pursuit, the Schmalkalden artist achieves a remarkable narrative economy. But why, in a picture cycle of at least 23 segments, is such economy necessary? One answer is that the artist preferred to save space for other things, and we will consider below the sorts of things he chose to emphasize. But for now let us note that he did *not* choose to emphasize the battle with Ascalon. Short of eliminating the battle altogether—hardly possible in such an extensive narrative of the Ywain story—the artist could hardly have deemphasized it more.

LEXIE 9: LUNETE GIVES YWAIN A RING

Ywain has pursued Ascalon through the gate and become trapped by the falling portcullis. As noted above, the fact that Lunete appears in a window

to hand Ywain a ring suggests that the space in which Ywain stands has no door, and he is trapped. However, like the fight scene, the fact that Ywain is trapped and in peril is clearly deemphasized, as a comparison to the corresponding scene(s) at Rodenegg makes clear. There, Ywain is trapped by the falling portcullis and then left in this perilous situation while the narrative lavishly depicts the death of Ascalon. Only then does the viewer learn that Ywain has received assistance, and a ring. At Schmalkalden, the aid comes simultaneously with the peril. As soon as Ywain is trapped, Lunete appears to help him. Ywain's plight is still clear, and the alternative—escape or capture—is still opened. But we also know right away that Ywain has a friend in the castle.

As at Rodenegg, the scene here is delineated by a doorway, which marks the hero's return from the wild outside to the courtly inside. But the symbolic values are entirely different. Rather than remaining in limbo between the outside and the court, with the outcome of his adventure-quest still very much in doubt, this Ywain returns immediately to the court world of friendly maidens with rings. Proairetically, he may still be in some danger, and the success/failure and escape/capture alternatives may still be open. But symbolically, Ywain's return to the court has a clearly positive value.

LEXIE 10: ASCALON'S DEATH

Proairetically, the scene functions in much the same way as the corresponding scene at Rodenegg, bringing the combat sequence to its definitive close by showing the death of one combatant, and, at the same time, interrupting the sequence that began with Ywain's entrapment, building up some suspense about what will happen to our protagonist. Symbolically, however, the effect is much different. While the Rodenegg scene explicitly evokes the Lamentation, endowing Laudine's grief for Ascalon with all the awesome weight of Mary's sorrow for Jesus, the Schmalkalden scene depicts a much less passionate deathbed. The difference may also be recognized in the iconographic sources for the scenes. While the Lamentation is surely the profoundest representation of grief known to the medieval artist, the depiction of the Death of Mary, which probably influenced the creation of the Schmalkalden scene, is immediately connected with her soul's assumption into heaven, and is a less sorrowful moment than the Lamentation, where the emphasis is entirely on death and loss.[56] The full story of Ywain can hardly be narrated without some mention (in a pictorial narrative, a depiction) of the death of Ascalon. But while the representation of this mo-

ment at Rodenegg functions more powerfully in the symbolic code than in the proairetic, presenting with overwhelming emphasis the emotion of grief, the Schmalkalden image functions primarily in the proairetic code, adapting an easily available stock image for death, and not attaching any profound symbolism to the moment.

Lexie 11: The Search for Ywain

Ywain's entrapment by the falling portcullis has opened a new alternative and begun a new sequence—trapped in the castle of the man he has killed, he may be caught, or he may somehow escape or otherwise turn the situation to his advantage. However much or however little the viewer knows about the story, this much is clear. It is also clear that Ywain has at least one friend in the castle—the maiden who gives him the ring. In this scene a body of men with drawn swords approach Ywain, who stands with his back to them, holding the ring.

Viewers who read the images in terms of prior knowledge of the story will certainly see this as a depiction of Ywain's invisibility, as Weber and Bonnet recognize. But what will viewers unfamiliar with the story perceive here? Ywain is clearly in danger, and yet he will not be captured and killed or banished—a few scenes hence, he will marry the widow of his victim. The ring obviously plays an important role in this sequence of events. But how does he escape? And what happens in this scene? Some of these "how" and "why" questions may be difficult for viewers to answer based solely on the pictures. But the overall sequence of events—the sequence, that is, of generalized proairetic functions, is clear enough. Ywain is in danger when the portcullis falls, but he is aided by a maiden who gives him a ring. Ywain's wounded opponent dies, and his men pursue Ywain. But he is in some way protected by the ring, and the maiden soon persuades the widow not to punish Ywain, but to marry him. Exactly how does the ring protect him? It is not clear what the uninformed viewer might conclude. The "ring that makes invisible" may have been a sufficiently widespread motive that the implied viewer could have been expected to recognize it.[57] If not, the viewer would have had to conclude that the ring represented some kind of pledge by the maiden to help and protect Ywain. It might appear that Ywain is captured in this scene and led before Laudine, who is persuaded by Lunete not only to spare him, but to marry him. Considered as an independent narrative and not as a retelling of Hartmann's *Iwein*, the sequence works perfectly well this way. As long as viewers understand that Ywain is in danger, but is saved by the widow's decision to marry him, it is not

important what stories they invent to explain how and why he is saved or what role the ring plays.

This might seem to point toward a fundamental difference between visual and verbal narrative. Viewers, it appears, are required to do more of their own work, to become their own narrators, to a far greater extent than readers or listeners. This is, however, only a difference in degree. Readers also construct the story "from the words on the page by an inferential process" (Scholes 112). Readers also "translate a text into a diegesis according to codes [they] have internalized," "substituting narrative units . . . for verbal units" (Scholes 113). In visual narrative, the process is freer, the codes more flexible. But the process is essentially the same.

LEXIE 12: LUNETE AND LAUDINE

The sequence showing Ywain in danger is interrupted here, the suspense maintained for one scene longer. Having just seen Ywain pursued by armed men, the viewer now sees a conversation between a married woman, no doubt recognizable (even if not identified by tituli) as the widow of Ywain's dead opponent, and the maiden who gave Ywain the ring. The general direction of the story is clear: the maiden intervenes on the knight's behalf. Some viewers, especially the uninformed, may well assume that Ywain has been captured, while others, especially the better informed, may assume that the ring has enabled Ywain to escape. But it does not really matter which scenario viewers imagine, as long as they understand that Ywain is in a precarious position in the castle of the man he has killed, and that the maiden speaks to the widow on his behalf.

LEXIE 13: YWAIN PRESENTED TO LAUDINE

Having spoken to the widow, the maiden now presents the knight to her. The sequence is still not ended, the alternative not resolved, for it is still possible that the meeting might not turn out well for Ywain. Nonetheless, the scene is not ambiguous like the corresponding one at Rodenegg. The moment depicted here is not one of submission or betrothal, which could end or significantly advance a sequence, but an intermediate moment of introduction, or presentation. The symbolic value of the scene is essentially neutral, as well. Grief and sorrow are not evident. Viewers do not yet know how the sequence will end, but they are given no reason to expect that it will end badly for Ywain.

Proairetically, the scene advances the story only by one small step. The knight is presented to the lady; it is still not clear what will happen

next, although the viewer may begin to guess. But the essential action of the scene is simply conversation. In the symbolic code, however, since the conversation is between knight and lady, that simple action accquires a suggestion of courtly activity that connects with the similar symbolic value of the feast scene, the cupbearer, and the first two scenes of the narrative to make the general idea of "courtliness" an important theme in the cycle as a whole.

LEXIE 14: LAUDINE'S ANNOUNCEMENT

That general appearance of courtliness is the primary significance of the next scene, as well. Having been persuaded to talk to Ywain in one conversation scene, having been introduced to him in another, Laudine now presents him to her court in a third. The proairetic value of the scene is again minimal; the story advances only incrementally. The viewer is still not entirely certain what the outcome of the sequence will be; it is still conceivable that Ywain is being presented to the court as a sort of trial, and that he will be taken away and killed. But there are no signs that the outcome will be anything but positive.

The pace of the narrative at this point has become remarkably slow. The falling portcullis trapped Ywain at the end of the second register; halfway through the fourth, the sequence "Ywain in danger" has still not found closure. Three scenes in a row depict essentially nothing but speech; this last one takes up a full third of a register. Pace in narrative is largely a matter of how far the sequences are broken down, and the sequence here has been broken down about as far as is reasonably possible, while the earlier sequence "single combat" was narrated about as rapidly as possible. Evidently, the Schmalkalden artist is more interested in conversation than in combat. He shows a marked preference for scenes of courtly manners and ceremony—scenes whose primary function is to say "this is courtly."[58] This predilection is directly related to the representative and self-reflexive purposes of the picture cycle as a whole—not so much to narrate a courtly tale as to embody courtliness.

LEXIE 15: THE MARRIAGE CEREMONY

Here, the sequence that began with Ywain's entrapment is ended; the alternative that the entrapment opened is resolved. The knight wins the lady, ending the larger sequence that began with Ywain's initial departure from court. The unambiguous happy ending, which readers or viewers in the romance genre expect, but which is denied to viewers at Rodenegg, is here

ceremoniously depicted. What is most noteworthy, however, is that the narrative does not end here. The knight has achieved one of the usual goals of *aventiure*—he has won a lady (and, implicitly, her land). Why is that not the end of the story?

In the Arthurian literary tradition, of course, winning the lady often does not turn out to be the end of the story. In *Iwein* and *Erec*, often taken as paradigmatic for the genre, the knight's initial success proves to be illusory—the knight turns out not to have been mature enough for his success. He must lose what he has gained and then win it back. However, this paradigm, as James Schultz has shown, is by no means valid for the entire romance genre. And it is by no means valid here: Ywain's adventures continue, but without any hint that this first success is illusory or defective.

LEXIE 16: YWAIN AND LAUDINE IN BED

Proairetically, this scene appears somewhat redundant, forming only an epilog to the wedding scene that concludes the first major sequence. On the other hand, if the wedding is seen as a sequence, then the consummation is a logical part of it. Although the wedding night is not narrated at all in Hartmann's *Iwein*, it is frequently narrated in other romances, and, in medieval reality, the couple was apparently escorted ceremonially to bed as a regular part of at least royal and noble weddings.[59] In this sense, the depiction of the wedding night may appear to be just one more example of the Schmalkalden painter's interest in courtly ritual; however, the full significance of the ritual becomes clear when we consider that this is obviously a dynastic marriage in which Ywain receives not only a bride but also her land. In order for the land to be transferred, the marriage had to be complete, and in high medieval custom, the consummation was required before the marriage was valid.[60] As Brundage puts it: "For the moneyed classes of society, marital sex, especially its commencement, was in many respects a social event, rather than the private business of the newlyweds" (504). The bed scene thus emphasizes the validity of Ywain's marriage to Laudine and of his establishment as lord of the land.

LEXIE 17: ARTHUR AT THE MAGIC WELL

For the second time, a new sequence is initiated by a knight pouring water on a stone. This is clearly the ritual act that sets in motion the adventure of the magic well. Ywain did it, defeated the knight who then appeared, and thus won the lady. Now a new adventurer appears, and it is Ywain who must defend the fountain. It is not at all clear from the pictures—though

it may have been from tituli—that this is Arthur or a member of his party. But that is not important to the general progress of the narrative: what is important is that a challenger has come to the magic well. That initiates a new sequence—"Ywain's defense of the well"—and opens the obvious alternatives: Ywain could succeed, or he could fail.

LEXIE 18: YWAIN DEFENDS THE WELL; LEXIES 19 AND 20: YWAIN RETURNS TO HIS CASTLE

The alternative is quickly resolved, as Ywain thrusts the challenger to the ground. The muralist devotes three scenes to this resolution, depicting three distinct nuclei. Ywain fights the intruder; he rides homeward with the intruder's horse; he arrives at his castle. This makes the pace of the narrative almost absurdly slow: why devote one scene to "riding homeward" and another to "arriving at home"? Part of the answer is, again, the painter's interest in the representation of courtliness—the knight on horseback, the ladies at the castle. Another part of the answer, however, involves the basic structure of the narrative. In Kemp's terminology, we have the narration of an "action," not an "act" (37–38). An "action" takes up time—in our terminology, it is a sequence—while an "act" is a moment. While the narration of "acts" is typical of both earlier and later visual narratives, Kemp finds that the narration of "actions" is characteristic of the late twelfth- and early thirteenth-century stained glass windows he studies—windows nearly contemporary with the Schmalkalden paintings. When "acts" are narrated visually, Kemp argues, a series of images, often with changing scenes and characters, are grouped together into a narrative by external factors—primarily the prerequisite knowledge of the story being told (37).[61] The narration of an "action," on the other hand, requires more than one picture and depends on the identity of persons and locations. That is precisely what we have here: not one image depicting the act of defending the well, but a series of images narrating the action or sequence "Ywain defends the well."

In such a narration, Kemp writes, "the degree of dependence on a text is decisively reduced; the ideal is a narrative that guides itself, that is understandable in itself" (38).[62] That is certainly the case here. The slow-paced narrative, devoting several images to each action or sequence, allows viewers to create diegesis through the application of several cultural and visual codes, without relying on outside knowledge of other versions of the story. The diegesis that the uninformed viewer will produce is, admittedly, different in some respects from the story that could be read out of

these images by a viewer relying on outside knowledge. That was the case with the "Search for Ywain," and it is again the case with the "Defense of the Well." Not only will uninformed viewers not identify the figure at the fountain in Scene 16 as Arthur, they will also not distinguish this figure from the unhorsed knight in Scene 17. In Scene 18, though viewers who know the Chrétien/Hartmann version well will understand that Ywain is riding in triumph to his new castle with Arthur and other companions, uninformed viewers can only see that Ywain is leading the other horse and will probably assume that Ywain has left his defeated opponent on the field of combat, or possibly even killed him. Considered without reference to the texts, the tale the Schmalkalden pictures tell in the fifth register is as follows. Ywain is now defender of the well; when an intruder appears and pours water onto the stone, Ywain defeats him, takes his horse, and returns to his castle. This story is superficially quite different from the story in the texts, but at a deeper level the stories are identical: proairetically, Ywain successfully defends the well against intruders; symbolically, his new role as the knight of the magic well is emphasized.[63]

LEXIE 21: CONVERSATIONS AT THE CASTLE

The two scenes at the beginning of the sixth register are so poorly preserved that it is not possible to say much about their narrative content. They appear to have been two more scenes of representative, rather generalized, courtly activity. Viewers reading the narrative by reference to outside knowledge could have identified these scenes as Gawain persuading Ywain to go away with him, but the narrative makes perfect sense if viewers simply assume that Ywain is conversing with his wife and his courtiers.

LEXIE 22: YWAIN'S SECOND DEPARTURE TO SEEK ADVENTURE

Once again, Ywain rides out into the woods from a castle or tower. It is, for the second time in the picture cycle, the stereotypical beginning of an adventure sequence. In the Chrétien/Hartmann version there is a reason for the second departure: Ywain has violated Laudine's trust and been banished by her, and he must undertake a new series of adventures in order to win her back. In the picture cycle, the second departure is not motivated at all, as indeed the first departure was not motivated, except by the convention of *aventiure*. The second departure sets up the usual alternative: return in glory or return in disgrace. The viewer must expect another register or two of adventures, followed by a return to court.

LEXIE 23: YWAIN WITH THE LION AND THE DRAGON
In the first of these adventures, Ywain fights with a lion against a dragon. As noted above, the images do not make it obvious that the lion was in danger before the knight assisted him: it is only clear that the knight and the lion are fighting together. How Ywain accquired a lion companion is not an issue. The association of the lion with the knight is of considerable importance in the symbolic code, as the role of the lion in heraldry makes clear. To be the lion-knight is to be powerful, fierce, and brave. Since the dragon, symbolically, is the embodiment of the wildness that the knight must always overcome, combat with a dragon is the ultimate knightly adventure.

In considering the further importance of this scene and analyzing the structure of the Schmalkalden narrative as a whole, we must admit our fundamental uncertainty about whether the dragon fight was originally the end of the narrative. The physical evidence, as we have seen, is limited: a window cut into the wall where the last scene of the sixth register might have been; a few traces of paint in the area where a seventh register would have appeared—but traces that may suggest some sort of decoration, rather than additional narrative. Let us now consider whether the structure of the narrative suggests anything about the possible ending of the picture cycle.

First, a major narrative sequence appears to be incomplete. The knight's second departure clearly arouses the expectation that he will experience a series of adventures and eventually return home. (It is possible that this was a one-event adventure sequence, and one last scene in the space of the window would have brought him triumphantly back to court, leading the lion.) Moreover, the symbolic opposition of court and forest appears to demand the knight's return to a court. There are two ways, however, in which it might have made sense for the narrative to end here. The artist might have wished to suggest that the knight's adventures were ongoing. By breaking the narrative off abruptly in the middle of a sequence, he might have sought to create the effect of a fade-out—the impression that the adventures continued indefinitely off-stage. Or the notion that Ywain was the "knight with the lion" might have been the thematic center of the whole narrative. Once the adventure in which he wins the lion had been depicted, the narrative might have been essentially over. It seems most likely, all the same, that another register of paintings would have narrated some or all of the adventures from the second part of the canonical version of the Ywain story and returned the knight to his court and his wife. However, even if we are today viewing and responding to a fragment of the original

work, enough remains to allow us a good understanding of the structure and theme of the cycle.

Structurally, the Schmalkalden cycle involves the opposition between court and forest that is common to most Arthurian romance. But in contrast to the Rodenegg Ywain the narrative here is clearly centered in the court, not the forest. A large scene of courtly festivity dominates the room, and the narrative devotes two interior scenes to courtly leisure before depicting the knight's departure. At its midpoint, the narrative then returns to the court, devoting an entire register to the elaborate narration of the wedding sequence. The knight then ventures forth again, but only briefly, and returns to the court for several scenes before departing again for what is apparently the last time. The narrative is so clearly centered in the court that it seems almost inevitable that the knight will return again: if the narrative originally ended as it does now, the suggestion that the adventures could go on indefinitely must have been very powerful indeed.[64] As in the Rodenegg narrative, Ywain's initial departure from the court initiates an adventure sequence by opening the alternative fail or succeed, return in glory or return in disgrace. Unlike in the Rodenegg cycle, the return to court here is unambiguously glorious. To be sure, Ywain is briefly in danger (the "search" scene), but the danger passes quickly, and the alternative is resolved by the wedding, which concludes the first major sequence.

Since the wedding is depicted so lavishly, some commentators see marriage as the thematic center of the picture cycle. Often including the tympanum painting in the narrative as the "wedding feast," they conclude that the room might have been decorated to commemorate a wedding.[65] Clearly, the artist did ascribe considerable importance to the wedding. Adventures, it appears, may be undertaken to win a wife and a land—or to serve a wife and land already won. However, the wedding, important though it is, marks neither the culmination of the knight's career nor the climax of the story, for the narrative quickly takes the knight on to further adventures. After the brief departure from court to defend the well, Ywain sets out on what appears to be a second major sequence of adventures.

In the Chrétien/Hartmann version, Ywain's second departure from court leads him away from his wife and his apparent success. Persuaded by Gawain to go out in search of *aventiure*, he fails to return at the promised time. Laudine renounces him, and he must laboriously regain all that he has already won. In the Schmalkalden narrative, the nadir of Ywain's career—his estrangement from Laudine and his madness—simply does not exist. In the absence of any obvious crisis, Ywain's second departure ap-

pears to be motivated only by the generic conventions that call for knights to seek adventure, and the adventures that follow this departure (only the lion-dragon episode is extant) do not appear thematically different from Ywain's earlier exploits. Indeed, none of Ywain's adventures appears to be motivated by anything more than romance convention. The structure of the narrative suggests no general telos: even Ywain's wedding appears as one adventure among many (albeit an important one), not as a starting point or a culmination. The ethics of adventure are not questioned, as they are at Rodenegg, but neither does adventure appear to have any particular moral or ethical justification. It is simply what knights do. The Schmalkalden paintings thus appear to be exemplary not in the sense that they show viewers how to act, but in the sense that they create an image of knighthood as viewers want to imagine it.

In order to understand this fully, we must recall the tremendous emphasis that the Schmalkalden paintings place on representations of the court. Of twenty-four scenes, including the feast, fourteen are indoor scenes, and twelve represent court life—conversation, ceremony, and the bedroom. I have discussed this aspect of the Schmalkalden cycle in more detail above (lexie #14). For now, it should suffice to recall that the painter's predilection for scenes of court life suggests that the purpose of the cycle is to embody or represent courtliness, and that the narrative unfolds within a frame of *muoze*, of courtly leisure. The tympanum painting, the cup-bearer, and the first two segments of the first register set the scene at the court where the narration takes place, rather than in the forest where the adventures occur. This encourages viewers to identify themselves not so much with the class of knights who experience adventures, as with the class of courtiers who enjoy sufficient *muoze* to partake of such tales.

It might be an imposition of modern ways of thought to equate this framing with fictionality. But certainly we may call it literariness. Like the Rodenegg murals, the Schmalkalden cycle offers an answer to the herdsman's question, "âventiure? waz ist daz?" But here the answer is not only much more positive, it is also different in essence. *Aventiure*, the Schmalkalden narrative seems to answer, is a game of courtly leisure. The direct connection between the *muoze* represented on the walls and the *muoze* that was presumably the purpose of the room suggests an emphasis on *aventiure* as narration rather than as activity, as literature rather than as deeds.

Notes

1. Lotz, quoted by Hase (col. 121). The fragments of paintings had first been recorded in 1862, in Lotz's *Kunsttopographie Deutschlands*, where the source was given as "Hess. Zeitschrift, IV. 244; H." (Hase identified the reporter "H" as a gymnasium teacher Heß in Schelensungen [col. 121].) The note had been repeated in Lotz, and in Dehn-Rotfelser's *Baudenkmäler im Regierungsbezirk Cassel* (1870), where Dr. Hagen encountered it (Hase col. 121). The story of the discovery is told in detail by Hase (cols. 121–127) and briefly outlined by Weber (*Kreis Schmalkalden* 268–69, "Iweinbilder" 76). The name of the Hessenhof comes from the building's use as a residence for the Hessian *Verwalter* in Schmalkalden from the fourteenth to the sixteenth centuries (Weber, "Iweinbilder" 75).

2. Gerland devotes considerable space to a detailed refutation of Hase's "chapel of St.Elisabeth" theory (22–26).

3. The 1952 book by Hans Lohse, which is difficult to find even in Schmalkalden, appears to be essentially a reworking of Weber (cf. Schupp's remark that it offers "gegenüber Weber nichts Neues" ["Anmerkungen" 422]).

4. Like the Rodenegg paintings, the Schmalkalden murals are not frescos in the technical sense, but rather seccos. For details on the technique, see *Restaurierte Kunstwerke* (226); cf. Ott and Walliczek (479). The exact dimensions of the room are as follows: north wall, 3.98 m; south wall, 3.27 m; east wall, 4.38 m; west wall, 4.10 m (Weber, "Iweinbilder" 77–78).

5. The room must have been used only in warm seasons, for it does not appear to have been heated, despite Weber's theory that the large alcove on the south wall might have been a fireplace (*Kreis Schmalkalden* 210, "Iweinbilder" 85). On the use of the room as a "höchst behagliche Trinkstube," see Weber ("Iweinbilder" 85; cf. *Kreis Schmalkalden* 211); also Nickel et al. (281), Masser ("Wege" 396), Schupp ("Anmerkungen" 423).

6. Recent archaeological investigations support Weber's assumption ("Iweinbilder" 78–79) that the room was originally on the ground floor. The ground level outside has risen by 1.5 m since the Ywain room was built (Zießler 7; but see Bonnet, *Rodenegg und Schmalkalden* 76). The apparently original layout of the room has now been restored: on the south side, where Weber found a large opening and a set of steps, there is again a wall; the only entrance is now the door in the west wall (Zießler 7–9, 18–19).

7. This effect can be quantified: at Rodenegg, the 11 scenes cover 41.8 square meters of wall space; at Schmalkalden, 23 scenes (not including the large painting on the south wall) cover roughly 27 square meters of wall and ceiling. (These are estimates of the total space available in the height of the paintings, not subtracting for doors, windows, or blank areas. The highly irregular dimensions of the room at Schmalkalden have been averaged to produce a room 3.595 m × 4.24 m, with a semi-circular vault having an apex 3.1975 m above the floor.)

8. Zießler (18), 1220–39; Zießler et al. (61), "um 1230"; Nickel et al. (283), "um 1225."

9. Also Zießler (6). Gerland's suggestion that the murals must have been

painted before or very soon after 1215, because literary activity at the nearby Wartburg ended with Landgrave Hermann I's death in that year, is rejected by Weber, who argues that wall paintings were not such a unique occurrence as to require the nearby presence of a literary center ("Iweinbilder" 116; and see Schupp, "Anmerkungen" 422). See Bumke (*Mäzene* 168) on the change in literary patronage at the Thuringian court after Hermann's death.

10. A *hospitium domini regis* was mentioned in 1246, suggesting that at that time the landgrave did have a residence in Schmalkalden, though not necessarily in the Hessenhof (Patze, *Entstehung* 412).

11. See Weber ("Iweinbilder" 75, *Kreis Schmalkalden* 206), Gerland (28), Schupp ("Anmerkungen" 422), Zießler (6). Gerland, however, pointing out that the Hessenhof and the neighboring Augustinerkloster are the central buildings of a new district of Schmalkalden, finds it also possible that the Hessenhof might have been the residence of the "Vogt (advocatus) des Klosters" (28).

12. For more extensive discussion of the social context for the production of such art, see Curschmann ("Der aventiure").

13. The dates of these manuscripts are no longer considered certain: for the *Parzival* (cgm 19), the dating now varies from the once-accepted 1228–1236 (Frühmorgen-Voss, "weltliche Literatur" 17) to P. Becker's cautious "2. Viertel oder Drittel 13. Jh." (83); for the *Tristan* (cgm 51), the traditional date of ca. 1240 (Frühmorgen-Voss, "weltliche Literatur" 17) gives way to P. Becker's "2. Viertel 13. Jh." (36), and Gichtel places the miniatures somewhat later, perhaps towards the end of the century ("Die Bilder" 396).

14. See the drawings in Masser ("Ritterhelm" fig. 1).

15. The apparent reinforcement of the mail at the knee is perhaps most obvious in the "Ywain vs. Key" scene (register 5, scene 17). Ashdown lists the use of such reinforcements at the knee and elsewhere as characteristic of the "chain mail reinforced" period of 1250–1325 (97–98).

16. See also Hase, who bases his designation of the paintings as Romanesque on the leaves of the ornamental frieze around the dinner picture and thus arrives at a date of about 1200 (col. 125). Patze and Schlesinger (*Geschichte* vol. 2, pt. 2, pp. 269–70) follow Weber in their brief description of the murals as late Romanesque.

17. Likewise Patze and Schlesinger (pt. 2, pp. 269–70); Patze elsewhere suggests "1220–1250" ("Schmalkalden" 387). After his inadequate look at the paintings, Hase suggested a date of about 1200.

18. See Weber ("Iweinbilder" 78) and Bonnet (*Rodenegg und Schmalkalden* 161). Zießler disagrees (19).

19. Bonnet's past-tense reference to the cupbearer as something that Weber could still see (*Rodenegg und Schmalkalden* 77; see Weber, "Iweinbilder" 80), implies that the figure is no longer visible; it is, however, faintly recognizable.

20. Gerland (27), Weber ("Iweinbilder" 82; *Kreis Schmalkalden* 212–13); Bonnet (*Rodenegg und Schmalkalden* 83); Ott ("Geglückte" 5).

21. The norm in Middle High German epic, at least, is that the feast precedes the consummation, for example: *Nibelungenlied*, tenth *aventiure*, double wedding of Sigfried-Krimhild, Gunther-Brünhild; Gottfried's *Tristan* 12548–12618, wedding of Mark and Isolde (with Brangaene substituted for the consummation); Wolfram's *Parzival* 199, 22–203, 10, wedding of Parzival and Condwiramurs, although

the wedding is without clergy and the "feast" is the careful feeding of the starving people of Pelrapeire.

22. On Last Supper iconography, see Schiller (2: esp. 44); Palli and Hoffscholte (13–14); and Laura Hibbard Loomis (esp. 74–76).

23. In his 1983 essay, Nickel suggests that the source of the image here is the drawing of the wedding feast of David and Michol in a manuscript of Peter Lombard's commentary on the psalms (Bamberg, Staatliche Bibliothek, cod. Bibl. 59, fol. 2v ("Fragen" 55, 69, figs. 5 and 6). Earlier, Nickel had suggested that the similarity between the miniature and the wall-painting resulted from a common reliance on pattern books (Nickel et al. 283). The Bamberg miniature shares with the Schmalkalden painting not only a standard table scene, but also the servants who approach at the right end of the table. The resemblance is indeed striking, but it is impossible to know whether there was a direct connection.

24. The scene numbering follows Bonnet. To avoid confusing repetition of the word "scene," I divide each register into "sections." The narrative is described briefly by Gerland (27–28); in detail by Weber ("Iweinbilder" 80–84) and Bonnet (*Rodenegg und Schmalkalden* 78–87); the content is summarized by Weber in *Kreis Schmalkalden* (211–13) and by Nickel (Nickel et al. 281–82).

25. Elsewhere, Bonnet suggests that the door may not have been present originally (*Rodenegg und Schmalkalden* 161); in that case, there would have been ample room for a scene like the one here postulated between present scenes 1 and 2.

26. Gerland could still discern "YWAN" under the victorious knight in register 5 and "VNA" under the seated woman of scene 13 (21).

27. See above, pp. 40–41, in the Rodenegg chapter.

28. See Boardmann, Palagia, and Woodford, esp. 760, and plates 626–641. The extended right hand is often empty or missing in the preserved monuments. In four of the 16 listed examples of this pose, Hercules wears the lionskin clasped or tied in front. The paws knotted in front also appear in several similar types of Hercules image, such as the "club over l. shoulder, r. hand lowered" type of the "Villa Albani Hercules" (761, pls. 652–53), and here and there throughout the corpus of Hercules images (728–838).

29. Hercules is shown in the same pose, though in full profile, on a casket in the Museé de Cluny, Paris (Goldschmidt and Weitzmann 1: 39, pl XXIII [41b]).

30. The manuscript, Schulpforta, Landesschule, Ms. A 10, was made in the monastery of Bosau near Zeitz, which is about 25 kilometers south of Leipzig and about 120 kilometers from Schmalkalden (see Laborde 218–25).

31. Masser sees this scene as evidence that the Schmalkalden paintings had been inspired directly by those at Rodenegg. The wild man, he argues, points Ywain back to the left instead of onward to the right because he was copied directly from the one at Rodenegg, where the flow of action is right to left ("Wege" 397). But the gesture of the Schmalkalden wild man can be explained as one of greeting rather than directing, and the figure is clearly not copied from the Rodenegg wild man, though the pose is similar. Bonnet finds that the painter here "setzte . . . so gut er konnte, die Angaben des Textes um" (*Rodenegg und Schmalkalden* 97).

32. Weber ("Iweinbilder" 81) identifies the tree as a linden and discusses the birds that sing in it (*Iwein* 681–83).

33. As Weber notes ("Iweinbilder" 81, *Kreis Schmalkalden* 211–12).

34. As Bonnet puts it, "die 'Fensterlösung' ist . . . im Bild sinnvoller" (*Rodenegg und Schmalkalden* 80).

35. On the death of Mary in art, see most helpfully Schiller (4, 2: 95–III); also Künstle (1: 564–72), Myslivec ("Tod Mariens" 333–38). A less systematic but more readable survey of the traditions, with further references, is Askew (24–29).

36. As Bonnet points out (*Rodenegg und Schmalkalden* 81).

37. As Bonnet notes (*Rodenegg und Schmalkalden* 82).

38. The Index of Christian Art catalogs an immense number of wedding scenes, a great many of which follow this pattern. One of the most commonly depicted marriages is that of Mary and Joseph, but espousal scenes also occur in many other contexts, including the decretals. Many of these are accessible in Melnikas (vol. 3, especially *causa* 28, figs. 12, 25, 41, pl. 2; *causa* 32, figs. 9, 16, 29, pl. 1). In general, rather than listing a large number of images, I refer to the Index and to Sandler. Bonnet (*Rodenegg und Schmalkalden* 162) suggests similarities to wedding scenes in a Munich manuscript of *Wilhelm von Orlens* (cgm 63), the Munich *Parzival* (cgm 19), and on the Quedlinburg tapestry.

39. For example, the priest stands to the right of the pair, who clasp hands, in London, British Library Additional 49999, a book of hours from the first half of the thirteenth century (fol. 10v, espousal of Mary and Joseph; see Index of Christian Art). A couple clasp hands surrounded by wedding guests, but without the presence of a clergyman in New York, Pierpont Morgan Library 638, fol. 42v, a manuscript of about 1250 (Index of Christian Art).

40. As Weber ("Iweinbilder" 82) and Bonnet (*Rodenegg und Schmalkalden* 82) note.

41. One very early depiction of a couple in bed is on an impost relief from about 1130–1150 in the cloister at Eschau near Strassburg, which, though located in a religious setting, appears to have a secular significance: on one side, it shows a horse tethered to a tree; on the other, a couple in bed (Kohlhaussen fig. 13). The scene reminds Kohlhaussen of Aeneas and Dido (43), but it is probably not necessary to create such an elaborate context for the vignette. A good many miniatures in the decretals depict pairs of lovers in bed (or elsewhere), but it appears that nearly all of these date from around 1300 or later (see below, pp. 168, 196). Artists depicting the life of David sometimes show him in bed with Bathsheba and other women, but, again, most of the examples are significantly later than the Schmalkalden paintings. One rather early and rather explicit example is New York, Pierpont Morgan Library, ms. 638, fol. 41v, from about 1250 (Index of Christian Art).

42. See Kohlhaussen (39 et al.), Swarzenski (78), Perella (116); Frühmorgen-Voss ("Tristan und Isolde" 120–21) and Ott ("Katalog" 169, no. 68) reject the identification as Tristan and Isolde. Suggested dates range all the way from 1150 (Kohlhaussen) to 1250 (first half of the thirteenth century: Swarzenski 78).

43. Loomis and Loomis identify the scene as Mark and Isolde in bed, with Brangaene bringing them the potion (43, figs. 19–23; bed scene, fig. 21). Frühmorgen-Voss ("Tristan und Isolde" 120) and Ott ("Katalog" 158–59, no. 35) are uncertain about the Tristan connection.

44. Another miniature shows Mars and Venus in bed, with Vulcan throwing a net over them (Boeckler, pl. 49).

45. See below, p. 121.

46. The central importance of the wedding in the Schmalkalden narrative has been noted by Weber ("Iweinbilder" 82) and Bonnet (*Rodenegg und Schmalkalden* 83).

47. Weber ("Iweinbilder" 83) considers it an error that the fifth register reads right to left, while all the others read left to right, but the arrangement is actually a logical response to the shape of the vault. The fourth register is directly overhead, so that the viewer must turn to read the fifth; turning, one continues to read south to north, but this is now right to left. The sixth register can then read left to right again, since the viewer's turn has been completed. The layout is unobtrusive, and the reading of the narrative proceeds smoothly.

48. As noted by Weber ("Iweinbilder" 83) and Bonnet (*Rodenegg und Schmalkalden* 84).

49. Cf. Bonnet's agreement (*Rodenegg und Schmalkalden* 84–85).

50. Loomis and Loomis come to the same conclusion (78).

51. Weber assumes a lost register of three scenes ("Iweinbilder" 84).

52. See above, p. 99.

53. In discussing the Tristan images—specifically, the Chertsey tiles—Ott points out that Kuhn's observation about the Tristan texts is equally valid for the pictures: "Der soziologische Ort ihres Erzählens ist die *muoze*: Feierabend, Fest usw." (Kuhn, "Tristan" 37; Ott, "'Tristan'" 204).

54. The "Bezugsmuster ritterlicher Handlung in der Welt" (Ott and Walliczek 489–90).

55. For example, in *Willehalm* (24, 19–25), Vivianz and Noupatriz fatally wound each other with their lances (although Vivianz fights on for some time despite his mortal wound). The moment is depicted in a miniature of the Wolfen-büttel manuscript (Herzog August Bibliothek, Codex Guelferbytanus 30.12 Aug. fol., fol. 80r), as is Willehalm's killing of Tesereiz with his lance (fol. 102r). For reproductions, see Heinzle (*Willehalm*).

56. See Künstle (1: 564–72); Schiller (4, pt. 2: 95–111).

57. Thuringian audiences might have been especially likely to know of the ring given to Jason in Herbort's *Liet von Troye*, since that work was written for Land-grave Hermann, just a decade or two before the Schmalkalden paintings (1190–1217, probably near the end of the period: see Steinhoff col. 1028). In general, see above, note 109 in Rodenegg chapter.

58. A similar group of pictures are the illuminations in the Munich *Parzi-val*, where seven of the twelve images are scenes of conversation and ceremony, including three lavishly depicted feasts (see Loomis and Loomis figs. 355–58).

59. See Barthélemy (139–40), Alwin Schultz (1: 632–33), and Weinhold (1: 398–99).

60. In canon law, after a long debate, thirteenth-century commentators reached substantive agreement that the consent of the partners constituted a legal marriage, and that sex was not required (Brundage 376 and 437, and see index under "marriage, consummation"). But "custom often insisted that sexual consummation was essential to complete a marriage" (Brundage 437), and the consummation was often directly connected to the transfer of property. In Italy, the consummation was

often delayed until after the payment of the dowery (Brundage 504); in Germany, it appears that the payment at least sometimes depended on the consummation: in the agreements between emperor Karl IV and Burggraf Friedrich of Nürnberg, regarding the marriage of Karl's daughter to Friedrich's son, the *Heimsteuer* and *Ehegeld* are to paid within two years after the *Beilager*. In this case, the *Beilager* is surely to be a symbolic, not a literal, consummation, since it is to take place when the groom reaches the age of eight (*Monumenta Zollerana* 4: nos. 130 and 310).

61. Kemp says "text" (37); I would argue that he should say "story," since there are many different ways for the prior knowledge of the story to be transmitted.

62. "Der Grad der Textabhängigkeit nimmt so entscheiden ab; das Ideal ist die sich selbst steuernde, aus sich heraus verständliche Erzählung" (38).

63. Van D'Elden suggests that this repetition of the fountain scene indicates an interest "in the transfer and maintenance of power" (261).

64. The point is not that the "structure of the Arthurian romance demands some sort of closure" in the sense of " 'happily ever after,' " as Van d'Elden argues (268), but that the narrative breaks off in mid-sequence. We must expect a particular kind of telic closure only if we expect all knights to "look like Erec" (James Schultz 5); as Schultz has shown, they do not.

65. E.g., Schupp ("Anmerkungen" 423); Bonnet (*Rodenegg und Schmalkalden* 29–30).

3. Exemplary Scenes of Adventure: Princeton University Library Garrett 125

The monumental narratives at Rodenegg and Schmalkalden have an obvious physical independence from texts of *Iwein*. Whatever we may assume about the textual knowledge of the creators and consumers of the mural cycles, it is clear that the viewing of the paintings did not ordinarily occur in direct association with the reading of the text. When we turn to illuminated manuscripts, we find a much closer physical connection between image and text. However, the questions we considered in examining the mural cycles arise again in the study of the manuscripts. In studying the iconography of the miniatures, we must ask whether the artists created images according to their reading of the text, or drew on existing iconographic traditions. And in considering the process by which viewers create diegesis from the visual narrative, we must ask whether they rely primarily on their knowledge of the written text, or on other codes, to make a story out of the pictures. As we did when considering the wall paintings, we must admit that generalizations about the typical viewer are essentially impossible today, and we must rely on a notion of the ideal or implied viewer. But in the case of textual illustrations, the visual narrative appears to have two separate functions, and thus two different implied viewers. The miniatures function, as we will see, both as illustrations of the text and as independent pictorial narratives.

Historical Background

Though the German cultural region produced the mural manifestations of the Ywain story, no illustrations of Hartmann's *Iwein* survive.[1] In France, however, two of the eleven extant manuscripts of Chrétien's *Yvain* are decorated with fairly extensive miniature cycles.[2] The earlier of the two is the manuscript now known as Princeton University Library Garrett 125.[3]

The Princeton manuscript was cataloged by de Ricci (1:890) as containing only the *Roman de Judas Machabée* of Gautier de Belleperche. But when McGrath studied the codex in the early 1960s, he found that it contained about one-eighth of the *Machabée*, a nearly complete version of Chrétien's *Yvain*, and smaller fragments of Chrétien's *Chevalier de la Charette* and the heroic epic *Garin de Monglane*.[4] While the two Chrétien romances and the *Machabée* were apparently written and illuminated as a unit, the *Garin*, which contains no miniatures, clearly did not belong to the original manuscript and may not have been part of the codex until the nineteenth-century rebinding.[5] It was presumably during this rebinding that many of the bifolia were cut apart and rebound singly, other sheets were reshuffled, and the whole manuscript was put back together in a totally chaotic order.

The language of Garrett 125 is basically Picard, although it reflects an effort to write in a literary standard language.[6] The style of the illuminations can be associated with that of several other manuscripts of apparent Picard (or Artesian) origin. Stones identifies four manuscripts illuminated by the same painter: the Psalter of Amiens formerly in the collection of Count Guy du Boisrouvray (private collection), a Book of Hours for the Use of Arras (Baltimore, Walters W 86), a Psalter-Hours for the Use of Amiens (Philadelphia, Free Library MS Widener 9), and a *Vies des pères* manuscript now in Paris (BN fr. 422)(Stones, "Context" 251).[7] In most of these cases it is clear that the manuscripts were made for patrons living in Picardy or Artois, but that does not quite prove that the painter was working in Amiens, as McGrath would have it ("A Newly Discovered Manuscript" 592–94). A second painter at work in Widener 9 can be associated with a larger number of manuscripts of a wider variety of types and geographical connections; as Stones puts it, "we cannot be sure just where the painters were based and whether it was the artist, the patron, or the book, or a combination of the above, which travelled" ("Context" 253).[8]

The miniatures of the Du Boisrouvray Psalter were dated by Porcher to about 1260, which might cast some doubt on McGrath's dating of the closely related Garrett 125 to the 1290s.[9] Nixon is more cautious, dating the handwriting of the Garrett *Yvain* to the second half of the thirteenth century and the illuminations to the last quarter of the century. One of the other manuscripts associated with the second artist of Widener 9 can be dated, through a complex series of references, to the period from 1280 to 1298 (Stones, "Context" 252). With all due caution, then, we may say that the Princeton *Yvain* is probably of northwest French origin, and was probably made in the last couple of decades of the thirteenth century.

Based on McGrath's collation of Garrett 125's *Machabée* text with that in BN fr. 19179 ("Romance of the Maccabees"),[10] and Rahilly's collation of the Garrett *Charette* with the editions of Foerster and Roques ("The Garrett Manuscript"), it is possible to estimate that roughly 136 folios—17 gatherings—may have been lost. It is unclear when the manuscript became a fragment and impossible to know with certainty whether the original codex contained more than *Yvain*, the *Charette*, and the *Machabée*. The original state, however, can be partially reconstructed. Both the beginning and the end of *Yvain* are preserved. The *Charette* follows immediately after *Yvain*: the text of the first romance ends in the first column on folio 34r; a miniature at the bottom of the column depicts the opening scene of the second romance, and at the top of column 2, the story of Lancelot begins. The end of the *Charette* and the beginning of the *Machabée* are missing, but the final gathering of the *Machabée* remains intact. The fact that the final folio in this gathering follows the end of the text and has been left entirely blank strongly suggests that this gathering was the last in the codex and that the *Machabée* was the last text in the book. The order *Yvain-Charette-Machabée* thus appears to have been the original.

My primary concern here is for the *Yvain* pictures. These seven miniatures, with one exception, illustrate only the second part of the romance, beginning with Yvain's wedding.[11]

> fol. 40r. Thematic Introduction (in initial A) (fig. 3-1).
> fol. 52r. Marriage of Yvain and Laudine (fig. 3-2).
> fol. 37r. Yvain's Rescue of the Lion from the Dragon (fig. 3-3).
> fol. 56v. Yvain's Battle Against the Giant Harpin (fig. 3-4).
> fol. 58v. Yvain's Fight Against the Seneschal and His Two Brothers, on Behalf of Lunete (fig. 3-5).
> fol. 26v. Pesme Avanture: Yvain's Combat with Two Demons (fig. 3-6).
> fol. 38r. Yvain's Fight with Gauvain (fig. 3-7).

Iconography

At first glance, it might seem that the source of the paintings in an illuminated manuscript is far more obvious than in a mural cycle: since the paintings are physically located on the same parchment as the text, it is easy to assume that the artist must have based the images directly on the

words. This is not necessarily the case, however, as is well known to art historians studying religious imagery. Illuminators of the Bible, for example, clearly did not develop new images from their own readings of the text, but employed a standard, traditional iconography. In secular books as well, illuminators often worked with standard images.[12] In those codices where instructions to miniaturists survive in the margins or in the empty spaces left for pictures that were never painted, we often find notations like "make a king here," suggesting that the artist was to employ a standard image, not study the text for clues about the appearance of a particular king.[13] Such instructions could be fairly elaborate, but were often as brief as the "une bataille cruelle" in a Lancelot manuscript (Meiss 13). Clearly, the artist who created images based on such cursory instructions must have relied on a standard idea of what a "cruel battle" should look like and not on detailed knowledge of the text at hand. To be sure, the secular artist, far more often than the Bible illustrator, encountered scenes for which no pictorial precedent existed, such as the moment in *Yvain* where the knight rescues a lion from combat with a dragon. Lions, dragons, and knights were certainly all parts of the standard repertoire, but that particular combination of the three was not, as we shall see, widespread enough for a pictorial tradition to have developed. In other scenes, however, such as Ywain's wedding, the miniature is clearly based not on the text, but on a highly standardized visual scheme for depicting weddings. The iconographic question, therefore, is a very real one: to what extent did the illuminator of Garrett 125 draw from standard iconography, and to what extent, if any, did he create new images based on a reading of Chrétien's *Yvain*?

Speaking of "the illuminator" deliberately oversimplifies a complex workshop system. In the earlier Middle Ages, text and image might have been the work of a single monastic scribe, but by the time of our *Yvain* manuscripts, production was mainly in the hands of specialized lay artisans working in urban workshops. The scribe was no longer the illuminator, and the two might not even work in the same town. Within the paintshop, the work might be divided among several individuals.[14] Someone—whether a patron or a *chef d'atelier*—conceived a plan, indicating which scenes should be depicted and what paintings should go where. Someone laid out the page, indicating the width of the columns and the locations of the pictures, someone copied the text, and someone produced the illuminations. Each of these tasks could be done by one person or by several. Since it is usually impossible to know precisely how many minds and hands were involved in the production of a given manuscript, I will simply refer to the

"illuminator" to designate the mind behind the selection, location, conception, and execution of the images.[15] Unanswerable questions of exactly who did what need not concern us as we begin to analyze the picture cycle of Garrett 125.

ILLUS. I. FOL. 40R. THEMATIC INTRODUCTION (FIG. 3-1)

In the large initial A of the text's first word ("Artus"), the artist has depicted the scene of storytelling that begins *Yvain*. Guinevere, emerging from a door at the right, has just interrupted Calogrenant's story, Calogrenant has leaped to his feet, and Key has opened his mouth to make rude remarks. The picture includes a number of seated knights. Key sneers as he speaks, and his right hand is raised in a lecturing gesture. Calogrenant's hands are lifted in a gesture that might be called defensive, and the queen raises a hand, as if to ask for calm. To be sure, it is probably not clear from the visual clues alone that this is a scene of storytelling. Since, however, as we will see, other episodes are pictorially represented by single segments, the first miniature may be said to represent the opening scene of storytelling in the same way that one moment from the battle with the two demons represents the entire Pesme Avanture episode. Moreover, the illustration combines all the key elements of the narrative segment "Guinevere interrupts Calogrenant"—the queen enters, Calogrenant rises, Key is nasty, the queen scolds him, and Calogrenant adopts a conciliatory attitude (F. 61– ca. 141).[16] Finally, even if the painting does not actually show Calogrenant telling his story, it does show the scene that leads him to tell it: Calogrenant narrates his adventures at the queen's behest. In the text, Calogrenant's narration inspires Yvain's adventures, and the story-telling scene depicted here thus sets in motion the action of the entire plot. We will consider later precisely what effect the scene has in the pictorial narrative.

ILLUS. 2. FOL. 52R. THE MARRIAGE OF YVAIN AND LAUDINE (FIG. 3-2)

The framing of the scene by a Gothic vault locates the action in a church or a chapel. Almost directly in the center stands a priest in white, holding his hands nearly shoulder high, his palms out. To the left stands Yvain, in a red robe; to the right Laudine, in blue with a white veil draped over her crown. The bride and groom reach across the front of the priest to join hands. To Yvain's right stand two more virtually identical men; to Laudine's left stand two more women.

Chrétien's text does not narrate the wedding scene in detail. The narrator simply informs us that the pair was joined by the chaplain, and this

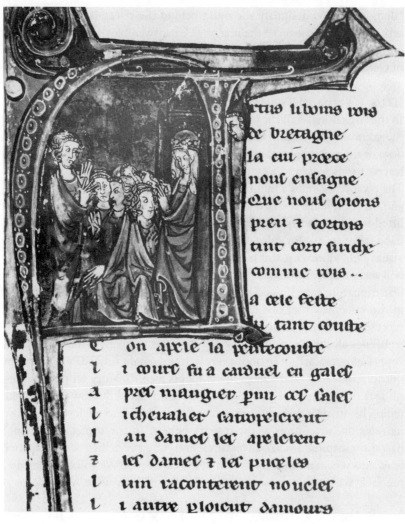

tus libuns rois
de bretagne
la cui proece
nous enfagne
que nous colons
preu 7 cortois
tant coro sundge
comme rois ..
a cele fette
u tant couste
e on apele la pentecouste
l i court fu a carduel en gales
a pres mangier puis ses cales
l i chevalier samopeleieut
l au dames les apeleient
z les dames 7 les puceles
l uin raconterent nouieles
l i autre ploicut damours

Fig. 3-1. fol. 40r. Thematic introduction (in initial A). Photo Princeton University Library.

succinct statement seems to have inspired the illustration. The illuminator, however, ignores the few details that the text does give, omitting the bishops and abbots who are said to have brought an array of mitres and crosses (F. 2156). As discussed in the preceding chapter, the depiction of the wedding ceremony was highly standardized in the iconographic tradition. The

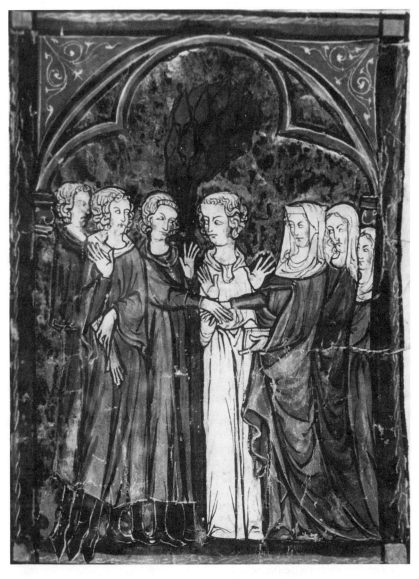

Fig. 3-2. fol. 52r. Marriage of Yvain and Laudine. Photo Princeton University Library.

frontal view depicting a priest (often a bishop) joining the hands of the bride and groom, who stand on either side of him, was almost universal in thirteenth and early fourteenth-century art.[17] An example from a secular manuscript that may be related to Garrett 125 is the marriage of Arthur and Guinevere in Robert de Boron's *Histoire* (BN fr. 95, fol. 273r).[18] The existence of a well-established pictorial tradition for the wedding made it unnecessary for the illuminator to develop a picture from the specific passage in question, and may have encouraged the inclusion of a wedding picture, despite the relative lack of attention given to the wedding in the text.

ILLUS. 3. FOL. 37R. YVAIN'S RESCUE OF THE LION (FIG. 3-3)
Against the gold background, three trees indicate a forest scene. At the far right, standing on a pile of rocks, the lion struggles to escape from the dragon. The lion is blue and almost as large as Yvain's horse. Its tail extends into the center of the picture, where the dragon holds the tail in its mouth. The dragon is a small brown creature that resembles nothing so much as a kangaroo. Combat between a lion and a dragon, though not without thirteenth-century literary analogues, was not a subject for which an iconographic tradition had been established.[19] Illustrations of lions and dragons in bestiaries (McCulloch, *Bestiaries* 112, 139–40) and elsewhere undoubtedly influenced the depiction of each creature, especially since the text does not bother to describe either (except to say that the dragon's mouth was "as wide as a pot" [F. 3368]).[20] But no obvious iconographic model existed for the combat between the two beasts, so the miniaturist draws his inspiration fairly directly from the text, illustrating rather closely the passage where Yvain sees

> . . . un lion . . .
> Et un serpant, qui le tenoit
> Par la coe et si li ardoit
> Trestoz les rains de flame ardant
> (ms. 3352–55; F. 3348–51).

> . . . a lion . . .
> and a serpent, which holds
> him by the tail and burns him up
> with sheets of hot flame.

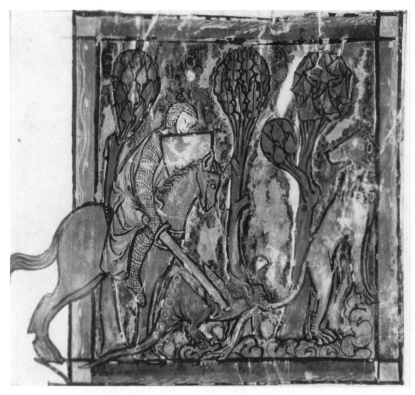

Fig. 3-3. fol. 37r. Yvain's rescue of the lion. Photo Princeton University Library.

A few lines later, the poet describes how Yvain protects his face with his shield and slices the dragon in half (F. 3365–81), and this turning point or climax of the battle is the precise moment illustrated: Yvain, approaching on horseback from the left, holds his shield next to his face to protect himself from the dragon's heat and reaches down with his sword to slice the dragon virtually in half.

ILLUS. 4. FOL. 56V. YVAIN'S BATTLE AGAINST HARPIN (FIG. 3-4)

The illustration derives several details from the text. Although Harpin's bearskin is omitted, he does carry a club, as in the text ("pel" F. 4199 et al.), not a sword as in the Paris manuscript's illustration of the scene. Harpin stands roughly in the center of the miniature, wearing a red tunic and brown stockings. He is so tall that Yvain's head reaches higher than his only because the knight is standing in the stirrups of a rearing horse. He

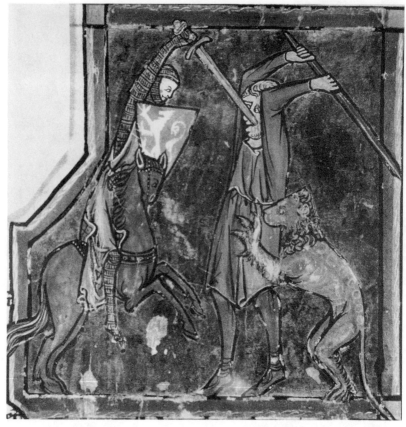

Fig. 3-4. fol. 56v. Yvain's battle against Harpin. Photo Princeton University Library.

swings his enormous club over his head. Yvain approaches from the left, wearing the usual mail and surcoat and carrying the lion shield. Like the preceding miniature, this illumination captures the turning point of the combat. Blood spurts from the giant's cheek as Yvain lands a blow with his sword. The nearly horse-sized blue lion attacks Harpin from behind, wrapping his forelegs around the giant's thighs and sinking his teeth into Harpin's hip.

Despite drawing these details from the text, the miniature does not illustrate one precise moment of the verbal narrative. In the text, the climax of the fight consists of three very short segments. Yvain strikes the giant's cheek with his sword (F. 4211–15); Harpin lands a terrible blow on Yvain (F. 4216–18); the lion springs and rips open the giant's hip (F. 4219–26). The

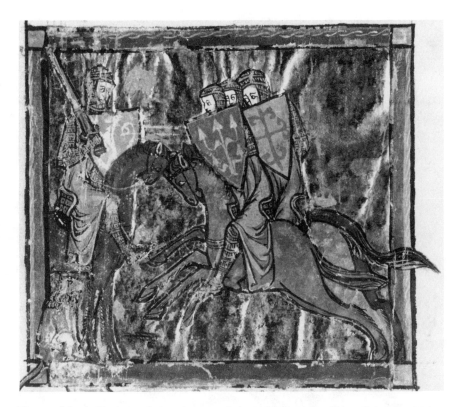

Fig. 3-5. fol. 58v. Yvain confronts the seneschal and his brothers. Photo Princeton University Library.

illustration reproduces the first and third segments with great precision, but ignores the intervening blow by Harpin, thus creating a single climax out of three moments in the text. This conflation is required by the pictorial medium, which cannot devote a separate image to each narrative moment, because such a series would isolate each segment and fail to convey the feeling that the three short segments form one climax. Thus, although the miniature derives several of its details from the text, it narrates the action in a manner appropriate to the visual medium and ultimately independent of the words.

ILLUS. 5. FOL. 58V. YVAIN CONFRONTS THE SENESCHAL AND HIS BROTHERS (FIG. 3-5)

The miniaturist depicts one particular moment in Chrétien's narrative— the first phase of the combat, when Yvain holds his ground, letting his

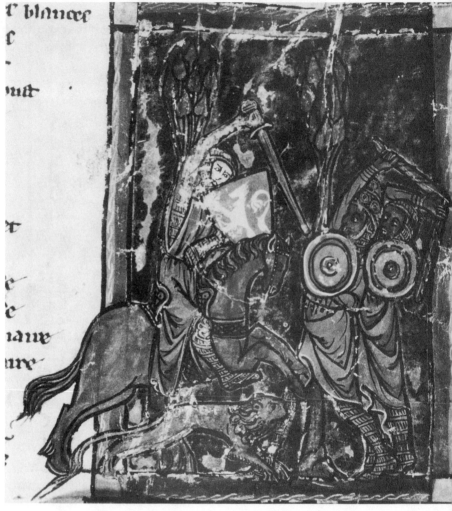

Fig. 3-6. fol. 26v. Pesme Avanture. Photo Princeton University Library.

three opponents break their lances against his shield (F. 4482–85). Yvain's horse is only partly visible in the illustration, as it emerges from the frame at left. Yvain sits firmly in the saddle, holding his shield in front of him with his left hand and brandishing his sword with his right, although, considering that Yvain unseats the seneschal with his lance in the next phase of the battle, absolute fidelity to the text would require him to hold a lance here. His attire and shield are as usual. As Yvain's three enemies gallop toward

him from the right, they lean forward slightly in the stirrups, and their lances break against Yvain's shield. The lion, now dog-sized, sits patiently at Yvain's side in the lower left-hand corner of the frame, even though, in the text, he has been sent away before the battle. The lion may be included as a sort of label for Yvain, the animal's companionship having become one of the knight's trademarks, or the lion's inactive presence in the miniature may have been intended to signify his temporary absence from the scene of action.

ILLUS. 6. FOL. 26V. PESME AVANTURE (FIG. 3-6)

Yvain fights the two "sons of a demon," who approach on foot from the right. Their evil nature is indicated by their dark skins and noncourtly arms—they carry small round shields and fight with clubs. Yvain, mounted, attacks from the left, striking a blow with his sword. The lion, now dog-sized, bites the leg of one demon. Like illustrations 3, 4, and 5, this minia-ture depicts the climax of the battle (ca. F. 5628f): the lion has come to Yvain's aid and the tide is turning against his ferocious opponents. The moment pictured, when the lion has attacked, but has not yet pulled his opponent to the ground, corresponds to F. 5630–33, but Chrétien does not provide a blow-by-blow account of the lion's attack. Therefore, the artist, who in illustrations 3, 4, and 5 faithfully reproduces many details of the verbal narrative, here finds no details to reproduce, and simply shows the lion biting the demon's leg.

ILLUS. 7. FOL. 38R. YVAIN'S FIGHT WITH GAUVAIN (FIG. 3-7)

The desperate fight of the two heroes fills the frame, the legs and tails of their horses spilling across the borders on each side. Gauvain, on a white horse, attacks from the right; Yvain, on his usual brown horse, approaches from the left. Both horses prance toward the middle of the scene, their forefeet off the ground. Both knights hold their long swords over their shoulders, ready to strike; both extend their left arms forward as if to shield themselves. Gauvain's shield is plain and olive-brown, Yvain's is pink and bears an eagle. Other combat scenes have depicted the turning point; since this battle is a brutal stalemate, the miniature shows a nondecisive moment that nonetheless conveys the desperateness of the fight.

Showing the intensity and evenness of a battle like that between Yvain and Gauvain is a problem in both the verbal and the visual media. Verbal artists, as if recognizing that they cannot hope to retain the interest of the reader or listener with a blow-by-blow description of a long fight, often uti-

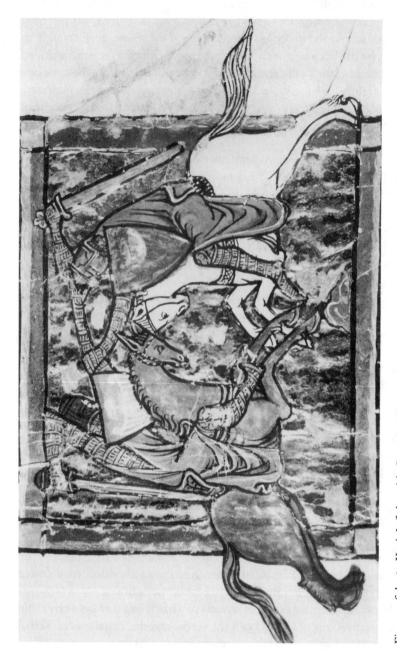

Fig. 3-7. fol. 38r. Yvain's fight with Gauvain. Photo Princeton University Library.

lize digression, simile, and other rhetorical devices to convey the difficulty of the fight, the equality of the opponents, the violence of the blows, and the exhaustion of the combatants.[21] Pictorial artists, on the other hand, unable to resort to rhetorical tricks, find a limited number of ways to show two mounted men fighting with lances and swords, and a more or less unvarying traditional depiction of single combat results. Here, therefore, when the story requires the depiction of an epic duel, the miniaturist ignores the text, with its digressions and its rhetoric, and presents a standard picture of mounted knights fighting with swords.[22]

In another respect, however, the problems faced by the miniaturist are more complex than those faced by the verbal narrator. The story depends on the fact that Yvain and Gauvain, though close friends, do not recognize one another. Since Yvain has adopted the *nom de guerre* "chevalier au lion" as an alias, he is known to the reader but not to his opponent. To set the stage for the incognito battle, therefore, the poet need only mention that Gauvain has made himself unrecognizable (F. 5874–75). The miniaturist, however, must find a way to indicate that the knights are disguised, while allowing the reader to recognize Yvain. The heraldic lion that has been established as Yvain's insignia is therefore abandoned, in favor of the eagle, and Gauvain is given a nondescript plain shield.[23] To identify Yvain for the reader, the erstwhile lion-knight is given the same horse and surcoat he has had in every other miniature. In sum, the picture of the Yvain-Gauvain combat is influenced very little by the text. Instead, it is a product of both a strong iconographic tradition and of the attempt to solve narrative problems posed by the pictorial medium.

Overall, the iconographic analysis of the *Yvain* miniatures of Garrett 125 indicates that the illuminator sometimes follows the text rather closely. He understands the importance of the initial scene and accurately reproduces numerous details from the text. In the illustrations of Yvain's rescue of the lion, his struggle with Harpin, and his battle against the seneschal and his brothers, the miniaturist incorporates specific details from the text into the pictures. In other cases—Yvain's wedding, his battle at Pesme Avanture, and his combat with Gauvain—the painter takes fewer details from the text, relying more heavily on images from well-established iconographic traditions. Particularly in the case of the Yvain-Gauvain battle, the artist devotes considerable thought to the independent solution of narrative problems in the pictorial medium. The production of the miniatures for Garrett 125 does not depend exclusively on close reading of the text or on iconographic tradition, but on a synthesis of both.[24]

Garrett 125 as Pictorial Narrative

In analyzing the Rodenegg and Schmalkalden cycles, I noted that although some medieval viewers may have had extensive prior knowledge of the story, presumably no viewers read from Hartmann's text while they examined the paintings. At least some users of an illustrated manuscript, however, must have encountered the pictures while reading the text. On the other hand, it is probable for several reasons that not all viewers were readers.

In the first place, many owners and users of vernacular manuscripts were probably either illiterate or only marginally literate. The point is, admittedly, open to some debate. Although the standard opinion remains Grundmann's conclusion that throughout most of the Middle Ages only those who were literate in Latin could read and write the vernacular languages, and that very few lay people acquired these skills ("Litteratus-illitteratus," esp. 4–5), some scholars have long contended that lay literacy was not so uncommon.[25] Nonetheless, it appears that the high medieval knight was stereotypically expected to be illiterate: the paradigmatic example is provided by Ulrich von Lichtenstein, whose supposedly autobiographical narrator-hero experiences great frustration when he receives a letter from his lady and must wait several days for his scribe to return before he can read it (p. 60). Similarly, Wolfram's pose as an active knight—"schildes ambet ist mîn art" (*Parzival* 115, 11)—apparently requires him to insist that he knows no letters (*Parzival* 115, 27; *Willehalm* 2, 19–22), and Hartmann's narrator appears to consider his own ability to read quite noteworthy—"ein ritter sô gelêret was" (*Der arme Heinrich* 1, cp. *Iwein* 21). On the other hand, these examples of aristocratic illiteracy are immediately qualified by their own fuller contexts. Ulrich, after all, is normally accompanied by a scribe, and thus possesses a sort of functional literacy, even though he himself cannot read. And Wolfram, despite his claim to be illiterate, revels in displays of erudition that strongly suggest access to literate traditions. Moreover, the ladies with whom Ulrich corresponds do not rely on scribes, for they can read and write themselves; indeed, literacy appears to have been considerably more common among aristocratic women than among their male counterparts,[26] and women were frequently the commissioners and owners of manuscripts.[27]

Still, whatever the actual statistics on lay literacy in the thirteenth and fourteenth centuries may have been, and however they may have broken down along gender lines, it remains evident that a large part of the audience

partook of its literature by listening.[28] The paradigmatic example may be found in the text of *Yvain* itself, when Yvain arrives at the court of Pesme Avanture and finds the nobleman's daughter reading to her parents from "a romance, I don't know of whom" ("un romanz, ne sai de cui" [F. 5366]). Knowledge of a story, even in a household that owned a manuscript, was primarily disseminated orally.

The key question for us, given this situation, is this: what did the various members of a household actually do with the pictures in an illuminated manuscript? If the romance manuscript at Pesme Avanture was illustrated, how did the daughter respond to the pictures? And how did her presumably illiterate father respond to the pictures, when he turned the pages of the manuscript? Scholars discussing illuminated manuscripts have traditionally paid surprisingly little attention to these questions, preferring to concentrate on issues of style, provenance, or iconography—in other words, on the production rather than on the reception, on the creation of the pictures rather than on the creation of diegesis from the pictures.[29] If we wish to approach the illuminations from the reception side of the narrative equation, the starting point is the recognition of the situation in which these images were viewed—one in which some users of the manuscript could read and others coud not, while others could but did not.[30]

If we reduce this complex situation to its simplest elements, we see that manuscript users may be divided into readers, who read the entire text themselves and looked at the pictures as they came to them, and, at the other extreme, viewers, who looked at the pictures without knowing the story at all. These two ends of the spectrum of manuscript consumers define the two functions of the miniature cycle and the two ways in which it must be analyzed—as an integral part of a multi-media artwork consumed by readers, and as independent pictorial narrative consumed by viewers more or less ignorant of the text. In reality, of course, the majority of the users of a manuscript like Garrett 125 probably fell somewhere between the two extremes: they possessed limited literacy or, probably more often, participated in group literacy, hearing the story, or parts of it, read aloud in formal or informal settings, or at least hearing about the story in conversation. Nonetheless, considering the pictures as they would have been perceived by the two groups at the extremes is essential to improving our understanding of the ways in which medieval pictorial narrative may have been received by all its audiences, including the large group in the middle of the spectrum.

PICTURES AS ILLUSTRATION

The term "illustration," usually used carelessly to refer to any picture in a book, might well serve to designate the role of the pictures as consumed by readers. The illustrative function is by no means simple. Very few secular books attempt to provide for every narrative moment an illustration in close proximity to the relevant textual passage.[31] Most, like Garrett 125, scatter a few pictures through a vast amount of text, and the images are often located some distance from the passages they "illustrate." The two variables in the interrelation of illustration and text, therefore, are selection and location: which narrative moments are pictured, and where are the images located? What principles underlie the selection of scenes and the choice of locations?

The selection of scenes to be depicted obviously requires some concept of narrative segmentation. Telling a story in a series of separate pictures requires dividing that story into a series of discrete units and then representing each of those units with a picture. A number of choices must be made. The illuminator may assign one picture to a sequence like "Ywain's adventure at the fountain" or to a nucleus such as "the moment when the lances break in the combat between Ywain and Esclados." The illuminator does not necessarily try to illustrate every segment that he perceives in the story. He may depict a nucleus in one miniature and a macro-level sequence in another. Nonetheless, an inquiry into the selection and location of images in a text might well begin with an attempt to determine what principle of segmentation is involved.

In Table 1, I have divided *Yvain* into four large sections and 22 episodes. As the table shows, the miniatures of Garrett 125 illustrate virtually every episode in the second part of Yvain's story, but only one episode—the climactic one, the wedding—from the first part of his story, and no episode from Calogrenant's narration. The omission of Calogrenant's story makes perfect sense in terms of the economical creation of pictorial narrative, since Calogrenant's adventures are nearly identical to Yvain's. The narrator of a text can easily tell the story in detail once and then simply remark that Yvain took the same route, came to the same place, performed the same actions—only with a different outcome. Since a pictorial narrative cannot tell us that Yvain did the same things Calogrenant had done, the easiest thing for the artist to do is to eliminate the Calogrenant narrative altogether—as is done at Rodenegg, Schmalkalden, and here.[32] But why is the first part of Yvain's story represented by only one image? Did the illustrator simply choose to ignore all the episodes in Yvain's life prior

TABLE 1. Episodes of *Yvain*

Episodes	Garrett 125	BN fr. 1433
I. Introduction		
1. storytelling scene	X	
II. Calogrenant's story		
2. Vavasour		
3. Wild man		
4. Fountain		
5. Calogrenant vs. Esclados		X
III. Yvain's story I		
6. Vavasour		X
7. Wild man		
8. Fountain		
9. Battle		X
10. Portcullis		X
11. Yvain trapped		X
12. Wedding	X	
IV. Yvain's story II		
13. Arthur at Yvain's court		X
14. Laudine's renunciation of Yvain		X
15. Yvain's madness		X
16. Yvain's healing		X
17. Rescue of the lion	X	X
18. Harpin	X	X
19. Rescue of Lunete	X	X
20. Pesme Avanture	X	X
21. Yvain vs. Gauvain	X	X
22. Yvain's reconciliation with Laudine		X

to his marriage? Or is some other principle of segmentation in operation? For an answer, we must first consider the nature of the other segments illustrated.

My division of the text into sections and episodes is an ad hoc segmentation, developed for the purpose of analyzing the two *Yvain* miniature cycles, not as an exhaustive analysis of Chrétien's text.[33] In general, my sections represent macro-level arcs of plot, each of which can be broken down into a number of sequences, which I have called episodes here. Breaking

these sequences down into their constituent elements generally produces not further sequences, but nuclei. If we consider the Garrett illuminations in terms of such a structural model, we find that, in the latter part of Yvain's life, each first-level sequence is represented by one picture. Yvain fights against Harpin, he rescues Lunette, he defeats the two "sons of the devil"; finally, he battles against his incognito friend and peer, Gauvain.

These sequences are not narrated; rather, a representative nucleus is depicted for each. In three of these five miniatures, the nucleus depicted is the one in which the basic alternative of the sequence is resolved—that is to say, the climax or turning point of the episode: Ywain rescues the lion, he defeats Harpin with the lion's aid, the lion joins the battle against two demons. But the illustration of the fight against the seneschal and his brothers depicts the beginning of the combat, and the Yvain-Gauvain illustration represents a random moment during the fight. The common principle is clearly that each narrative sequence is represented by the depiction of one representative nucleus from the sequence.

If we consider the first part of the Garrett 125 miniature cycle in light of this principle, we find that the illuminator must have seen the entire "Yvain wins Laudine" action as one sequence at the same level as the others illustrated—as one adventure, structurally analogous to "Yvain battles Harpin" or any of the others illustrated—and not as a meta-level arc of plot, of which the winning of Laudine is only a part. The wedding is the representative nucleus of this sequence, not a first-level sequence in its own right. The level at which modern scholars perceive the double sequence of adventures in the text of *Yvain* thus disappears entirely. The miniature cycle does not depict two meta-sequences of adventures, in which Yvain first wins and then loses Laudine, to win her back again in a second major series of adventures, but simply a single series of adventures, in the first of which Ywain wins his bride.

This theory is supported by the principle of location that is evidently at work in the manuscript, as Table 2 indicates. The last illumination (Yvain vs. Gauvain) appears within the text of the large segment it illustrates, and before the specific moment depicted. The whole Yvain and Gauvain episode begins at ms. 5866 (F. 5872), the miniature appears between ms. 6028 and 6029 (F. 6040 and 6041), and the actual battle begins at ms. 6037 (F. 6106). The placement of the other five illuminations in the second part of *Yvain* follows the same principle: the miniature is located within the episode and before, although not usually immediately before, the specific segment illustrated. The "Pesme Avanture" episode begins at ms. 5056 (F.

TABLE 2. Locations of minatures, Garrett 125

Large box = large segment; small box = specific moment illustrated; solid box = minature. Line numbers are from Rahilly's transcription.

5107), when Yvain and the maiden arrive at the mysterious castle; the illustration of Yvain's fight with the two demonic warriors interrupts the text between ms. 5406 and 5407 (F. 5456, 57). Yvain's evil opponents then appear at ms. 5460 (F. 5512); the fight itself starts at ms. 5517 (F. 5570). The "Rescue of Lunete" episode begins with Yvain's arrival at the place of judgment at ms. 4304 (F. 4318), the illumination is located after ms. 4435 (F. 4474), and the fight with the seneschal and his brothers begins immediately after the illustration at ms. 4436 (F. 4475). The Harpin episode begins with Yvain's arrival at the oppressed court at ms. 3772 (F. 3772), the miniature appears between ms. 4114 and 4115 (F. 4122 and 4125), and the actual combat begins at ms. 4184 (F. 4194). The episode in which Yvain frees the lion is unusually short, and the picture illustrating it has been placed at the very beginning of the episode (just before ms. 3341 [F. 3341]), thus technically violating the postulated rule while remaining clearly within its spirit. Since the designer of Garrett 125 followed this principle so consistently in these five segments, it is reasonable to assume that he followed it in the first segment as well, and that he regarded the entire story up to the wedding as one long *aventiure*—"Yvain wins Laudine," the first stage of Yvain's career. The wedding picture is the first illustration after the introductory scene, and appears (after ms. 2058 [F. 2078]) shortly before the brief narration of the actual wedding begins at ms. 2129 (F. 2150).

The whole poem, then, is seen as one series of adventures, of which one is not much more important than another. How Yvain wins Laudine is not important; marriage to the lady for whose sake the knightly deeds are done is simply the starting point of the *aventiure* chain. Based on this understanding of the story of Ywain, the illuminator of Garrett 125 has divided the text into a prologue and six episodes, devoting a miniature to each of these large structural units. In each case, the picture illustrates an important moment, often the climax of the episode, and appears in the text shortly before the moment depicted.

Nonetheless, this theory does not explain the omission of Yvain's estrangement from Laudine and his madness. The "Yvain wins Laudine" sequence is clearly closed out by the wedding, and Yvain's rejection by Laudine, life in the wilderness, and rescue by the ladies of Norison cannot possibly all be seen as belonging to the lion sequence. These sections have simply been omitted. The effect of this omission on readers is surely to guide their reception of the text: although they read the story of Yvain's exile, the illustrations suggest that these segments are not important, or at least not as important as others. The program of illuminations pushes

readers toward an unproblematic understanding of Ywain's adventures as representative of knightly behavior. The illuminator of Garrett 125 evidently understood Ywain's adventures as unambiguously exemplary, and created a miniature cycle that would guide the reader of the manuscript toward such a reading. Under the influence of the pictures, the reader may ignore the question of Ywain's guilt and redemption, madness and recovery, and simply read the "Yvain in the wilderness" section as one more typical courtly adventure.

On the other hand, readers may engage themselves more actively with the book. They may complain about the selection of scenes for illustration and refuse to accept the reading of the text toward which the paintings push them. Nonetheless, they can hardly avoid being influenced by the pictures. Any reading of the text that emphasizes Ywain's failure to return to Laudine on time and the purgatorial nature of his subsequent adventures is surely weakened when the text is accompanied by a picture cycle that ignores Ywain's guilt altogether. Readers, then, however they might read the text alone, are guided by the pictures toward an understanding of Ywain's career as unproblematic and exemplary.

PICTURES AS NARRATIVE

At the other extreme are those viewers who do not read, and do not know the story in advance, but only look at the pictures. Obviously, these non-reading viewers have no choice but to understand Ywain's story as the pictures tell it. What these viewers find in the manuscript is a complete, coherent, pictorial narrative of the Ywain story—but not Chrétien's *Yvain*. The pictorial narrative begins with the image of some knights and a queen talking. The reader, or the viewer who has been told the story as the text tells it, will undoubtedly identify this scene as Calogrenant's narration of the fountain adventure. If the scene is so identified, the historiated initial serves as a sort of prologue, self-reflexively thematizing courtly story-telling in much the same way as Chrétien's text, although, since no scenes from Calogrenant's story are depicted, the thematization of *aventiure* is not so well developed as it is in the text. When we consider the picture from the point of view of the nonreader, however, we find that we cannot insist too strongly on the identification of the scene as one of storytelling. Clearly, some courtly folk are gathered. One man, standing, speaks, and the rest appear to form an audience. One of these, however, seems to have interrupted the speaker (probably a common occurrence during informal and even formal storytelling at court). And the queen is just entering, gestur-

ing as if to request calm or quiet. The gist of the scene, for the uninformed viewer, is that knights and a lady are talking at court. The situation in which the speaker stands while most of the listeners are seated may suggest storytelling, but even if it does not, the image is nonetheless one of courtly discourse, which serves to link the courtly world of the viewer with the courtly world in which the story takes place. Since the link to the Arthurian world is established through the activity of courtly discourse, rather than courtly combat, viewers are invited to identify themselves with the Arthurian knights in their role at court, not in the forest of adventure. Like the corresponding scene at Schmalkalden, the opening image here may thus emphasize, even to the nonreading viewer, the literariness of the narrative to be presented, suggesting that the subject of the narrative is primarily discourse—the story as narrative—rather than action. The scene is set at the court, where narration occurs, rather than in the forest, where action takes place.

The narrative begins at court in another sense, too. The next scene after the prologue is the wedding, and only after the wedding does the knight ride out in search of *aventiure*. This is no knight-errant who must establish himself at court and provide himself with a bride through his first series of adventures. This knight's adventures begin at court, and are undertaken for the wife. This beginning, it is important to note, does not imply any particular ending. Since the knight already has a position at court and a noble wife—the usual goals of the romance quest—his adventures have no obvious telos.

After marrying, the knight experiences a series of adventures. In the first of these, he discovers a lion and a dragon fighting and rescues the lion, who then becomes a loyal companion. Up to this point, the pictorial narrative might be summed up as follows. Knights tell stories: here is one. There once was a knight who married a beautiful lady and rode out to seek adventure in her service. He soon freed a lion from a dragon, and the lion became his loyal companion. Together, they had many adventures. The rest of the narrative relates a series of these adventures. One might see a certain progression in the first three episodes: the hero must overcome first one giant, then three knights at once, then two creatures—the lords of Pesme Avanture—who must have appeared the very embodiment of evil. But the final miniature, showing the hero, without the aid of his lion, without his usual heraldic insignia, in combat with another knight, does not offer any sense of closure. It is not even clear how this combat will end. Whereas the hero appeared to be winning each of the preceding fights, he here ap-

pears to be achieving no more than a draw. The pictorial narrative evinces no interest in a conclusion, and since the beginning has not opened any alternatives, there is no need for one. The series of adventures could be continued indefinitely, it seems; there is no particular significance to the fact that it breaks off here. The pictorial narrative in Garrett 125 is open-ended, episodic, and unproblematic. It shows the adventures of the lion-knight not as a symbolic or allegorical progression, but as a series of exemplary scenes of knightliness. At the same time, the image of courtly conversation that begins the miniature cycle may suggest, by locating the narrative at the court where storytelling takes place, that this exemplary knightliness is purely fictitious, that the exemplariness relates to the Arthurian world rather than the real world.

Described in this way, the picture cycle of Garrett 125 shows obvious similarities to the murals at Schmalkalden. However, the structural analysis of the miniature cycle reveals significant differences, alluded to but not fully explored above, between the Princeton narrative and the two cycles of wall paintings, in terms of the way narration takes place and the ways in which viewers may create diegesis from the visual text. As noted already, the Princeton miniatures do not actually narrate upper level sequences at all, but represent them by depicting key nuclei.

The distinction I draw here between fully narrating sequences and depicting selected nuclei is similar to Kemp's distinction between the narration of acts and the narration of actions (Kemp 37–38; see above, p. 122). Acts, in Kemp's terminology, are punctual; they are single events. Actions are durative; they are series of events. Building a narrative from a series of acts means that the viewer is faced with a series of separate events, and must link them together to create diegesis based on external codes such as the prior knowledge of a text or story. I disagree with Kemp to some extent on this point: nonreading viewers of the Princeton *Yvain* miniatures *can* create diegesis without prior knowledge of the text or the story, but the story they will create differs significantly from that created by similar viewers of, for example, the Schmalkalden murals.

Essentially, the diegesis created from the depiction of acts or nuclei will be much more elemental than that created from the narration of actions or sequences. Without the opening and closing of alternatives that the narration of sequences involves, viewers of an acts-based narrative can develop much less of an idea of the connections between episodes and the motivations of events. Uninformed, nonreading viewers of the Garrett miniatures can tell themselves only a basic story: there was a knight; he

married a lady, then had a series of adventures. In the first adventure, he rescued a lion from a dragon. Aided by the lion, he then fought a giant, and so on. Although the story remains skeletal, it is coherent and meaningful in terms of genre-based codes which inform viewers that these are typical things for a knight to do in a romance narrative.

Not narrating sequences, again, means primarily not opening and resolving alternatives. At the first level, we do not, for example, see Yvain enter the clearing where the lion and the dragon are fighting, and wonder whether he will intervene, how he will intervene, and whether he will be successful. Similarly, at a higher level, we do not see him ride out to seek adventure, and therefore the basic alternative of the larger adventure sequence—succeed or fail, return in glory or return in disgrace—is not opened. Not only does the narrative not move toward a telos in the sense of a goal for the knight's quest, the narrative has no overall structure beyond the serial occurrence of one adventure after another. This simple, episodic structure points directly to the thematic value of the miniature cycle: the viewer finds in these images no questioning of the ethics of adventure, no moralizing about the value of adventure, but the presentation of a series of representative episodes of romance adventure. The viewer who relies on the images and the reader who is influenced by the pictures thus end up with similar understandings of the story of Yvain. Both perceive him as an exemplary romance knight, and his story as a straightforward series of exemplary scenes of adventure.

Clearly, even though it exists in close association with a text, this pictorial narrative is an independent interpretation of the Ywain story, with the power not only to create a particular understanding of the Ywain story for viewers relying solely or primarily on the pictures, but also to strongly influence readers of the text. Far from being merely an illustrative adjunct to the text, the miniatures in Garrett 125 are both an independent pictorial narrative and a part of a carefully planned multimedia work of art.

Notes

1. Two crude marginal drawings in the Paris *Iwein* (BN all. 115)—at least one of which was probably added by a manuscript user—are discussed in Rushing ("Adventures" 224–25). The fifteenth-century manuscript-maker, Diebolt Lauber, appears to have offered an illuminated *Iwein* in his "catalog," but none survive, and we cannot be certain that any were ever made (see Rushing, "Adventures" 223–24).

2. On the *Yvain* manuscripts, see Micha (27–64); Jonin (15–25); and the new catalog by Busby et al.

3. A London dealer, Quaritch, obtained the manuscript at the sale of the books of Étienne Mallet, on May 4, 1926. It was purchased from Quaritch in 1928 by Robert Garrett of Baltimore, who later gave it to the Princeton University Library. On the provenance, see Rahilly ("The Garrett Manuscript" 8); also Nixon (57).

4. On the contents of the manuscript, see McGrath ("A Newly Discovered Manuscript" esp. 383–84; "Romance of the Maccabees" 66–72) and Rahilly ("The Garrett Manuscript" 4–8; "Manuscrit Garrett 125" 407). Rahilly's description ("The Garrett Manuscript" 3–4) needs at least two corrections: there are 42–43 lines per column (44 in the *Garin* section), not 40–42, and 71 folios, not 70, the last being blank.

5. The *Garin* was written in a clearly different hand (cp. Rahilly, "The Garrett Manuscript" 4, "Manuscrit Garrett 125" 408; Hendrickson 164), on darker parchment, with different rulings, different pen flourishes, and different prickmarks (on the inner margin in the other texts, missing in the *Garin*): it presents an obviously different overall appearance.

6. On the presence of non-Picardian, particularly Francian, features, suggesting a scribal attempt to write in a literary standard language, see Rahilly ("The Garrett Manuscript" 11–42). The dialect and the style of the miniatures led McGrath to the assumption that Garret 125 was "probably produced at Amiens" ("A Newly Discovered Manuscript" 592).

7. The connection with the Du Boisruvray Psalter was first made by McGrath ("A Newly Discovered Manuscript" 592); the manuscript was at that time on loan to the Bibliothèque Nationale.

8. On the second painter of Widener 9, see Stones ("Context" 252–253).

9. Porcher, as quoted by McGrath ("A Newly Discovered Manuscript" 592). McGrath dates Garrett 125 by reference to other illuminated Arthurian manuscripts, placing it between BN fr. 95 (ca. 1290) and the Morgan *Lancelot*, ca. 1300 ("A Newly Discovered Manuscript" 590). For agreement with this dating, see Rahilly ("Manuscrit Garrett 125" 409; "The Garrett Manuscript" 4) and Woledge (5).

10. Gautier's *Machabée* remains unedited; on this and other Maccabees romances, see Smeets.

11. Since Garrett 125's four missing *Yvain* folios all belong in the later part of the text, after the wedding illustration, and no significant episodes are left unillustrated after that point, one may safely assume that no illustrations are missing from *Yvain*.

12. See Stones's general remarks on the use of "moduli" ("The Illustration of the French Prose *Lancelot*" 29–32); also her "Arthurian Art" (37).

13. On illuminators' instructions, see Meiss (12–17); Branner (12–15); Ross ("Methods" 65–66); Evans (178).

14. This three-step process is clearly demonstrable in a painting of Alexander and the cyclops in Royal 19.D.1 (fol. 38v), where the painter, failing to understand the point of the drawing, gave the cyclops two eyes (Ross, *Alexander-Books* 66, pl. 10). For a good general introduction to workshop procedures, see Branner (7–21).

15. See above, note 112, in Rodenegg chapter.

16. References to the text of *Yvain* are to Foerster's edition, indicated by an "F"; quotations from Garrett 125—"ms."—follow Rahilly's transcription ("The Garret Manuscript").

17. See above, p. 107, in Schmalkalden chapter.

18. McGrath assigns Garrett 125 and BN fr. 95 both to Amiens, perhaps to the same atelier ("A Newly Discovered Manuscript" 591–92). BN fr. 95 was illuminated ca. 1290 (Loomis and Loomis fig. 224) and McGrath places Garrett 125 in the following decade.

19. On the literary tradition of the helpful lion, see Zenker's exhaustive accumulation of information (145–69) and Woledge's more selective and helpful discussion (189–94). Combat between dragons and panthers appears to have been considerably more common than dragon-lion battles, occurring primarily in Latin literature (see Lecouteux 2: 186–87).

20. McGrath finds that "the kangaroo-like appearance of the viper is in conformity with the mediaeval conception of this beast as found in . . . Romanesque and Gothic bestiaries." However, the specific models he suggests (586)—the "Wivre" and "Aspis" illustrations in Pierre le Picard's bestiary (Arsenal 283 [in Cahier pl. xix]), resemble the Princeton dragon only in a general way.

21. Thus Chrétien, for example, begins his narration of the Yvain-Guavain combat with a long digression on how Love and Hate can dwell in one vessel (F. 5991–6104).

22. On the iconographic tradition of single combat, see above, p. 49, in the Rodenegg chapter.

23. In the thirteenth century, Gawain usually carries a shield "d'argent au franc-canton de gueles." The best discussion of Gawain's arms is Pastoureau, "Études" (3–5); see also Pastoureau, *Armorial* (69–70) and Brault (38–42).

24. McGrath finds that the miniaturist has "read the text carefully," and translated it into pictures that tell the story in a clear, straightforward manner ("A Newly Discovered Manuscript" 586). The artist was not adapting pre-existing iconography, McGrath claims, but inventing pictures based on the text he read, "attempting to create an iconography solely for, and by means of, the text he decorates" (587). My analysis of the miniatures has shown these findings to be not so much wrong as overly simplistic.

25. See Turner for a recent statement of this argument with references to older scholarship.

26. See Ulrich's *Frauendienst*, for example, p. 59, l. 13; other examples are listed by Grundmann ("Die Frauen").

27. See Grundmann ("Die Frauen" 146–50).

28. See Crosby's pioneering article on "Oral Delivery". Green has argued in a series of recent articles for what he calls the "intermediate mode," in which "a medieval audience listens to a reciter who delivers his work not by memory or by extemporizing formulaic composition, but from a manuscript which he has in front of him" ("Primary Reception" 291; see also "Über Mündlichkeit und Schriftlichkeit" and "Reception of Hartmann's Works").

29. Some important recent studies of the actual function of illuminations in-

clude Curschmann ("Texte—Bilder—Strukturen" and "Imagined Exegesis") and Solterer.

30. As a warning against assuming that anyone who could read, did read the text, it may be instructive to think for a moment about the reception of lavishly illustrated "coffee table books" in modern culture: even though virtually everyone who turns the pages of these books can read, many or most do not read the text of these books, but only look at the pictures.

31. Virtually the only example is the Munich and Nürnberg *Willehalm* (cgm 193/III and Germanisches Nationalmuseum Hz. 1104–1105). See Frühmorgen-Voss ("weltliche Literatur" 29 and pls. 10–12).

32. Let me be very clear about the differences between these narrative strategies. In the texts, Calogrenant narrates his adventures, and Yvain then enacts them. Yvain's adventures as deeds follow directly from Calogrenant's adventures as narration. The effect is to thematize narration, to make the entire work logocentric or self-reflexive. This could be done in pictures, I think, but none of the Yvain cycles attempt it. BN 1433 does depict Calogrenant's fountain adventure, but there is no hint that this is narration as opposed to action. Garrett 125, however, does begin with a scene of storytelling, and thematizes narration in its own way, as we shall see.

33. For one attempt to describe the narrative segments of *Yvain*, see Linke (97–106).

4. Adventures Right and Wrong: The Illuminated Paris *Yvain*

Historical Background

The other illuminated *Yvain* manuscript—Paris, Bibliothèque Nationale fr. 1433, which contains the Gauvain romance *L'Âtre perilleux* (folios A, B, 1–60v) and *Yvain* (folios 61–117)—offers a considerably more extensive pictorial narrative and depicts a far greater number of scenes from Chrétien's text than does Garrett 125.[1] The Paris illuminations, therefore, may seem at first glance to have a more purely illustrative function, to come much closer to rendering Chrétien's narrative in images. Nonetheless, the miniatures of BN fr. 1433 develop an independent pictorial narrative, which can be understood by nonreading viewers, and which guides readers toward a particular understanding of Chrétien's text.

BN fr. 1433 has proved extremely difficult to date and place with precision, in part because its full-page miniatures are almost without parallel in French vernacular illumination (Stones, "Context" 258). In the most extensive recent analysis of the miniatures, Stones sees the style as broadly derivative of well-known Parisian styles of the early fourteenth century. Stones finds analogous styles and formats in manuscripts dating from as early as 1317 and as late as 1344, though she suspects that certain architectural elements clearly suggesting a date in the second quarter of the century (e.g., fol. 60) result from later overpainting (Stones, "Context" 258–59). Taking Stones's analysis along with Nixon's somewhat more confident dating of the handwriting to the first quarter of the fourteenth century (74), we might arrive at a date not later than about 1340, and most probably in the 1310s or 1320s.

Although style of the miniatures is clearly Parisian or northern French, the dialect is Picard and the script is Picard or Flemish. It is possible to imagine a variety of explanations for this combination of traits, including François Avril's suggestion that the manuscript might have been made in a

northern French or Flemish workshop whose chief illuminator was of Parisian origin (quoted in Walters 5),[2] but no such theory can be conclusively proven.[3]

Though BN fr. 1433 contains only three more miniatures than Garrett 125, six of them are divided into as many as four compartments, and several narrative moments are often combined in one frame. The result is a much more extensive pictorial narrative.

> fol. 61r. Thematic Introduction (fig. 4-1)
> fol. 65r. Calogrenant-Esclados Battle (fig. 4-2)
> fol. 67v. Yvain with the Vavasour (fig. 4-3)
> fol. 69v. Yvain's Defeat of Esclados (fig. 4-4)
> fol. 72v. Esclados's Funeral (fig. 4-5)
> fol. 80v. Yvain's Defeat of Key (fig. 4-6)
> fol. 85r. Yvain's Madness and Recovery; How He Got the Lion
> (fig. 4-7)
> fol. 90r. Yvain's Rescue of Lunete and Fight with Harpin (fig. 4-8)
> fol. 104r. Pesme Avanture and Yvain vs. Gauvain (fig. 4-9)
> fol. 118r. Yvain's Reunion with Laudine (fig. 4-10)

The general point that vernacular picture cycles do not create new images ad hoc for each narrative moment, but rely heavily on existing iconographic traditions, has been established in detail in the preceeding chapters. I propose, therefore, to discuss the iconography of Paris BN fr. 1433 in somewhat more summary fashion, reserving a more detailed account of the images for a section analyzing the structure of the visual narrative.

Iconography

Perhaps the most notable aspect of the visual narrative technique in the Paris *Yvain* is the frequently used method of combining two or more narrative moments in one compartment. For example, in the miniature on fol. 69v, the upper left compartment is mostly taken up with a depiction of Yvain and Esclados fighting with swords. But to the far right in the same frame, partly overlapping with the main action, Yvain's horse disappears through a gate in a tower, and is trapped by the falling portcullis. (The action then passes through the gate into the next frame, where Yvain stands

talking to Lunete.)[4] Similarly, in the first compartment of the Rescue of Lunete-Battle with Harpin miniature (fol. 90r), Yvain, sitting on his horse, converses with the imprisoned Lunete in the center of the frame, and rides away to the right of the same frame. The horses overlap considerably. In the lower register of the same miniature, Yvain fights against two of his enemies, and then, just to the left (this register reads right to left), rides away embracing Lunete. Here, the two moments overlap so extensively that the two mounted Yvains appear to grow out of the same spot. This extreme is also reached in the depiction of Calogrenant's battle with Esclados (fol. 65r), in which it almost appears that a double-ended horse is being ridden by two knights. Finally, in the depiction of the battle between Yvain and Gauvain (fol. 104r), two or three moments are illustrated in one frame: Yvain and Gauvain fight to the left and slightly in the background, while in the center foreground they embrace, and Arthur with his courtiers emerges from a doorway to the right. A variation or refinement of the technique appears in another compartment of the same miniature. The lion watches from a window in a tower as Yvain fights against the two "sons of the devil," then pounces on one of the demons, dragging him down from behind. Two moments in the fight are thus depicted, even though most of the figures in the action only appear once.

The extreme overlapping, to the point that Siamese-twin knights appear to ride two-ended horses, is rare and perhaps unique in Arthurian illustration.[5] However, the basic technique of presenting multiple narrative moments in one frame is neither new nor unique to the Paris *Yvain*. It is, rather, an adaptation of the very old method that Wickhoff called "continuous" (8)—a method found, for example, in the sixth-century *Wiener Genesis*. Several manuscripts more nearly contemporary with the Paris *Yvain* employ similar approaches. In the top register of the illumination on fol. 1 of a *Conte del Graal* manuscript (BN fr. 12577, ca. 1330, Loomis fig. 263), Perceval rides away from his mother and then, in the same compartment, kneels in front of a group of knights. In the lower register of the same miniature, Perceval's mother collapses in grief in front of her house, while, just to the right, Perceval rides along with drawn bow, and farther to the right, he kills the Red Knight.[6] The horses of the two Percevals overlap, but they do not seem to grow out of one body, as do the horses of the two Calogrenant's. The 1433 illuminator is clearly adapting an already known technique, not inventing a new one.

The illuminator appears to follow the text rather closely in a few details. In the Calogrenant-Esclados miniature, for example, the stone's olive

color may illustrate the text's statement that the stone is an emerald (F. 424). The stone is also speckled with dots that might represent the holes, and red spots that probably represent the rubies mentioned in the text (F. 425–26). In depicting the three hundred noble seamstresses enslaved at Pesme Avanture (fol. 104r), the artist picks up the detail of the golden thread (F. 5196), but since Chrétien's description of the scene is otherwise rather vague, the miniaturist simply depicts a great many women sewing and knitting—one of whom (at the right front of the group) sews with golden thread.

Despite these efforts to depict details from the text, the paintings frequently diverge from it in more significant ways. The giant Harpin, for instance, fights with sword and shield (fol. 90r), in contradiction of the text's statement that he has always relied on his strength and never deigned to arm himself (F. 4196–97 and 4208–10). In the battle against the two "fiz de deable" (104r), Yvain and his lion attack the same demon, leaving the other momentarily unopposed, although this contradicts both the text and the logic of the situation. In the text, when the lion attacks one demon, the other one turns to help his comrade, and Yvain takes advantage of his distraction to behead him (F. 5649–58).

In several instances, the artist relies on well-established iconographic traditions, even when they produce images that ignore or contradict certain details from the text. In depicting the portcullis that falls on Yvain's horse (fol. 69v), for example, the miniaturist employs a standard image of a grid with spikes at the bottom, ignoring the specific description of the scene in the text, which clearly calls for some kind of giant guillotine.[7] The depiction of Esclados in his coffin, in the bottom register of the same miniature, may have been influenced in a general way by the iconography of the Holy Women at the Sepulcher, which typically shows three women standing around a sarcophagus. Here, Esclados lies in his coffin, wrapped in white cloth, while three mourners stand at his head, and two at his feet. But there is no angel atop the casket, the women do not carry jars of ointment, and the sarcophagus is not empty.[8] If the pictures closely followed the text, this would be the *Bahrprobe*, but it is not—no freshly bleeding wounds are visible. Rather than depicting Ascalon's evidential bleeding, the illuminator shows a standard scene of mourning.

For Esclados's funeral (fol. 72v), the artist relies on traditional iconography to create an elaborate image of a procession led by two acolytes with palm fronds, a robed cleric with two aspergills, and a hooded woman, presumably a nun, who carries a situla for holy water. These four are followed

by six pallbearers carrying the draped casket, and the body is followed by a large group of mourners, one of whom (in blue) may be Laudine. The equipping of the procession generally follows Chrétien's description of the scene, which mentions holy water, a cross, candles, nuns, incense, and a priest (F. 1166–70). But the illustrator probably needed no textual instructions in order to depict a funeral procession—he could draw on a number of iconographic models. One important source of funeral imagery appears to have been the burial of the Virgin Mary, which transalpine artists generally depicted as a procession of two to twelve apostles (most often four) carrying a draped casket on a bier.[9] The leader, usually John, frequently bears a palm frond. More elaborate depictions, in which members of the procession carry aspergills and situlae, are relatively rare.[10] Such processions appear somewhat more frequently in the margins of manuscripts, often with animals as the participants. For example, in a *Romance of Alexander* illuminated at Bruges around 1340 by Jehan de Grise, a marginal illumination depicts the funeral of Renart the fox, showing an ape with aspergill and situla, and lions with crosses and candles.[11] In the Paris *Yvain*, the funeral scene interrupts a text passage describing Laudine's violent grief, yet there is no sign of this in the illustration. The artist relies on standard funeral iconography to create a ceremonial scene that is considerably grander than the corresponding depiction in the text.

In depicting Harpin with a shield and sword, in contradiction of Chrétien's depiction, the artist again relies on standard iconography (fol. 90r). Although the text is unclear about whether Harpin rode a horse, both he and Yvain are mounted here, in accordance with typical courtly iconography (if one combatant is mounted, then both are on horseback) and with pictorial logic (Yvain has just ridden out from a castle and has had no time to dismount).[12] Harpin wears a rough brown garment and tan stockings, but he carries a black shield with a gold bend, and fights with a sword. The image of the giant with courtly arms probably reflects the influence of the iconographic tradition for depicting Goliath, whom late thirteenth- and fourteenth-century miniatures almost invariably show as an enormous, but otherwise normal knight.[13] Goliath usually fights on foot, but he appears mounted in a picture Bible that was made by a major workshop in Paris or northern France at roughly the same time as the Paris *Yvain*.[14]

To a much greater extent than Garrett 125, BN fr. 1433 devotes elaborate scenes to moments that receive little or no attention in the Old French text—most notably Yvain's reception by the vavasour, the funeral of Es-

clados, and Yvain's intimate reconciliation with Laudine. Chrétien devotes a mere seventeen lines to the whole episode of Yvain's overnight stay with the vavasour and his daughter, and does not describe the arrival at all. But here (fol. 67v), in an illustration covering slightly more than half the page, the vavasour and his daughter stand in front of a castle gate as Yvain approaches on foot, leading his horse and carrying his shield. Yvain and the host clasp one another's right hands; both the host and his daughter raise their hands in greeting. The only model for such a scene in the text of *Yvain* is Calogrenant's arrival at the vavasour's castle, and the most memorable feature of that episode—the host standing on the drawbridge with a moulted falcon (F. 179)—is ignored by the illuminator. As we shall see, however, the scene has a clear function in the pictorial narrative—it marks the transition from Calogrenant's story to Yvain's.

In the final miniature (fol. 118r), Yvain's reunion with Laudine is narrated in far more detail than it is in the text. In the upper register, at left, Yvain and Lunete ride toward the right, accompanied by the lion, who prances like a dog at their horses' feet. In the center of the compartment, Yvain kneels before Laudine, who emerges from a doorway at far right. Lunete stands by Yvain, with one hand on his shoulders, the other raised. Although the text does indicate that Yvain falls fully armed at Laudine's feet (F. 6730–31), the folded hands that the miniature's Yvain raises to Laudine as he kneels suggest that the painter was creating a standard scene of submission, relying more on iconographic stereotypes than on a close reading of the text.[15]

The lower register is divided into two sections. In the first, Laudine sits facing right, her cheek in her right hand. Yvain sits facing her, his hands spread in a somewhat desperate, imploring gesture. The scene is roughly parallel to F. 6777–89, where Yvain begs Laudine, who has already been tricked into promising to do all that is in her power to help him gain his lady's favor, to forgive him. At Rodenegg, the conclusion of the cycle with a similar scene imparts a negative tone to the entire narrative. Here, Laudine's gesture may suggest a reluctance to accept Yvain; but the next section of the painting makes clear that any hesitation is only temporary.

The next scene is divided from the first by the gothic vaulting, which also sets the scene in a room. Mostly covered by blankets, but obviously nude, Yvain and Laudine embrace in bed. Beside the bed in the foreground lies the lion, sleeping near his master like a faithful dog. Behind the bed, Lunete steals out of the room, carrying a pitcher and a candlestick. This

final scene of Yvain's reunion with Laudine is not explicitly narrated in the text, but the knight's sexual satisfaction is implicit in the reference to Yvain's "peace" [16]:

> Ore a mes sire Yvains sa pes,
> Si poez croire, qu'onques mes
> Ne fu de rien nule si liez,
> Comant qu'il et esté iriez. (F. 6799–6802)

> Now my lord Yvain has his peace,
> and you can believe
> that nothing had ever made him so happy
> no matter how unhappy he had been before.

The painter is no doubt influenced by the iconographic tradition of lovers in bed, which, from the beginnings discussed above, has become relatively widespread in a variety of contexts, from the decretals, to the life of David, to the romances, by the early fourteenth century.[17] The entire page of painting is devoted to scenes that Chrétien narrates cursorily, if at all. The illuminator has set out to narrate pictorially the reconciliation of Yvain and Laudine, and has independently thought out the necessary components of the episode, including its ultimate conclusion.

BN fr. 1433 as Pictorial Narrative

The procedure in the final miniature group is typical of the Paris manuscript: the goal of the illuminator seems to have been to create a complete pictorial narrative of Yvain's life. This does not necessarily mean retelling Chrétien's story in pictures; indeed, on the whole, at the level of pictorial detail, BN fr. 1433 follows the text less closely than Garret 125.[18] As a narrative, however, the Paris illuminations tell a story that is much more "complete," in comparison to the story told by Chrétien's text, than the story told by the Princeton miniatures. This completeness, however, does not produce a pictorial duplicate of the story told in the text, but an independent narrative with independent emphases. Understanding the function of the miniature cycle again requires analyzing the illuminations in terms of their two functions—as illustration and as pictorial narrative.

PICTURES AS ILLUSTRATION—STRUCTURE

The greater completeness of the pictorial narrative in BN fr. 1433, compared to that in Garrett 125, is obvious from a glance at Table 1. in the previous chapter. While the Princeton manuscript illustrates seven of the 22 major episodes into which I have divided the text, the Paris miniatures illustrate fifteen. Despite a slight bias in favor of Yvain's second series of adventures, the miniatures of the Paris manuscript are distributed relatively evenly through the text, and every major section is illustrated. In the first part, however, some interesting choices have been made. The inclusion of Calogrenant's battle with Esclados rather than only Yvain's suggests a desire to illustrate the text of *Yvain* rather than the story of Yvain, but the details of these two scenes reflect the different economics of narrative in the verbal and pictorial media. Since Yvain's story up to the battle with Esclados exactly duplicates Calogrenant's, there is no need to narrate both in detail. Chrétien's narrator tells the story in detail the first time, and summarily the second. An entirely independent illustration cycle that set out to narrate the complete story as Chrétien tells it would have to narrate the story in full each time. Since that would be extremely uneconomical, and risk confusing the viewer unable to see the connection between Calogrenant's adventures and Yvain's, the creators of the other Yvain cycles all chose to ignore Calogrenant's adventures, and simply narrate the story of Yvain. The illuminator of the Paris manuscript, on the other hand, depicts both episodes, but includes different details from each. Calogrenant is shown pouring the water on the rock; Yvain is not. In the Calogrenant scene, Esclados is shown emerging from his castle; in the Yvain episode, the pictorial narration begins in the middle of the sword fight. The inclusion of these different details from each battle allows the illuminator to convey the idea that the two episodes have parallel beginnings, but different conclusions. Although the inclusion of both episodes suggests a desire to illustrate *all* narrative moments, one moment of immense significance has been omitted from the first part of the miniature cycle—the wedding of Yvain and Laudine. The significance of this omission will be discussed below.

When we consider the location of the miniatures in BN fr. 1433, we find that the illuminator, unlike the designer of Garrett 125, makes no systematic effort to place the illustrations within the text passages illustrated. Several of the illustrations (2, 3, 4, 6, 7) do indeed appear within the corresponding text passages (see Table 3). But the effect of a miniature like illustration 7, whose four compartments cover more than 700 lines of text,

TABLE 3. Locations of minatures, BN fr. 1433

Fol. 65v. Calogrenant vs. Esclados

516

410–477/478–580

517

Fol. 67v. Yvain welcomed by the vavasour

790

777–792

791

Fol. 69v. Yvain defeats Esclados and is trapped in his castle

992

824–872	970–1054
907–	960
1144-1172 and/or 1173-1202	

993

Fol. 72v. Esclados's funeral

1300

1399–1506

1301

Fol. 80v. Yvain vs. Key

2276

2240–2257
2258–2282

2277

Fol. 85r. Yvain's madness and recovery; How he got the lion

2728

2704–2780	2781–2887
2888–ca. 3009	3364–3484

2783

Fol. 90r. Harpin; Rescue of Lunete

3364

3563–3769	4194–4249
4318–4635	

3365

Fol. 104r. Pesme Avanture; Yvain vs. Gauvain

5076

5107–5185	5185–ca. 5347
5570–5693	6106–6527

5077

Fol. 118r. Yvain and Laudine

6813

6716–6717	6720–6758
6759–6798	6799–6813??

end of *Yvain*

Numbers outside boxes are line numbers (from Förster) between which the minature appears; numbers within boxes indicate the lines corresponding to the episode depicted.

is clearly different from that of the Garrett 125 illuminations, which depict the turning point of an episode shortly before that point arrives in the text. And illustration 8, which covers almost 1100 lines of text, appears some 200 lines before the beginning of the episode it illustrates, within the episode covered by the preceding illustration. Two principles appear to be at work in the creation of the Paris *Yvain*'s miniatures. One produces large miniatures that illustrate single narrative moments—"Yvain arrives at the vavasour's castle," "Yvain defeats Key."[19] The other principle generates three- and four-part miniatures that narrate entire "chapters" of the story—"Calogrenant's adventure at the fountain," "Yvain's defeat of Esclados and imprisonment in the victim's castle," "Yvain's madness and recovery," "Yvain's rescue of Lunete and defeat of Harpin," "Yvain's ordeal at Pesme Avanture and battle with Gauvain," "reconciliation of Yvain and Laudine."[20]

In Chrétien's text, at least two of these "chapters" reflect a structural principle that is sometimes referred to as "interlace."[21] For example, this structure binds the fight with Harpin and the rescue of Lunete into a unit—Lunete asks Yvain for help; he fights and defeats Harpin before returning just in time to save Lunete. The three-part miniature on fol. 90r appears to reflect this structure. In the upper left-hand corner, Yvain speaks with the imprisoned Lunete and then rides away. In the next frame, he battles with Harpin, and the bottom register depicts his rescue of Lunete. Just as in the text, the rescue of Lunete surrounds the Harpin action. On the other hand, illustration 9 unwinds the text's interlocking of the Pesme Avanture episode and the Yvain-Gauvain combat. In the text, the two episodes are thoroughly interwoven, insofar as Yvain and the maiden are on their way to the fight with Gauvain when they pause at Pesme Avanture. In the miniature, this interlace is not visually evident, and the episodes appear to be arranged in chronological order. Yvain arrives at a castle, then sees the enslaved maidens, then fights the "sons of the devil," then fights Gauvain. If considered as direct illustration of the text, the miniature on fol. 104 might seem to reflect the interlace structure; considered as independent pictorial narrative, however, the miniature appears to have replaced the interlocking with a simple seriality. Moreover, after this consideration of the Pesme Avanture-Yvain vs. Gauvain miniature, the Harpin-Lunete's rescue pictures no longer seem so clearly interlaced. Perhaps the arrangement of the miniature on fol. 90 merely reflects the chronology of events. And since the other multi-section miniatures all follow simple chronological principles, it is probably best to regard them not as interlace structures,

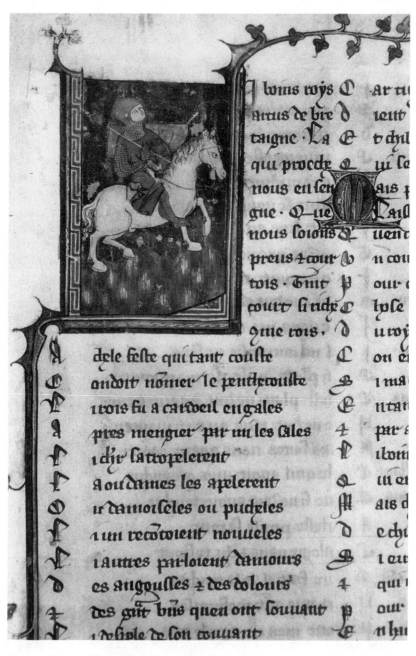

J louis roys E
artus de bre d
taigne · La E
qui procede e
nous en sen
gne · Que
nous soions
preus 4 cour
tois · Tant
court si riche
gne rois ·

ar tu
ient
t chil
ui se
ais
Tail
uen
n cou
our
tpse
u roi

dele feste qui tant couste
ondoit nomer le penthecouste
rois fu a carduel en gales
pres mengier par mi les sales
i chr satropelerent
a ou dames les apelerent
ir damoiseles ou pucheles
i un recordoient nouueles
i autres parloient damours
es angousses 4 des dolours
des grit bris quen ont souuant
i dorsiple de son couuant

C
B
E
4
F
a
M
d
B
4
p
E

ou e
i ma
ntar
par
itoir
in ei
ais d
e chi
i eur
qui
our
n hu

Fig. 4-1. fol. 61r. Thematic introduction. Photo Bibliothèque Nationale, Paris.

but as an efficient method for narrating a large number of moments in a limited space.

These large miniatures, so spectacular in appearance and narratively so complex, very likely absorb the reader's attention longer and more deeply than the smaller, single-scene miniatures in Garrett 125. The power of the miniatures to guide the reader's understanding of the text may, therefore, be even greater than in the Princeton manuscript. But before considering what the effect of the illuminations may be as illustrations, let us consider the pictures as an independent pictorial narrative.

PICTURES AS NARRATIVE—STRUCTURAL ANALYSIS

For the nonreading viewer, the miniatures of BN fr. 1433 tell a far different story from the one told by the Princeton pictures. To understand exactly what story the Paris illuminations tell, let us consider them in some detail, employing the methodology developed first in the Rodenegg chapter. In the preceding chapter, we found that the Garrett illuminator, in contrast to the creators of the two Ywain mural cycles, depicted primarily acts, not actions, isolated events, not major sequences. Alternatives were not opened and resolved, and thus the narrative embodied no obvious telos, but unfolded as a series of exemplary images of knighthood. Consideration of the Paris miniature cycle, however, deters us from any hasty conclusion that the narration of acts rather than actions is characteristic of book illustrations as opposed to wall paintings. Here, although the narrative is not as fully integrated as in the mural cycles, alternatives are opened and closed, and an overarching sequence is developed fully enough to provide a clear telos for the narrative.

Lexie 1: Thematic Introduction (fig. 4-1)

The text of *Yvain* begins with a large historiated initial "L" (of "Li boins roys"), from which an ornate boundary extends around the entire page. Within the L, against a gold background, a knight sits on a white horse, wearing a red coat, mail, and an open-faced helmet, carrying a pink shield slung over his back, and holding a thin white lance. This anonymous knight has no function at all in the proairetic code, but symbolically, the image serves as a thematic introduction to the work—an announcement that a story of knights is to be told.[22]

Lexie 2: Calogrenant vs. Esclados (fig. 4-2)

Alone among the Ywain picture cycles, the Paris cycle begins with Calogrenant's story. It is not clear from the picture alone that this is a

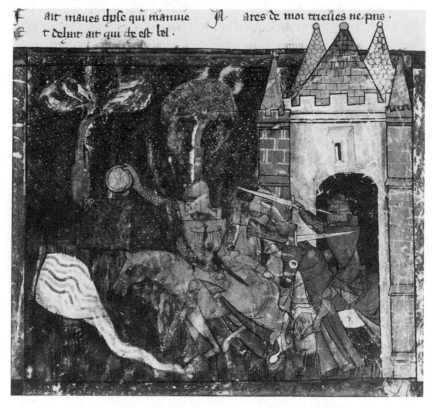

Fig. 4-2. fol. 65r. Calogrenant vs. Esclados. Photo Bibliothèque Nationale, Paris.

knight called Calogrenant; however, it is clear from the heraldry and clothing that this is not the same knight who is the protagonist of the rest of the narrative.

The Paris illuminator's technique of depicting multiple moments in one frame allows an entire lower-level sequence—an action, not merely an act—to be narrated here. To the left, Calogrenant pours the water onto the rock—an act that, as we have already established, is easily recognizable as initiating a courtly adventure sequence. An alternative is clearly opened: by provoking *aventiure*, a knight invites combat, and he may succeed or fail. The combat comes immediately, in the right-hand section of the miniature, where Esclados emerges from a castle gate to engage Calogrenant in a swordfight. Esclados's shield and clothing, as well as the trappings of his horse, display three clubs or axes on a red background. Heraldic signs, potentially indexes of considerable symbolic importance, are in this case

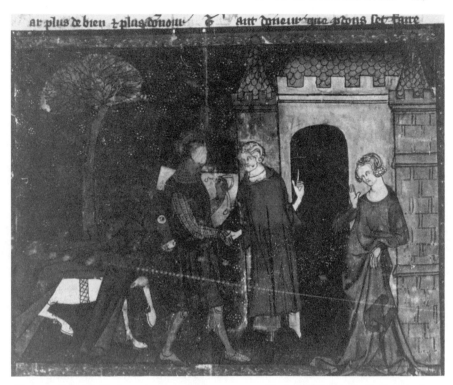

Fig. 4-3. fol. 67v. Yvain welcomed by the vavasour. Photo Bibliothèque Nationale, Paris.

informants, serving to create a sense of courtliness. Esclados's crown, on the other hand, identifies him as a king, and thus raises the stakes involved in fighting against him, since by defeating a king, an adventurer may win a kingdom. It is not as clear as it could be that Esclados, the castle's defender, is winning the fight against the intruding adventurer, although the blow he strikes to Calogrenant's head must surely be judged more effective than Calogrenant's blow to Esclados's shield. Nonetheless, nonreading viewers who did not award the decision to Esclados might guess that the intruder had failed in his adventure when they turned to the next miniature and found that a new adventurer had replaced the first one on the romance stage.

Lexie 3: Yvain Welcomed by the "Vavasour" (fig. 4-3)
The primary function of the second miniature, in fact, is to introduce this new adventurer, the lion-knight. No viewer could deduce the whole relationship of Yvain to Calogrenant from the pictures alone, but it should

be clear from the overall progression of the pictorial narrative that this knight has arrived to try where the first knight failed. In that sense, the image does open an alternative: a new knight has arrived on the scene—will he experience success or failure? But this question is so vague and general that we are probably not justified in saying that an alternative opens or that a sequence begins here. The miniature functions more as a prelude, introducing the lion-knight, establishing him as the main character of the adventures to come.[23]

Lexie 4: Yvain Defeats Esclados but is Trapped in His Castle (fig. 4-4)

This is the first of BN fr. 1433's multipart miniatures. The illumination covers more than two-thirds of the page and is divided into two registers; the upper register is further divided into two parts. Each of these miniatures narrates a sequence of events, but not necessarily a structural sequence (in the Barthesian sense).[24] For example, the first section depicts Yvain and Esclados in combat. It is difficult to tell which knight has gotten the upper hand, although Esclados's shield is badly cut up. The nucleus or function "fight with swords" clearly opens an alternative: which knight will be victorious? The answer is not immediately clear to the nonreading viewer. Just to the right of the swordfight scene stands a gate tower; Yvain and his horse disappear through the gate just as the portcullis falls, striking the horse behind the saddle. Spurts of blood show up red on the blue cloth of the horse's trappings. The action proceeds logically through the gate into an interior scene, where Yvain stands, still with drawn sword, speaking to a maiden. He has, it appears, been trapped by the falling portcullis—but what has happened to his opponent? That is made clear by the third section of the miniature—the lower register—in which Esclados lies in his coffin. Taking the miniature as a whole, then, the viewer can see that Yvain or the lion-knight fights with another knight (probably recognizable, by virtue of his gold surcoat, as the fountain knight of the first miniature), and pursues him into a castle, where Yvain becomes trapped, and his opponent dies. The artist resolves the sequence "combat" not by depicting the decisive blow, but by showing that the one combatant is dead. This manner of concluding the sequence has, in addition to its proairetic value, powerful resonance in the symbolic code, for the result of *aventiure* is shown not as glory, but as death.

Clearly, unlike in Garrett 125, we have here a complete sequence, an action, rather than a single act. In comparison to the narration in the mural cycles, however, the narration is highly elliptical; viewers are required to

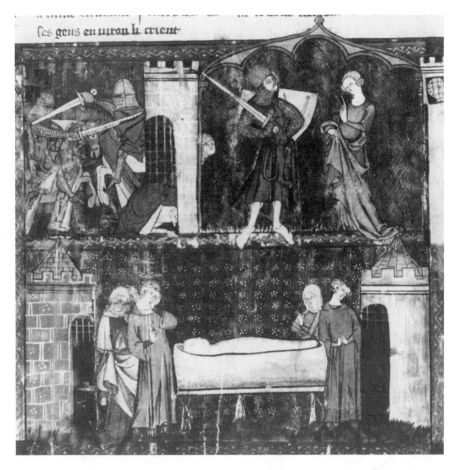

Fig. 4-4. fol. 69v. Yvain defeats Esclados but is trapped in his castle. Photo Bibliothèque Nationale, Paris.

read the entire sequence to the end in order to understand fully what has happened in the first scene. Although, at a relatively high level, a complete sequence—an action—has been narrated, that narration has been accomplished, at a lower level, by the depiction of a series of acts—fight, pursuit, conversation, lying in state—that viewers must put together to create a sequence. Nonetheless, although viewers relying on the pictures to follow the story must work somewhat harder here than at Rodenegg or Schmalkalden, the Paris illuminations do narrate sequences.

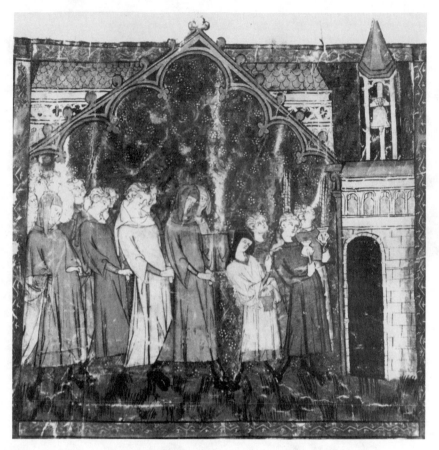

Fig. 4-5. fol. 72v. Esclados's funeral. Photo Bibliothèque Nationale, Paris.

Moreover, and perhaps most important, these sequences extend from one miniature to another. Here, although the combat sequence has been closed by the death of one combatant, a new sequence has been initiated by the depiction of Yvain trapped. His entrapment is indicated by a variety of details: the fact that the space is bounded by two towers and a roof, the fact that he stands with drawn sword, as if still in action, and the presence of mailed heads peering into the scene from either side. These heads probably represent the search for Yvain going on outside, since their presence is otherwise at odds with the crucial fact (in the text) that there are no witnesses to Lunete's conversation with Yvain. Finally, Lunete's pose is rather stern: she raises the index finger of her left hand as if lecturing, or warn-

ing, Yvain. It seems clear that Yvain is trapped in the castle of the man he has killed. He is obviously in danger, and the alternative that begins a new sequence is thus opened: how will Yvain's predicament be resolved? More generally, will his defeat of Esclados have positive (for Yvain) or negative results? Neither question will be answered immediately; the more general one will remain open until the end of the narrative.

Lexie 5: Esclados's Funeral (fig. 4-5)

The next miniature does nothing to advance the sequence that begins with Yvain's entrapment. Indeed, since the fight sequence has already been definitively closed by the depiction of Esclados in his coffin, the grand presentation of Esclados's funeral serves, in the proairetic code, only to reiterate what has already been narrated. The scene's symbolic value is more important: it stresses, in a depiction of a funeral procession so elaborate as to be virtually unique in the visual arts of its time, that the result of the knightly combat in the previous miniature has been death and mourning. What is not shown here is as important as what is depicted. If the pictorial narrative were following the text closely, or if the goal were to recreate the story as told in the text, the obvious ceremony to depict at this point would not be the funeral of Esclados, but the marriage of Yvain and Laudine. The inclusion of the funeral and not the wedding has far-reaching implications that will not become apparent until we have considered the complete narrative. At this point, it must suffice to point out that the artist could have presented both ceremonies, or the wedding and not the funeral—and he chose to present the funeral.[25]

Lexie 6: Yvain vs. Key (fig. 4-6)

Perhaps more than any other miniature, this illumination typifies the Paris artist's hybrid approach to pictorial narrative and book illustration. If we expect to read the same story out of the pictures as out of the text, the images appear to make sense only as illustrations. That is not to say that we cannot recognize what is happening in the miniature: it contains, in its two registers, a complete fight sequence. But what this fight sequence has to do with the story narrated up to now is not so clear. Understanding the connection appears to require external knowledge of the story. That is only true, however, as long as we expect the product of the purely visual diegesis to resemble closely the story available to readers of the text. If we consider the visual narrative on its own terms, we will find that connections can indeed be made.

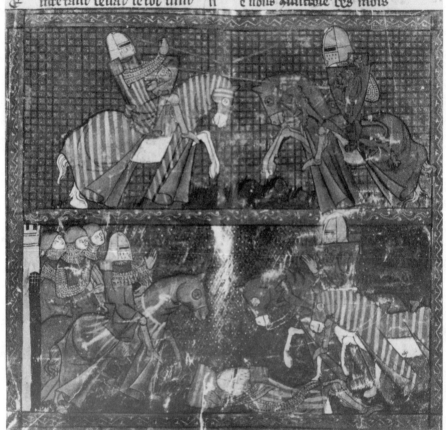

en fu mout atel yot tel e sire yuain z par le fram
e se pot taire de dire el ena le deual en sa main
nisi amsi q or gelies our de que il li uouoit rendre
ous qui les autres desplisies i lidult sire faites arendre
t ue pourquit cest il vn dois tel deual quele mesferoie
le uous pardunst deste fois e riens du nre reteuoie
our de quais mais ueb auit t qui estes nous fair li vois
nre tant deuab le roi uint e nous ausltroie des mois

Fig. 4-6. fol. 80v. Yvain vs. Key. Photo Bibliothèque Nationale, Paris.

In the top register of the miniature, Yvain rides against a new opponent. This knight and his horse are gaudily dressed in pink and white stripes (perhaps in allusion to Key's character as a fop and a dandy) but since the arms are not elsewhere associated with Key,[26] Yvain's foe is not identifiable on visual clues alone. The image opens the basic alternative of the sequence—will Yvain win or be defeated? It also, however, implies the resolution: the strange knight's lance breaks while Yvain's remains whole, and Yvain's foe begins to topple backwards. Yvain is already victorious. In the second register, Yvain's foe lies crumpled on the ground, defeated or dead (viewers relying solely on visual clues have no reason to think he is alive), while Yvain rides, leading his enemy's horse, toward another knight, whose hand is raised in friendly salute. To the reader of the text, this knight is readily identifiable as Arthur, and the whole miniature is easily understood as the episode in which Arthur's knights arrive at the fountain, and Yvain defeats Key. This new knight, however, is not identifiable based on purely visual clues, although he may be identifiable as a ruler by virtue of his eagle heraldry.[27] It is clear that he and Yvain do not approach each other as enemies, but his presence must remain rather mysterious to viewers who rely solely on the images. In Chrétien's version of the story, this episode does not resolve the alternative opened by Yvain's entrapment. Instead, it follows after the episodes that resolve that alternative, and belongs to a new sequence. Thus, if we read the pictorial narrative by comparing it to the text, the visual narrative appears highly eliptical, and rather confusing. The artist, it might appear, is intent on illustrating an episode, not advancing a visual narrative; on depicting an act, not an action, an isolated moment, not a part of a sequence that connects one miniature to another.

If we read the images independently of the text, however, we find that we can indeed understand the Yvain vs. Key episode as part of a visual narrative (although we will not be able to name the candy-striped knight). A major sequence begins with Yvain's entrapment in lexie 3, which opens an alternative that is reducible to some such formula as "positive outcome or negative outcome." In an admittedly eliptical way, Yvain's victory here closes that alternative and ends that sequence. Viewers who are truly reliant on the pictures alone have considerable latitude in their construction of diegesis, for the visual narrative is far from being as complete as it might be. Who is this knight whom Yvain fights? Perhaps a comrade or vassal of the knight Yvain has killed? Who is the knight whom Yvain greets? Someone who has power to resolve the situation provoked by Yvain's killing of the fountain knight? None of this is clear. But it is clear that Yvain has been

victorious, and that he is no longer in danger. On one level, at least, the alternative opened by his entrapment has been resolved, and the sequence has ended.

In contrast to the visual narratives of the mural cycles, the narrative here leaves a great deal up to the viewer. The links between episodes are not made explicit, and the narrative might appear to be one of acts, of isolated moments. Yet in contrast to the illuminations of Garrett 125, the Paris miniatures do create sequences that extend from one miniature to another over many folios, that narrate actions, and not just acts. In sum, the Paris picture cycle appears to occupy a sort of intermediate position, between illustration and pictorial narrative, between the depiction of acts and the narration of actions.

Lexie 7: Yvain's Madness and Recovery; or, How He Got the Lion (fig. 4-7)

The victory or success Yvain appears to have attained in his combat with the candy-striped knight is to be short-lived. A few folios later, in the first compartment of the four-part miniature on fol. 85r, he is denounced by a maiden—whom the well-informed viewer knows as Lunete. This reversal of fortune is so sudden that it appears that the "Yvain in danger" sequence has not really ended at all. The picture cycle thus maintains its hybrid status between the depiction of acts and the narration of actions or the creation of sequences. Viewers who rely on the pictures alone must go to some lengths to explain to themselves why Yvain is denounced and by whom, and how he got from the victorious situation of the preceding lexie to the humiliating situation of the denunciation scene. Nonetheless, it is clear that, up to this point, the Paris picture cycle has initiated and sustained an overarching *aventiure* sequence, which reaches from Yvain's entrapment toward a still uncertain end.

The four parts of the folio 84 miniature do not add up to a proairetic sequence in themselves, although they do contain an important thematic or symbolic progression. In the upper left-hand section, Lunete appears before Arthur's court—or, at least, for the uninformed viewer, a maiden leading a horse approaches a group of men sitting in front of a tent, one of whom wears a crown, and one of whom is identifiable, by his blue clothing, as the protagonist of the narrative. Yvain extends his hand to Lunete, in a gesture presumably intended to indicate that she is removing his ring. That is an understanding that requires some knowledge of the story as Chrétien tells it, but even the least informed viewer can create a meaningful diegesis by taking this image in the context of the following picture.

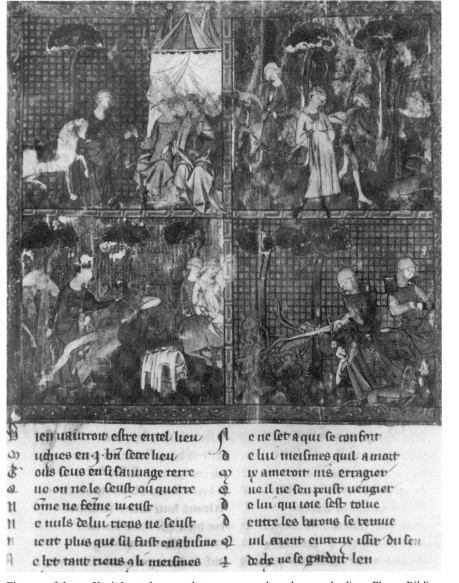

ien uiauroit estre entel lieu e ne set a qui se consint

uchies en .j. bu secre lieu e lui meisnes quil a mort

ous ceus en si sauuage terre ly ameroit nis erragien

no on ne le ceust ou querre ne il ne sen peust uengier

ome ne seme ni eust e lui qui toie cest tolue

e nuls delui riens ne seust entre les barons se remue

ient plus que sil fust enabisine nil aient enrreux issir du sen

e lst tant rieus g li meisines de de ne se gardoit len

Fig. 4-7. fol. 85r. Yvain's madness and recovery; or, how he got the lion. Photo Bibliothèque Nationale, Paris.

In the upper right-hand section of the miniature, while the maiden (Lunete) rides away looking sorrowful, Yvain goes mad. He appears twice, first in the act of tearing his clothes, then nude, shooting at a stag with a bow and arrow.[28] In the far right of the image is a hermit's hut, with the hermit peering out of a window over the door. On the window ledge is a cup and a leg of meat. For well-informed viewers, the whole image is a fairly detailed representation of Yvain's madness, while uninformed viewers might understand certain details in other ways (they might, for example, identify the hermit as the mad Yvain). But the essential direction of the story is clear enough to any and all viewers: Yvain has received some sort of bad news and has gone insane as a result.

What this bad news may have been is not clear to nonreading, uninformed viewers. Readers, or viewers who know the text, will understand that Yvain has sinned against his wife and been sent into exile. But uninformed viewers must explain Yvain's madness in some other way. Given the conventions of courtly romance, they might well reckon that the maiden has brought a negative message from Yvain's lady. Or, considering the tremendous emphasis placed on the mourning that follows Esclados's death, such viewers might conclude that Yvain has been rebuked for killing this knight—and perhaps for killing the candy-striped knight as well. What is clear is that the lion-knight's adventures up to this point have been, in some way, sufficiently flawed to prevent his obtaining lasting success. Instead, they have resulted in his madness.

Yvain's insanity is cured in the next section, the lower left-hand section of the miniature, by a lady who rubs ointment on him as he sleeps, naked, on a rock.[29] If we read strictly by reference to the text, we can label this scene "Yvain is rescued by the ladies of Noroison." But the less-informed viewer cannot name Yvain's healer, and, more important, the pictorial narrative has simplified the story. Only one lady appears to rub the healing ointment onto Yvain, while two horses watch from the left and a pile of clothes lie on a rock to the right. Then, in the rightmost part of the image, two figures ride away. One is clearly the lady with the ointment; the other is Yvain, now wearing the clothes that were lying on the rock.

Finally, in the last section of the miniature, Yvain kills a dragon, thus freeing a lion, who is horribly entangled with the dragon and apparently struggling to escape. The killing of the dragon occupies the center of the frame; to the right, Yvain rides away, out of the frame, with the lion following at his side like a dog. Once again, Yvain wears the blue surcoat with the gold lion—his arms having accquired a new significance now that he is, literally, "the knight with the lion."

Proairetically, these four images add an interesting twist to the "Yvain in danger" sequence. Apparently victorious, and then apparently safe at a royal court, Yvain is thrust into madness by the maiden's words. The alternative that is thereby opened—will he recover or not?—is immediately resolved by his healing. The fight with the lion is presented as an act, not a sequence: Yvain is already striking the decisive blow when we first see the dragon. But the way in which Yvain rides away out of the frame strongly suggests further adventures to come.

Symbolically, this miniature occupies a position of central importance in the visual narrative. "Going mad," as it is depicted here, is "going wild." Yvain becomes, symbolically, a "wild man."[30] Wildness, as previously noted, is the symbolic opposite of courtliness.[31] Yvain's wild condition in the second section of the miniature is the exact opposite of the courtly state depicted in the first section. His tearing off of his courtly clothes leaves him naked, like an animal; his return to sanity is marked by a return to courtly clothes. Yvain's killing of the dragon, an obvious and well-known symbol for wildness, marks his final defeat of his own wildness and his complete restoration as a courtly knight. The symbolic opposition of wildness and courtliness has another dimension as well. In the first cycle of adventures, before his madness, Yvain fought against courtly knights, killing at least one, who was greatly mourned, and perhaps killing another. It may go too far to suggest that the pictures present Yvain as a rather bloodthirsty knight, but they certainly dwell on the death and mourning that his fighting brings. This first series of battles eventually results in Yvain's expulsion from courtly society. In the dragon episode, for the first time, Yvain fights not against a courtly foe, but against a beast that is the very embodiment of wildness. If he thereby overcomes, symbolically, the wildness in himself, he also tames the wildness of the lion, who becomes a thoroughly courtly beast, as full of loyalty and courage as any knight. But Yvain's adventures are clearly not over. Though he has defeated the dragon, he remains in the forest, surrounded by wildness. Symbolically, if not proairetically, the conclusion of the sequence appears to require a return to court.

Lexie 8: The Defeat of Harpin; the Rescue of Lunete (fig. 4-8)

In the upper left section, Lunete's face appears in the window of a tower; Yvain sits on his horse outside, apparently in conversation with her. In the same frame, he rides away toward the left, out of the frame. He looks skyward, and his right hand is raised in what may be a gesture of prayer. The nonreading, uninformed viewer will not connect this image

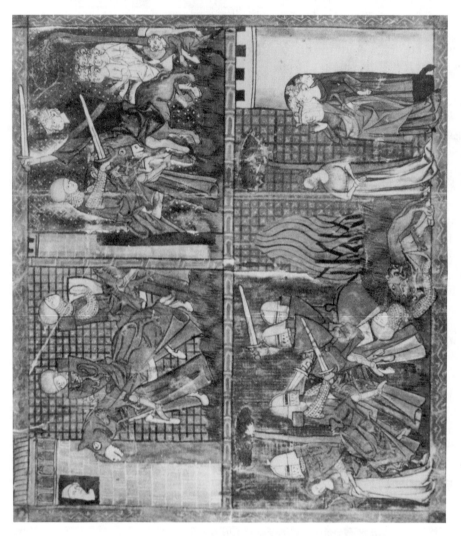

Fig. 4-8. fol. 90r. Yvain's rescue of Lunete and fight with Harpin. Photo Bibliothèque Nationale, Paris.

with the story of Lunete's troubles with Laudine's seneschal. Nonetheless, the image clearly opens a sequence: the knight has apparently agreed to undertake something for the woman. Her position in a tower strongly suggests some sort of imprisonment—otherwise, why would she not come down and talk to the knight outside, or perhaps invite him in? At the very least, the image opens an alternative involving the knight: he is embarking upon a new adventure—will he succeed or fail? For astute viewers, the image probably opens an alternative involving the maiden as well: she is in danger; will she be rescued in time?

The resolution of these alternatives is delayed by the depiction of the Harpin episode in the next frame. Here, Yvain fights against the mounted giant, whose four prisoners, tormented by the dwarf, wait in the background. The image leaves the outcome of the combat undecided, depicting a random point from the swordfight, not a decisive moment. The artist thus returns to his earlier habit of depicting acts rather than actions, isolated representative moments rather than ongoing sequences. And yet, although understanding the connection between the "rescue of Lunete" sequence and the "defeat of Harpin" sequence as it is in the text certainly requires external knowledge, it is possible to understand the sequence presented here as a coherent visual narrative. One only needs to assume that the fight with the giant is somehow part of the mission undertaken for the maiden, a necessary preliminary to the rescue scene below. This understanding not only departs rather far from the text; it is also not very satisfactory as visual narrative, since the links between the fight with the giant and the rescue of the maiden seem so tenuous. Nevertheless, the possibility of such a reading reinforces the idea that the Paris miniature cycle represents an intermediate mode of pictorial narrative.

The Harpin scene certainly does not close the alternative opened in the first compartment of this miniature. That is done in the complex lower register, which combines three nuclei in one frame. Contrary to the norm, the register reads right to left. At right, a group of courtly people, including a queen, emerge from a tower; Lunete stands bound to a tree, her hands tied, next to a large fire. It should not be difficult for viewers to recognize that this maiden who is about to be burned at the stake is the same maiden with whom the knight spoke in the first segment of the miniature.[32] The first nucleus, then, is clear: Lunete is in danger. This opens an alternative, or, rather, maintains an alternative already opened in the first compartment: will she perish, or be rescued?

The answer does not come in the next nucleus, where Yvain and his

lion fight against three knights whom the informed viewer knows to be
the seneschal and his brothers. In front of the pyre, the lion has knocked
one knight to the ground and is biting his chest—this fighter, at least, is
clearly *hors de combat*. But to the left of the fire, Yvain exchanges sword
blows with two other knights, and neither Yvain nor his two opponents
appear to have the upper hand. As so often in this manuscript, the painter
represents the battle by showing a representative moment, not a decisive
moment. We have, again, the depiction of an act, not the narration of an
action. But this time, the representative moment is fully integrated into
a sequence so that the difference between representation and narration is
blurred. The nucleus "combat" holds the main alternative of the sequence
open: will Lunete be rescued?

The answer finally comes in the far left-hand portion of the register,
where Yvain, still mounted and in full armor, as if he has come immediately
from battle, embraces Lunete, and escorts her away, out of the frame, and
out of danger. His victory is thus not shown in itself, but implied through
its results: we know Yvain has defeated his foes because we can see that he
has succeeded in rescuing the maiden. The miniature as a whole narrates
a well-defined and coherent sequence; although the technique within the
sequence is more a representation of acts than a narration of actions, the
moments represented are given an overarching, telic structure by the basic
alternative opened by Lunete's peril, and the several images add up to a
coherent narrative.

The action of this miniature, and of the second adventure cycle in
general, has an important symbolic aspect. Starting with the killing of the
dragon, all Yvain's battles share obvious differences from his encounters
with Esclados and Key. First, Yvain no longer fights in courtly single com-
bat against other knights, but against uncourtly foes—the dragon, a giant,
knights who are so uncourtly as to fight three against one; and later, against
two demons. Perhaps more important, the motivation for Yvain's fighting,
which was not shown in the earlier episodes, is visually obvious in each
of these later battles. In every case it is clear that Yvain is fighting to help
someone. The lion is trying to escape the dragon, Harpin's prisoners sit
pitifully under the lash of the dwarf, Lunete stands at the stake near the
flames, the many damsels labor with their sewing at Pesme Avanture. Non-
reading viewers cannot know the full story behind any of these episodes,
but they cannot avoid noting that Yvain is now fighting against manifestly
evil opponents in order to assist people (and an animal) in distress. Yvain's
motivation, which earlier appeared to be nothing but the egocentric pur-

suit of *aventiure*, now appears—since his recovery from madness—clearly altruistic. He now fights to help others, and that is obvious even to the reader who relies on visual clues alone.

Lexie 9: Pesme Avanture, Yvain vs. Gauvain (fig. 4-9)

In the penultimate miniature, the Paris *Yvain* illuminator's tendency toward the representative depiction of acts again predominates, although the four segments may be understood as forming a generalized adventure sequence. The first segment, in which Yvain and the damsel sent by the younger daughter of the Count of the Black Thorn ride up to a castle gate, certainly appears to open a sequence. Adventure sequences in courtly literature often begin with the knight's arrival at a strange castle—one need think only of Pesme Avanture, the Joie de la Court episode in *Erec*, and Parzival's arrival at the Grail castle, for examples. Here, the arrival at a gate, in initiating a sequence, opens that most basic of *aventiure* alternatives—will the knight meet with success or failure?

The next segment sheds no immediate light on the question. Emerging from the other side of the gate, which forms a boundary between the two segments, Yvain and the damsel ride into an interior filled with ladies. At the right front of the group, one lady is sewing with golden thread, one behind her holds yarn, and the rest appear to be involved in sewing and knitting. To readers or informed viewers, these are the three hundred enslaved maidens of Pesme Avanture. Even completely uninformed viewers may well conclude that these are courtly ladies who would not be performing these menial tasks were they not in some way imprisoned or enslaved. Understood in this way, the image presents the knight with one of the basic situations of *aventiure*—that of ladies in distress. Since it is a foregone conclusion that the knight will endeavor to assist the ladies, the scene thus opens a basic adventure alternative: will the knight succeed in rescuing the ladies, or will he fail?

If the second segment is read in this way, the action of the third segment (the left half of the lower register), will inevitably be understood as Yvain's battle against the ladies' oppressors, even by viewers who do not know that the large, dark-skinned knights with horned helmets are the "fiz de deable" of Chrétien's text (F. 5271). Yvain strikes a blow to the face of one opponent, just as the lion leaps onto his back, dragging him to his knees. The battle is clearly won, even though the other opponent still stands, raising his weapon. The lion appears twice, first peering out through a window in a tower, and then leaping into the fray. Uninformed

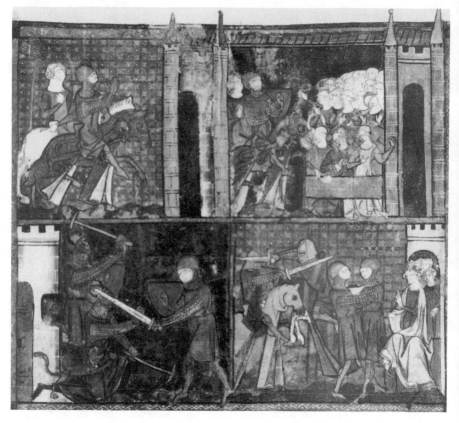

Fig. 4-9. fol. 104r. Pesme Avanture, Yvain vs. Gauvain. Photo Bibliothèque Nationale, Paris.

viewers might figure out that the lion had been locked in the tower to keep him out of the fight, but had struggled free to aid his master, but it seems rather unlikely. Such details most likely belong more or less exclusively to the illustrative function of the miniatures.

In terms of the visual narrative, this victory does not conclude the sequence. In the next segment, Yvain fights with an unknown knight. To the reader, or the viewer who reads the images in terms of Chrétien's story, this is the incognito combat with Gauvain, which is not a part of the Pesme Avanture sequence in the strict sense at all, although it does belong to the same larger interlace structure as the arrival at Pesme Avanture (Yvain and the maiden are on their way to the fight with Gauvain when they

stop for the night at the castle). Viewers relying purely on the pictures could make other connections, however, understanding the fight with the strange knight as one more part of Yvain's struggle to aid the imprisoned ladies. What is perhaps most important is that this battle, unlike Yvain's encounters with courtly foes in the first adventure cycle, does not end in the death, or even the defeat, of Yvain's opponent. It is Yvain's first equal combat against a single knightly foe since his recovery from madness, and, most significantly, it ends undecided, with the friendly embrace of the two knights, and the reappearance of a king with his court.

The final image of this miniature, in which the two knights embrace and the king and his courtiers emerge from a tower, represents a peaceful resolution of both the miniature's two open alternatives—will the knight succeed in helping the ladies? and will the knight be successful in his ad- ventures at this castle? The pictures themselves, to be sure, would not allow any very detailed explanation of how the conflict has been resolved—or, rather, they would allow *any* explanation the viewer might imagine—but the four parts of the miniature do make sense as a visual narrative sequence.

In any reading, it is clear that the lion-knight has now been fully re- stored to the courtly position that he lost when he was driven into wildness by the maiden's denunciation. For the first time since that moment, he is seen in the company of other knights, not as a foe but as a comrade. He embraces one knight in friendship, and a king, representative of the court as an ideal even if not specifically identifiable as Arthur, raises his hand to Yvain in greeting. This return to court might seem to conclude Yvain's adventures, but it does not. One more reward is in store for the lion-knight.

Lexie 10: Yvain's (Re)union with Laudine (fig. 4-10)

In large, almost monumental images on two registers, the basic alter- native of the entire adventure sequence is resolved, and the whole narrative is brought to an end. In the upper register, Yvain and Lunete, accompa- nied by the lion, ride up to a castle, and Yvain kneels before Laudine. The knight's submission to his lady might end his adventures, but the final con- clusion is again delayed. The following segment, in which Lunete argues with Laudine, will be understood by the informed viewer as the scene in which Lunete convinces Laudine to accept Yvain again, despite his earlier violation of her trust. In terms of purely visual narrative, the scene serves as a "retarding moment," delaying the final resolution. In the last scene Yvain and Laudine embrace in bed.

The knight's romantic union with the lady resolves, once and for all,

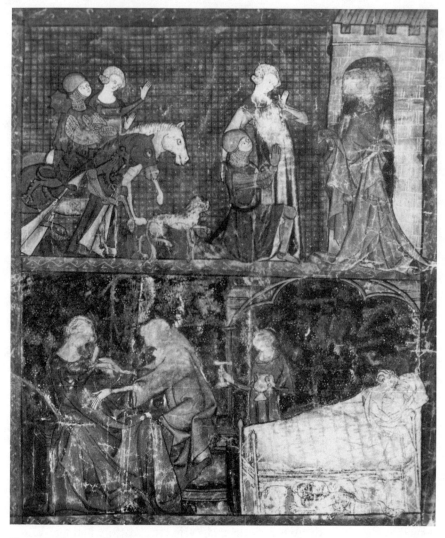

Fig. 4-10. fol. 118r. Yvain's (re)union with Laudine. Photo Bibliothèque Nationale, Paris.

the basic alternative opened by his appearance on the romance stage in the second miniature: would his adventures lead to success or failure? Clearly he has succeeded; and winning a lady is revealed as the goal of his adventures. In the visual narrative, it is important to note, this is not Yvain's reunion with the lady, but his first union with her. In the story the pic-

tures tell, Yvain's first cycle of adventures did not end with marriage to Laudine, but with his defeat of the candy-striped knight and his reception at a royal court. This apparent success was immediately taken away, when Yvain was denounced by the maiden and thereupon went mad. The defeat of Esclados not only did not lead directly to the union with the lady, it did not lead immediately to any glory, but only to death and mourning. Only after passing through the nadir of his madness and undertaking a second series of adventures did the lion-knight achieve a successful conclusion to his search for *aventiure*.

The concluding scene stands in symbolic contrast to the wilderness episode, which appears, in the pictures as in the text, between the first and second series of adventures. There the knight is alone (except for the hermit, who exists, by definition, outside society), entirely cut off from courtly society, a position in which he has placed himself through the excessive egoism of his early adventures. In the end, the king and others welcome him back to court, and his integration (or reintegration) into society is dramatically symbolized by the sexual/romantic union with the courtly lady.[33]

By depicting the funeral instead of the wedding in the knight's first series of adventures, and delaying the consummation of the knight's love for his lady to the end of the story, the illuminator of BN fr. 1433 creates a structure analogous to the structure of Chrétien's narrative. Yvain's first success in apparently unmotivated combat is relativized by the sorrow which his actions bring, and only by undertaking a series of properly motivated battles can the lion-knight at last achieve the romantic bliss that is finally revealed as the goal of his adventures. While the miniature cycle of Garrett 125 consists of a series of unproblematic adventures undertaken for a wife, the images in BN fr. 1433 tell the tale of a knight who achieves an apparent triumph that turns out to be success of the wrong kind. Unlike the case in the text, however, the knight's guilt appears to consist not in overstaying the deadline but in killing without motivation.[34]

PICTURES AS ILLUSTRATION—THEME

Readers of the manuscript would not depend on the pictures for their understanding of the text. As we saw in the preceding chapter, however, even for readers, the understanding of the text may be influenced or guided by the story the pictures tell. In the case of the Paris *Yvain*, the effect of the miniatures must have been to steer readers toward an understanding of Chrétien's text that is strikingly similar to the widely accepted mod-

ern interpretation that finds in *Yvain* two cycles of adventure, the first of which is marked by an error or flaw and thus can lead the hero only to false, temporary success, the second of which redeems the first and leads to genuine, lasting success. Whether medieval audiences inevitably, or even usually, understood the text in that way is another question. But readers of this manuscript, whose experience of the text incuded the viewing of these pictures, would surely have been guided toward an understanding of Yvain's initial victories as bloodthirsty and self-serving, of his later adventures as altruistic and helpful to individuals in distress, and of his winning of Laudine as a reward for having found the right path. While readers of Garrett 125 must have been more likely than readers of unillustrated manuscripts to see Yvain's career as unproblematic, readers of the Paris *Yvain* must have been more likely to recognize the hero's double path, the falseness of his early success, and the purgatorial nature of his second series of adventures.

Notes

1. BN fr. 1433—manuscript "P" of *Yvain*—consists of 120 parchment folios. For descriptions, see Nixon (73–75) and Jonin (15); also Bibliothèque Imperial (1:225); Micha (44); Woledge (4); and Bibliothèque Nationale (29). For more details of description and discussion of the provenance, see Middleton (201–3).

2. A similar theory is among those proposed by Woledge (24) to explain the combination of Picard language with Parisian paintings: a Picard copyist could have been working in Paris, a Parisian painter could have been working in Picardy, or the manuscript could have been written in Picardy and taken to Paris to be illuminated.

3. For the latest efforts to date and place the manuscript, see Stones ("Context" 257–60) and Nixon (73–74); for another recent attempt to summarize the views of art historians, including the unpublished opinions of François Avril, Nigel Morgan, and Stones, see Walters (5, 21–22), who concludes that the manuscript dates from between 1315 and 1330 and "shows the influence of Paris and northern France or Flanders" (5). On the dialect, see Micha (44), Woledge (4), and Jonin (15). McGrath notes that the language of the manuscript is clearly Picard, but the style of the miniatures is Parisian ("A Newly Discovered Manuscript" 586n). As far as the date is concerned, Micha (44) and the *Catalogue des Manuscrites français* (1:225) simply identify the manuscript as "thirteenth century"; Woledge (4) reports this as the consensus dating. Suggested dates based on the miniatures include the following: Loomis (100), 1300–1325; *Les manuscrites á peintures*, "vers 1330" (29). Stones's discussion of the date in her dissertation (78, 292–93, 496) is superseded by her analysis in "Context." Vitzthum's older theory associated the style of the

miniatures with a group of manuscripts he located in the Low Countries (Tournai, Gent, Utrecht) and dated in the 1330s to 1350s (178–85).

4. The action passes through doors or gates in a similiar fashion in at least one other miniature—in the Pesme Avanture sequence, Yvain and the damsel approach a gate in the first compartment and emerge from it in the second.

5. No other examples are published in Loomis and Loomis.

6. Compare also the former Yates Thompson *Lancelot* (now Pierpont Morgan Library ms. 805–6, ca. 1300–1325), in its illustrations of Lancelot on the sword bridge (fol. 166, Loomis and Loomis fig. 252) and of Gawain and Hector in the Perilous Cemetery (fol. 207, Loomis and Loomis fig. 253), *Lancelot*, BN fr. 122 (dated 1344), fol. 1, (3 moments) Lancelot on the sword bridge, his fight with the lion and the panther, his fight with Meleagant (Loomis fig. 267), *Les grandes chroniques de France*, London BM Royal 16 G VI (1325–50), fol. 166r, Roland's battle and "*disposition*" with Ferragut (Lejeune and Stiennon, p. 391, fig. 283).

7. ". . . une porte colant / De fer, esmolue et tranchant" (F. 923–24).

8. On the iconography of the Holy Women at the Sepulcher, see Schiller 3: 18–31, especially 29–30; Myslivec and Jászai 54–62, and Reau, vol. 2, pt. 2: 542–43.

9. On the iconography of Mary's funeral, see Schiller (vol. 4, pt. 2: 126); also Reau (vol. 2, pt. 2: 611–13). I have also consulted the Index of Christian Art.

10. One appears in Cambridge, St. John's College Library K. 21, *Miscellany*, thirteenth-fourteenth century, fol. 64r. Other marginal images depict processions of clergy with tapers, crosses, buckets, etc., without including the bier that would indicate a funeral. For example, an illustration in the "Belleville Breviary," Paris, BN lat. 10484, fol. 218v, depicts a procession with tapers and a cross, and a reliquary carried on poles like a coffin (Randall, fig. 567). Compare Randall (figs. 566, 574).

11. Oxford, Bodleian 264, fol. 79v; in Randall, fig. 599. Similarly elaborate animal processions may be found in an East Anglian Psalter of 1320–1325 (London BL Add 49622, formerly C.W. Dyson Perrins 13, fol. 133 [Randall fig. 569]), an English Psalter and Hours from about 1300 (Baltimore, Walters Gallery 102 , fol. 73–81 [McCulloch, "Funeral" 9–12]); and a Flemish Psalter from the first quarter of the fourteenth century (Copenhagen, Kongelige Bibliothek, ms. 3384.8°, fol. 292 [Randall fig. 573]). Human processions never seem to be quite so elaborate, but a Franco-Flemish Book of Hours from the early fourteenth century shows a procession approaching a church, with mourners carrying a cross and four tapers (Brussels, Bibliothèque Royale, MS. 9391, fol. 116r [Randall fig. 568]). It is interesting to note how many of these processions appear in manuscripts from roughly the same date and region as the Paris *Yvain*.

12. In the text, since the first phase of the fight involves Yvain attacking with his lance, one must assume that he, at least, is mounted. It is not clear in Chrétien's text whether Harpin rides a horse. Initially, he "vint batant" (F. 4090), which Nolting-Hauff translates as "herangaloppierte," and later he "vient le cors" (F. 4198), but neither phrase explicitly means that he was mounted. In Hartmann, the giant "kam dort zuo in geriten" (4916).

13. 1 Samuel 17: 5–7 describes Goliath's immensely heavy armor and spear; medieval artists generally depicted him in the arms of their day (Reau 2, pt. 1:

261). A survey of the Index of Christian Art shows Goliath armed in 196 of 204 thirteenth- and fourteenth-century depictions of the scene.

14. New York Public Library, Spencer 22. This manuscript was copied from a century-old Spanish original, which had apparently been handed down through several generations from King Sancho el Fuerte of Navarra (1153–1234) to the French-Champenoise royal family (see Bucher esp. 63, 70–75). Other mounted Goliaths appear on an ivory casket at Sens (Reau 2, pt. 1: 261); in a Psalter at Mount Athos (Monastery, Dionysiu 60, fol. 210v [Index of Christian Art]); and in the original of Spencer 22, Amiens, Bibliothèque de la Ville 108 (see Bucher 1: 228 and 2: pls. 206–207).

15. On this gesture of submission, see above, p. 63.

16. The word "pes" had a variety of sexual meanings ranging from the sentimental to the obscene (see Tobler and Lommatzsch [7: col. 57]; Godefroy [5: 697]).

17. On the earlier tradition see above, pp. 107, 130. Courtly examples include the two bed scenes of the Hermitage ivory casket of about 1325 (Mark and Brangaene, Tristan and Isolde; see Loomis and Loomis 55–56, figs. 88–89), and the "conception of Merlin" in BN fr. 95 (Loomis and Loomis fig. 233) of about 1290. Sex scenes from the life of David include two in the early fourteenth-century Tickhill Psalter (David with a concubine, fol. 63r, and David with Bathsheba, fol 71r; see Index of Christian Art), a rather explicit depiction of David with Bathsheba in New York, Pierpont Morgan 638, fol. 41v, about 1250 (Index of Christian Art), and David with Bathsheba in the early fourteenth-century Queen Mary Psalter (London, British Library Royal 2.B.VII, fol. 57r; see Index of Christian Art). On sex scenes in the decretals, see Melnikas, *causa* 33, figs. 17, 18, 19 (all from around 1300), *causa* 31, fig. 44 (1340s), *causa* 32, fig. 19 (date not given). In all these images, except the conception of Merlin, the lovers are nude, though covered to varying degrees by bedclothes.

18. Based on a comparison of the "Harpin" and "Rescue of Lunete" episodes in the two miniature cycles, McGrath recognizes that Garrett 125 tends to stay closer to the text. But he remains bound to the assumption that the illustrator's invariable goal was the precise and thorough translation of text into pictures, and winds up ascribing "superior reading skills and powers of visualization" to the illuminator of Garrett 125 ("A Newly Discovered Manuscript" 588).

19. Another example is the single miniatures in *L'Âtre Perilleux*.

20. Yet another principle of illustration produces the double page spread at the very beginning of the codex, wherein about half of *L'Âtre Perilleux* is illustrated.

21. See Uitti ("Le Chevalier au Lion" 226).

22. As Hindman notes, similar miniatures open a number of Arthurian texts (though she only cites one from a manuscript other than BN fr. 1433, where a similar image introduces the *L'Âtre perilleux*), "evidently signify[ing] this type of romance" (121).

23. To Hindman, this is "a miniature we would not expect to find" (120), but the present analysis shows that it serves a clear function in the pictorial narrative.

24. Can these miniatures actually be referred to as lexies, or does each contain

several lexies? If lexie means "reading unit," then each miniature may as well be described as a lexie, although there are certainly subunits in each.

25. Hindman notes the surprising elaboration of the funeral and "suppression" of the wedding (120–21); her conclusions about the illuminator's motivations are somewhat different from mine (see below, note 33).

26. The arms are not assigned him elsewhere. See Pastoureau (*Armorial* 79; "Études" 6).

27. Arthur's usual arms—azure, three crowns or—were widely established by the second half of the thirteenth century (Brault 44–45). On the eagle as an attribute of a ruler, see above, p. 000, in the Schmalkalden chapter.

28. The clothes that Yvain is tearing off are not the blue clothes he wears in the preceding image, but a red shirt and a pink cloak. This detail—which could potentially confuse a viewer relying on the pictures alone—is one more indication of the Paris cycle's intermediate position between independent narration of actions or sequences and illustrative depiction of acts.

29. We would gain some small insight into the uses or abuses of illuminated manuscripts if we knew when, by whom, and why the central section of Yvain's nude body has been so badly rubbed and smeared as to be almost obliterated.

30. The point has been made relatively often of Hartmann's text (see Kern 340–341; Wehrli 66; Wells 41; Mohr 76). In other texts, Tristan and Lancelot both become temporary wild men when they go mad from love (see Bernheimer 12–14). Wildness, in all these instances, is symbolically becoming less than human, losing the reason that makes man different from animals (see Hayden White, esp. 18–21). Ywain's madness has been connected to the madness of Nebuchadnezzar (Daniel 4) by Wehrli (66) and others, and the parallel is unmistakable, although Wells's warning against seeing Nebuchadnezzar in every wild man (esp. 57–58) should also be heeded. On Ywain as a type of wild man "driven mad by God's grace so that he may suffer and eventually be saved," see Doob (139–53).

31. See above, p. 68, in the Rodenegg chapter.

32. The structural identity of the tower here with the tower in the first segment of the miniature is unaffected by the fact that the two towers do not closely resemble one another.

33. Drawing on the work of Georges Duby and others, Hindman concludes that the Paris miniature cycle makes the story Yvain into one of a "bachelor," or landless younger son, who can only become a part of society and accquire land in his own right through a series of quests or adventures (esp. 124). Yvain's marriage to a widow with land "fulfills one of the fantasies" of such bachelors (123).

34. There is, of course, debate about the identification of Yvain's guilt in the text: several critics have argued (especially with regard to Hartmann's text) that it consists in his continued pursuit of the mortally wounded Ascalon ("her Îwein jaget in âne zuht" [1056])—that is, in acting overly bloodthirsty. See, in particular, Wapnewski (66–67); for dissenting opinions, Salmon ("'Âne zuht'"), Le Sage. The point appears not to have been argued so often with regard to Chrétien's text— the French has the more innocuous "grant aleüre" (F. 935) instead of "âne zuht"— but Le Sage (107–8) notes that Chrétien's version, on the whole, contains more criticism of Yvain's pursuit of Esclados than Hartmann's text.

5. The Adventure of the Horse's Rear: Ywain on English Misericords

The four works just considered are all narrative: each tells a story about Ywain. The works still to be discussed represent the Ywain material rather than narrating it; they do not tell a story, so much as allude to one. Misericord carvings in five English churches depict one dramatic moment from the Ywain story: the scene in which Ywain's horse is sliced in half by the falling portcullis, leaving Ywain trapped in Laudine's castle. The central question for interpretation is whether viewers are expected to base their understanding of the image—either literal or symbolic—on their knowledge of the Ywain story, or on other codes, including the image itself and the location of each Ywain scene in the context of a group of diverse carvings.

Misericords

Misericord carvings are a literally obscure genre of medieval art, hidden under the seats of choir stalls. Misericords are the small shelves that project from the undersides of the folding seats.[1] When the seat is folded down, the misericord is invisible under the seat; when the seat is folded up, the misericord forms a small ledge, on which the stall's occupant can support himself while remaining in a more or less standing position. The area under this small ledge is often elaborately carved. But since the carving is invisible when the seat is folded down and hidden by the occupant's body when the misericord is in use, the fascinating variety of images must have always been easy to overlook.

At least since Thomas Wright wrote on the carvings in the mid-nineteenth century, the designation "misericord" has been explained as a reference to the seats having been intended as an act of mercy (*misericordia*) to choristers exhausted from long periods of standing during worship.[2] But

the idea that the "mercy seats" provided surreptitious support for the pos-
teriors of old, infirm, or lazy clerics during parts of the divine service when
the occupants of the choir were expected to stand may need correction in
light of certain monastic rules that require the use of misericords at specific
times. For example, a set of instructions for Carthusian novices describes
how the monks sit on their misericords on a number of holy days and fes-
tivals, but on their seats "all the rest of the time" (*Tractatus* vol. 6, pt. i, v).[3]
Misericords appear as an alternative seat to be used during portions of the
worship service that call for sitting. In the twelfth-century Cistercian rule
of Stephanus Abbas, misericords seem to be reserved primarily for silent
and/or private prayer (cols. 1419, 1438, 1458). But in at least three passages
Stephanus also indicates, like the author of the Carthusian rule, that either
misericords or seats may be used, depending, apparently, on the liturgi-
cal calendar (cols. 1419, 1448, 1454–55). Clearly, in the practices described
here, the primary use of misericords was not to give surreptitious support
to monks who were supposed to be standing, but to provide an alternate
form of seating for certain periods of the liturgical day and year.[4]

The occupants of choir stalls were not always monks, but they were
also not ordinary parishioners. Seating in the chancel was usually reserved
for members of clerical orders and lay orders (Ganz and Seeger 13), though
large churches sometimes provided additional seating in the choir for
"favoured visitors and local devotees" (Dickinson 448). Most often, choir
stalls are found in churches with monastic or collegiate connections—as is
the case with most of the sites of Ywain misericords.[5] Stalls with miseri-
cords, however, were also constructed in parish churches, often in connec-
tion with chantry chapels, as is probably the case at Enville. The appearance
of misericords in ordinary parish churches is particularly common in the
east of England, for example at Boston (Cox and Harvey 257). With at
least eight offices and one mass daily, members of medieval religious orders
clearly spent a great deal of their lives in choir stalls.[6] Nonetheless, one
wonders how often misericords became the subject of conversation, since
the cleric was nearly always either sitting on the misericord or standing in
front of it, and must have rarely had the chance to look at the carving.

General Iconography of Misericords

The practically hidden existence of misericords has been said to explain the
wide variety of subjects carved on them. The frequent assertion that scrip-

tural or legendary subjects "were evidently unsuitable to such a position (on the bottom part of a seat)" (Hart 240)[7] is not quite accurate, since religious and legendary scenes do occur in small numbers, but misericords were apparently deemed especially appropriate for nonreligious scenes. Biblical and hagiographic themes and obvious moral allegories are rare, while secular motifs abound.[8] At Lincoln, only five of over one hundred misericord carvings treat scriptural or hagiographic subjects; at New College, Oxford, not one of the sixty-two has a religious theme; at Chester, just six of the forty-eight have overtly religious subjects.[9] Similar ratios seem to be the norm. The astonishing variety of misericord carvings includes decorative motifs, scenes from daily life, animals from the bestiary, and scenes from secular literature.[10] The orchard scene from the Tristan story, for example, is depicted at Lincoln and Chester, and the flight of Alexander appears at Lincoln, Chester, and six other locations. Popular domestic scenes included wives beating husbands (Boston and Lincoln) and teachers beating schoolboys (Boston). Attacks on friars also seem to have been fairly common, the friars often represented by preaching foxes or wolves. Several fascinating misericords depict the carver at work on a misericord. Despite their location in churches, misericord carvings only rarely involve overtly religious themes, and while some of the images may be interpretable allegorically, one would have to stretch rather far to find spiritual meaning for others. We must be open to the possibility of allegorical significance, but we must not assume that all misericord carvings are to be given religious interpretations.[11]

Ywain Misericords

Loomis (79), following Bond (77), lists five English misericords displaying the portcullis scene from the Ywain story—in the chapel of Oxford's New College, Chester Cathedral, Lincoln Minster, St. Botolph's in Boston, and "formerly" at St. Peter per Mountergate, Norwich. A sixth misericord—in the village of Enville near Stourbridge in Shropshire—has been mentioned in specialized works on English misericords, but remained unknown, until recently, to those approaching the Ywain material as literary historians.[12] All four of the extant misericords listed by Bond and Loomis share a common design. Directly under the seat, as if supporting it, is a gate tower with a partially descended portcullis. Protruding from beneath the portcullis is the rear of Ywain's horse, and sometimes a leg or foot of Ywain

Fig. 5-1. Oxford, New College. Photo Royal Commission on the Historical Monuments of England. Copyright (©) RCHME Crown Copyright.

as well. On either side, the "supporters" are armed guardsmen, sometimes enclosed in watchtowers.

OXFORD (FIG. 5-1)

In the chapel of New College in Oxford, the Ywain misericord is centrally located on the south side of the choir.[13] Directly under the seat is the square gatehouse, with hexagonal towers on each corner. The supporters on each side are watchtowers, each with a closed gate. An oversized soldier in a visorless helmet peers from each, visible from the mustache up. Each of the two towers also bears a flag, the banner on the right bearing a diagonal cross, the one on the left a chevron. In the central tower, the portcullis has fallen about two-thirds of the way to the ground, trapping the horse and rider. We see only the somewhat crudely carved rear of the horse—the body, the hind legs, and the tail, with some hint of a saddle. The knight's right foot is also visible, protruding from between two spikes of the portcullis.

The building of New College was begun in 1380,[14] and the chapel was officially dedicated in 1386 (Stone 189). The stalls, with the misericord carvings, may not have been finished by the time of the dedication, but they were certainly in place just a few years later.[15] Determining the exact year of the misericords is probably impossible—and not essential for present purposes—but the alternative date of "about 1480" proposed by Loomis (79) and Cox and Harvey (259–61) is almost certainly untenable. The straight-edged misericord seats at New College are indeed simpler than the typical late fourteenth-century design (Druce 247; Remnant xx), but this makes an early date more likely than a later one.[16] Moreover, the records of New College, which seem to be very complete in the late fifteenth century, do not mention the addition of misericords at that time (see Steer, *Archives*).

LINCOLN (FIG. 5-2)

At Lincoln, the Ywain carving is found in the upper row of stalls, on the west side of the choir, near the northwest corner, under the name North Kelsey.[17] The central gatehouse has round towers on each of its four corners. The supporters are heads in visorless helmets, mustached, with camails. Foliage curls from the ends of the seat down to the heads. The equine posterior and the rear of the saddle are clearly carved; neither of the knight's feet is shown. The Lincoln misericords date from the last half, and probably the last three decades of the fourteenth century: the most frequently proposed date is ca. 1370.[18] The stalls were clearly begun, though

Fig. 5-2. Lincoln Cathedral. Photo Royal Commission on the Historical Monuments of England. Copyright (©) RCHME Crown Copyright.

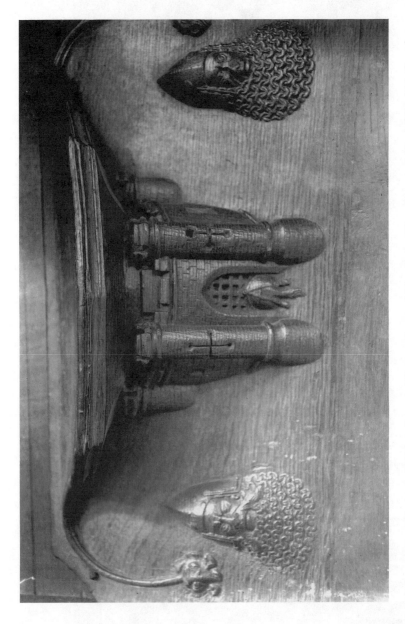

Fig. 5-3. Chester Cathedral. Photo Conway Library, Courtauld Institute of Art. By permission of Fred H. Crossley and Maurice H. Ridgway.

not necessarily finished, during the period 1350–80, when the treasurer of the chapter was John of Welburn, whom the *Muniments of the Dean and Chapter of Lincoln* describe as responsible for initiating and directing the work on new stalls.[19]

CHESTER (FIG. 5-3)

At Chester, the Ywain misericord is in the short row of stalls at the west end of the choir on the south side of the aisle.[20] The gatehouse, located directly under the seat, is square, with round towers on the corners. Under the portcullis, we see only the rear of the horse; no part of the knight is visible. The saddle and trappings, and the feet and tail of the horse are much more clearly depicted than at Oxford. The supporters, like those at Lincoln, are the heads of mustached men wearing visorless helmets and camails. The Chester stallwork and misericords are similar to those at Lincoln, and appear to have been executed by the same craftsmen,[21] but the work at Chester is "in almost every way a refinement and an aesthetic improvement" (Tracy 53). It is probably safe to assume, therefore, that the Chester carvings were made somewhat later than those at Lincoln: a date of ca. 1380–ca. 1390 is likely.[22]

BOSTON

The design of the Boston misericord was probably identical to that of the Oxford carving, although all that remains of the supporters at present is the right-hand watchtower. Since the area immediately above the tower is damaged, it is easy to assume that there was once a head there. The left supporter was most likely identical to the right, as is usually the case, but one can say with certainty only that something rectangular has been removed from that side. The central tower supports a hexagonal seat, but appears square itself. As elsewhere, only the rear of the horse is visible. The detailed carving shows saddle straps and horseshoes, but no sign of the knight. Since the Boston Ywain is not, as Loomis thought, a direct but "very crude" copy of the Lincoln misericord (Loomis and Loomis 79), there is no compelling reason to assume it postdates the Lincoln carving, as Cox and Harvey do, suggesting a date of ca. 1375 (259–61). Based on the shape of the seat, however, it is probably safe to assign the Boston misericords to the late fourteenth or possibly the early fifteenth century.[23]

ENVILLE (FIG. 5-4)

The Enville Ywain misericord, one of four misericords in the parish Church of St. Mary the Virgin at Enville, differs significantly from the four de-

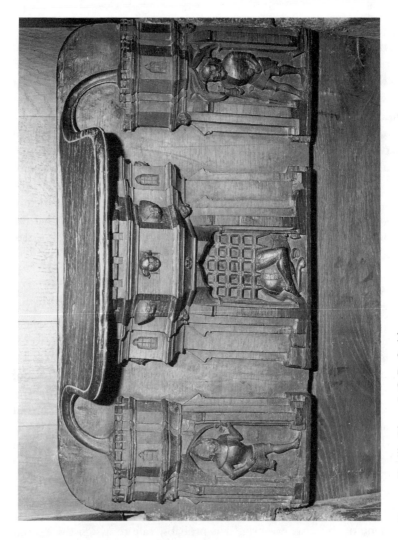

Fig. 5-4. Enville. Photo J. C. D. Smith.

scribed by Loomis. The basic pattern is the familiar one, with the gate tower directly under the seat and smaller watchtowers with guardsmen as supporters, but the carving at Enville is much more elaborate than on any of the other Ywain misericords. The supporting towers are almost as high as the central gate tower, and the armed guardsmen are portrayed at full length, standing before their watchtowers holding pikes. The figure on the left wears a conical, unvisored helmet; the one on the right is bareheaded. The whole carving is rich in architectural detail, including windows, crenelated battlements, and gargoyles. As on the other misericords, the central part shows Ywain and his horse trapped under the falling portcullis, seen from behind. But at Enville, the knight and horse disappear into the gateway at an angle. The horse is seen in a three-quarter view rather than directly from behind. Most of one leg of the knight is visible. Most remarkably, those parts of the horse and rider that have already passed through the gate can be seen in outline through the bars of the portcullis. The horse crumples under the weight of the portcullis as one of the spikes pierces the knight's leg. In the central tower, five small heads peer out of windows above the gate. At least two are the helmeted heads of soldiers; directly over the gateway is the head of a woman.[24]

Estimates of the date of the Enville misericords have ranged from the late fourteenth century to the late fifteenth, but a review of the available evidence shows the earlier date to be much more likely.[25] The visual data, though not without ambiguity, plainly support the earlier dating. The simple shape of the seat varies sharply from both the late fifteenth-century and the late fourteenth-century norms, and in itself suggests either an extremely early date in the late thirteenth or early fourteenth century or a very late date in the early sixteenth.[26] The early and late dates, however, are contradicted by the armor of both the knight and the standing guardsmen, which belongs to the "Camail and Jupon" period of 1360–1410 (see Ashdown 166–93; Pakula 198). The Enville knight bears a strong resemblance to the famous "falling knight" on a Lincoln misericord of ca. 1370 (Anderson, *Choir Stalls* fig. 10), whose armor is carved in minute detail and represents almost perfectly the Camail and Jupon armor as drawn by Pakula (198). The visual evidence thus points toward the earlier date: while the shape of the seat would indicate a date either earlier or later than those proposed, the style of armor depicted makes a date in the late fourteenth century more likely than one in the late fifteenth.

The available documentary evidence, though admittedly indirect, also supports the earlier date. A chantry was founded in the Enville church by a

local nobleman, Philip de Lutteley: grants of land made to the chantry by him and his family are recorded in 1367, 1370, and 1373 (Shaw 2: 275–76; Scott 282). Carved choir stalls were usually associated with chantry chapels or collegiate bodies within churches,[27] and the description of Enville church in the *Visitations of the Archdeaconry of Staffordshire 1829–41* assumes that the "handsomely carved" stalls originally belonged to the "chantry of Lutteley" (10).[28] If the recorded grants of land indicate the date of the founding of the chantry, and the stalls may be assumed to date from more or less the same time as the chantry foundation, then the documentary evidence appears to confirm the late fourteenth-century date.

NORWICH

The Ywain misericord described by Loomis, following Bond, as "formerly" at St. Peter per Mountergate in Norwich (Loomis 79, Bond 77) is no longer present in the church, and attempts to discover when it was removed and what was done with it have proved futile. Published descriptions of the church and its misericords provide an unclear picture of what the carving looked like, and when and why it disappeared. Bond does not give a source for his knowledge of the misericord, but the earliest published reference to the carving appears to be in Francis Blomefield's *An Essay Towards a Topographical History of the County of Norfolk*. In his 1806 edition, Blomefield writes "round the chancel are 24 STALLS [capitals in original], which belonged to the several chantry and soul priests" (96). He describes 16 misericords, among them the supposed Ywain representation. In 1829, Chambers still finds "eighteen remains of stalls, with some curious small carvings, hidden almost by the pews, but described by Blomefield" (1071–72).[29] In 1849, Hart speaks of the stalls and carvings in the past tense, saying St. Peter per Mountergate "contained twenty-four stalls; and our County Historian [Blomefield] has described fifteen [sic] of the Misereres, not one which now remains!" (237)[30] It thus appears that the misericords were still extant in 1829, but had somehow disappeared by 1849. I have found no published account of a renovation of the church between 1829 and 1849, but, in 1860, the gallery and pews were removed, and the church was "reseated" (Hale 169; William White 461). If the original stalls with their misericords had not already been removed, they must have been removed at this time. If so, they were not necessarily destroyed—they might have been sold, stored, or placed in a museum. But it has proved impossible to discover a trace of their whereabouts.

Further confusion surrounds the description of the Norwich Ywain.

Bond's brief mention implies that the Norwich carving depicts the portcullis scene in more or less the same way as the extant Ywain misericords. However, Blomefield describes the carving as follows: "Two old heads, between them a castle; a watchman on top holds a spear in one hand and a shield, on which a castle, in the other; he looks at a lion entering below, but as he enters is caught by the fall of the portcullis on him" (96).[31] The carving described is clearly similar to the five surviving ones, with the obvious and significant exception that here the lion, not the horse, is impaled by the portcullis. If Bond's source was directly or indirectly Blomefield, one wonders why he identified this carving with the Ywain story and the other carvings. Must the Norwich misericord be stricken from the list of Ywain images?

Perhaps not. If the Norwich carving resembled the one at Oxford, where the depiction of the horse is fairly crude and lacks specifically equine details, an antiquarian unfamiliar with the Ywain story could possibly have seen the rather indeterminate squashed quadruped with a tail as a lion rather than a horse.[32] On the other hand, even if Blomefield's description is correct, the carving might still derive from the tradition of Ywain iconography. If the misericords of St. Peter per Mountergate date from the building of the present church in 1486, they were made a century later than the four other Bond-Loomis misericords.[33] As we will see, the falling portcullis motive acquired a life of its own in visual tradition, quite independent from the Ywain story. The Norwich artist could easily have seen one or more of the older misericords or otherwise encountered the motive, and, not fully aware of the narrative context, converted the horse to a lion, perhaps influenced by some vague traditional awareness that the older carvings depicted the "Knight with the Lion."

Misericords as Representation of the Ywain Story

The misericords depict one dramatic moment rather than a series of events —a nucleus, in our Barthesian terminology, rather than a narrative sequence. As nuclei, they are not narratives, but only fragments of narrative, visual equivalents to sentences like "the portcullis fell on the knight." Unlike the single-scene narrative methods described by Wickhoff and Weitzmann, the misericord carvings neither depict several actions in one picture nor telescope a sequence into one image.[34] They do not narrate but rather *represent* the story, by depicting one of its most dramatic and picturesque

scenes. They are visual allusions to a widely known tale; as is the case with verbal allusions, viewers who know the story may be reminded of it in its entirety, but the allusion itself does not in any way contain the entire story. As a dramatic image, a fragment of narrative, moreover, the port-cullis scene is fully capable of standing alone. For viewers who know the Ywain story, the scene is an allusion to it; for other viewers, it is simply a narrative vignette in which a portcullis falls on a knight. How important knowledge of the Ywain story is for the understanding of the misericord scene remains to be considered.

Iconography

Our understanding of the sources of misericord motives has progressed considerably beyond the naive assumptions that led Loomis to imagine that the portcullis scene from the Middle English verse romance *Ywain and Gawain* "struck the fancy of some carver," who created the first misericord, which had "several imitators" (79). The inadequacy of the assumption that the image is directly inspired by a text is demonstrated by a consideration of the possible sources of the Ywain misericords, the interrelationships among the carvings, and especially by the differences between the En-ville misericord and the misericords listed by Loomis. *Ywain and Gawain* does predate the misericords by twenty-five to fifty years, and could have served as the source through which misericord carvers became acquainted with the motive from the Ywain story.[35] Knowledge of the French *Yvain*, however, could also have been widespread in fourteenth-century England, and it is probably impossible to know whether, as Anderson wonders, the "translation inspired the carvers, or was merely a contemporary expression of the popularity of the story" (*Choir Stalls* 25).

The question of the source of the Ywain motive is, of course, part of a larger question about misericord sources in general. The larger question, however, has no general answer. A bewildering variety of sources for specific misericords have been identified, including "wall-paintings, manu-script illuminations, and the woodcut pictures and marginal ornaments of early printed books," as well as the *exempla* of medieval preachers (Ander-son, "Iconography" xxvii).[36] Considering the variety of possible sources for misericords, it is certainly inaccurate to imagine a woodcarver hearing the story of Ywain and then carving one of its more dramatic scenes at his next misericord job—and impossible to assume direct inspiration of the Ywain

scene by a text. Instead, the misericords must be understood as one kind of pictorial concretization of a story that circulated in a variety of forms. The source of the misericord motive is most likely a diffuse secondary oral tradition, somewhere at the base of which is a textual version of the story—either Chrétien's romance or the Middle English version. But the route from text to misericord is in all likelihood so indirect that the existence of texts is essentially irrelevant to understanding the misericords. There is no way to prove that the portcullis scene's first appearance on an English misericord did not result directly from a cleric's or woodcarver's knowledge of a text. But even if it did, a consideration of the interrelationships of the various misericords shows that the scene quickly acquired a life of its own in the new genre.

The similarity of the four Ywain misericords listed by Bond and Loomis has led a number of scholars to assume various connections between them—the one is supposed to have been copied from the other, or two or more are supposed to have been carved by the same craftsman.[37] As already noted, the Lincoln and Chester stalls may well have been executed by the same group of craftsmen. Some effort has been made to connect this group with the royal carpenters William and Hugh Herland, and to postulate the influence of a court style on the stalls at Lincoln and Chester (Harvey 56). The specific connection is not provable, and has not found general acceptance.[38] Charles Tracy, however, has suggested that although these woodworkers were probably Midlanders and Northerners, the work they did in the Chester and Lincoln carvings was of a style associated with London and the Southeast (54–55). The group may have been connected with Master Edmund of St. Andrew, from Newstead, who worked on St. Stephen's chapel at Windsor starting in 1355 (Tracy 55). The carvings at New College may also be related to those at Lincoln and Chester. One Oxford misericord shows, in essence, the Ywain scene without the horse and knight: a gate tower with a partly lowered portcullis, with two helmeted heads as supporters (Steer, *Misericords* no. 21). The gate tower and especially the head on the right side strongly resemble the tower and the heads on the Ywain misericords at both Chester and Lincoln.[39] Steer speculates that, since Hugh Herland designed the timberwork at New College, he may have played at least an advisory role in the selection of carvers (*Misericords* 7). If he was involved at Lincoln and Chester as well, his involvement might explain the appearance of the Ywain scene in all three places. Although the theory of Herland's involvement at Lincoln and Chester has not been generally accepted, the carvings at Oxford, Lincoln,

and Chester do appear to be fairly closely related. It is tempting to seek a connection between the Lincoln and Boston misericords, as Loomis does (79), since the two churches are geographically so close, but the Boston misericord differs sharply from the one at Lincoln. In its use of gate towers, rather than helmeted heads, as supporters, the Boston carving resembles the Oxford misericord more than any of the others. Ultimately, it is not possible to trace with certainty the precise relationships among the Ywain misericords, or to idenitfy which groups of craftsmen were responsible for which carvings (although the Lincoln-Chester connection appears most plausible). Nonetheless, the similarity of the four older carvings makes it relatively certain that either the misericord that was carved first served as a model for the other three, or the four share a common source. Whatever its original source, whatever its precise route of transmission, the motive of the portcullis falling on a knight became part of the repertoire of a certain group or groups of misericord makers in late fourteenth-century England.

The extent to which the motive became a self-propagating and independent iconographic tradition is demonstrated by the Enville carving. In addition to its unique design and style, the Enville misericord differs from the other four and directly contradicts the traditional story in one significant detail. The fact that the portcullis in this carving impales the knight as well as the horse completely unhinges the Ywain plot, since the rest of the story depends on Ywain's escaping unscathed from the falling gate episode. The carver of the Enville misericord must have had little or no knowledge of the tale, and based his carving on an established iconographic tradition, which was to him simply "portcullis falls on knight." The appearance of a detail diverging so sharply from the original narrative indicates how completely the pictorial motive had become detached from the story that originally contained it. Clearly, the carvers were not "illustrating" a text or a story, but dealing in their own medium with a motive that was visually interesting even without the narrative context.

Thematic Analysis

The complete isolation of the motive from its original—or any other—narrative context suggests that viewers are not expected to base their understanding of the scene primarily on knowledge of the Ywain story. We do not know how likely medieval viewers of these misericords were to have known the story of Ywain, although the general literary situation of the

time, the fact that *Ywain and Gawain* exists in only one manuscript, and the relatively small number of Ywain pictures all suggest that the story was not as well known as those of Tristan or Parzival, perhaps especially in England. It may be likely that a fair number of viewers could at least name the knight under the portcullis, but it does not appear safe to assume that occupants of medieval English choir stalls knew the Ywain story in any detail. The real question is not whether viewers knew the story in advance, but whether they were expected to understand the image in terms of that knowledge.

The key to answering this question is the recognition that knowledge of the story does not add anything to the understanding of the image. At the proairetic level, a knight rides through a gate, and a portcullis falls on his horse. That is all we have, no matter how much the viewer knows about other versions of the story. At other levels of meaning, the canonical version of the tale is itself susceptible of far too many interpretations to be useful for attaching a symbolic or allegorical meaning to the misericord scene. Anderson's interpretation of the Ywain scene as an "example of ambition and pride" ("Iconography" xxxiv) rests on shaky ground, insofar as it relies on her assumption that the armed men who serve as supporters in all five misericords represent the men who came to seize Ywain when he was trapped. In order to interpret the scene in this way, viewers would have had not only to possess and activate a detailed knowledge of the story, but also to understand the story in a specific way. Moreover, Anderson's argument that the guardsmen are included in all five monuments for the sake of "some moralization" ignores the importance of the independent iconographic tradition, as does her claim that otherwise "at least one of the carvers would have substituted the damsel or the lion, both of whom play much more important parts in the romance" ("Iconography" xxxiv).

At the same time, the argument that Ywain's entrapment in the misericord scene represents the punishment of the sin of pride can be made just as well—indeed, better—without assuming that viewers of the carvings knew the story in advance and understood it in a certain way. In a symbolic or allegorical code, the mounted knight could easily be taken as representing pride, and his destruction, or at least entrapment, by the falling portcullis could easily be taken as the humiliation of the overly proud, even as a sort of pictorialization of Proverbs 16:18: "Pride goeth before destruction, and an haughty spirit before a fall."[40] Indeed, this understanding of the Ywain misericords is probably more likely for viewers who do not activate prior knowledge of the story and thus are not influenced by different under-

standings of the Ywain material. It appears, therefore, that whether or not viewers knew the story in advance did not determine their understanding of the misericord carvings. The "ideal viewer," as at Rodenegg and Schmalkalden, was one who, if he knew the story of Ywain from another source, did not rely on that knowledge to interpret the image.

Understanding, then, must have been based primarily on the image itself and the context in which it appeared. Context, however, would not appear to have pointed the viewer of any of the Ywain misericords to any very specific understanding of the image. The sets of misericords in which the Ywain scene appears all contain the diverse and unrelated motives that are typical of English misericord carvings. The selection of motives in the immediate vicinity of the Ywain scenes appears equally random: at Chester, Ywain appears between a falcon and a grotesque animal, at Lincoln, between oak leaves and the bust of an angel, at Oxford, between foliage and an ape's head, at Boston, between a dragon and griffin and a winged monster.[41] Only at Enville does the immediate context appear at all significant. There the only other misericord on the north side of the choir depicts a man holding a missal and a woman holding a rosary, together in a pew, with the devil standing behind them, perhaps suggesting that their superficial piety does not protect them from temptation, and perhaps providing an appropriate context for the allegorical association of Ywain's entrapment with the fall of Pride.

This general lack of any apparent organizing principle in sets of misericord carvings also casts doubt on Ott's claim ("Minne" 117) that the Ywain carvings formed part of "Slaves of Love" series, which also included Tristan (as at Lincoln and Chester) and often Aristotle and Phyllis (but never in the same choir with the Ywain scene). At Lincoln, for example, just four of the more than one hundred misericord carvings depict figures that might arguably be considered "slaves of love."[42] Only two are adjacent to one another: Tristan and Isolde in S.26 and the Capture of the Unicorn in S.27. It is difficult to imagine that a few images of slaves of love, scattered through an immense number of carvings, could have been understood as forming a thematic unity. Moreover, in order to understand the portcullis scene, standing alone and removed from all narrative context, as indicating Ywain's status as a slave of love, a viewer would be required first to recall from other sources the rest of the Ywain story and then spontaneously interpret that story in a very specific way.

It appears that neither the viewer's knowledge of the story nor the

context in which the carvings appear can have been of decisive importance in guiding reception of the Ywain portcullis scene. In the end, viewers must have been guided primarily by the visual codes of the carving itself. As an image, the portcullis episode is characterized above all by a strong comic value. Removed entirely from its usual narrative context, the scene is not so much a moment in a story as a visual joke. As Szklenar points out, "the idea of such an incident, even removed from its context in the novel" retains its "scurrilous fascination" and wins a "certain value of its own" (173).[43] Perhaps the best interpretation of the scene's significance admits that the depiction of the portcullis episode from the rear presents the viewer with a portion of the equine anatomy that even today provokes laughter. Indeed, returning to our structuralist terminology, we might identify a code of anatomical humor, in which the horse's rear not only carries a strong laughter-producing value, but also makes any person associated with that anatomical region into a figure of fun—the object of a rather coarse joke. A joke, of course, is not necessarily without meaning, and the humorous association of the knight with the horse's rear may function even more powerfully than his entrapment by the portcullis to suggest the humiliation of the proud. This symbolic significance, however, is not to be contemplated with great seriousness, but laughed about, in the burlesque, carnival spirit of so many misericord carvings.[44]

Notes

1. For descriptions, see Bloxam (44–45); Cox and Harvey (255); Druce (245–47); Remnant (xvii); Anderson (*Misericords* 5).

2. See Wright (112). This explanation is almost universal in writing on misericords: see, for example, Remnant (xvii), Ganz and Seeger (19).

3. A section of these instructions is quoted by Bloxam (45).

4. Misericords may have originated as clandestine aids to the weary. An early medieval prohibition of sitting in church is reflected in Peter Damiani's eleventh-century condemnation of the canons of Besançon (Wolfgang 79), but such rules were obviously altered. Theoretical justification for sitting in the choir may be found in Gulielmus Durantis's comment that "the seats in the choir admonish us that the body must sometimes be refreshed: because that which hath not alternate rest wanteth durability" (paragraph 32, p. 26 in translation). Durantis does not mention misericords.

5. See Cox and Harvey (257); Anderson (*Imagery* 267).

6. Cf. Remnant (xvii); Tracy (xix).

7. Cf. Scheuber (27); Ganz and Seeger (23).

8. See Anderson ("Iconography" xxiv–xxvi).

9. See Stone (88–89); Bennett (10–11); Steer (*Misericords*); Anderson (*Choir Stalls* 41–47).

10. Anderson surveys the range of misericord subjects in "Iconography" (esp. xxiv–xxvii) and *Misericords* (11–30); for an older survey, see Wright (114–26). Remnant provides a comprehensive catalog of all misericords in Great Britain; consult her indexes for details on any of the scenes mentioned in this paragraph.

11. As Anderson describes the problem, we cannot assume "that every detail in church imagery was meant to convey a religious message," but we also cannot ignore the possibility that any detail might have had a religious significance ("Iconography" xxvii). Ott ("Minne" 108) also warns against assuming a religious meaning just because misericord carvings are located in churches.

12. On the Enville misericords, see Rushing ("Enville"); also Remnant (140); Jeavons (50); Roe (80). The most recent literary historians to list the Ywain misericords, Ott and Walliczek (475–76), and Cormeau and Störmer (229), repeat the Bond-Loomis listing and thus fail to mention Enville.

13. No. 45 in Steer (*Misericords*, pictured p. 33).

14. The charter was issued in 1379 (Remnant 133; Cook 178).

15. Stone (189), proposes a date of around 1390; see also Remnant (133); *Royal Commission* (89). Steer (*Misericords* 7) and Tracy (xiv, see also 59) give the date as 1386.

16. On the problems of misericord dating, and the possiblity of using the shape of the ledge and other factors to estimate the date, see Remnant (xx–xxi) and Druce (247).

17. The name indicates the prebend to which the stall was allocated (Anderson, *Choir Stalls* 8). The stall is designated N.24 by Anderson (*Choir Stalls* 42, illus. p. 21), who errs in saying that the Ywain stall is labelled Milton Manor (42).

18. See most recently Tracy (xxiv, and see 52); also Cox and Harvey (259–61); Bennett (3). For less specific suggestions, see Anderson ("Iconography" xxxi), 1350–80; Loomis (79), last quarter of the fourteenth century.

19. He is described as "inceptor et consultor inceptionis facture stallorum novorum in ecclessia Cathedrali Lincolniensi" (Wickenden 180). See also Stone (188); Anderson (*Choir Stalls* 13–14; "Iconography" xxxi).

20. Location S(c) in Bennett (10).

21. See most recently Tracy (53–54); also Anderson ("Iconography" xxxi, *Choir Stalls* 10–11) and Stone (188). Compare, however, Bennett's opinion that while the Chester carvers certainly "knew the Lincoln designs," and some of the same men may have been involved at both places, the Chester carving is clearly inferior to the Lincoln work, and thus unlikely to have been done by the same hands (14).

22. Dates proposed include ca. 1380 (Bennet 3 and Richards 95); ca. 1390 (Tracy 53, Wolfgang 81, Remnant 24, and MacLean 77).

23. Orange says only "fourteenth century" (8); Loomis places the carving in the last quarter of the fourteenth century (79); Bond (226) and Remnant (87) suggest 1390.

24. Jeavons (50) assumes that this represents Lunete.

25. Jeavons (50) identifies the stalls as "original late fifteenth-century work"; Remnant (140) accepts his dating without comment. Roe, on the other hand, finds that the plan, and the architecture and costumes depicted are "coterminous with the latter part of the fourteenth century" (80). For a more detailed review of the evidence, see Rushing ("Enville Ywain" 280–82).

26. Typical seat shapes are illustrated by Druce (245); the late fourteenth-century ledge is also described by Remnant (xx) and exemplified by the Ywain misericords at Lincoln, Boston, and Chester.

27. See Cox and Harvey (257) and Anderson (*Imagery* 267).

28. But see Pevsner: "the foundation of a chantry 1333 is recorded, but nothing quite matches it" (129).

29. The discrepancy between Blomefield's 24 stalls and Chambers's 18 appears inexplicable.

30. In 1883, William White states, in the past tense which seems to confirm that the stalls have disappeared, "in the chancel were twenty-four stalls" (461). White's additional statement that "there are sixteen ancient stalls in the chancel" (461) probably refers to the Victorian stalls still present in the church, as does Messent's inclusion of "ancient stalls" in a 1932 list of things to see in the church (72).

31. See also Hart's summary (238).

32. The story of Ywain was no doubt not widely known in 1806, although Thomas Warton had published excerpts of *Ywain and Gawain* in 1781 and Joseph Ritson had published an edition of the poem in 1802 (*Ywain and Gawain* xii).

33. On the date of construction, see Blomefield (92), White (461), and Cautley (230).

34. See above, p. 17, in the introduction.

35. *Ywain and Gawain* was written between 1325 and 1350; it exists in a unique (unillustrated) manuscript of 1400–1425 (British Museum MS Cotton Galba E. ix) (*Ywain and Gawain* lvii–lviii).

36. On specific sources of individual misericords, see Anderson, *Imagery* (19–20, 78, 167–78), *History and Imagery* (166–67), "Twelfth-Century Design Sources"; Stone (122, 151); Hart (239); Purvis (116–27). As far as the possibility of an *exemplum* as source is concerned, it is worth noting that Owst's two books on medieval preaching do not cite any sermons mentioning Ywain.

37. The relative dating of the misericords is, as we have seen, too unclear to shed much light on their precise interrelations.

38. See Stone (188); Anderson (*Choir Stalls* 11, "Iconography" xxxii); Tracy (54).

39. The relationship has been noted by Steer (*Misericords* 7, 20).

40. The "falling knight" misericord at Lincoln has frequently been understood in this way (see Anderson, "Iconography" xxxii).

41. At Chester, the original order of the stalls was apparently scrambled during a nineteenth-century restoration (Bennett 12–13), making conclusions about the immediate context impossible.

42. N. 24, Ywain; S. 21, woman preparing to strike a man; S. 26, Tristan and Isolde; S. 27, capture of the unicorn (see Anderson, *Choir Stalls* 41–51). The situation is similar at Chester, where five misericords scattered through a total of 48 depict

possible "slaves of love" (South Side a, Ywain; h, "Slaying of unicorn;" o, "Quarreling couple"; North Side m, "Fighting couple;" s, Tristan and Isolde [Bennett 10–11]).

43. Szklenar argues "daß die Vorstellung eines solchen Vorfalles auch aus dem Romanzusammenhang gelöst und verselbständigt ihren skurillen Reiz behielt und einen gewissen Eigenwert gewinnen konnte" (173).

44. Ott also stresses the humor of the misericords he discusses, arguing that they, like many or most "Slaves of Love" images, are not intended as serious warnings against *amor carnalis* but as an ironic game with the well-known topos ("Minne," esp. 124).

6. Adventure Turned to Slavery: The Malterer Embroidery

While the misericords detach one scene from the Ywain material, the Malterer embroidery in Freiburg's Augustinermuseum depicts the character Ywain in isolation from the narrative tradition. Through the decades, the *Maltererteppich* has probably attracted more interpreters than any other Ywain pictorialization except the Rodenegg murals; yet the main result has been a great fog of confusion regarding the work's origin, patrons, and theme, and the content of the second Ywain scene.

Historical Background

The *Maltererteppich*, which was made between about 1310 and 1330, in or near Freiburg, has been called one of the "finest surviving examples of late medieval textile art" (Smith, "Power" 203).[1] In an unusually long, narrow format (491 × 67.5 cm), which suggests that the embroidery was not intended to be hung on the wall, but on the back of a long bench,[2] it presents a row of eleven quatrefoil medallions embroidered in wool on a woven linen background.[3] The first and last medallions (fig. 6-1) display the arms of the Malterers, a patrician family of Freiburg, and create a frame for the other quatrefoils, which present a series of narrative vignettes.[4] Arranged in pairs, medallions two through nine depict scenes from stories popular in the fourteenth century—Samson and Delilah (2 and 3), Aristotle and Phyllis (4 and 5), Virgil in the basket (6 and 7), and Ywain (8 and 9). The tenth quatrefoil depicts a unicorn laying its head in the lap of a seated maiden in the well-known gesture of unicornian submissiveness. In the first medallion stands the name Anna, in the last Johannes. The arms thus appear to identify the patrons as Johannes and Anna Malterer; unfortunately, although Johannes is easily identified with a documented historical person, the identity of Anna has remained controversial. The work was in the

Dominican convent of St. Katharine in Freiburg from an early date, but it is not clear whether the embroidery was made for the convent, or made for a secular setting and then given to the convent.[5]

The uncertainty regarding the identity of Anna and the original functional context of the Malterer embroidery dominated early discussions of the work (Schweitzer, F. Maurer, Mertens) to an unfortunate extent. The interpretation was made to depend on establishing whether the embroidery was created for the convent or for secular purposes, and establishing this was made to depend on identifying Anna. Ultimately, as we will see, determining the precise provenance of the embroidery cannot solve the interpretive problems posed by the work, since a secular setting does not rule out a religious meaning, and a religious setting does not rule out a secular meaning. Our interpretation of the embroidery must be based on the work itself, and on our knowledge of the Slaves of Women topos that it embodies. Nonetheless, since so much has been written about the identification of Johannes and Anna, a brief review of the evidence is in order.

THE MALTERER FAMILY

Hermann Schweitzer, in his 1901 article, assumed, apparently a priori, that Johannes and Anna must have been husband and wife, and the label "wedding tapestry of Johannes and Anna Malterer" has become the standard designation for the emboidery (52).[6] The fact that Johannes Malterer's only recorded wife was named Gisela did not disturb Schweitzer, who relied upon the evidence of the embroidery to assert the existence of a "first wife" named Anna (52).[7] Perhaps it was the second wife, Schweitzer thought, who insisted on getting this relic of a first marriage out of the house by giving it to the convent (53–54).[8] Heinrich Maurer, in 1907, seems to have been the first to suggest that the embroidery's Anna was a sister of Johannes and that the embroidery was a wedding gift from sister to brother ("Freiburger Bürger" 26). In 1953, Friedrich Maurer adopted the theory that the siblings Johannes and Anna commissioned the embroidery for the St. Katherine convent, where Anna was a nun (230).[9] Unfortunately, though Maurer follows Schweitzer (53) in asserting that the sister Anna is "urkundlich mehrfach bezeugt" (F. Maurer 230), the documents they quote contain no clear reference to a sister of Johannes. Taken together, these theories create the general impression that a hopeless confusion surrounds the effort to identify Johannes and Anna.[10]

In reality, though the details of the Malterer family's early fourteenth-

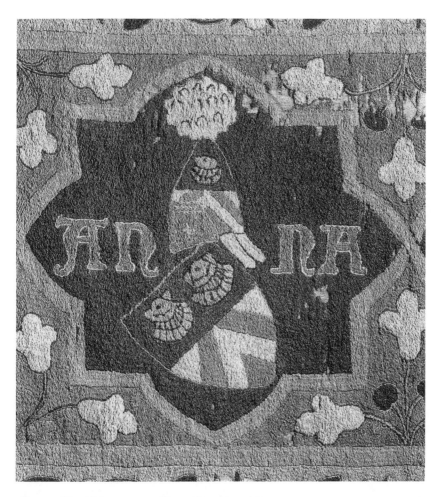

Fig. 6-1. The Malterer arms. Photo Hans Peter Vieser.

century genealogy are not entirely clear, enough published evidence is available to make it unnecessary to conjure up undocumented wives and sisters. The two articles by Heinrich Maurer, in particular, present a reasonably clear genealogy of the relevant generations.[11] The embroidery's Johannes may be identified with fair certainty as the Johannes der Malterer who was born about 1295 and died on February 17, 1360.[12] He married Gisela von Kaisersberg, and they had four children: Martin, Margarethe, Elisabeth, and Gisela. Johannes was apparently the only child—or at least the

only son to have issue—of Friedrich Malterer, who died in 1320, and his wife Katharina. Friedrich had two sisters, Gertrut and Anna. This Anna, Johannes's aunt, appears to be the only real candidate for identification with the Anna of the embroidery, and there is no good reason not to accept this identification.[13] Anna was a nun (or possibly a lay-sister) in the convent of St. Katharine, which owned the embroidery, and it is easy to imagine the wealthy Johannes commissioning the work as a gift to the chapter, on behalf of himself and his cloistered aunt. Schweitzer's identification of the embroidery's Anna with an undocumented first wife of Johannes thus appears to be a groundless and pointless speculation that should no longer be propagated. The erroneous identification of the nun as Johannes's sister probably arises from the misunderstanding of references to her as "suror [sic] nostra" and "swester" in the convent's *Seelbuch*.[14] But even if we can conclude with a fair degree of confidence that the Anna of the embroidery was Johannes's aunt, and that the embroidery was made for the convent,[15] this does not tell us how to interpret the work. As we know from our survey of misericord themes, an immense variety of secular images appeared even in the choir stalls of cathedrals. And as the existence of the Wienhausen Tristan embroideries indicates, the presence of worldly tapestries in a convent is by no means unheard of.[16] Even if we could know with absolute certainty that the Malterer embroidery was (or was not) made for the convent, that would not tell us whether to expect a religious meaning or a secular one.

The general identification of the Malterer family as the patrons of the embroidery is, ultimately, of more importance than the precise identification of Johannes and Anna, for it tells us a great deal about the social milieu in which the embroidery was created and the socio-semiotic significance of the work for its patrons. The Malterers were a family experiencing a rapid rise in power and wealth, transforming themselves in one or two generations from well-to-do miners to powerful urban patricians. Johannes's father had amassed considerable wealth from moneylending, speculative investment, and silver mines, and the family fortune grew until Johannes's son Martin was probably among the first multi-millionaires of the Middle Ages (Boesch 264).[17] Johannes himself became a financier and an important moneylender: his debtors included the cities of Freiburg and Endingen, along with several counts, margraves, lords, convents, and an abbott (H. Maurer, "Martin Malterer" 201). At least by the time of Johannes, the Malterers had begun to amass power as well as wealth. Johannes was a *Ratsherr*, an elder of Freiburg.[18] With wealth and power

came social prestige. Johannes Malterer's name appears on a number of documents in lists of witnesses who belong to the urban nobility, but the marriages of the Malterer women are the best indication of the social success made possible by the family's wealth. Johannes's daughter, Elizabeth, married Otto, son of Markgraf Heinrich IV von Hachberg in 1356 (H. Maurer, "Martin Malterer").[19] Of Johannes's granddaughters, one married a *Herr* and one a *Ritter*; one a *Graf* and another a *Markgraf*. The embroidery for its patrons was a status symbol, indicating their arrival in the class having the wealth and power to sponsor the creation of such artworks.

Interpretation

EARLY EFFORTS

The paired images of the Malterer embroidery belong to the well-known topos of the Slaves of Women or Slaves of Love, which catalogs famous and powerful men humiliated or destroyed by the love of women. The topos is notoriously ambiguous: its message can equally well be that since wise and powerful men like Aristotle and Samson were destroyed by women (or love), ordinary men are in terrible danger, or that since wise and powerful men like these were susceptible to love, ordinary men are justified in being lovers, too. Interpretation of the Malterer embroidery is complicated further by the association of the topos with the equally ambiguous image of the unicorn, which can symbolize Christ and divine love, or appear as another victim of woman—the free and powerful animal that can only be captured when it is lured to the lap of a maiden.

Many interpreters have tried to resolve these ambiguities by reference to the functional context of the embroidery. Schweitzer thought that Anna was Johannes's wife, and that the topos appeared here as a positive testimony to the power of love. Maurer thought that Anna was the sister of Johannes, that the embroidery was made for the convent, and that the topos appeared as a warning against carnal love, as opposed to the divine love represented by the unicorn (226–227).[20] Probably no scholar has argued more consistently for the importance of the functional context in interpreting medieval art objects than Norbert Ott.[21] But what Ott's survey of various manifestations of the Slaves of Love topos actually demonstrates is that the "Gebrauchszusammenhang" does not always provide a key to the meaning. Clearly, the Aristotle and Phyllis scenes on ivory

"Minnekästchen" are unlikely to have been intended or understood as serious warnings against love or against woman's wiles,[22] but even if the secular context makes the didactic meaning unlikely, the opposite is not necessarily true: a religious context does not make the didactic interpretation inevitable. Misericord carvings, for example, despite their location in the choir stalls, often treat obviously humorous themes. And yet, although Ott treats them as almost automatically humorous, due to their location and their use as "Gesäßstütze" ("Minne" 123), misericords sometimes depict religious themes of unquestionable seriousness (see above, p. 200, in the misericord chapter). Ott's deliberations suggest two things. The Slaves of Love topos often appears in secular contexts, in which it is not likely to have been taken seriously. But even in the religious environment for which, it now seems, the Malterer embroidery was most likely made, the topos could appear as a parodistic or ironic citation of a well-known topos rather than a serious warning against concupiscence (Ott, "Minne" esp. 123–25). Ott cites, for example, a set of wood sculptures in the Benedictine abbey at Trier, which includes, along with Samson and Delilah and Virgil in the basket, a woman who rides on a kneeling man while beating his bare buttocks with a cooking spoon—a humorous exaggeration and domestication of the topos that lends a playful, parodistic, humorous tone to the whole series ("Minne" 123).

Contextual arguments about the Malterer embroidery are all the more problematic because of their circularity. Schweitzer assumes that the embroidery was made for a married couple because he thinks it is a positive statement of the power of love, and he uses the presumed secular setting to support his interpretation; Maurer believes the embroidery was made for the convent because he interprets it as a condemnation of worldly love, and he uses the presumed religious context to support his interpretation. The Malterer embroidery cannot be interpreted through identification of its functional context. We must carefully consider the images themselves and the structure that the Slaves of Women topos imposes on them.

The Problem of the Second Ywain Scene

The stories represented in the first three sets of paired medallions are well known, and the narrative content of each pair is easily understandable for viewers even marginally familiar with the stories. The second Ywain scene, however, has consistently caused difficulties for interpreters, as we will see. In the first pair of quatrefoils, Samson, his long hair flowing behind him, kills a lion with his bare hands (medallion 2), then kneels submissively

while Delilah cuts his hair with a large pair of shears (3). The story, from Judges 16, must have been almost universally known in fourteenth-century Freiburg, as, indeed, it is today.[23] In the second pair of images, Aristotle sits before a lectern loaded with books, reaching out through a window to tickle a maiden under the chin (4); in the next scene (5), he crawls on all fours, wearing a bridle, while the maiden sits "sidesaddle" atop him, holding a whip. The story of the philosopher's humiliation by a woman originated in the Middle East, became a widespread motive in Western literature and pictorial art in the thirteenth century, and remained popular at least through the fifteenth.[24] In the third pair of quatrefoils, Virgil stands outside a tower, holding hands with a maiden who appears in a window (6); in the next medallion, he dangles in a basket outside a window with closed shutters, while the maiden stands atop the tower. The tale of Virgil's attempt at adultery and his resulting exposure to ridicule appears in a number of sources beginning in the thirteenth century, and in a variety of pictorial manifestations.[25]

The eighth and ninth quatrefoils present scenes from the Ywain story. In the eighth, Ywain and Ascalon fight on foot, with swords, and Ywain, identified by a lion's-head crest, lands a blow on the crowned head of Ascalon, who falls to the ground (fig. 6-2). The storm that Ywain has unleashed still rages, represented by cloud, rain, and hail. The fountain, with its anvil-shaped stone, appears in the middle foreground. In the ninth medallion, we again see Ywain, identified by the lion rampant on his shield (fig. 6-3). Next to him stands a maiden, presumably Lunete. With her right hand, she grasps his elbow, pulling his left arm toward her. Ywain's hand is raised, and one finger points upward. With her left hand, the maiden holds a large ring next to Ywain's raised finger. Both Ywain and the maiden gaze toward a married woman (recognizable as such by virtue of her wimple), presumably Laudine, who is seated on a throne before them. The scene is reminiscent of several moments in *Iwein*, but it corresponds precisely to none. Interpreters, therefore, who have proceeded from the assumption that the embroidery's Ywain scenes were based directly on Hartmann's text, have been persistently baffled by the second scene.

Schweitzer plausibly enough identifies the second Ywain scene as Lunete's presentation of Ywain to Laudine (49). But because he understands the image strictly in terms of Hartmann's text, Schweitzer endows the scene with the full significance that it has there, reading it as something like "with Lunete's support, and the aid of the magic ring, Ywain wins the hand of Laudine." The resulting necessity of fitting a moment

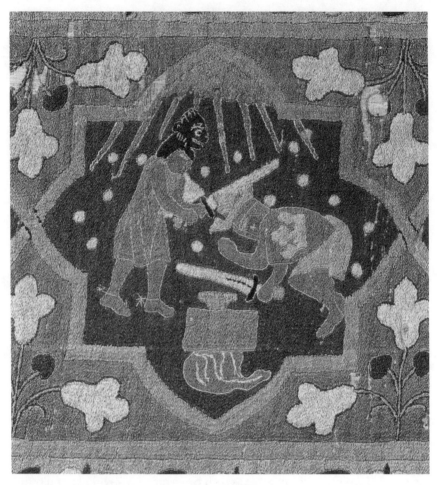

Fig. 6-2. Ywain and Ascalon. Photo Hans Peter Vieser.

of male success into a topos of male humiliation leads to the conclusion that here Laudine is the slave of love, reduced to shamelessly marrying her husband's killer (Schweitzer 50). This interpretation appears immediately improbable not so much because the appearance of a female slave of love in this series of male *Minnesklaven* would be surprising as because it contradicts the basic structure of the embroidery. In each pair of medallions, the first depicts the victim of love prior to his fall; the second shows the victim under love's control. In this pair, Laudine does not appear in the first scene

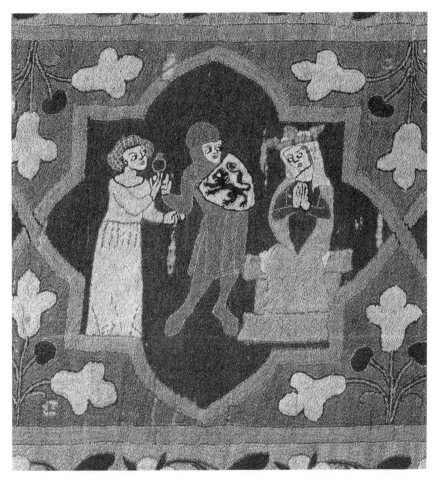

Fig. 6-3. Ywain, Lunete, and Laudine. Photo Hans Peter Vieser.

at all, and her shame is by no means obvious in the second. To interpret the scene this way, one must assume both that viewers would have known from another version of the story that Laudine had married her husband's slayer, and that they would have found her behavior shameful—which is at best uncertain.[26]

Friedrich Maurer, on his way to interpreting the embroidery as a condemnation of erotic love, argues that each pair of medallions presents a clear pattern of "honor" and "suffering"—the hero at the height of his powers, then the hero humiliated by love (225–226). If each pair of medal-

lions depicts its hero's *êre* and *leid*, the ninth must show Ywain's humilia-
tion. Maurer therefore sees in the second Ywain image the scene at Arthur's
court where Lunete delivers Laudine's renunciation of the tardy Ywain and
confiscates his ring to demonstrate his loss of Laudine's grace. Since, in
Iwein, Laudine is not present when Lunete takes the ring from the errant
knight, Maurer claims that her appearance here in the second Ywain quatre-
foil is not intended to indicate her real presence, but only to suggest that
she has sent Lunete to Ywain (229). There is no visual sign, however, that
might indicate this to the viewer, and the fact that Ywain and Lunete obvi-
ously stare at Laudine certainly suggests her presence.[27] Moreover, it does
not really look as if Lunete is taking the ring from Ywain—she appears,
rather, to be giving it to him, or perhaps displaying it in a symbolic ges-
ture. And the way she takes Ywain's elbow looks more like a protective or
conspiratorial gesture than an aggressive one. Maurer's explanation of the
second Ywain scene simply conflicts too sharply with the visual evidence
to be acceptable.[28]

Moreover, as Mertens points out, the embroidery is hardly governed
by the *êre/leid* structure; indeed, the first medallion shows the hero at the
height of his glory only in the Samson and Ywain pairs. Aristotle and
Virgil are shown at the beginning of their downfall, already involved in
shame-bringing dalliance.[29] Mertens, therefore, returns to a simpler under-
standing of the Slaves of Love topos, proposing that the actual theme of
the work is the power of "Minne" to rob the strongest and wisest men of
their senses (87). In the context of this interpretation of the whole, Mertens
finds that the second Ywain scene can only be Lunete giving Ywain the
magic ring, while Ywain sees Laudine and falls hopelessly in love with her
(87). This interpretation, however, like Maurer's, requires the viewer to
imagine a spatial separation of Ywain from Laudine: one has to imagine a
wall separating the pair with the ring from the lady on the throne. Again,
though the interpretation of the whole embroidery is plausible, the expla-
nation of the problematic scene is not quite reconcilable with the visual
facts.

Most recently, Smith follows Mertens in arguing that the second
Ywain scene represents the pledge of love between Ywain and Laudine
("'To Women's Wiles'" 150–151), or the moment in which they become
engaged ("Power" 217–18).[30] But like the interpretations of Schweitzer,
Maurer, and Mertens, Smith's understanding of the image relies too heavily
on text-based knowledge of the Ywain story, and is not reconcilable with
the evidence of the image itself.

What these interpretive failures demonstrate is that it is impossible to understand the scene as corresponding directly to anything in Hartmann's text. The problem has not been so much that scholars assume a direct text-picture connection in the minds of the makers and viewers of the embroidery, but that modern interpreters automatically connect the pictures with the canonical literary texts in their own minds. "Canonical" and "literary" are the key words here. The stories of Aristotle and Phyllis, Virgil in the basket, and Samson and Delilah all exist in texts, and yet scholars do not assume that images based on these stories must correspond in detail to scenes in specific texts. But although the book of Judges certainly belongs to the canon in the original sense of the word, none of these texts are thought of today as belonging to the canon of high medieval "literature." Because *Iwein* is "literature," modern scholars automatically equate the story with the received text, and assume that the scenes depicted must correspond directly to scenes in that text. As is so often the case with medieval images, that leads interpreters of the Malterer embroidery astray. Since no scene in *Iwein* combines all the elements of the embroidery's second Ywain picture, one must free oneself from the text in order to understand the image. Viewers cannot have created stories from the images by recalling the text of Hartmann's poem and comparing the images to it. Or, to put it in semiotic terms, the codes by which medieval viewers of the embroidery created a diegesis from the narrative images were not derived from the text of Hartmann's *Iwein*. Instead, these codes were provided by the rhetorical structure of the embroidery, the topos of the Slaves of Love, and general notions of what was exemplary and what was shameful for literary knights—something that we might call genre expectations.

The structure of the embroidery, with its obvious binary arrangement of scenes, invites viewers to create from each pair of images a simple story based on a contrast. The serial arrangement of several pairs encourages viewers to assume that the contrast will be the same in each pair. Thus, by the time viewers reach the Ywain scenes, they are prepared to create the story of a downfall. At this point, by relying on general notions about literary knighthood, they can easily identify the first scene as depicting a glorious victory for the knight with the lion. Then, since they expect the second scene to show this knight's downfall, they are thoroughly ready to understand that the hero has been humiliated by being forced to surrender to a woman.

This does not require any advance knowledge of the Ywain story. The viewer of the two Ywain scenes can see that the first scene presents an

exemplary knight involved in the exemplary action of defeating an opponent, while the second medallion shows this same knight surrendering to a woman. Considered as an illustration of this or that moment from Hartmann's *Iwein*, the second scene is indeed confusing; considered as part of a pictorial mini-narrative, the scene is perfectly clear.[31] It is not "Ywain wins Laudine"—no visual clue indicates his reconciliation with her. And there is no need to suppose that Laudine's presence is imaginary or symbolic. Instead, the scene might be best described as "Ywain surrenders to Laudine," or, more generically, "knight surrenders to lady."[32] Ywain's posture and his and Lunete's eyes seem to show fear, and Lunete takes Ywain's elbow in a protective gesture. Laudine's position on a throne indicates power, but her downcast eyes and clasped hands indicate nothing but grief.[33] The ring presented by Lunete, which belongs to an entirely different narrative segment in the text, is included here simply because it is an attribute of Ywain, like the lion.[34] The whole scene places such an emphasis on Ywain's submission that a new version of the story is created—one in which Ywain's presentation to Laudine is not a victory, but a defeat. This "reading" is further supported by the topos of the Slaves of Women, which provides the structure for the embroidery.

SLAVES OF WOMEN TOPOS

Given the fundamentally ambiguous nature of this topos, it is not surprising that it goes by many names. *Minnesklaven*, and "Slaves of Love" suggest that the heros are overpowered by romantic or erotic desire, while *Weiberlisten*, *Frauensklaven*, "Power of Women," and similar names suggest an actively wicked role for the seductive woman.[35] Theoretically, one might draw a distinction between the Slaves of Love topos, which presents examples of the power of love, not necessarily as a warning, but often as a consolation to lovers, and the Slaves of Women topos, which presents examples of the destructive power of women, and has obvious roots in clerical antifeminism.[36] In practice, however, the two topoi are not so easily separated. This is true, first of all, because of the inherent ambiguity of the topos. Alexander, for example, might appear as the victim of woman's wiles in one instance, and as the victim of the abstract power of love in another. His humiliation might be depicted in one case as a jest, and in another as a solemn warning against women or concupiscence.[37] Moreover, the two topoi are linked at an allegorical level by the tendency of medieval theologians to see woman as a personification of sexuality (see Schnell 478). Warning against the wiles of specific women might thus often amount to

the same thing as warning against cupidity in the abstract. The *Frauens-klaven* and the *Minnesklaven* must be regarded not as two topoi, but two sides of the same topos.[38]

The complete history of this long-lived and diverse topos need not and can not be presented here. Like medieval antifeminism in general, the tradition has roots in patristic writings—for example, in Jerome's letter to Eustochium, which cites Samson, David, Solomon, and Ammon as strong, spiritual, or wise men who were brought down by the love of woman.[39] From these patristic origins, the topos became a common subject of rhetorical exercises and didactic poems in medieval Latin,[40] and eventually found its way into vernacular literature. The earliest list of *Minnesklaven* in German is probably the passage in Hartmann's *Erec* (2811–2821), where the hero is said to have the wisdom of Solomon, the beauty of Absalon, the strength of Samson, and the generosity of Alexander. Although the comparisons are ostensibly invoked as evidence of Erec's good qualities, the figures named are so well known as victims of woman that the praise turns into an ironic foreshadowing of Erec's downfall.[41] In another early German example, a poem by Reinmar von Zweter (Roethe, *Spruch* 103) lists Adam, Samson, and Solomon as examples of men who lose "wirde" and "tugent" due to the love of women. In one sermon (1:245–46), Berthold von Regensburg cites the examples of Adam, Samson, and Solomon as proof that woman overpowers man's heart more quickly than wine; in another (2:60), he points out that neither the wisdom of David and Solomon nor the strength of Samson protected the men from carnal desire. These three biblical figures are among the most consistent members of *Frauensklaven* catalogs for the next four centuries. The first German author to expand the catalog by including nonbiblical characters was the writer of a poem published by Ettmüller as Frauenlob's *Spruch* 141, which lists men betrayed by women:

> Adâm den êrsten menschen den betrouc ein wîp,
> Samsônes lîp
> wart durch ein wîp geblendet,
> Davît wart geschendet,
> her Salomôn ouch gotes rîchs durch ein wîp gepfendet;
> Absâlôns schoene in niht vervienc,
> in het ein wîp betoeret.
> Swie gwaltec Alexander was, dem geschach alsus,
> Virgîlîus

wart betrogen mit falschen sitten,
Ôlofern versnitten;
dâ wart ouch Aristoteles von eim wîbe geritten;
Troyâ diu stat und al ir lant wart durch
ein wîp zestoeret.
Achillî dem geschach alsam;
der wilde Asahel wart zam;
Artûses scham
von wîbe kam
Parcivâl grôzse sorge nam:
sît daz ie vuogt der minnen stam,
wâz schadet, ob ein reinez wîp mich brennet unde vroeret?

<div align="right">(Ettmüller 102)[42]</div>

Adam, the first man, was betrayed by a woman,
Samson
was blinded by a woman,
David was dishonored,
Lord Solomon lost God's kingdom due to a woman;
Absalon's beauty did not prevent
a woman from making a fool of him.
As powerful as Alexander was, the same thing happened to him;
Virgil
was betrayed by false ways,
Holofernes was cut up;
Aristotle also was ridden by a woman;
Troy—the city and the whole land—was
destroyed by a woman.
The same thing happened to Achilles;
Wild Azahel was tamed;
Arthur's disgrace
came from a woman;
Parzival had great worries:
since love always goes that way
what does it hurt if a pure woman burns and freezes me?

The ironic twist of the last two lines does not affect the value of the strophe as evidence for the existence of a "victims of woman" tradition that included biblical, Greco-Roman, and Arthurian characters.

The tradition finds pictorial expression in a set of wall paintings in Constance, in the Haus zur Kunkel, or Weberhaus. Painted between 1306 and 1316 under the patronage of Konrad von Überlingen, a doctor and *Domherr*, the twelve medallions depict Adam, Samson, Solomon, Alexander, Virgil, Holofernes, Aristotle, Achilles, Arthur, Parzival, and Azahel.[43] Each medallion includes (some rather fragmentarily) the appropriate verse from the Pseudo-Frauenlob stanza. Though it is impossible to establish a direct connection between the Constance pictures and the Malterer embroidery, the paintings do at least suggest that the *Frauensklaven* topos was experiencing a sort of local vogue in the general vicinity of Freiburg at roughly the time of the embroidery's creation.[44]

As the pseudo-Frauenlob poem and the Haus zur Kunkel paintings show, the early fourteenth-century artist could choose from a large number of potential Slaves of Women. It may not be possible to know with certainty what led the Malterer artist to choose these particular four men, but Smith's recently published attempt to explain the choices is well worth considering.[45] Samson belongs to the Slaves of Love from the patristic origins of the topos. Samson, the strong, was early paired with Solomon, the wise, and this pairing came to be associated with the crucial virtues of strength and wisdom, *sapientia et fortitudo*, as the "two inseparable sides of the complete personality" (Smith, "Power" 209). Samson and Solomon are perhaps the essential pair of *Frauensklaven* in literature throughout the Middle Ages, bound together by the strength and wisdom dyad, as well as by the alliteration of their names (Smith, "Power" 211). But when the topos begins to appear in the visual arts, in the thirteenth century, Aristotle replaces Samson as the standard representative of wisdom. This may be due in part, as Smith suggests, to a visual equivalent to the alliteration that links Samson and Solomon. Samson's strength is almost invariably represented, as it is on the Malterer embroidery, by the scene in which he slays a lion with his hands, while Aristotle's disgrace is invariably represented by his being ridden by the woman. As Smith points out, "The juxtaposition between Samson mounted on the lion and Phyllis mounted on Aristotle has an immediate visual impact, as images that simultaneously mirror and reverse each other, the man as rider in one transformed into man as mount in the other" ("Power" 212). Equally important, however, is the fact that the adaptation of the topos into the visual arts occurs more or less simultaneously with the flourishing of vernacular narrative in both the literary and the visual arts. In the context of the literarization of vernacular narrative and the corresponding vernacularization of previously clerical materials, and considering the extent to which the visual arts are associated

with vernacular culture as the "literature of the laity," it is not surprising that a representative of lay wisdom replaces the biblical Solomon in visual versions of the Slaves of Women.[46] Moreover, in the twelfth century, the traditional pairing of *sapientia et fortitudo* was adapted into vernacular literature as *clergie et chevalrie*, clerks and knights, and Aristotle was perceived as the premier "clerk" (Smith, "Power" 214–15).[47] The Malterer artist's choice of Samson and Aristotle as the first two Slaves of Women is thus almost inevitable.

The structural opposition of strength and wisdom, or clerks and knights, makes the choice of another clerk and another knight for the second pair of slaves almost inevitable as well. Virgil, like Aristotle, was popularly known in the Middle Ages as a "clerk" (Smith, "Power" 216), and the story of his adventure with the emperor's daughter belonged, like the story of Aristotle and Phyllis, largely to vernacular culture. The choice of a genuine knight rather than a biblical strong man or hero was probably to be expected; indeed, in an early visual version of the Slaves of Women topos, the famous carved capital in Saint-Pierre at Caen, Aristotle and Virgil are joined by Lancelot and Gawain.[48] The choice of Ywain, rather than some other knight, is somewhat harder to explain, especially since he appears in no other known group of Women's Slaves. His identity as the lion-knight may have made him "the natural counterpart of Samson the lion-slayer," as Smith suggests ("Power" 218–219). But the relationship was probably not so much thematic as visual. Ywain's heraldic identity as the Knight of the Lion may well have made him, symbolically, "as strong as a lion," and the lion on his shield and crest certainly reflects the lion in the first Samson scene. But the makers and viewers of the embroidery in the fourteenth century who knew that Ywain was the lion-knight may well not have known precisely why, and if they did, then they knew that he was not a conqueror of the lion like Samson, but a friend of the lion. Ywain's identity as a knight made him a potential partner of Samson and opposite of Virgil in the strength and wisdom, knights and clerks structure of the embroidery, and the fact that he, like Samson, was associated—above all, visually—with a lion may have been the decisive factor that led to his inclusion, rather than that of some other knight.

Ywain thus becomes a part of the Slaves of Women topos. Whatever they may know about Ywain from other sources, viewers are expected to recognize that, here, he appears a Slave of Woman. The topos in itself, however, is a fundamentally ambiguous framework for interpretation or understanding. Smith has shown the importance of the rhetorical formula

"more and less" in the development of the slaves topos—the argument that what was true of great men is equally true of lesser ones (" 'To Women's Wiles,' " especially 30–31). But, as I have already suggested, this formula itself can be turned either way: a preacher or didactic poet can use the examples of great men in order to frighten and warn lesser men, as does Berthold of Regensburg, while "lesser" men can use the examples of the great to justify their own weaknesses, as does the author of "Adâm den êrsten menschen," where the list of famous love slaves serves to justify the poet's own position. In which direction has the Malterer artist turned the topos?

YWAIN BEYOND THE TEXTS

The first thing we must consider is the relationship of the image to the story of Ywain. What we have here is not a condensation of the story into two scenes, or a narration of the story through the presentation of two key nuclei—indeed, what we have here is hardly a narration at all. The Malterer embroidery's two scenes do not *tell* the story of Ywain; they make reference to it. They are not a narrative but an allusion, a representation of the well-known tale, the pictorial equivalent of allusions to narrative in lyric poetry.[49] A line like the Pseudo-Frauenlob's "dâ wart auch Aristoteles von eim wîbe geritten" is not a condensed form of the story of the philosopher's humiliation, but an easily understandable reference to a story that everyone in the poet's audience is expected to know something about. This does not mean that they must know some particular version of the complete story. Only a rudimentary knowledge of the story is necessary for understanding the allusion; one need only know that Aristotle was an exemplary wise man made ridiculous by a woman, and since the poem itself makes the humiliation obvious, the only necessary prior knowledge is that Aristotle was wise. If viewers know more about the story of Aristotle and Phyllis, they are not asked to activate this knowledge. On the embroidery, both Aristotle's wisdom (or learning, connoted by the books) and his humiliation are visually so obvious that understanding does not depend even on the viewer's ability to name the learned love slave. The only prior knowledge that is required is a general idea of the topos, or of the cultural codes underlying it—that love can be humiliating, and that the wise and powerful are proverbially susceptible to it.[50]

Likewise, no matter how much viewers may know about Ywain, all they are asked to remember here is that he was a great knight, and that he encountered difficulties because of a woman. Indeed, if viewers insist upon activating too much knowledge of the Ywain story, as so many mod-

ern interpreters have done, they will fail to understand the embroidery, for if the entire canonical story of Ywain is considered, he does not appear to belong to the Slaves of Women at all. Likewise, Gawain, who appears on the Caen capital, is no slave of love in the major texts where he appears. He is a well-known womanizer, but his amorous adventures rarely, if ever, bring him any serious trouble. Certainly Parzival, who according to Pseudo-Frauenlob encountered "great worries" because of women, encounters, in the canonical version of the story, nothing of the sort, but, on the contrary, is helped out of his troubles by the love of a good woman. The topos has great power to remake the stories to which it alludes, by, in Eco's term, "narcotizing" virtually all the information that the name Ywain (or Gawain or Parzival), as a signifier operating in the medieval semiotic universe, might otherwise evoke.[51]

I do not mean to suggest that historical viewers of the embroidery were familiar with the Slaves of Women topos but not the Ywain story. Many viewers may have known something about Ywain. Indeed, several details of both scenes—the rain and hail in the first scene, the presence of Lunete in the second—must remain unexplained surplus information to a viewer ignorant of the Ywain story. This, and the inclusion of Ywain in a topos where he does not traditionally belong, might even suggest that the story or the text was particularly well known in the immediate milieu for which the embroidery was made. All this must remain speculation; the point is that it need not matter how well viewers knew the Ywain story or how they knew it. The "implied viewer" appears to be one who is familiar with the Slaves of Women topos and recognizes Ywain as an exemplary Arthurian knight, but does not know much about the Ywain story as Hartmann tells it. However much knowledge of Ywain viewers may have had, the context here asks them to activate only the most rudimentary aspects of it.

Like the English misericords, the Malterer embroidery removes Ywain not only from the canonical texts, but also from his usual narrative context. However, while the misericords adopt the portcullis scene as pure narrative, almost entirely detached from the character, the embroidery adopts the character, nearly ignoring the story. In earlier chapters, I have spoken of diegesis and of viewers creating a story from the pictures, but the two Ywain images of the Malterer embroidery are hardly a narrative at all. To be sure, in making sense of the images, viewers do tell themselves a rudimentary story, but it is a story firmly rooted in the rhetoric of the Slaves of Women topos, simply a fleshing out of the formula "he was

strong (or wise), but he fell victim to a woman." In terms of a typology of medieval images, the embroidery's scenes are not narrative, but belong to another category, which I have proposed labelling "representative," since the images represent or allude to a story rather than narrating it. The term may appear problematic, if we assert that virtually no knowledge of the Ywain story is essential for the understanding of the images, since we can hardly speak of an allusion if viewers have no knowledge of the thing alluded to. But if we trace the process of diegesis in the opposite direction, we find that the creators of the embroidery must have known some version of the Ywain story (which is far from saying that they knew a text). If we create our typology from the makers' standpoint, the images are representative or allusive, as opposed to narrative; from the viewers' standpoint, they are rhetorical, as opposed to diegetical.

INTERPRETATION: THE TOPOS AS GAME

The Malterer embroidery presents four Slaves of Women, followed by the unicorn. In addition to resolving the inherent ambiguity of the Slaves topos, interpreters must also explain the relationship of the Slaves to the unicorn scene, which is itself notoriously multivalent.[52] Schweitzer sees a sharp contrast between the slaves of love and the unicorn scene, the virgin's control of the unicorn representing the power of chastity to control the animal nature to which the three men and Laudine have fallen victim. Nonetheless, he appears not to see the emboidery as a condemnation of love, in which case he would not reject the idea of its having been made for a convent and insist on seeing it as an appropriate decoration for the house of a married couple (especially 50–53). Maurer's interpretation is more consistent: he sees the topos here as a warning against carnal love, contrasted with the *caritas* of the unicorn scene. Mertens sees the Slaves of Love topos here as a demonstration of the power of love to rob even the greatest men of their senses, but he does not attach any particular didactic significance to it; the embroidery appears, in his interpretation, to be an artistic affirmation of love's power, not a religious or moralistic warning against it (87). For Smith, the second Ywain scene emphasizes not so much Ywain's submission to Laudine as her proposal of marriage to him. The Slaves of Love series thus ends with a love that leads to marriage ("Power" 225). Structurally, Smith argues, the engagement scene is not only a part of the Slaves of Love series, but also is paired with the unicorn scene to form a dyad of "strength and chastity" ("Power" 225). The embroidery as a whole affirms the value of marriage, but in a clerical manner that values the spirit

over the flesh. It does not reject sexuality, but endorses a married love that "transcends carnal desire" on the model of "Christ's love for the Virgin and for the Church" ("Power" 227). I have already discussed the weakness of Smith's interpretation of the second Ywain scene. Her interpretation of the whole is further weakened by her claim that viewers were to pair the engagement scene not only with the first Ywain scene but also with the unicorn. It is hard to imagine that viewers, after "reading" the embroidery in terms of a structure of four paired images plus one, would then suddenly perceive a new structure, and associate the one unpaired image with one of the paired scenes.[53]

If we, finally, consider the embroidery itself, we find that every pair, as well as the unicorn scene, shows a woman in control, a woman in a dominant position. Samson and Ywain are strong, Aristotle and Virgil are wise, yet each falls under the control of a woman. The unicorn, too, the wild and untameable animal, is subdued.[54] The unicorn, however, has clear erotic connotations that most writers on the Malterer embroidery have ignored or downplayed.[55] The animal's one horn is an obvious phallic image—the Malterer unicorn's massive horn perhaps more obviously so than the delicate spikes adorning some medieval unicorns.[56] The phallic unicorn, in the usual reading, is "tamed" by the maiden. But the laying of the phallus-like horn in the lady's lap is a rather obvious allusion to the sex act, which suggests that perhaps the unicorn does not object to being tamed.[57] This sexual imagery is, of course, not explicit or pornographic, but playfully allusive, and thus it appears that the whole embroidery might best be understood as a playful affirmation of the power of love, similar to the Pseudo-Frauenlob stanza.

The works of Smith and Ott have done much to point us away from the assumption that the meaning of a work like the Malterer embroidery must be an allegorical either-or—either an affirmation or a condemnation of love. Like the Ywain misericords, the Malterer embroidery's imagery operates in the realm of play. It represents a "playful treatment of quotations and . . . motives" (Ott, "Minne" 124–25).[58] Such unserious treatment of a serious traditional topos like the Slaves of Love marks an advanced stage in the process of literarization—a stage in which the literature of the laity no longer means just recasting vernacular materials in literary forms or transposing classical materials into vernacular forms, but approaching literary, clerical materials and forms with a thoroughly vernacular, secular sensibility.[59]

We cannot be certain, of course, how the makers of the embroidery

meant the Slaves of Women imagery to be taken. If the work was made for the convent, it may have been intended and understood as a serious warning against fleshly love. But more important for present purposes than establishing the meaning is understanding the process by which Ywain comes to be included here. The medieval process of literarization has resulted in the adaptation of a vernacular story into a topos of Latinate and Christian origin. In absorbing the story, the topos has reduced the main character to an exemplary figure and the plot to a rhetorical structure opposing the two halves of the figure's exemplariness. Ywain has become a Slave of Woman. But the literarization process has also altered the value of the rhetorical structure and of the topos itself, making Ywain's slavery not so much a subject of allegory as of play.[60]

Notes

1. Suggested dates include "um 1310/20" (Schuette and Müller-Christensen 37); "um 1310" (Schroth 61); first third of the fourteenth century (Jaques 165); first half of the fourteenth century (F. Maurer 224, Mertens 85); 1325 (Loomis and Loomis 79); ca. 1330 (Schweitzer 52); 1310–20 (Einhorn 325); early fourteenth century (Smith, "Power" 203). Eißengarthen rightly complains that earlier suggestions of a date have not involved "Herausarbeitung der Stilbezüge" (23); her own comparison of the embroidery's style to that of several windows in the Freiburg Münster (24–27) suggests that the embroidery was more likely made after about 1320 than before—thus her suggestion of "1320/30" (23 and 30).

2. Smith ("Power" 204); Eißengarthen (23).

3. Dimensions given are according to Eißengarthen (23).

4. The arms—"quergeteilt, oben zwei Pilgermuscheln, unten zwei Sparren, das obere Feld blau, das untere weiß, die Sparen rot" (Boesch 265)—appear on the seal of Johannes der Malterer on a document of June, 1330 (H. Maurer, "Martin Malterer" 199–200).

5. The embroidery became the property of the convent Adelhausen when it was united with St. Katharine's in 1694 (Gombert and Krummer-Schroth n.pag.).

6. "Hochzeitsteppich des Johannes und der Anna Malterer" (Schweitzer 52). The Augustinermuseum adopted the designation (F. Maurer 224), as did Gombert and Krummer-Schrott (n.pag.), Schrott (61), and Beer (139). In 1985, Ott still regarded this designation as "gewöhnlich" ("Minne" 108).

7. The identification of Anna as Johannes's wife would be impossible according to the heraldic customs of later centuries, by which a woman displays her father's arms, either quartered with her husband's or side by side with his, in which case the husband's are always on the (heraldic) right. H. Maurer and F. Maurer reject Schweitzer's identification for precisely this reason, and Schweitzer, himself recognizing the difficulty, attempts to solve the problem by postulating a first wife

of "nicht wappenfähigen Geschlechte" (52). However, the general heraldic situation at the date of the tapestry is not clear enough to support such arguments: thirteenth-century women sometimes used the arms of their fathers (or mothers), sometimes the arms of their husbands, sometimes both, and sometimes their own unique arms (Pastoureau, *Traité* 47–48).

8. Smith reviews the debate, but not the evidence, and ultimately adopts the marriage theory because it fits her reading of the tapestry ("Power" 207).

9. A view accepted by Gombert and Krummer-Schrott (n. pag.). Long before, Knötel had proposed much the same interpretation, suggesting that the commissioning of the tapestry might have commemorated Anna's entry into the convent (80). Most recently, Eißengarthen finds that Anna is probably Johannes's sister, but also raises the possibility that she might have been his daughter (30).

10. Fechter (108–9) adopts the sister theory from Schweitzer; his brief comments are then accepted by McConeghy in his survey of the Ywain pictures (xxxvii).

11. On the Malterer family, see Heinrich Maurer ("Freiburger Bürger" and "Martin Malterer"), Boesch, Schweitzer, and Friedrich Maurer. Research on the Malterers has been hindered by the loss of most family records in an early fifteenth-century fire; a further complication is the presence in thirteenth and fourteenth-century Freiburg of two apparently unrelated Malterer families, each of which produced a Johannes in roughly the same generation (H. Maurer, "Freiburger Bürger" 13).

12. H. Maurer ("Freiburger Bürger" 24; "Martin Malterer" 214); Schweitzer (52).

13. Martin's bride Gräfin Anna von Thierstein could possibly be the Anna of the tapestry (in which case the tapestry might have been a wedding gift from Johannes to his daughter-in-law), but this wedding could hardly have taken place before the mid-1350s, given Martin's birthdate of ca. 1336, and the tapestry is generally considered to be two or three decades older. Moreover, though it was possible for a woman to display the arms of her husband (Pastoureau, *Traité* 47), the rich burgher celebrating his son's marriage to a noblewoman would surely have displayed *her* family's arms in this place.

14. The confusion surrounding this identification is exemplified by H. Maurer, who identifies the tapestry's Anna as Johannes's aunt, and then bewilderingly suggests that the tapestry was a wedding gift from Anna to her *brother* Johannes ("Freiburger Bürger" 25–26). The *Seelbuch* of the St. Katharine convent mentions Anna three times (Schweitzer 52–53). The first reference records the death day (April 10) of "anna maltrerin suror nostra." The second records that Johannes had taken over yearly payments for the soul masses for Friedrich, Katherine, Gertrut, and Anna Malterer—presumably his father, mother, and two aunts. The third notes the payment of one pound for "anna die maltrerin" on October 14. Schweitzer finds this to refer "without doubt" to a married woman, but he does not explain his certainty. The form "maltrerin"—a female "maltrer"—is identical to the form used in the first reference ("maltrerinen" in the second), except for the insertion of the definite article.

15. This conclusion may be supported by the fact that the embroidery technique used is the "cloister stitch," so-called for its popularity among German and

Swiss nuns of the fourteenth and fifteenth centuries. The stitch was also used by lay embroiderers, however (Smith, "Power" 204).

16. See Schuette and Müller-Christensen (38, plates 193–95); also Ott ("Katalog der Tristan-Bildzeugnisse" 148–50).

17. My discussion of the Malterer family's wealth and status is compiled from the following, except where a more specific source is noted: H. Maurer, "Martin Malterer" (202–4); Schweitzer (51–52); Boesch (265). On the family's phenomenal wealth, see also Stülpnagel (299–300).

18. He was "Mitglied des Rates der nachgehenden Vierundzwanzig"—a type of junior elder—in 1324, and became a member of the "Altvierundzwanzig"—a full-fledged elder—in 1327 (H. Maurer, "Freiburger Bürger" 17).

19. The marital link to the Hachbergs is cited by Fleckenstein as evidence of the Freiburg urban patriciate's rise to social parity with the nobility (89).

20. This is more or less the interpretation adopted by Gombert and Krummer-Schroth, who identify the motive of the pairs as "Weiberlisten," the girl with the unicorn as a symbol of divine love, and the tapestry's theme as "die Tragik weltlicher Minne" (n.pag.). On the unicorn as a symbol of divine love, see Beer (47–49, 95–100); Wehrhahn-Strauch (esp. col. 1520); Einhorn. Eißengarthen finds that the maiden's raised arms allude to iconography of the Annunciation, and thus strengthen the spiritual reading of the unicorn scene (24). In addition, Eißengarthen argues, the white roses and lilies in the borders of the embroidery further support a spiritual interpretation (24).

21. See not only the "Minne" article cited elsewhere in this chapter, but also Ott and Walliczek (esp. 480–81, 499–500).

22. Ott ("Minne" 118; "Katalog der Tristan-Bildzeugnisse" nos. 38–44).

23. On pictorial manifestations, see Bulst.

24. The earliest extant version is an eighth-century Persian tale, ʿAmr ben al Gahiz (Stammler, "Philosoph" 14). The earliest extant Western version seems to be an *exemplum* of Jacob of Vitry (Greven 15–16), probably written between 1229 and 1240 (Greven vii); an anonymous Alemannic verse novelle of ca. 1300 (*Gesammtabenteuer* 1: 21–35) is the first source to give the name Phyllis to the seductress; another important early version is the Old French *Lai d'Aristote*. An immense variety of pictorial forms also existed, beginning in the thirteenth century. On the literary and pictorial traditions, see Künstle (1: 177–78), Sauer (343 and 446), and especially Stammler ("Philosoph," "Aristoteles").

25. The earliest extant versions of "Virgil in the basket" are the thirteenth-century *Nero's Daughter* (BN lat. 6186, fol.149v, published by Spargo 372–73) and Jan Enikel's *Weltchronik* (vv. 23695–24138, in *Gesammtabenteuer* 2: 513–24). On these and other literary versions, see Spargo (156–63); Tunison (138–39); Comparetti (326–39). A good discussion of the pictorial tradition is by Jacobowitz and Stepanek (117–20); see also van Marle (*Iconographie* 495–96); Künstle (178); Koch.

26. Mertens offers strong evidence that the medieval audience would not have seen anything unusual in Laudine's rapid remarriage. See especially his section on "Witwenehe" (39–40).

27. Cf. Mertens (86–87).

28. Maurer evidently recognizes the weakness of this interpretation, for he

adds a postscript to his article, offering a second suggestion: the scene could be the courtship scene (as Schweitzer had thought), if it is seen as signifying "all das, was zu [der] Entehrung führt" (248). This seems even more unlikely than Maurer's first suggestion, since it would require each viewer to complete the story mentally and draw the correct conclusion about the relationship of this scene to the whole story.

29. Cf. Mertens (86); Smith ("'To Women's Wiles'" 231).

30. Eißengarthen identifies the second Ywain scene as the "Episode mit dem Zauberring," by which she apparently means the entire courtship of Laudine, which, she says, the ring makes possible (23–24). This reading, she argues, is proven by the "ikonographische Vorformulierung" in Rodenegg (23–24, 91); however, the scene here does not particularly resemble anything at Rodenegg.

31. Schupp correctly points out that viewers of the tapestry would not have been so concerned as modern readers to "harmonize" the tapestry with the romance, but his concept of "eine bildgestützte Mündlichkeit" may overestimate the prior knowledge of the Ywain story that is neccessary for the understanding of the Malterer embroidery ("'Scriptorialisches'" 155).

32. The caption in Loomis and Loomis, "Iwain presented to Laudine" (pl. 167; cf. Schweitzer 49) is accurate enough, but it fails to convey the negative tone of the image.

33. On the clasped hands, see Bäuml and Bäuml (134).

34. Schupp considers this possibility, but in the end he sees the ring primarily as a wedding band, symbolic of Ywain's enslavement ("'Scriptoralisches'" 150, 155).

35. On the topos in general, see Schnell (475–505); Smith ("'To Women's Wiles'"); F. Maurer; more compactly, Reinitzer (600–603); Roethe (596–97). Schweitzer was the first to identify the Malterer embroidery with the topos (46).

36. The distinction has been proposed by Schnell (475–505).

37. For a similar statement, see Jacobowitz and Stepanek (102).

38. Schupp makes a little too much of the distinction (152, 155).

39. Letter 22, to Eustochium (xii) (*PL* 22: col. 401). Augustine, in his commentary on Genesis, equates Solomon's worship of idols for the sake of women with Adam's eating the forbidden fruit for the sake of Eve (*De genesi ad litteram* xi.42.59). The relevant passages from Jerome and Augustine, together with other examples of patristic misogyny, are translated in Blamires (75, 81). On Augustine's Genesis exegesis as a possible source of the topos, see Schnell (476); Grimm (13).

40. For a number of examples from medieval Latin, see Walther, proverbs 519–21, 5026, 5026a, 1443, 8330b, 9196, 9216–19, 9250, and 12343. In general, and for many more examples, see Reinitzer (601–02); Roethe (596–97). Smith's dissertation includes an excellent discussion of the history of the topos ("'To Women's Wiles,'" esp. ch. 2).

41. See Reinitzer (599–605). An earlier list of love's victims—placed by Maurer in a different category because it does not stress the disgrace of the male lovers—appears in *Parzival* (586,12ff; see F. Maurer 235–36).

42. The stanza's attribution to Frauenlob is rejected by Thomas (*Untersuchungen* 81–85), and it does not appear in the new Stackmann and Bertau Frauenlob edition. It was first mentioned in connection with the *Maltererteppich* by F. Maurer (239).

43. See F. Maurer (239); most recently Ott ("Minne" 112), who gives further bibliography. Some of the paintings are reproduced in Schmidt-Pech (plates between 32 and 33); Mone gives detailed descriptions (286–87).

44. The Pseudo-Frauenlob passage itself appears as a textual gloss on a page of pen-and-ink *Minnesklaven* in a south German picture encyclopedia now in the Library of Congress (Rosenwald Collection ms. no. 3, fol. 8r; see Ott, "Minne" 112 and fig. 3). Mertens notes other pictorial manifestations of the topos, finding its "purest" representation on a painted pane of glass in the Stuttgart Landesmuseum, where Aristotle, Virgil, and Samson appear, together with a fool who notes "Die dint all mir gelich und sind doch vernunftig staryck und rich" (Mertens 88, with reference to Stammler, "Philosoph" 22).

45. "Power of Women" (esp. 208–16); also " 'To Women's Wiles' " (149–61).

46. Aristotle might appear to represent classical, intellectual culture, but the tale of Aristotle and Phyllis belongs at least as much to the vernacular realm. See note 23 above.

47. See also " 'To Women's Wiles' " (187). In the *Lai d'Aristote*, an early manifestation of the Aristotle and Phyllis story, he is called "le meillor clerc du monde" (quoted in Smith, "Power" 215).

48. See Smith ("Power" 216); on the Caen capital also Loomis and Loomis (71–72, figs. 138–39); Ott ("Minne" 120–21, fig. 5).

49. Bonnet has noted the representative character of the Malterer tapestry's scenes, saying that the "Brunnenszene" stands for the "ganzen Roman" (*Rodenegg und Schmalkalden* 157). The problem with this formulation is not so much that it is overly text-oriented (she says "romance" instead of "story"), but that it assumes that the reference is to the entire story as told in the texts. The images here allude to the story in a general way; they do not metonymically represent or condense the entire canonical version.

50. This is Barthes's "referential code," the code of "endoxal" knowledge, of the "informal knowledge" that members of a culture are expected to possess (see Gross 169).

51. See Eco (*Role of the Reader*, esp. 27).

52. On the ambiguity of the maiden with the unicorn, see Einhorn, who notes that the image can represent either worldly love or chastity, or can have allegorical or typological significance. The significance of a given image must be determined by its context, Einhorn says; it can rarely be determined from the image alone (173).

53. Earlier, in her dissertation, Smith stressed the ambiguity of the topos, arguing that the Malterer embroidery and similar works, and especially the unicorn image, are "eloquently bivalent" (255) and that any interpretation seeking to read them as either secular or spiritual will be inadequate.

54. Schupp also stresses this aspect of the unicorn scene (" 'Scriptorialisches' " 150).

55. Smith does the fullest justice to the eroticism of the unicorn, citing an overtly erotic carving on an Alsatian *Minnekästchen* (Einhorn D-290, p. 352 and fig. 104), where the lady places the animal's horn between her thighs ("Power" 222–24). For general agreement, see Ott ("Minne" 124).

56. See the 174 unicorn images reproduced in Einhorn.

57. This is perhaps made somewhat more obvious than usual on the Malterer embroidery by the way the maiden grasps the horn in her hand.

58. I quote here from Ott's most concise formulation of this position ("Minne" 124): "So programmatisch streng, ernsthaft vor dem *amor carnalis* warnend jedenfalls scheint der Appellcharakter der Minnesklaven-Darstellungen weder im profan-höfischen noch im kirchlich-klösterlichen Gebrauchskreis gewesen zu sein. Vielmehr war Travestie angezeigt, ist es das Sowohl-als-Auch, der spielerische Umgang mit Zitaten und signalhaft verwendeten, mehrdeutigen Motiven, auf die das Publikum sich bezieht."

59. In her dissertation, Smith argues that the choice between secular and spiritual connotations is difficult to make for the Malterer embroidery and many other medieval images, because the images themselves are deliberately ambiguous, or "bivalent" (" 'To Women's Wiles' " 252). This bivalence was a response to a situation in which the Church's earlier hegemony over Western culture and thought was steadily eroding, although the Church nonetheless retained immense power. A carefully cultivated bivalence could allow artists to appear faithful to the official doctrine of *contemptus mundi*, creating works that officially deplored the "pleasures and rewards of the world," while making these pleasures and rewards appear very nice (253). Thus the *contemptus mundi* theme could function as "one strategy by which new, secular impulses could be expressed within a still essentially Christian, other-world oriented value structure" (254). The problem with this formulation is that it makes the process seem more deliberate and less playful than it probably was.

60. In stressing the unseriousness of the Malterer embroidery's implicit attitude toward the Slaves of Women topos, I alter the stance taken in my article on the embroidery, where I suggest that the work is most likely a straightforward, serious manifestation of the topos (Rushing, "Iwein as Slave," esp. 134). I have been influenced in this respect by a rereading of Ott ("Minne") and especially Smith (" 'To Women's Wiles' " and "Power"), although I do not ultimately adopt her interpretation.

7. Ywain in the Adventurer's Hall of Fame: The Runkelstein "Triads"

Ywain becomes part of another well-established topos at castle Runkelstein, near Bozen, where the wall of a second-floor balcony overlooking the courtyard is painted with the "triads," a unique expansion of the Nine Worthies topos. Here the isolation of the character from his usual narrative context is even more total than on the Malterer embroidery. Ywain appears as an exemplary figure in a long series of other heros, and any connection to a narrative version of his story, let alone a textual one, is tenuous indeed.

Historical Background

The Runkelstein Hall of Fame begins with the traditional "Worthies": the three greatest heros of antiquity—Hector, Alexander the Great, and Julius Caesar; the three greatest Old Testament heros—Joshua, David, and Judas Macabee; and the three greatest Christian kings—Arthur, Charlemagne, and Godfrey of Bouillion. The triads continue with the three greatest knights of the Round Table—Parzival, Gawain, and Ywain; the three most famous pairs of lovers—Aglie and Wilhelm von Österreich, Isolde and Tristan, and Amelie and Willehalm von Orlens; the three bravest heros—Dietrich von Bern, Siegfried, and Dietleib;[1] the three strongest giants—Waltram, Ortnit (?), and Schrutan; the three most terrible female giants—Riel (Ruel), Ritsch (?), and Ruchin (?); and the three most famous dwarfs, whose identities are uncertain.[2]

Parzival, Gawain, and Ywain stand before a background that could be either a battlement or a tent—in either case, a setting reminiscent of the court or the tournament (fig. 7-1). They are fully armed, and carry lances with banners. Both the banners and the shields display the knights' arms: Parzival's an anchor, Gawain's a white stag, and Ywain's a gold eagle on a blue background. These are not the arms usually associated with any of

these knights (see below), but the figures were identified by inscriptions and verses, one of which labeled the three as "die frumsten zu der tafl rund" (A. Becker xxv).[3]

HISTORY OF RUNKELSTEIN

The castle Runkelstein was built in the 1230s by the brothers Friedrich and Berchthild von Wanga and underwent several changes of ownership during the next 150 years.[4] Already in very poor condition, it was acquired in 1385[5] by the brothers Nicolaus and Franz Vintler, who rebuilt and expanded the castle, and commissioned elaborate wall paintings, including pictorial versions of the stories of Tristan, Wigalois, and Garel, and various depictions of courtly life, as well as the triads.[6] Although ownership of the castle was shared by the brothers, it is Nicolaus who appears to take credit for the renovation in two inscriptions—one on the cornerstone of the castle (see note 4), and one at the east end of the triads, which reads "RELTNIV SVALCIN 14 . . ."—the reversed name Niclaus Vintler and the beginning of a fifteenth-century date (Lutterotti 24–25).

Like the Malterers in Freiburg, the Vintlers were a family of newly acquired riches and social status, having begun a rapid increase in wealth and prestige when Nicolaus's father, Konrad, married the daughter of a Bozen businessman in 1355.[7] The family became immensely wealthy, and Nicolaus became an important financier, a major public figure, and a close associate of two dukes. From 1393, he added "ab dem Runkelstein" to his name, thereby emphasizing his family's rise into the class of knightly aristocrats (Rasmo, "Runkelstein" 115). As a further sign of the family's arrival in the noble ranks, the Vintlers made their court a center of literary and artistic activity. A manuscript of Heinrich von München's *Weltchronik* was written for Nicolaus by Heinz Sentlinger of Munich, who also wrote a shorter version of the chronicle for Nicolaus's nephew Leopold.[8] Though Sentlinger's literary importance has sometimes been exaggerated,[9] the commissioning of such a mammoth manuscript as the *Weltchronik* (306 folios, about 100,000 lines of verse) nonetheless suggests the extent of the Vintlers' interest in literary production. In the next generation, Vintler literary activity was not limited to patronage: Nicolaus's nephew Hans Vintler (d. 1419) completed the didactic poem *Die pluemen der tugent* (*The Flowers of Virtue*) in 1411.[10] The wall paintings, though not directly related to any of these works, are a product of the same interest in literary and artistic acitivity.

DATE AND ARTIST

The final acquisition of the castle by the Vintlers in 1388 provides a clear terminus post quem for the paintings, and the fragmentary date "14. . ." at the east end of the triads suggests that at least that section of the paintings was not completed until the fifteenth century.[11] Since the same inscription identifies the patron as Nicolaus Vintler, work on the paintings must have at least begun before his death in 1413; further evidence for a terminus ante quem is provided by Rasmo's observation that if the work had not been substantially finished by 1407, when the Vintler's castles were besieged by Duke Friedrich IV, it very likely never would have been ("Runkelstein" 118–120). A date in the first five years of the 1400s thus appears most likely.[12]

As is the case at Rodenegg, historical study of the paintings at Runkelstein has suffered from scholarly over-eagerness to assign known names to known works. In this case, the name of Hans Stocinger of Bozen, who signed the painting of the annunciation in the parish church at Terlan in 1407,[13] has attracted a number of attributions. Van Marle (*Italian Schools* 247–49) makes him responsible for not only the annunciation but all the paintings of the life of Mary and the youth of Christ at Terlan, while Atz suggests a number of further attributions, all of which have proved untenable (Ringler 69). Rasmo adds the frescos in the cemetery chapel at Terlan and in St. Martin Kampill near Bozen to Stocinger's oeuvre ("Überraschende Funde" 100). It is Lutterotti who makes Stocinger responsible for the triads, the Garel paintings, and the chapel at Runkelstein (25).[14] More careful scholars ascribe very little to the painter with any certainty. Weingartner allots him only the easternmost vault in the nave at Terlan, probably the paintings at Kampill, and possibly the chapel at Runkelstein ("Wandmalerei Deutschtirols" 14–21).[15] There is clearly no reason to accept Lutterotti's attribution of the triads to Stocinger. The various paintings at Runkelstein are the works of several more or less contemporary hands (Weingartner, "Die profane Wandmalerei" 23–24); the painters were in all likelihood local artists.[16]

LATE MEDIEVAL AND MODERN RESTORATIONS

The Runkelstein paintings evidently deteriorated badly during their first century of existence. Soon after taking possession of Runkelstein in about 1500, Emperor Maximilian I became interested in the paintings, and aware of their need for restoration.[17] In 1502, he recorded in his diary his intent of restoring the castle and the paintings "because of the good old stories."[18] The emperor, however, appears to have had difficulty in convincing the

local authorities to cooperate and in finding a suitable and willing artist. In 1503, he wrote to his "Amtmann" in Bozen, saying that he had sent the court painter Jörg Köldrer to paint Runkelstein (Schönherr, "Urkunden" xix, item 721), but apparently nothing was done, for in the following year, Maximilian sent Friedrich Pacher to report on the condition of the paintings.[19] Again, the paintings were apparently not restored. In 1508, Maximilian ordered the work done by Marx Reichlich (Zimerman and Kreyczi xxxii, item 2615), and the restoration was evidently carried out at last.[20]

Like so many monuments of the German Middle Ages, the paintings at Runkelstein appear to have been largely forgotten after the time of Maximillian. They did not attract significant attention again until the mid-nineteenth century, when the badly decayed castle attracted a series of celebrated visitors, including Ludwig I of Bavaria, Joseph Viktor von Scheffel, and Anselm Feuerbach, and the paintings became the subject of passionate romantic medievalist interest (Lutterotti 5). Copies of the frescos were published by Ignaz Seelos and Ignaz V. Zingerle in 1857.[21] In 1868, part of the north wall collapsed, destroying some of the Garel and Tristan paintings. In the 1870s, an imperial commission determined that Runkelstein could not be restored at a reasonable cost and decided instead to have the paintings copied, so that at least knowledge of their contents would survive. Copies exhibited in Vienna and Innsbruck in 1877 attracted a large number of viewers, among them Kaiser Franz Joseph.[22] It was the emperor who eventually ordered the restoration of Runkelstein, after the castle had been purchased and given to him by Archduke Johann Salvator in 1880. Restored in 1884–1888, Runkelstein was given to the city of Bozen in 1893 (Lutterotti 6).

Iconography

Like the Malterer Ywain, the Runkelstein painting removes Ywain from his usual narrative context, setting the character into the new context of a traditional topos. However, while the Slaves of Love topos attaches a minimal plot to the character, the Runkelstein triads remove the knight entirely from the context of any narrative, situating Ywain in a new structure—the topos of the Nine Worthies. This traditional catalog of nine heros originates in Jacques de Longuyon's Alexander romance, *Les Voeux du Paon*, written in about 1312–1313.[23] Longuyon devotes several lines to each of the "nine best men, who have been since the beginning, / when God made the

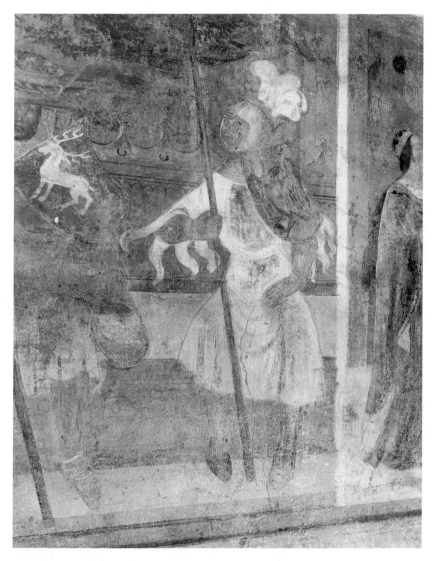

Fig. 7-1. Ywain among the worthies. Photo Landesdenkmalamt Südtirol.

heavens and the earth and the wind":[24] Hector, Alexander, Julius Caesar, Joshua, David, Judas Macabee, Arthur, Charlemagne, and Godfrey of Buillion (vv. 7477–7579, Ritchie 4: 402–6). From this passage in Longuyon's immensely popular text arose a massive and diverse tradition, which remained important in the verbal and visual arts for five centuries.[25] The Nine Worthies were adapted and expanded in various ways, most notably through the addition of various local "tenth worthies" and the creation of a parallel list of nine (or ten) Worthy Women.[26] But the Runkelstein triads extend the Nine Worthies in an apparently unique manner, drawing additional figures from courtly and heroic literature, so that practically every possible type of exemplary figure is included.

The Nine Worthies topos is a structure that presents a representative sampling of heros from the major divisions of history: the Old Testament, classical antiquity, and the Christian era.[27] At Runkelstein the structure is greatly expanded, so that it provides a framework for presenting a cross-section of the narrative material actively circulating in the Bozen area around 1400. The metaphor "cross-section" is deliberately chosen. If we imagine the various narrative traditions as long lines in space, the topos functions as a plane intersecting with those lines. But this imaginary plane is selective in a way no geometric plane could be, so that only some of the many possible narrative traditions intersect with it.

The principles guiding this selectivity are not easily elucidated. The well-known popularity of heroic epic in Tirol[28] may explain the disproportionate emphasis on heroic literature, and the importance of courtly literature to courtly society is so great that the inclusion of Arthurian knights in any expansion of the topos is almost inevitable. And since the original Nine Worthies topos establishes the triad as a structural principle, three knights of the Round Table must be chosen.[29] But can we explain the choice of Gawain, Parzival, and Ywain, rather than, say, Lancelot, Erec, and Calogrenant? A possible source is an episode in der Stricker's *Daniel von dem blühenden Tal* (263–313), where Daniel jousts successfully (i.e., he stays in the saddle) against Gawain, Parzival, and Ywain, who then judge Daniel to be "ein guot ritter" (317), worthy of acceptance into Arthurian society.[30] The three thus appear in *Daniel* in their triads role as the three most exemplary knights of Arthur's court. It is impossible to know whether the Runkelstein painter was familiar with the text or story of *Daniel*, but he clearly chose the three knights by the same principle that der Stricker followed. Needing three exemplary representatives of the Arthurian realm, both artists choose Gawain, Parzival, and Ywain. In *Daniel*, the three are adopted into a new narrative context, which detaches them entirely from

their original stories. At Runkelstein, they are adopted into the expanded Nine Worthies topos, and thus removed from any narrative context.

Thematic Analysis

The detachment of character from story means that however much viewers may know about Ywain from other sources, the Runkelstein painting asks them to activate virtually none of that knowledge. Almost all the information that might potentially be associated with the signifier "Ywain" is here narcotized. Viewers are expected only to recall that Ywain is an exemplary knight—and that much is clear from the context, even to viewers totally ignorant of the lion-knight. This reduction of the character to an exemplary figure detached from his usual narrative context is at Runkelstein so complete that Ywain appears without his usual identifying attribute, his lion. The gold eagle on his shield and banner do not in any way identify Ywain. Only the written name marks the image as Ywain. Parzival and Gawain also bear arms that are nowhere else assigned them—Parzival an anchor and Gawain a white stag. At the time the frescos were painted, to be sure, the use of arms for Arthurian characters was not yet fully standardized.[31] But Ywain is, from the beginning, the "knight with the lion," and he is consistently portrayed with a rampant lion on his shield. His appearance without his lion is clearly more meaningful than Gawain's appearance without his *argent a canton gules*. The makers of the frescos evidently considered heraldic images an essential part of the appearance of Arthurian knights, but had little interest in the specific attributes of individual characters.[32] The heraldic images function only as general references to the code of heraldry in its entirety, and as an index of courtliness, not as specific references to particular knights or particular characteristics. Without Ywain's usual attributes or obvious reference to his actions, the Runkelstein figure primarily serves to represent Ywain's qualities, which are not unique to Ywain, but are the qualities of a typical, exemplary knight.

This exemplary function is inherent in the structure of the triads. As Haug points out, the figures of each triad embody the highest potential of the type represented: the pairs of lovers stand for model behavior in courtly love, the heros embody the virtue of bravery, the three knights represent the chivalric ideal, and so on ("Bildprogramm" 33–35). The fragmentarily preserved verses over the three Arthurian knights further identify these as the most worthy knights of the Round Table. Detached from their original narrative contexts, the figures have become examples of literary ideals.[33]

This exemplarity has a social component as well. Like the lords of Rodank and the Malterers, the Vintlers sought to signify their own relatively new social and economic status by decorating their walls with knightly images. Considering that the triads include various ideal giants and dwarves, one can hardly argue that the Vintlers wanted to identify themselves with those characters. What the triads represent is a level of literary sophistication that the brothers wished to claim for themselves. The paintings advertise not that the Vintlers belong to the same class as Arthur, Ywain, and the three greatest giantesses, but that they belong to the class of people who commision this sort of art.

In the Runkelstein triad, the figure of Ywain has become entirely detached from the narrative traditions in which the character was born and has no proairetic value whatsoever—its function is entirely limited to the referential and symbolic codes. The signifier "Ywain" has been reduced to an exemplary name that fits into the paradigm of the expanded Nine Worthies topos no more or less well than any of several other names. Indeed, Ywain here verges on becoming "a featureless member of the featureless cast of Arthurian supporting characters" that I referred to in the introduction; his appearance here is not much different from those dozens of appearances in the Vulgate cycle and other romances that I have declined to include in the canon of Ywain pictures. The Runkelstein Ywain belongs in the canon, however, because he is here not a faceless member of the supporting cast, but clearly a star—one of the chosen three representatives of Arthurian knighthood. Since it is as the hero of his own romance that Ywain earns his star status, it is undoubtedly appropriate to include the Runkelstein Ywain in the group of images derived from the Ywain story.[34] Moreover, even though the character has here become more fully detached from the narrative tradition than in any of the other Ywain pictures, that process is not much different from the process by which, on the Malterer tapestry, Ywain becomes a part of the Slaves of Women topos. Like the embroidery's Ywain scenes, the Runkelstein Ywain represents the adoption of a figure from a narrative tradition into a well-defined topos. Ywain here is one exemplary knight among others: he has become a Worthy. And now that Ywain has become a Worthy, we are no longer facing images of adventure in the sense that we have up to now. What we have here is no longer an image of adventure, but the adventurer as an image—as an iconic image of courtliness.

Notes

1. Heinzle's designation, "die drei kühnsten Recken" ("Triaden" 74), re-places the "three best swords," a label proposed by I. Zingerle ("Die Fresken" 468) and adopted almost universally in later scholarship (e.g. Lutterotti, 23–24; Malfér 15–20), although Loomis refers to the triad simply as "three heros" (49). Heinzle (74) finds it unlikely that swords determined one and only one triad, points out that the names of the giants' swords are also given in the inscriptions, and deciphers a titulus: "die kūstñ gar."

2. I. Zingerle first interpreted the figures not as dwarfs but as Arthur, Gawain, and Ywain ("Die Fresken" 468; Seelos and Zingerle [4]); however, his 1878 article tentatively identifies them as the dwarfs Goldemar, Bibung, and Alberich ("Zu den Bildern" 29). Heinzle suggests that one of the figures—probably the first but possibly the second—might represent Laurin (85–87).

3. On the inscriptions, see Lutterotti (23); Malfér (2); Heinzle ("Triaden" 94).

4. On the castle's history, see Lutterotti (6), Atz (253), A. Becker (xxiv), Loomis and Loomis (48).

5. Some confusion about the date has arisen from the fact that the property was transferred in 1385, as a diocesal document records, but the brothers did not take physical possession of the castle until 1388, as the cornerstone inscription indicates. Those who place the purchase in 1385 include Malfér (1), Lutterotti (8), Loomis and Loomis (48), Weingartner (*Kunstdenkmäler* 1:54); A. Becker (xxiv) says 1387. The best history of the transaction is Rasmo ("Runkelstein" 114–15), who reproduces the document of 1385 and the later inscription. The inscription is now only partly legible (see Gerola 517–518); it was recorded in the seventeenth century in a Vintler family chronicle, and published by A. Becker (xxv).

6. The best description and analysis of all the paintings is Haug et. al.

7. My account of the Vintler family basically follows Rasmo ("Runkelstein" 115); see also Lutterotti (8–9); Weingartner (*Tiroler Burgenkunde* 22); Loomis and Loomis (48); Oswald von Zingerle.

8. Sentlinger's *Weltchronik* is Munich, Bayerisches Staatsbibliothek, cgm 7330 (see Gichtel, *Weltchronik* 1–2). The shorter version is Wolfenbüttel, Herzog August-Bibliothek, cod. 1.16.Aug.fol. (Ott, "Heinrich von München" 828; Oswald von Zingerle 7).

9. Beda Weber's 1849 description of Sentlinger as court chaplain and poet of the Vintlers (Buchner 156) is of doubtful accuracy, and Sentlinger's identity with the author Heinrich von München has been rejected (Gichtel, *Weltchronik* 14–15; Ott, "Heinrich von München" 828). Lutterotti (9) errs in naming Sentlinger as the author of the chronicle, and in referring to the work as the "Christherren-chronik, eine Chronik deutscher Kaiser." The *Christherre-Chronik* is a fragmentary rhymed version of the Bible, and the primary source for the first part of Heinrich von München's chronicle (Ott, "Christherre-Chronik" 1213–1215, "Heinrich von München" 829–832).

10. Lutterotti (9) refers to Hans as the "Vetter der Besitzer"; Loomis calls

him a "cousin" (48). Oswald von Zingerle provides the clearest presentation of the family relationships (5–7). On the *pluemen der tugent*, a work based primarily on Tommaso dei Gozzadini's *Fiori di virtù* (early fourteenth century), see Dörrer (4:699–700, 5:1112). The *pluemen* does not mention Arthur, Parzival, Gawain, or Ywain, according to the "Namenregister" in Zingerle's edition.

11. The inscription was apparently first noticed by Lutterotti; he also pointed out its significance for dating the works (24–5).

12. Rasmo ("Runkelstein" 167) suggests that the arms over the door in the balcony—Vintler quartered with Obertor—indicates a date after 1393. Loomis says only "ca.1400" (plates 61–76); Weingartner ("profane Wandmalerei" 23) suggests the second half of the period 1385–1414.

13. For his "signature" ("hanch picturam fecit hans stocinger, pichtor de bosano") see Ringler (69); and cf. the longer version quoted by Atz (730) and Rasmo (*Affreschi* 266).

14. Malfér (2) and Wyss (85) adopt Lutterotti's opinion.

15. Cf. Weingartner ("profane Wandmalerei" 23–4; *Kunstdenkmäler* 2:42, 333); Rasmo ("Runkelstein" 150) rejects Lutterotti in favor of Weingartner's cautious approach, as does Morassi (410–4).

16. Atz distinguished the hands of four "Meister," including that of one who did only the Triads, and that of the restorer "Friedrich Lebenspacher" (672). Rasmo ("Runkelstein" 150) claims that the closer study allowed by restoration of the paintings in the 1960's has shown more clearly than ever "die Herkunft der Maler aus einer lokalen Werkstatt."

17. Rasmo ("Runkelstein" 124–5) gives the clearest account of this restoration, and my account basically follows his. I have consulted the published documents where possible.

18. "Item daz sloss Runckstain mit dem mal lassen zu vernewen von wegen der guten alten istori und dieselb istori in schrift zu wegen bringen" (Zimerman xlii, item 230; also quoted in Schönherr, "Runkelstein" 688; A. Becker xxiv; Loomis and Loomis 48).

19. Two documents exist: a letter to the official at Bozen, saying that since no suitable painter can be found in Bozen, Pacher is being sent; and a letter to Pacher, ordering him to go to Runkelstein and study the paintings (Schönherr, "Urkunden" xxi, items 736 and 737).

20. In 1509, Maximilian refers to the paintings, "das wir verneuen haben lassen" (Rasmo, "Runkelstein" 124). Schönherr's report that 100 guilders were allotted "zum gemäl auf Runkelstain" in 1511 suggests that the restoration was then not yet complete ("Runkelstein" 669). Heinzle, "Triaden" (63n) finds the identity of the restorer uncertain. The several false starts have often led to the impression that more than one of the painters mentioned worked on the restoration. Egg and Pfaundler (158) and Loomis (48) report that Kölderer, Reichlich and Pacher all worked on the restoration; A. Becker (xxiv) reports that Pacher did the work.

21. Seelos and Zingerle. The triad with Ywain is plate 2.

22. See the "Berichte" of the *Central-Commission* for the years 1874–1877, the "Notizen" for 1876, and the reports by Schmidt and A. Becker; also Schönherr ("Runkelstein") for a thoroughly romantic report on the castle (especially 656).

23. Longuyon's romance exists in more than thirty extant manuscripts; it was furnished with two continuations and translated into Spanish, Middle Dutch, Middle English, Scottish, and Latin (Schroeder, *Der Topos* 42).

24. The ".ix.meillours, qui furent puis le commencement/ Que Diex ot fait le ciel et la terre et la vent" (7574–7575, Ritchie 4: 406).

25. On the Nine Worthies topos, see Schroeder (*Der Topos*); also Wyss. Schroeder's catalog of 91 pieces of verbal and visual art is necessarily incomplete; he adds 25 English manifestations of the topos in "The Nine Worthies: A Supplement." Another addition to the catalog is Peter Suchenwirt's "Der Fürsten Warnung" (see Kurras).

26. On the tenth Worthy, Schroeder (*Der Topos* 203–215); on the nine Worthy Women, Schroeder (*Der Topos* 168–202, 216–223).

27. On the three ages of the world as a source for Longuyon's organization of the Nine Worthies, see Schroeder (*Der Topos* 52–54).

28. See Hoffmann for a discussion of Tirol's importance in the development and reception of heroic epic.

29. The Suchenwirt poem "Der Fürsten Warnung" (see above, note 25), has been proposed as the "source" of the Runkelstein triads—a suggestion correctly rejected by Heinzle, "Triaden" (66). Appearing in a manuscript that was probably written in Südtirol between 1411 and 1413, the poem does provide a chronologically and geographically proximate precedent for the triadic extension of the topos (Heinzle, "Triaden" 67). The *ubi sunt* song from the Kolmarer Liederhandschrift published by Hübner (and mentioned by Heinzle, "Triaden" 67–8) also must be rejected as a source: the song lists the Nine Worthies along with various other famous names—including Dietrich, Witege, and Heine (?)—but the triadic structure is practically nonexistent in the stanza where the German heros are named (Hübner 378–80).

30. This seems to be the only appearance of specifically this trio in medieval German literature.

31. Arthurian heraldry was not truly standardized until the fifteenth-century proliferation of Arthurian rolls of arms. See Brault (37–50), Pastoureau (*Armorial*; "Études" 3–8).

32. Consideration of the heraldry of the other triads tends to confirm this assertion. Despite the existence of a well-developed heraldic tradition for the Nine Worthies, those Runkelstein Worthies who bear recognizable arms show considerable variation from the norm. David displays a geometric pattern of three triangles instead of his usual harp, and Godfrey of Bouillon's lion above a lattice is unique to Runkelstein. On the other hand, on the recognizable half of his shield, Charlemagne gets his usual field strewn with lillies, and Judas Macabee gets the lion that is his usual sign in Germany. (On the heraldry of the Nine Worthies, see Schroeder *Der Topos* 225–50 and 261–92.) Other recognizable arms at Runkelstein include the following: Wilhelm von Österreich, five eagles; Tristan, a boar, which is typically assigned to him in German sources; Dietrich, a lion on a red field, as described in the Norse sagas (Malfér 19); Siegfried, a crown, as in *Nibelungenlied* 215, 2 (Malfér 19); Dietleib, a unicorn (Zingerle's suggestion, the animal is unclear [Heinzle, "Triaden" 73]), as in *Rosengarten* F (*Die Gedichte vom Rosengarten* iv, 7) On the arms

of the three heros, see Heinzle (71–74). The arms of the giants are unique and/or puzzling (Heinzle 76–78).

33. Cf. Haug: the three knights of the Round Table "vertreten . . . die ideale ritterlich-höfische Verhaltensnorm" ("das Bildprogramm" 33). Also Mertens, who describes the Runkelstein Ywain as an "exemplarischer Artusritter ohne spezifische Bedeutung" (89).

34. Also because others have already placed the Runkelstein painting in the canon of Ywain images: see Szklenar 173, Ott and Walliczek 475.

Conclusion

In the Introduction, we saw how medieval intellectuals from Gregory the Great to Thomasin of Zirclaria developed a theoretical framework for understanding images as "the literature of the laity," as an independent mode of communication. In the course of this study, I have attempted to develop a substantial body of concrete evidence for the argument that images like the Ywain images were both produced and received in substantive independence from texts.

As far as production is concerned, we can now offer a tentative general answer to the fundamental question of secular iconography: when artists began to create images based on vernacular story materials, did they draw their vocabulary from the already established traditions of Christian iconography, or did they create a new pictorial vocabulary in response to the texts and stories they were depicting? The answer seems to be that they did some of both—they followed the text or the story fairly closely in some instances and created independent visual solutions to narrative problems in others—but they were deeply influenced by iconographic traditions, and drew on standard pictorial vocabulary whenever possible.

Manuscript illuminators appear to have adhered closely to the text more often than muralists or other artists, but even miniaturists paid close attention to the written word in relatively few cases. In Garrett 125's depiction of the combat between Ywain and Harpin, the appearance of the giant himself owes little to the cursory description in the text, and one of the details the text does give—the fact that a bearskin protects the giant's chest—is omitted in the miniature. On the other hand, the action depicted reflects precisely two details from the text—Ywain lands a blow that cuts the giant's cheek, and the lion attacks, ripping open Harpin's hip. Likewise, the same manuscript's version of Ywain's rescue of the lion may draw on standard images of lions and dragons, but it follows the text's account of the action in some detail: the dragon holds the lion's tail in its mouth, while Ywain, protecting his face with his shield, slices the dragon in half with his sword. Ywain's gesture with his shield is less obvious in the Paris

manuscript's depiction of this scene, but there, too, the dragon bites the lion's tail, and Ywain's sword slices through the body of the dragon. Such attention to the details of the text, however, is rare in the manuscripts, and virtually nonexistent in the other Ywain images.

More common is the creation of images that do not follow the text in detail but reflect knowledge of the story and careful consideration of how best to narrate certain incidents in the visual medium. For example, the story tells us that, when Ywain chases Esclados/Ascalon through his castle gate, the portcullis falls and slices Ywain's horse in half. That implies a rather unusual portcullis—something more like a giant guillotine than the usual latticework with spikes. But in depicting just such a monstrous blade the Rodenegg painter cannot be said to have followed the text closely, for Hartmann's text provides no clear picture of the slicing gate, though it makes the effectiveness of the falling door quite clear (1075–1118). So unless we want to imagine that the Rodenegg painter had access to Chrétien's text, where the giant blade is vividly described (F. 907–952), we must assume that he did not know a description of Ascalon's gate, and did not employ a stock image, but independently considered what sort of device would be needed to cut a horse in half, and created the appropriate image based on that consideration (scene 6).

Another narrative moment, the search for Ywain, posed similar problems, which could not be solved by reliance on stock images or by consultation of the texts. How could Ywain's invisibility be presented visually? At Rodenegg, the painter shows Ywain behind a curtain, thus indicating that he is in the room but that the searchers cannot see him. At Schmalkalden, Ywain stands with his back to the searchers, contemplating the ring that he holds in his hand. While pre-informed viewers could certainly have read either of these images as indicating invisibility, it is difficult to imagine how ignorant viewers would have responded. At Rodenegg they would probably have assumed that Ywain was well hidden, while at Schmalkalden they might have thought that he was being captured. What is important in the present context is that the painters responded independently to Ywain's invisibility, a narrative motive for which standard images were not available.[1]

Standard images, however, clearly made up the bulk of the medieval artist's vocabulary, in the vernacular as well as the Christian realm. The influence of conventional imagery can be divided into three categories, which we might, by taking modest liberties with linguistic and rhetorical terminology, designate as morphemes, words, and topoi. Our morphemes would be the small units of pictorial vocabulary that can be put together to

create new scenes. Lions and dragons, for example, were both stock images in the medieval artist's repertoire; when called upon to portray the combat between a lion and a dragon, the artist had no difficulty in combining the two standard images. Even more important, stock images of people talking (with a certain repertoire of gestures to indicate speech), people riding horses, and so forth enabled artists to easily depict a variety of typical scenes.

Our visual "words" would then be the well-established ways of depicting certain activities, such as single combat, weddings, processions, and feasts, which were not normally associated with specific events and did not normally evoke specific connotations, but could be and usually were used any time an artist needed to depict a combat, a wedding, a procession, or a feast. Not only our Ywain material, but also the whole realm of medieval vernacular iconography is full of standard images of jousts, sword fights, and feasts, as a glance through the images reproduced by Loomis and Loomis, or Lejeunne and Stiennon, makes clear. In a somewhat extreme example, the twelve surviving miniatures from the Munich *Parzival* include three feasts, one sword fight, and two fairly standard scenes of conversation.[2] Some of these stock images can be traced to specific sources in Christian iconography. The standard medieval feast scene, for example, is clearly derived from the traditional depiction of the Last Supper. But that does not mean that medieval artists and viewers automatically thought of Christ's Passion every time they created or saw a feast scene. Images like feasts, weddings, and processions were so common that they had presumably lost most if not all of their power to connote the meanings associated with their original contexts in Christian iconography.

The existence of these traditional images contributes much to the freedom of the images from the texts. Artists instructed to depict a joust or a wedding, for instance, had no need to look for details in the text: they could simply employ a standard image. This pictorial vocabulary has its own internal consistency, which generally takes precedence over fidelity to details of a text or a story. It is pointless to speak of divergence from a text when, for example, the Rodenegg painter shows Ywain and Ascalon with intact shields at the climax of their battle, long after the point in Hartmann's text where the shields were hacked to pieces. The shield is simply part of the depiction of a fighting knight in the pictorial vocabulary of the Middle Ages. On the other hand, the standard iconography could be altered in small ways when the narrative required it. For example, the basic, standard image of mounted knights fighting with swords could easily be tailored

to fit specific circumstances. In the Rodenegg sword fight, Ywain strikes Ascalon a serious wound in the head, as the story demands. This is not a matter of fidelity to a text, but one method of visually indicating the outcome of the battle. Ywain kills Ascalon in this duel, and so the artist must show the fatal blow. By contrast, the depictions of the indecisive combat between Ywain and Gawain in the Princeton and Paris manuscripts show no wounds, but only indecisive blows. Stock images, it is clear, could easily be adapted to fit a variety of narrative contexts.

Finally, the creators of the Ywain images also sometimes adopted well-established iconographic traditions, or visual topoi, to narrate segments of the Ywain story. The most significant example is the dramatic allusion to the Lamentation of Christ with which the Rodenegg murals depict the death of Ascalon in Laudine's arms. The topos of the Lamentation offers far more than a convenient, standard way of presenting a death scene. It carries such powerful associations that it is capable of playing a central role in the thematic development of the narrative, enabling the Rodenegg cycle to question seriously the norms of the courtly genre. The Rodenegg "Lamentation" is obviously an extreme example of the power of pictorial topoi to retain their original connotations in new contexts. As we have seen, the standard images of medieval iconography did not usually do that. A funeral procession did not inevitably evoke thoughts of St. Mary just because the depiction was derived from the iconography of the Virgin's funeral. Generally, the existence of a standardized iconography simply provided artists with a convenient, ready-made set of images with which to narrate. Given this vocabulary, artists had little need to follow slavishly the words of a text. They had the freedom to create new works of art in their own media.

In terms of reception, one of the most important things we can learn from our examination of the Ywain imagery is that images can, in fact, narrate without words, or, to put it another way, that viewers can create diegesis from pictorial narratives without knowing the story in advance. As noted in the introduction, this is still frequently denied by image-text theorists.[3] But structural analysis of the visual narratives of Ywain has shown that they can indeed be read in much the same way that verbal narratives are read—in terms of iconographic, literary, and cultural codes. To be sure, some sets of images leave more up to the viewers' imaginations than others; or, in other words, pictorial narratives vary in the degree to which they control the diegetic process. This variation is to some extent a matter of the difference between the narration of actions and the narration of acts. The

narration of actions, which characterizes the picture cycles at Rodenegg and Schmalkalden and, to a great extent, the miniature cycle in the Paris *Yvain*, presents a continuous series of moments, linked together by internal elements. The narration of acts, which we find in the illuminations of the Princeton *Yvain*, presents a more discontinuous series of moments, and leaves the links, to a much greater extent, up to the viewers. In this situation, viewers may rely more heavily on external codes, such as prior knowledge of the story, but they do not necessarily do so: they may simply create a more skeletal diegesis, one in which the plot is reduced to a series of episodes that can be seen as typical of a given genre or understood in some other way.

Indeed, not only can the visual narratives be understood without reference to the texts, they very often must be read independently, in order to be understood properly at all. The best reading of the images is never one that relies heavily on the Chrétien/Hartmann text; in several instances, too much knowledge of the text can actually interfere with understanding the images. This is perhaps most dramatically true of the Rodenegg paintings and the Malterer embroidery. In the case of the Rodenegg cycle, viewers who insist on recalling the entire story as the texts tell it will miss the point of the narrative's negative ending, and thus create for themselves not only a very different diegesis from the one apparently intended, but also, even more important, a very different exegesis. Likewise, the second Ywain scene of the Malterer embroidery can hardly be understood at all by viewers who try to match it with one specific moment in the Chrétien/Hartmann text, and the acceptance of Ywain as a "Slave of Woman" also requires viewers to forget much of what they might know about Ywain from the texts. The situation is somewhat different with the manuscripts, since some—though by no means all—viewers of the images in a book encounter them while reading the text. Nonreading viewers, however, can create diegesis based on the images alone, and even for readers, the text does not necessarily control the understanding of the images. On the contrary, the images exercise considerable influence over the viewer/reader's understanding of the text.

The general point to be learned here is that medieval viewers were expected to understand the images on their own terms, to create narrative (visual diegesis) and meaning (visual exegesis) based on the images themselves, read in terms of a variety of semiotic codes, not in terms of the canonical texts. I have, in the course of this study, sometimes considered the possible responses of different hypothetical groups of viewers—from

those who knew the textual version of the story well, on the one extreme, to those totally ignorant of the story on the other—and one can hardly doubt that the stories viewers tell themselves as they look at the pictures may vary in significant details, depending on how much prior knowledge viewers possess. What is most important, however, is that the images do not ask viewers to read them by comparing them to the texts, but to view them as independent works of art. The implied viewer or reader of an Ywain picture cycle or an Ywain text is not one who already knows the story of Ywain and can match moments in the visual narrative with moments in the canonical version, but one who knows the codes of courtly culture, and can create story and meaning from the images.[4]

As independent narratives and allusions to narrative, the Ywain images participate independently in the creation of vernacular literature. The images, in fact, take part in the literarization process in much the same way as the texts do. Most concretely, like vernacular texts, visual works of art based on vernacular materials employ a wide variety of previously literate—that is, classical and/or Christian—topoi, allusions, and rhetorical devices. The formal aspects of this have been exhaustively discussed in the individual chapters, as have the ways in which the existence of iconographic traditions and conventional topoi sometimes influences not only the way in which scenes are depicted, but also which scenes are depicted, what structure a pictorial narrative takes, and even what thematic value is given to a story or a character. This use of iconographic traditions—mostly derived from religious art—and of topoi derived from the religious or classical realm is exactly analogous to, but entirely independent of, the similar use of literate traditions in the creation of a new vernacular literature. In this way, the vernacular-based images are fully engaged, side by side with vernacular texts, in creating a literature for the laity.

But the most important way in which the Ywain images participate in the literarization process is that each pictorialization of the material represents an independent reflection on the meaning and significance of the material, the genre, and the literature being created. The Rodenegg cycle—the earliest set of Ywain images—displays the most negative attitude toward the story of Ywain. With its bipartite structure, dominated by the Lamentation-influenced Death of Ascalon at the visual midpoint, it contrasts the glory of knightly *aventiure* with the grief, despair, and defeat that result from it. No viewers, no matter how much prior knowledge or how positive an understanding of the Ywain story they brought to their viewing of the Rodenegg paintings, could avoid perceiving the Rodenegg

Ywain as at least a serious questioning, if not an outright rejection, of the ethical system of *aventiure*-based romance. The miniatures of Paris BN fr. 1433 come closer than any other picture cycle to reproducing in a general way the bipartite structure of Chrétien's text, although they do not attempt to duplicate the text's structure in detail. Ywain's early successes in combat are first relativized by the grief associated with Esclados's funeral, which is lavishly depicted, while Ywain's wedding is not, and the consummation of his love for Laudine is delayed until the end of the story; the ethical value of the knight's early success is then called even more sharply into question by Lunete's denunciation of Ywain, which leads to his temporary madness. In a second series of adventures, in each of which the evil nature of his opponent and the virtue of his cause is visually obvious, Ywain finally achieves a blissful union with Laudine.

Both the Schmalkalden murals and the Princeton miniatures deproblematize the story of Ywain, presenting it as a simple series of exemplary adventures with no obvious telos. Depending on exactly what the fragmentarily preserved first scene or two at Schmakalden depicted, and on how uninformed viewers understood the storytelling scene that begins the Garrett cycle, both sets of pictures may have begun with self-reflexive reminders that the adventures were fiction and not reality. Both cycles present Ywain's adventures as intrinsically valuable *qua* adventures, and not susceptible to ethical questioning from outside the *aventiure*-realm.

While these cyclical works all narrate one version or another of the Ywain story, images of another sort detach individual elements from the original narrative context. The misericords isolate one dramatic scene— the portcullis falling on Ywain's horse—and, by depicting it from a ludicrous angle, convert it from a dramatic moment into a humorous one. The Malterer tapestry removes the character, along with a general idea that he was a knight who suffered much for love, from his original context, and places him in a new structure, derived from the topos of the Slaves of Love. Ywain thus appears as a knight who was ruined by a woman (or by erotic love, which amounts, in the widespread medieval view, to the same thing). Finally, the Runkelstein painting detaches the character entirely from all narrative context, and places him in a new topos—the expanded Nine Worthies—which makes him into an exemplary knight with no more precisely defined qualities than his exemplariness.

It may seem surprising that it is the earliest of the Ywain picture cycles that embodies the most serious doubts about the ethics of *aventiure*, and the latest Ywain picture that makes the character into a pure image of

courtliness, but this development runs parallel to the general trend in literature, where the first-generation Arthurian romances contain the most serious contemplation of the ethical implications of the genre, and the later poems make knightly adventure into a more or less unproblematic game.

Ultimately, it is the astonishing diversity of attitudes toward the story, the character, and the romance genre that leaves the most lasting impression after a survey of the Ywain pictures. Each pictorial manifestation of Ywain is remarkably different from all the others, although certain basic parameters of story and character do provide enough minimal unity to keep all the works recognizable as versions of the Ywain material. This sort of diversity is discussed in an entirely different context by Robert Scholes, in a short essay on the structural or semtiotic analysis of narrative fiction:

> One of the primary qualities of those texts we understand as fiction is that they generate a diegetic order that has an astonishing independence from its text. To put it simply, once a story is told, it can be recreated in a recognizable way by a totally new set of words . . . or in another medium altogether. (112)

If we substitute *narratives* for the first "texts" and *origins* for the second "text," we have here an excellent description of the situation of the Ywain pictures. In fact, in medieval culture, the origins of stories tend to disappear in a way that would please the most deconstructive post-structuralists. Only in limited and technical ways and in isolated cases can we speak meaningfully of the origins of a story, and the origins that we can trace are often of limited relevance to a particular manifestation of a narrative subject. What we must imagine is a skeletal, deep-structural form of a story floating in semiotic space, capable of being concretized, with widely varying results, in any medium and in an immense variety of contexts. Ywain's origins may lie somewhere in the unknown realms of Celtic folklore, his story may have been invented, to a great extent, by Chrétien de Troyes, and given canonical written form by Chrétien and Hartmann.[5] But none of these origins is especially relevant for the understanding of any particular work of art. The images and sets of images we have discussed are not pictorializations of texts, but visual manifestations of the story. Each is a self-reflexive participant in the literarization of vernacular narrative, embodying an independent attitude toward the story, the character, and the idea of romance adventure.

Notes

1. The only other effort to depict this narrative segment is in the Paris manuscript, where Ywain is shown conversing with Lunete, while two heads, representing the searchers, peer into the room where they stand. Instead of trying to show that Ywain is invisible, the artist here has chosen to show in an entirely different way that Lunette keeps Ywain safe while Esclados's men search for him.

2. Munich, Bayerische Staatsbibliothek, cgm 19. See Loomis and Loomis (figs. 355–58); Schirok (9–12).

3. A particularly emphatic statement of this position is Grabar's argument that "a narrative in visual form is effective *as narrative* only when its textual source is present (as in manuscripts or through inscriptions) or when the viewer already knows the story" (564) and that "Narrative images do not serve to tell a story but to remind the viewer of a story" (564).

4. An analogous situation in our own culture involves films based on books. The makers of such movies frequently make significant alterations in plot, characterization, and theme; they clearly expect viewers—whether they have read the book or not—to respond on all levels to the film itself, not to the book. Any number of examples could be given, from the highest cinematic art to the most trivial; one which comes readily to the mind of a Germanist is the *Blue Angel*, whose viewers would become badly confused if they tried to follow the plot and understand the theme by constantly comparing the movie to the novel, *Professor Unrath*, on which it is based.

5. On Celtic sources, see Loomis (*Arthurian Tradition* 269–73) and Frappier ("Chrétien de Troyes" 182–83); for reasonable doubt about their importance for Chrétien, see Uitti ("Le Chevalier au Lion" 190–98).

Works Cited

Abbas, Stephanus. *Usus Antiquiores Ordninis Cisterciensis*. Migne PL 166: cols. 1383–1510.

Ackermann, H. "Die Iwein-Fresken auf Schloß Rodenegg." *Der Schlern* 57 (1983): 391–421.

Amira, Karl von. "Die Handgebärden in den Bilderhandschriften des Sachsenspiegels." *Abhandlungen der königlich bayerischen Akademie der Wissenschaften: Philosophisch-philologische Klasse* 23 (1909): 163–263.

Anderson, M. D. *The Choir Stalls of Lincoln Minster*. Lincoln: Friends of Lincoln Cathedral, 1967.

——. "Iconography of British Misericords." Remnant xxii–xl.

——. *The Imagery of British Churches*. London: Murray, 1955.

——. *History and Imagery in British Churches*. London: 1971.

——. *Misericords: Medieval Life in English Woodcarving*. Harmondsworth: Penguin, 1954.

——. (as Mrs. Trenchard Cox). "The Twelfth-Century Design Sources of the Worcester Cathedral Misericords." *Archaeologia* 97 (1959): 165–78.

Ashdown, Charles Henry. *British and Foreign Arms and Armour*. London: Jack, 1909.

Askew, Pamela. *Caravaggio's Death of the Virgin*. Princeton, NJ: Princeton University Press, 1990.

Atz, Karl. *Kunstgeschichte von Tirol und Vorarlberg*. 2nd ed. Innsbruck: Wagner, 1909.

Augustine of Hippo, Saint. *De genesi ad litteram*. Migne PL 34: cols. 245–486.

Bæksted, Anders. *Islands Runeindskrifter*. Bibliotheca Arnamagnaena 2. København: Munksgaard, 1942.

Bal, Mieke and Norman Bryson. "Semiotics and Art History." *Art Bulletin* 73 (1991): 174–208.

Barasch, Moshe. *Gestures of Despair in Medieval and Early Renaissance Art*. New York: New York University Press, 1976.

Barthélemy, Dominique. "Parenté." *Histoire de la vie privée*. Ed. Philippe Ariès and Georges Duby. vol. 2. Paris: Seuil, 1985. 96–161. 5 vols.

Barthes, Roland. "Introduction to the Structural Analysis of Narratives." *Image-Music-Text*. Trans. Stephen Heath. Rpt. in *A Barthes Reader*. Ed. Susan Sontag. New York: Hill and Wang, 1982. 251–95.

——. *S/Z*. Trans. and ed. Richard Miller. New York: Hill and Wang, 1974.

Bäuml, Betty and Franz H. Bäuml. *A Dictionary of Gestures*. Metuchen, NJ: Scarecrow Press, 1975.

Bäuml, Franz H. "The Oral Tradition and Middle High German Literature." *Oral Tradition* 1/2 (1986): 398–445.

———. "The Unmaking of the Hero: Some Critical Implications of the Transition from Oral to Written Epic." *The Epic in Medieval Society: Aesthetic and Moral Values*. Ed. Harald Scholler. Tübingen: Niemeyer, 1977. 86–99.

———. "Varieties and Consequences of Medieval Literacy and Illiteracy." *Speculum* 55 (1980): 237–65.

[Becker, A.] "Schloß Runkelstein und seine Wandgemälde." *Mittheilungen der k.k. Central-Commission zur Erforschung und Erhaltung der Kunst- und historischen Denkmale* ns 4 (1878): xxiii–xxix.

Becker, Peter Jörg. *Handschriften und Frühdrucke mittelhochdeutscher Epen*: Eneide, Tristrant, Tristan, Erec, Iwein, Parzival, Willehalm, Jüngerer Titurel, Nibelungenlied *und ihre Reproduktion und Rezeption im späteren Mittelalter und in der frühen Neuzeit*. Wiesbaden: Reichert, 1977.

Beer, Rüdiger Robert. *Einhorn: Fabelwelt und Wirklichkeit*. München: Callwey, 1972.

Bennett, Brian. *The Choir Stalls of Chester Cathedral*. Chester: Mason, n.d.

Benoît de Sainte-Maure. *Roman de Troie*. Ed. Léopold Constans. Société des Anciens Textes Français. Paris: Didot, 1904.

"Bericht der k.k. Central-Commission für Erforschung und Erhaltung der Kunst- und historischen Denkmale über ihre Thätigkeit in den Jahren 1874 und 1875." *Mittheilungen der k.k. Central-Commission zur Erforschung und Erhaltung der Kunst- und historischen Denkmale* ns 2 (1876): i–xx.

"Bericht der k.k. Central-Commission für Erforschung und Erhaltung der Kunst- und historischen Denkmale über ihre Thätigkeit in den Jahren 1875 und 1876." *Mittheilungen der k.k. Central-Commission zur Erforschung und Erhaltung der Kunst- und historischen Denkmale* ns 3 (1877): i–clvi.

"Bericht der k.k. Central-Commission für Erforschung und Erhaltung der Kunst- und historischen Denkmale über ihre Thätigkeit in den Jahren 1876 und 1877." *Mittheilungen der k.k. Central-Commission für Erforschung und Erhaltung der Kunst- und historischen Denkmale* ns 4 (1878): i–xviii.

Bernheimer, Richard. *Wild Men in the Middle Ages: A Study in Art, Sentiment, and Demonology*. Cambridge, MA: Harvard University Press, 1952.

Bernström, John. "Løve." *Kulturhistorisk Leksikon for nordisk middelalder*. København: Rosenkilde og Bagger, 1966. 22 vols. 1956–78.

Berthold von Regensburg. *Vollständige Ausgabe seiner Predigten*. Ed. Franz Pfeiffer. 2 vols. Wien, 1862. Berlin: de Gruyter, 1965.

Bibliothèque Impériale [later Nationale][Paris]—Départment des Manuscrits. *Catalogue des manuscrits français*. Vol. 1. Paris, 1868. 6 vols. 1868–1902.

Bibliothèque Nationale [Paris]. *Les Manuscrits á Peintures en France du XIIIe au XVIe siècle*. [Paris]: Bibliothèque Nationale, 1955.

Blamires, Alcuin, ed. *Woman Defamed and Woman Defended: An Anthology of Medieval Texts*. Oxford: Clarendon, 1992.

Blomefield, Francis. *An Essay Towards a Topographical History of the County of Norfolk* Vol. 4. *The History of the City and County of Norwich*. Pt. 2. London, 1806. 11 vols. 1805–1810.

Bloxam, Matthew Holbeche. *The Principles of Gothic Ecclesiastical Architecture* Vol. 2. 11th ed. London, 1882. 2 vols.

Boardmann, John, Olga Palagia, and Susan Woodford. "Herakles." *Lexikon Iconographicum Mythologiae Classicae*. Zürich: Artemis, 1988. 5 vols. to date. 1981-.

Boeckler, Albert. *Heinrich von Veldecke, Eneide: Die Bilder der Berliner Handschrift*. Lepizig: Harrasowitz, 1939.

Boesch, Gottfried. "Die Gefallenen der Schlacht bei Sempach aus dem Adel des deutschen Südwestens." *Alemannisches Jahrbuch* (1958): 233–78.

Bond, Francis. *Wood Carvings in English Churches*. Vol 1. *Misericords*. Oxford: Oxford University Press, 1910. 2 vols.

Bonnet, Anne Marie. *Rodenegg und Schmalkalden: Untersuchungen zur Illustration einer ritterlich-höfischen Erzählung und zur Entstehung profaner Epenillustration in den ersten Jahrzehnten des 13. Jahrhunderts*. tuduv-Studien: Reihe Kunstgeschichte 22. München: tuduv, 1986.

——— (as Anne Marie Birlauf-Bonnet). "Überlegungen zur Brixener Malerei in den ersten Jahrzehnten des 13. Jahrhunderts." *Wiener Jahrbuch zur Kunstgeschichte* 37 (1984): 23–39, 187–98.

Booth, Wayne C. *The Rhetoric of Fiction*. 2nd ed. Chicago: University of Chicago Press, 1983.

Brandt, Wolfgang. "Die Beschreibung häßlicher Menschen in höfischen Romanen: Zur narrativen Integrierung eines Topos." *Germanisch-Romanische Monatsschrift* 66 (1985): 257–78.

Branner, Robert. *Manuscript Painting in Paris During the Reign of Saint Louis: A Study of Styles*. California Studies in the History of Art. Berkeley: University of California Press, 1977.

Brault, Gerard J. *Early Blazon: Heraldic Terminology in the Twelfth and Thirteenth Centuries with Special Reference to Arthurian Literature*. Oxford: Clarendon, 1972.

Brenk, Beat. "Le Texte et l'image dans la *Vie des saints* au Moyen Âge: Rôle du concepteur et rôle du peintre." *Texte et image: Actes du Colloque international de Chantilly (October 13–15, 1982)*. Paris: Les Belles Lettres, 1984. 31–39.

Brilliant, Richard. *Visual Narratives: Storytelling in Etruscan and Roman Art*. Ithaca, NY: Cornell University Press, 1984.

Brinkmann, Hennig. *Mittelalterliche Hermeneutik*. Tübingen: Niemeyer, 1980.

———. "Verhüllung ('Integumentum') als literarische Darstellungsform im Mittelalter." *Der Begriff der Repraesentatio im Mittelalter: Stellvertretung, Symbol, Zeichen, Bild*. Ed. Albert Zimmermann. Miscellanea Mediaevalia 8. Berlin: de Gruyter, 1971. 314–339.

Brundage, James A. *Law, Sex, and Christian Society in Medieval Europe*. Chicago: University of Chicago Press, 1987.

Bucher, François. *The Pamplona Bibles: A Facsimile Compiled from Two Picture Bibles with Martyrologies Commissioned by King Sancho el Fuerte of Navarra (1194–1234): Amiens Manuscript Latin 108 and Harburg Ms. 1,2, lat 4°, 15*. New Haven, CT: Yale University Press, 1970.

Buchner, Max. "Sentlinger, Heinz." Stammler and Langosch 4: cols. 156–57.

Bulst, W. A. "Samson." Kirschbaum et al. 4: cols. 30–38.

Bumke, Joachim. *Mäzene im Mittelalter: Die Gönner und Auftraggeber der höfischen Literatur in Deutschland 1150–1300*. München: Beck, 1979.

Burin, Elizabeth. "The Pierre Sala Manuscript." Busby et al. 1: 323–30.

Busby, Keith et al., eds. *Les manuscrits de Chrétien de Troyes: The Manuscripts of Chrétien de Troyes*. 2 vols. Faux Titre: Études de Langue et Littérature Françaises 71. Amsterdam: Rodopi, 1993.

Cahier, Charles and Arthur Martin. *Mélanges d'archéologie, d'histoire, et de littérature*. 4 vols. Paris, 1847–56.

Camille, Michael. "The Book of Signs: Writing and Visual Difference in Gothic Manuscript Illumination." *Word & Image* 1 (1985): 133–48.

———. "Labouring for the Lord: The Ploughman and the Social Order in the Luttrell Psalter." *Art History* 10 (1987): 423–452.

———. "Seeing and Reading: Some Visual Implications of Medieval Literacy and Illiteracy." *Art History* 8 (1985): 26–49.

———. "Visual Signs of the Sacred Page: Books in the *Bible Moralisée*." *Word & Image* 5 (1989): 111–30.

Carruthers, Mary J. *The Book of Memory: A Study of Memory in Medieval Culture*. Cambridge Studies in Medieval Literature 10. Cambridge: Cambridge University Press, 1990.

Cautley, H. Munro. *Norfolk Churches*. Ipswich: Adlard, 1949.

[Chambers, John]. *A General History of the County of Norfolk, Intended to Convey all the Information of a Norfolk Tour* Vol. 2. Norwich, 1829. 2 vols.

Chaucer, Geoffrey. *The Works of Geoffrey Chaucer*. Ed. F. N. Robinson. 2nd ed. Boston: Houghton Mifflin, 1957.

Chrétien de Troyes. *Erec und Eneide*. Ed. Wendelin Foerster. Sämtliche Werke 3. Halle: Niemeyer, 1890.

———. *Le Chevalier au Lion (Yvain)*. Ed. Mario Roques. Les Romans de Chrétien de Troyes 4. Paris: Champion, 1982.

———. *Le Conte du Graal (Perceval)*. Ed. Félix Lecoy. 2 vols. Les Romans de Chrétien de Troyes 5 and 6. Paris: Champion, 1972, 1975.

———. *Yvain (Der Löwenritter)*. Ed. Wendelin Foerster. Romanische Bibliothek 5. 4th ed. Halle: Niemeyer, 1912.

———. *Yvain*. Princeton, NJ, Princeton University Library. Garrett ms. 125.

———. *Yvain*. Paris, Bibliothèque National. MS. BN fr. 1433.

Comparetti, Domenico. *Vergil in the Middle Ages*. Trans. E. F. M. Benecke. New York: Stechert, 1929.

Cook, G. H. *English Collegiate Churches of the Middle Ages*. London: Phoenix House, 1959.

Cormeau, Christoph, ed. *Deutsche Literatur im Mittelalter: Kontakte und Perspektiven Hugo Kuhn zum Gedenken*. Stuttgart: Metzler, 1979.

———. "Hartmann von Aue." Ruh vol. 3: cols. 500–520.

Cormeau, Christoph and Wilhelm Störmer. *Hartmann von Aue: Epoche—Werk—Wirkung*. Beck'sche Elementarbücher; Arbeitsbücher zur Literaturgeschichte. München: Beck, 1985.

Cox, J. C. and Alfred Harvey. *English Church Furniture*. London: Methuen, 1907.

Crosby, Ruth. "Oral Delivery in the Middle Ages." *Speculum* 11 (1936): 88–110.

Curschmann, Michael. "Das Abenteuer des Erzählens: Über den Erzähler in Wol-

frams *Parzival.*" *Deutsche Vierteljahresschrift für Literaturwissenschaft und Geistesgeschichte* 45 (1971): 627–67.

———. "*Der aventiure bilde nemen*: The Intellectual and Social Environment of the Iwein Murals at Rodenegg Castle." *Chrétien de Troyes and the German Middle Ages.* Ed. Martin H. Jones and Roy Wisbey. Cambridge: D. S. Brewer, 1993. 219–27.

———. "Hören-Lesen-Sehen: Buch und Schriftlichkeit im Selbstverständnis der volkssprachlichen literarischen Kultur Deutschlands um 1200." *Beiträge zur Geschichte der deutschen Sprache und Literatur* 106 (1984): 218–57.

———. "Images of Tristan." *Gottfried von Strassburg and the Medieval Tristan Legend: Papers from an Anglo-North American Symposium.* Ed. Adrian Stevens and Roy Wisbey. London: Brewer/Institute of Germanic Studies, 1990. 1–17.

———. "Imagined Exegesis: Text and Picture in the Exegetical Works of Rupert of Deutz, Honorius Augustodensis, and Gerhoch of Reichersberg." *Traditio* 44 (1988): 145–69.

———. "'Nibelungenlied' und 'Nibelungenklage': über Mündlichkeit und Schriftlichkeit im Prozess der Episierung." Cormeau, *Deutsche Literatur* 85–119.

———. "Oral Poetry in Mediaeval English, French, and German Literature: Some Notes on Recent Research." *Speculum* 42 (1967): 36–52.

———. "*Pictura laicorum litteratura?* Überlegungen zum Verhältnis von Bild und volkssprachlicher Schriftlichkeit im Hoch- und Spätmittelalter bis zum Codex Manesse." *Pragmatische Schriftlichkeit im Mittelalter: Erscheinungsformen und Entwicklungsstufen* (Akten des internationalen Kolloquiums, 17.–19. Mai 1989). Münstersche Mittelalter-Schriften 65. Ed. Hagen Keller, Klaus Grubmüller, and Nikolaus Staubach. München: Fink, 1992. 211–29.

———. "Texte—Bilder—Strukturen: Der *Hortus deliciarum* und die frühmittelhochdeutsche Geistlichendichtung." *Deutsche Vierteljahresschrift für Literaturwissenschaft und Geistesgeschichte* 55 (1981): 379–418.

Curtius, Ernst Robert. *European Literature and the Latin Middle Ages.* Trans. Willard R. Trask. Bollingen Series 36. Princeton, NJ: Princeton University Press, 1973.

Dallapiazza, Michael. "Häßlichkeit und Individualität: Ansätze zur Überwindung der Idealität des Schönen in Wolframs von Eschenbach *Parzival.*" *Deutsche Vierteljahresschrift für Literaturwissenschaft und Geistesgeschichte* 59 (1985): 400–421.

Dante Alighieri. *The Banquet.* Trans. Christopher Ryan. Stanford French and Italian Studies 61. Saratoga, CA: ANMA Libri, 1989.

———. *Il Convivio.* Ed. G. Busnelli and G. Vandelli, 2nd ed. by Antonio Enzo Quaglio. 2 vols. Florence: Felice le Monnier, 1968. Vols. 4 and 5 of *Opere di Dante: Nuova Edizione sotto gli Auspice della Fondazione Giorgio Cini.* Ed. Vittore Branca, Francesco Maggini, and Bruno Nardi. 8 vols. to date. 1953– .

dell'Antonio, Maria Maddalena. "Gli affreschi romanici della Chiesa di Nostra Signora di Bressanone." *Rivista d'Arte* ns 12 (1930): 311–21.

Demus, Otto. *Romanesque Mural Painting.* Trans. Mary Whitall. London: Thames and Hudson, 1970.

de Ricci, Seymour. *Census of Medieval and Renaissance Manuscripts in the United States and Canada*. New York, 1935.

Dickinson, J. C. *The Later Middle Ages*. An Ecclesiastical History of England. London: Black, 1979.

Diemer, Peter and Dorothea Diemer. "Die Bilder der Berliner Veldeke-Handschrift." Heinrich von Veldecke. *Eneasroman: Die Berliner Bilderhandschrift mit Übersetzung und Kommentar*. Hans Fromm, ed. Bibliothek des Mittelalters 4. Frankfurt am Main: Deutscher Klassiker Verlag, 1992. 911–70.

———. "*Qui pinget florem non pingit floris odorem*: Die Illustrationen der Carmina Burana (Clm 4660)." *Jahrbuch des Zentralinstituts für Kunstgeschichte* 3 (1987): 43–75.

Doob, Penelope B. R. *Nebuchadnezzar's Children: Conventions of Madness in Middle English Literature*. New Haven, CT: Yale University Press, 1974.

Dörrer, A. "Vintler, Hans." Stammler and Langosch 4: cols. 698–701; 5: col. 1112.

Druce, George C. "Misericords: Their Form and Decoration." *Journal of the British Archaeological Association* ns 36, pt. 2 (1931): 244–64.

Duggan, Lawrence G. "Was Art Really the 'Book of the Illiterate'?" *Word & Image* 5 (1989): 227–51.

Durantis, Gulielmus. *The Symbolism of Churches and Church Ornaments: A Translation of the First Book of the* Rationale Divinorum Officiorum. Trans. John Mann Neale and Benjamin Webb. London, 1893.

Eco, Umberto. *The Role of the Reader: Explorations in the Semiotics of Texts*. Bloomington: Indiana University Press, 1979.

Egg, Erich, and Wolfgang Pfaundler. *Kaiser Maximillian I. und Tirol*. Innsbruck: Tyrolia, [1969].

Einhorn, Jürgen W. *Spiritalis Unicornis: Das Einhorn als Bedeutungsträger in Literatur und Kunst des Mittelalters*. Münstersche Mittelalter-Schriften 13. München: Fink, 1976.

Eißengarthen, Jutta. *Mittelalterliche Textilien aus Kloster Adelhausen im Augustinermuseum Freiburg*. Freiburg: Adelhaussenstiftung, 1985.

Eneas: Roman du XIIe siècle. J.-J. Salverda de Grave, ed. 2 vols. Les Classiques Français du Moyen Âge 44, 62. 1925–29. Paris: Champion, 1985 and 1983.

Ettmüller, Ludwig, ed. *Leiche, Sprüche, Streitgespräche und Lieder*. By Frauenlob (Heinrich von Meissen). Quedlinburg, 1843.

Evans, Joan. *Art in Medieval France 987–1498: A Study in Patronage*. London: Oxford University Press, 1948.

Fechter, Werner. *Das Publikum der mittelhochdeutschen Dichtung*. Frankfurt am Main: Diesterweg, 1935.

Fleckenstein, Josef. "Bürgertum und Rittertum in der Geschichte des mittelalterlichen Freiburg." *Freiburg im Mittelalter: Vorträge zum Stadtjubiläum 1970*. Ed. Wolfgang Müller. Baden: Konkordia, 1970. 77–95.

Fleming, John V. "Chaucer and the Visual Arts of His Time." *New Perspectives in Chaucer Criticism*. Ed. Donald M. Rose. Norman, OK: Pilgrim Books, 1981. 121–36.

Frappier, Jean. "Chrétien de Troyes." *Arthurian Literature in the Middle Ages: A*

Collaborative History. Ed. Roger Sherman Loomis. Oxford: Clarendon, 1959. 157–191.

———. *Chrétien de Troyes: The Man and His Work.* Trans. Raymond J. Cormier. Athens: Ohio University Press, 1982.

Freymond, E. "Beiträge zur Kenntnis der altfranzösischen Artusromane in Prosa." *Zeitschrift für französische Sprache und Literatur* 17 (1895): 1–128.

Friedman, John Block. *The Monstrous Races in Medieval Art and Thought.* Cambridge, MA: Harvard University Press, 1981.

Frodl-Kraft, Eva. "Das Margaretenfenster in Ardagger: Studien zur österreichischen Malerei in der 1. Hälfte des 13. Jahrhunderts." *Wiener Jahrbuch für Kunstgeschichte* 16 (1954): 9–46.

Frühmorgen-Voss, Hella. "Bildtypen in der Manessischen Liederhandschrift." Frühmorgen-Voss, *Text und Illustration* 57–88.

———. "Mittelhochdeutsche weltliche Literatur und ihre Illustration: Ein Beitrag zur Überlieferungsgeschichte." Frühmorgen-Voss, *Text und Illustration* 1–56.

———. *Text und Illustration im Mittelalter: Aufsätze zu den Wechselbeziehungen zwischen Literatur und bildende Kunst.* Ed. Norbert H. Ott. München: Beck, 1975.

———. "Tristan und Isolde in mittelalterlichen Bildzeugnissen." Frühmorgen-Voss, *Text und Illustration.* 119–139.

Frühmorgen-Voss, Hella and Norbert H. Ott. *Katalog der deutschsprachigen illustrierten Handschriften des Mittelalters.* Veröffentlichungen der Kommission für deutsche Literatur des Mittelalters der Bayerischen Akademie der Wissenschaften. Vol. 1, fascicle 2. München: Beck, 1987. 1 volume to date. 1986- .

Ganz, Paul Leonhard and Theodor Seeger. *Das Chorgestühl in der Schweiz.* Frauenfeld: Huber, 1946.

Garber, Josef. *Die romanischen Wandgemälde Tirols.* Wien: Krystall-Verlag, 1928.

Die Gedichte vom Rosengarten zu Worms. Ed. Georg Holz. Halle: Niemeyer, 1893.

Gellinek, Christian J. "Iwein's Duel and Laudine's Marriage." *The Epic in Medieval Society: Aesthetic and Moral Values.* Ed. Harald Scholler. Tübingen: Niemeyer, 1977. 226–239.

Gerland, Otto. *Die spätromanischen Wandmalereien im Hessenhof zu Schmalkalden.* Leipzig, 1896.

Gerola, Giuseppe. "Per la datazione degli affreschi di Castel Roncolo." *Atti del Reale Istituto Veneto di Scienze, Lettere ed Arti* 82 (1922–23): 511–21.

Gesammtabenteuer: Hundert altdeutsche Erzählungen: Ritter- und Pfaffen-Mären, Stadt- und Dorfgeschichten, Schwänke, Wundersagen und Legenden Ed. Friedrich von der Hagen. Stuttgart and Tübingen, 1850.

Gichtel, Paul. "Die Bilder der Münchner Tristan-Handschrift cgm 51: Eine Bestandsaufnahme." *Buch und Welt: Festschrift für Gustav Hofmann.* Ed. Hans Striedl and Joachim Wieder. Wiesbaden: Harrassowitz, 1965. 391–467.

———. *Die Weltchronik Heinrichs von München in der Runkelsteiner Handschrift des Heinz Sentlinger.* Diss. München 1937. München: Gebrüder Giehrl, 1937.

Godefroy, Frédéric Eugène. *Dictionnaire de l'ancienne langue français et des tous ses dialects* Paris: Viewez, 1881–1902.

Goldschmidt, Adolph and Kurt Weitzmann. *Die byzantinischen Elfenbeinskulpturen des X.–XIII. Jahrhunderts.* 2 vols. Berlin: Cassirer, 1934.

Gombert, H. and I. Krummer-Schroth. *Mittelalterliche Kunst im Augustinermuseum Freiburg im Breisgau.* Freiburg: Schillinger, 1965.

Gombrich, E. H. "The Evidence of Images." *Interpretation: Theory and Practice.* Ed. Charles S. Singleton. Baltimore: Johns Hopkins University Press, 1969. 35–104.

Gottfried von Straßburg. *Tristan.* Deutsche Klassiker des Mittelalters, ns 4. Ed. Reinhold Beckstein and Peter Ganz. 2 vols. Wiesbaden: Brockhaus, 1978.

———. *Tristan und Isolde: Mit der Fortsetzung Ulrichs von Türheim: Faksimile-Ausgabe des Cgm 51 der Bayerischen Staatsbibliothek München.* 2 vols. Stuttgart: Müller und Schindler, 1979.

Grabar, Oleg. "History of Art and History of Literature: Some Random Thoughts." *New Literary History* 3 (1972): 559–68.

Green, Dennis H. "On the Primary Reception of Narrative Literature in Medieval Germany." *Forum for Modern Language Studies* 20 (1984): 289–308.

———. "The Reception of Hartmann's Works: Listening, Reading, or Both?" *Modern Language Review* 81 (1986): 357–68.

———. "Über Mündlichkeit und Schriftlichkeit in der deutschen Literatur des Mittelalters." *Philologie als Kulturwissenschaft: Studien zur Literatur und Geschichte des Mittelalters: Festschrift für Karl Stackmann zum 65. Geburtstag.* Ed. Ludger Grenzmann, Hubert Herkommer, and Dieter Wuttke. Göttingen: Vandenhoeck und Ruprecht. 1–20.

Gregory I, Pope. *Registrum Epistolarum.* Monumenta Germaniae Historica: Epistolarum 2. Ed. Ludwig Hartmann. Berlin, 1899.

Greven, Joseph, ed. *Die Exempla aus den Sermones feriales et communes.* By Jakob von Vitry. Sammlung mittellateinischer Texte 9. Heidelberg: Winter, 1914.

Grimm, R. R. "Die Paradiesehe: eine erotische Utopie des Mittelalters." *"Getempert und gemischet": Festschrift für Wolfgang Mohr zum 65. Geburtstag.* Ed. Franz Hundsnurscher and Ulrich Müller. Göppinger Arbeiten zur Germanistik 65. Göppingen: Kümmerle, 1971. 1–25.

Gross, Ruth V. "Rich Text/Poor Text: A Kafkan Confusion." *PMLA* 95 (1980): 168–182.

Grundmann, Herbert. "Die Frauen und die Literatur im Mittelalter." *Archiv für Kulturgeschichte* 26 (1936): 129–61.

———. "Litteratus-illitteratus: Der Wandel einer Bildungsnorm vom Altertum zum Mittelalter." *Archiv für Kulturgeschichte* 40 (1958): 1–65.

Hale, Richard. "The Church of England in Nineteenth Century Norwich." *Norwich in the Nineteenth Century.* Ed. Christopher Barringer. Norwich: Gliddon, 1984. 160–175.

Harf-Lancer, Laurence. "L'image et le fantastique dans les manuscrits des romans de Chrétien de Troyes." Busby et al. 1:457–88.

Hart, Richard. "On Misereres; With an Especial Reference to those in Norwich Cathedral, and a Brief Description of Each." *Norfolk Archaeology* 2 (1849): 234–52.

Hartmann von Aue. *Der arme Heinrich*. Ed. Hermann Paul. 14th ed. by Ludwig Wolff. Altdeutsche Textbibliothek 3. Tübingen: Niemeyer, 1972.

———. *Erec*. Ed. Albert Leitzmann, revised by Ludwig Wolff. 6th ed. by Christoph Cormeau and Kurt Gärtner. Altdeutsche Textbibliothek 39. Tübingen: Niemeyer, 1985.

———. *Iwein: Eine Erzählung von Hartmann von Aue*. Ed. G. F. Benecke, Karl Lachmann and Ludwig Wolff. 2 vols. 7th ed. Berlin: de Gruyter, 1968.

Harvey, John. *Gothic England: A Survey of National Culture 1300–1550*. New York: Scribner, 1947.

Hase, C. W. "Die neuentdeckten spätromanischen Wandmalereien in Schmalkalden, aus dem Leben der hl. Elisabeth." *Zeitschrift für christliche Kunst* 6 (1893): 122–28.

Haug, Walter. "Das Bildprogramm im Sommerhaus von Runkelstein." Haug et al. 15–62.

———. *Literaturtheorie im deutschen Mittelalter von den Anfängen bis zum Ende des 13. Jahrhunderts: Eine Einführung*. Germanistische Einführungen in Gegenstand, Methoden und Ergebnisse der Disziplinen und Teilgebiete. Darmstadt: Wissenschaftliche Buchgesellschaft, 1985.

Haug, Walter et al. *Runkelstein: Die Wandmalereien des Sommerhauses*. Wiesbaden: Reichert, 1982.

Havelock, Eric A. *The Muse Learns to Write: Reflections on Orality and Literacy from Antiquity to the Present*. New Haven, CT: Yale University Press, 1986.

Heinrich von Veldecke. *Eneide*. Ed. Gabriele Schieb and Theodor Frings. 3 vols. Deutsche Texte des Mittelalters 58, 59, 62. Berlin: Akademie-Verlag, 1964, 1965, 1970.

Heinzle, Joachim. "Die Triaden auf Runkelstein und die mittelhochdeutsche Heldendichtung." Haug et al. 63–93.

———. *Willehalm: nach der Handschrift 857 der Stiftsbibliothek St. Gallen*. By Wolfram von Eschenbach. Bibliothek des Mittelalters 9. Frankfurt: Deutscher Klassiker Verlag, 1991.

Hendrickson, William L. "Un nouveau fragment de *Garin de Monglane*." *Romania* 96 (1975): 163–93.

Henry, Avril. *Biblia Pauperum: A Facsimile and Edition*. Ithaca, NY: Cornell University Press, 1987.

Herbort von Fritzlar. *Herbort's von Fritslâr Liet von Troye*. Ed. Ge. Karl Frommann. Bibliothek der gesammten deutschen Literatur 5. Quedlinburg, 1837.

Hermand, Jost. *Literaturwissenschaft und Kunstwissenschaft: Methodische Wechselbeziehungen seit 1900*. 2nd ed. Sammlung Metzler 41. Stuttgart: J. B. Metzler, 1971.

Herr Ivan Lejon-riddaren, en svensk rimmad dikt ifrån 1300-talet, till tillhörande sagokretsen om konung Arthur och hans runda bord. Ed. J. W. Liffman and George Stephens. Stockholm, [1845]–49.

Hindman, Sandra. "King Arthur, His Knights, and the French Aristocracy in Picardy." *Yale French Studies Special Edition, Contexts: Style and Values in Medieval Art and Literature*. Ed. Daniel Poiron and Nancy Freeman Regalado. New Haven, CT: Yale University, 1991. 114–33.

Hoffmann, Werner. "Deutsche Heldenepik in Tirol: Ergebnisse und Probleme ihrer Erforschung." Kühebacher 32–67.

Hölscher, Tonio. "Die Geschichtsauffassung in der römischen Repräsentationskunst." *Jahrbuch des deutschen Archäologischen Instituts* 95 (1980): 265–321.

———. *Römische Bildsprache als semantisches System.* Abhandlungen der Heidelberger Akademie der Wissenschaften, Philosophisch-historische Klasse. Jahrgang 1987. 2. Abhandlung. Heidelberg: Winter, 1987.

Hoppe, Karl. *Die Sage von Heinrich dem Löwen: Ihr Ursprung, ihre Entwicklung, und ihre Überlieferung.* Veröffentlichungen des Niedersächsischen Amtes für Landesplanung und Statistik. Reihe A: Forschungen zur Landes- und Volkskunde. II: Volkstum und Kultur (Schriften des Niedersächsichen Heimatbundes) 22. Bremen: Walter Dorn, 1952.

Huber, Christoph. "Höfischer Roman als Integumentum? Das Votum Thomasins von Zerklaere." *Zeitschrift für deutsches Altertum und Philologie* 115 (1986): 79–100.

Hübner, Arthur. "Das Deutsche im Ackermann aus Böhmen." *Sitzungsberichte der preussischen Akademie der Wissenschaften, Philosophisch-historische Klasse* 1935: 323–98.

Hugh of Fouilloy. *De Claustro Animae.* Migne PL 176: cols. 1018–1184.

Huot, Sylvia. *From Song to Book: The Poetics of Writing in Old French Lyric and Lyrical Narrative Poetry.* Ithaca, NY: Cornell University Press, 1987.

Husband, Timothy. *The Wild Man: Medieval Myth and Symbolism.* New York: Metropolitan Museum, 1980.

Ívens Saga. Editiones Arnamagnaeanae, ser. B, 18. Ed. Foster W. Blaisdell. Copenhagen: Reitzeln, 1979.

Jacobowitz, Ellen S., and Stephanie Loeb Stepanek. *The Prints of Lucas van Leyden and his Contemporaries.* Washington: National Gallery of Art, 1983.

James, Montague Rhodes. *Marvels of the East: A Full Reproduction of the Three Known Copies, with an Introduction and Notes.* Roxburghe Club. Oxford: Oxford University Press, 1929.

Jaques, Renate. *Deutsche Textilkunst in ihrer Entwicklung bis zur Gegenwart.* Berlin: Rembrandt-Verlag, 1942.

Jeavons, S. A. "Medieval Woodwork in South Staffordshire." *Birmingham and Midland Institute: Birmingham Archaeological Society: Transactions and Proceedings* 67 (1947–1948): 42–54.

Jerome, Saint. *Epistola XXII ad Eustochium.* Migne PL 22: cols. 394–423.

Jones, William R. "Art and Christian Piety: Iconoclasm in Medieval Europe." *The Image and the Word: Confrontations in Judaism, Christianity, and Islam.* Ed. Joseph Gutmann. Missoula, MT: Scholar's Press, 1977. 75–105.

Jonin, Pierre. "Prolégomènes à une Édition d'Yvain." *Publication des Annales de la Faculté des Lettres Aix-en-Provence* ns 19. [Aix-en-Provence]: Ophyro, 1958.

Kemp, Wolfgang. *Sermo Corporeus: Die Erzählung der mittelalterlichen Glasfenster.* München: Schirmer-Mosel, 1987.

Kern, Peter. "Interpretation der Erzählung durch Erzählung: Zur Bedeutung von Wiederholung, Variation und Umkehrung in Hartmanns 'Iwein.'" *Zeitschrift für deutsche Philologie* 92 (1973): 338–59.

Kessler, Herbert. "Pictorial Narrative and Church Mission in Sixth-Century Gaul." Kessler and Simpson. 75–91.

Kessler, Herbert. "Reading Ancient and Medieval Art." *Word & Image* 5 (1989): 1.

Kessler, Herbert and Marianna Shreve Simpson, eds. *Pictorial Narrative in Antiquity and the Middle Ages*. Studies in the History of Art 16. Washington, DC: National Gallery of Art, 1985.

Kirschbaum, Engelbert et al., eds. *Lexikon der christlichen Ikonographie*. 8 vols. Rom: Herder, 1968–76.

Kitzinger, Ernst. *The Mosaics of Monreale*. Palermo: Flaccavio, 1960.

Kluckhohn, Paul. "Der Minnesang als Standesdichtung." *Archiv für Kulturgeschichte* 11 (1914). Rpt. in *Der deutsche Minnesang*. Ed. Hans Fromm. Vol. 1. Wege der Forschung 15. Bad Homburg vor der Höhe: Gentner, 1961. 58–84. 2 vols.

Knapp, Fritz Peter. "Historische Wahrheit und poetische Lüge: Die Gattungen weltlicher Epik und ihre theoretische Rechtfertigung im Hochmittelalter." *Deutsche Vierteljahresschrift für Literaturwissenschaft und Geistesgeschichte* 54 (1980): 580–635.

Knötel, Paul. "Schlesische Iweinbilder aus dem 14. Jahrhundert." *Mitteilungen der schlesischen Gesellschaft für Volkskunde* 20 (1918): 72–98.

Koch, Georg Friedrich. "Virgil im Korbe." *Festschrift für Erich Meyer zum sechzigsten Geburtstag am 29. Oktober 1957: Studien zu den Werken in den Sammlungen des Museums für Kunst und Gewerbe Hamburg*. Ed. Werner Gramberg et al. Hamburg: Hauswedel, 1959. 105–21.

Kohlhaussen, Heinrich. "Das Paar vom Bussen." *Festschrift Friedrich Winkler*. Ed. Hans Möhle. Berlin: Gebr. Mann, 1959. 29–48.

Kristjánsson, Jónas. *Eddas and Sagas: Iceland's Medieval Literature*. Trans. Peter Foot. Reykjavik: Hið íslenska bókmenntafélag, 1988.

Kühebacher, Egon, ed. *Deutsche Heldenepik in Tirol: König Laurin und Dietrich von Bern in der Dichtung des Mittelalters*. Beiträge der Neustifter Tagung 1977 des Südtiroler Kulturinstituts. Schriftenreihe des Südtiroler Kulturinstitutes 7. Bozen: Athesia, 1979.

Kuhn, Hugo. "Thomasin von Zerklare." Stammler and Langosch 4: cols. 466–72.

———. "Tristan, Nibelungenlied, Artusstruktur." *Sitzungsberichte der Bayerischen Akademie der Wissenschaften, Philosophisch-historische Klasse*. Jahrgang 1973, Heft 5.

Künstle, Karl. *Ikonographie der christlichen Kunst*. Freiburg: Herder, 1928.

Kurras, L. "'Der Fürsten Warnung': Ein unbekanntes Wappengedicht Peter Suchenwirts?" *Zeitschrift für deutsches Altertum und Philologie* 108 (1979): 239–47.

Laborde, A. de. *Les manuscrits à peintures de la cité de dieu de Saint Augustine*. 3 vols. Paris: Société des Bibliophiles Français, 1909.

Lavin, Marilyn Aronberg. *The Place of Narrative: Mural Decoration in Italian Churches, 431–1600*. Chicago: University of Chicago Press, 1990.

Lazarev, Viktor. "New Light on the Problem of the Pisan School." *Burlington Magazine* 68 (1936): 61–73.

Leander-Touati, Anne-Marie. *The Great Trajanic Frieze: The Study of a Monument*

and of the Mechanisms of Message Transmission in Roman Art. Skrifter Utgivna ac Svenska Institut i Rom, 4°, XLV. Stockholm: Paul Åströms Förlag, 1987.

Lecouteux, Claude. *Les monstres dans la littérature allemande du Moyen Âge: Contribution à l'étude du merveilleux médiéval*. 3 vols. Göppinger Arbeiten zur Germanistik 330. Göppingen: Kümmerle, 1982.

Lejeune, Rita, and Jacques Stiennon. *La legende de Roland dans l'art du Moyen Âge*. 2 vols. Brussels: Arcade, 1966.

Le Sage, David. "'Âne zuht' or 'ane schulde'? The Question of Iwein's Guilt." *Modern Language Review* 77 (1982): 100–113.

Linke, Hansjürgen. *Epische Strukturen in der Dichtung Hartmanns von Aue: Untersuchungen zur Formkritik, Werkstruktur und Vortragsgliederung*. München: Fink, 1968.

Lohse, Hans. *Iwein, der Ritter mit dem Löwen: Die Dichtung des Hartmann von Aue und ihre Wiedergabe durch die spätromanischen Wandmalereien im Hessenhof zu Schmalkalden*. Schmalkalden: n.p., 1952.

Loomis, Laura Hibbard. "The Table of the Last Supper in Religious and Secular Iconography." *Art Studies* 5 (1927): 71–88.

Loomis, Roger Sherman. *Arthurian Tradition and Chrétien de Troyes*. New York: Columbia University Press, 1949.

Loomis, Roger Sherman and Laura Hibbard Loomis. *Arthurian Legends in Medieval Art*. MLA Monograph Series. New York: Modern Language Association, 1938.

Lord, Albert B. *The Singer of Tales*. Harvard Studies in Comparative Literature 24. Cambridge, MA, 1960. New York: Atheneum, 1973.

Luard, Henry Richards, ed. *Lives of Edward the Confessor*. Rerum Britannicarum Medii Aevi Scriptores 3. London, 1858.

Lutterotti, Otto. *Schloß Runkelstein bei Bozen und seine Wandgemälde*. Innsbruck: Inn, 1931.

Mackowitz, Heinz. "Meister Hugo und die romanischen Wandmalereien im Raume Brixen." *Akten des XXV. Internationalen Kongresses für Kunstgeschichte: Wien, 4.-10. September, 1983*. Ed. Hermann Fillitz and Martina Pippal. Vol. 9: *Eröffnungs- und Plenarvorträge: Arbeitsgruppe "Neue Forschungsergebnisse und Arbeitsvorhaben."* Wien: Böhlau, 1985. 47–52, illus. 1–4. 9 vols.

MacLean, Sally-Beth. *Chester Art: A Subject List of Extant and Lost Art Including Items Relevant to Early Drama*. Kalamazoo, MI: Medieval Institute Publications, 1982.

Magnani, Luigi. *Gli Affreschi della Basilica di Aquileia*. Torino: ERI, Edizione RAI, 1960.

Maguire, Henry. "The Depiction of Sorrow in Middle Byzantine Art." *Dumbarton Oaks Papers* 31 (1977): 123–74.

Malfér, Viktor. *Die Triaden auf Schloß Runkelstein: Ihre Gestalten in Geschichte und Sage*. 3rd ed. Bozen: Heimatschutzverein Bozen, 1980.

Mannhardt, Wilhelm. *Wald- und Feldkulte. Erster Theil: Der Baumkultus der Germanen und ihrer Nachbarstämme*. Berlin, 1875.

Masser, Achim. "Die 'Iwein'-Fresken von Burg Rodenegg in Südtirol und der zeit-

genössische Ritterhelm." *Zeitschrift für deutsches Altertum und Philologie* 112 (1983): 177–98.

———. "Wege der Darbietung und der zeitgenössischen Rezeption höfischer Literatur." Kühebacher 382–406.

———. Review of *Rodenegg und Schmalkalden*, by Anne-Marie Bonnet. *Anzeiger für deutsches Altertum* 100 (1989): 91–97.

Maurer, Friedrich. "Der Topos von den 'Minnesklaven': Zur Geschichte einer thematischen Gemeinschaft zwischen bildender Kunst und Dichtung im Mittelalter." *Deutsche Vierteljahresschrift für Literaturwissenschaft und Geistesgeschichte* 27 (1953): 182–206. (Rpt. in Maurer, *Dichtung und Sprache des Mittelalters: Gesammelte Aufsätze*. Bern and München: Francke, 1963. 224–48.)

Maurer, Heinrich. "Ein Freiburger Bürger und seine Nachkommen." *Zeitschrift für die Geschichte des Oberrheins* ns 22 (1907): 9–51.

———. "Martin Malterer von Freiburg." *Zeitschrift der Gesellschaft für Beförderung der Geschichts-, Altertums-, und Volkskunde von Freiburg, dem Breisgau und den angrenzenden Landschaften* 6 (1883–1887): 193–240.

McConeghy, Patrick, ed. and trans. *Iwein*. By Hartmann von Aue. Garland Library of Medieval Literature A 19. New York: Garland, 1984.

McCulloch, Florence. "The Funeral of Renart the Fox in a Walters Book of Hours." *Journal of the Walters Art Gallery* 25–26 (1962–63): 9–27.

———. *Medieval Latin and French Bestiaries*. University of North Carolina Studies in the Romance Languages and Literatures 33. Rev. ed. Chapel Hill: University of North Carolina Press, 1962.

McGrath, Robert L. "A Newly Discovered Manuscript of Chrétien de Troyes' *Yvain* and *Lancelot* in the Princeton University Library." *Speculum* 38 (1963): 583–94.

———. "The Romance of the Maccabees in Mediaeval Art and Literature." Diss. Princeton University, 1963.

Meier, Christel and Uwe Ruberg. "Einleitung." *Text und Bild: Aspekte des Zusammenwirkens zweier Künste in Mittelalter und früher Neuzeit*. Ed. Christel Meier and Uwe Ruberg. Wiesbaden: Reichert, 1980. 9–18.

Meiss, Millard. *French Painting in the Time of Jean de Berry: the Late XIVth Century and the Patronage of the Duke*. National Gallery of Art: Kress Foundation Studies in the History of European Art 2. New York: Phaidon, 1967.

Melnikas, Anthony. *The Corpus of the Miniatures in the Manuscripts of Decretum Gratiani*. 3 vols. Studia Gratiana 16–18. Rome, 1975.

Mertens, Volker. *Laudine: Soziale Problematik im* Iwein *Hartmanns von Aue*. Zeitschrift für deutsche Philologie Beiheft 3. Berlin: Schmidt, 1978.

Messent, Claude J. W. *The City Churches of Norwich*. Norwich: Hunt, 1932.

Micha, Alexandre. *La Tradition Manuscrite des Romans de Chrétien de Troyes*. Paris: Droz, 1939.

Middleton, Roger. "Additional Notes on the History of Selected Manuscripts." Busby et al. 2: 177–243.

Migne, J.-P. *Patrologia Latina*. Paris, 1844–64. 221 vols.

Millet, Gabriel. *Recherches sur l'iconographie de l'évangile aux XIVe, XVe et XVIe siècles*. 12th ed. Paris: Boccard, 1960.

Mohr, Wolfgang. "Iweins Wahnsinn: Die Aventiure und ihr 'Sinn.'" *Zeitschrift für deutsches Altertum und Philologie* 100 (1971): 73–94.

Möller, Lise Lotte. *Die wilden Leute des Mittelalters*. Exhibition Catalog. Museum für Kunst und Gewerbe, Hamburg, 1963. [Hamburg], n.p., [1963].

Mone, F. J. "Bemerkungen zur Kunstgeschichte." *Zeitschrift für die Geschichte des Oberrheins* 17 (1865): 257–89.

Monumenta Zollerana: Urkunden-Buch zur Geschichte des Hauses Hohenzollern. Ed. Rudolph Freiherr von Stillfried and Traugott Maercker. Vol. 4. *Urkunden der Fränkischen Linie 1363–1378*. Berlin: Ernst und Korn, 1858. 8 vols. 1852–1866.

Morassi, Antonio. *Storia della Pittura nella Venezia Tridentia: dalle Origini alla Fine del Quattrocento*. [Roma]: Libreria dello Stato, [1934].

Muir, Lynette R. "A Reappraisal of the Prose *Yvain* (National Library of Wales MS. 444-D)." *Romania* 85 (1964): 355–65.

Mulertt, Werner. "Der 'wilde Mann' in Frankreich." *Zeitschrift für französische Sprache und Literatur* 56 (1932): 69–88.

Myslivec, J. "Tod Mariens." Kirschbaum et al. 4: cols. 333–38.

Myslivec, J. and G. Jászai. "Frauen am Grab." Kirschbaum et al. 2: cols. 54–62.

Neumann, Friedrich. "Einleitung." Thomasin iii–li.

Das Nibelungenlied. Ed. Karl Bartsch and Helmut de Boor. Deutsche Klassiker des Mittelalters. 20th ed. Wiesbaden: Brockhaus, 1972.

Nickel, Heinrich L. "Zu einigen Fragen der sächsischen Wandmalerei im 12. und in der ersten Hälfte des 13. Jahrhunderts." *Wandmalerei des Hochfeudalismus im europäische-byzantinischen Spannungsfeld (12. und 13. Jahrhundert)*. Ed. Heinrich L. Nickel. Martin-Luther-Universität Halle-Wittenberg Wissenschaftliche Beiträge 1983/14 (H 3). Halle: Martin-Luther-Universität, 1983.

Nickel, Heinrich L. et al. *Mittelalterliche Wandmalerei in der DDR*. Leipzig: Seemann, 1979.

Nixon, Terry. "Catalogue of Manuscripts." Busby et al. 2: 1–85.

Nolting-Hauff, Ilse, trans. *Yvain*. By Chrétien de Troyes. Klassische Texte des romanischen Mittelalters in zweisprachigen Ausgaben. München: Eidos, 1962.

Nöth, Winfried. *Handbook of Semiotics*. Advances in Semiotics. Bloomington: Indiana University Press, 1990.

"Notizen." *Mittheilungen der k.k. Central-Commission zur Erforschung und Erhaltung der Kunst- und historischen Denkmale* ns (1876): lxii–lxiii.

Oechelhaeuser, Adolf von. *Der Bilderkreis zum Wälschen Gaste des Thomasin von Zerclaere*. Heidelberg, 1890.

Ong, Walter J. *Interface of the Word: Studies in the Evolution of Consciousness and Culture*. Ithaca, NY: Cornell University Press, 1977.

Orange, John. *A Ten Minute Guide to the Choir Stalls and Misericords Including Some Information about Boston Parish Church*. [Boston, Eng.?]: n. p., 1979.

Ott, Norbert H. "Christherre-Chronik." Ruh 1: cols. 1213–1217.

———. "Epische Stoffe in mittelalterlichen Bildzeugnissen." *Epische Stoffe des Mittelalters*. Ed. Volker Mertens and Ulrich Müller. Stuttgart: PUB, 1984. 449–74.

———. "Geglückte Minne-Aventiure: Zur Szenenauswahl literarischer Bildzeugnisse im Mittelalter: Die Beispiele des Rodenecker *Iwein*, des Runkelsteiner

Tristan, des Braunschweiger Gawan- und des Frankfurter *Wilhelm-von-Orlens*-Teppichs." *Jahrbuch der Oswald von Wolkenstein Gesellschaft* 2 (1982/3): 1–32.

⸻. "Heinrich von München." Ruh 3: cols. 827–37.

⸻. "Katalog der Tristan-Bildzeugnisse." Frühmorgen-Voss, *Text und Illustration* 140–71.

⸻. "Minne oder *amor carnalis*? Zur Funktion der Minnesklaven-Darstellungen in mittelalterlicher Kunst." *Liebe in der deutschen Literatur: St. Andrews-Colloquium 1985.* Ed. Jeffrey Aschcroft, Dietrich Huschenbett, and William Henry Jackson. Tübingen: Niemeyer, 1987. 107–25.

⸻. "Text und Illustration im Mittelalter: Eine Einleitung." Frühmorgen-Voss, *Text und Illustration* ix–xxxi.

⸻. " 'Tristan' auf Runkelstein und die übrigen zyklischen Darstellungen des Tristanstoffes: Textrezeption oder medieninterne Eigengesetzlichkeit der Bildprogramme?" Haug et al. 194–239.

Ott, Norbert H. and Wolfgang Walliczek. "Bildprogramm und Textstruktur: Anmerkungen zu den 'Iwein'-Zyklen auf Rodeneck und in Schmalkalden." Cormeau, *Deutsche Literatur* 473–500.

"Owein, or the Countess of the Fountain." *The Mabinogion.* Trans. Jeffrey Gantz. Penguin Classics. Harmondsworth: Penguin, 1976. 192–216.

Owst, G. R. *Literature and Pulpit in Medieval England: A Neglected Chapter in the History of English Letters and of the English People.* 1933. Oxford: Basil Blackwell, 1966.

⸻. *Preaching in Medieval England: An Introduction to Sermon Manuscripts of the Period c. 1350–1450.* Cambridge: Cambridge University Press, 1926.

Pächt, Otto. *The Rise of Pictorial Narrative in Twelfth-Century England.* Oxford: Clarendon, 1962.

Pächt, Otto, C. R. Dodwell, and Francis Wormald. *The St. Albans Psalter (Albani Psalter).* Studies of the Warburg Institute 25. London: Warburg Institute, 1960.

Pakula, Marvin H. *Heraldry and Armor of the Middle Ages.* South Brunswick: Barnes, 1972.

Palli, E. Lucchesi, and L. Hoffscholte. "Abendmahl." Kirschbaum, et al. 1: cols. 10–18.

Panofsky, Erwin. *Studies in Iconology: Humanistic Themes in the Art of the Renaissance.* 1939. New York: Harper and Row, 1962.

Pastoureau, Michel. *Armorial des Chevaliers de la Table Ronde.* Paris: Léopard d'Or, 1983.

⸻. "Études d'héraldique arthurienne: les armoiries de Gauvain." *Archivum Heraldicum* 98 (1984): 2–10.

⸻. *Traité d'héraldique.* Paris: Picard, 1979.

Patze, Hans. *Die Entstehung der Landesherrschaft in Thüringen.* Teil 1. Mitteldeutsche Forschungen 22. Köln: Böhlau, 1962.

⸻. "Schmalkalden." *Thüringen.* Ed. Hans Patze. Stuttgart: Kröner, 1968. Vol. 9 of *Handbuch der historischen Stätten.* 15 vols. 1958–1977.

Patze, Hans and Walter Schlesinger. *Geschichte Thüringens.* Vol. 2. *Hohes und spätes*

Mittelalter. Mitteldeutsche Forschungen 48. Köln: Böhlau, 1973–1974. 4 vols. 1968–1972.

Paulsen, Peter. *Drachenkämpfer, Löwenritter und die Heinrichsage: Eine Studie über die Kirchtür von Valthjofstad auf Island.* Köln/Graz: Böhlau, 1966.

Peil, Dietmar. *Die Gebärde bei Chrétien, Hartmann und Wolfram: Erec-Iwein-Parzival.* Medium Aevum Philologische Studien 28. München: Fink, 1975.

Perella, Nicolas James. *The Kiss Sacred and Profane: An Interpretative History of Kiss Symbolism and Related Relgio-Erotic Themes.* Berkeley and Los Angeles: University of California Press, 1969.

Perriccioli-Saggese, Alessandra. *I Romanzi Cavallereschi Miniati a Napoli.* Miniatura e Arti Minori in Campania: Collano di Saggi e di Studi 14. [Napoli]: Napoletana, 1979.

Pevsner, Nikolaus. *The Buildings of England: Staffordshire.* Harmondsworth: Penguin Books, 1974.

Pickering, F. P. *Literature and Art in the Middle Ages.* London: Macmillan, 1970.

Purvis, J. S. "The Use of Continental Woodcuts and Prints by the 'Ripon School' of Woodcarvers in the early Sixteenth Century." *Archaeologia* 85 (1935): 107–27.

Rahilly, Leonard James. "The Garrett Manuscript no. 125 of Chrestien's *Chevalier de la Charette* and *Chevalier au Lion*: A Critical Study, with Transcription." Diss., Princeton University, 1971.

——. "Le manuscrit Garrett 125 du *Chevalier de la Charrette* et du *Chevalier au lion*: un nouveau manuscrit." *Romania* 94 (1973): 407–10.

Randall, Lilian M. C. *Images in the Margins of Gothic Manuscripts.* Berkeley and Los Angeles: University of California Press, 1966.

Rasmo, Nicolò. *Affreschi Medioevali Atesini.* n.p.: Electra, n.d. Identical with Rasmo, Nicolò. *Affreschi del Trentino e dell'Alto Adige.* [Trento]: Instituto Trentino—Alto Adige per Assizurazioni—Trento, 1971.

——. "Aspects of Art." *Trentino Alto Adige.* Sandro Gattei et al. Trans. Rudolph Carpanini, Richard J. Dury, Richard McKeon Sadleir. N.p.: Electra for Banca Nazionale del Lavoro, 1979. 168–74.

——. *Kunstschätze Südtirols.* Rosenheim: Rosenheimer, 1985. [Expanded and updated version of *Kunst in Südtirol*, 1973.]

——. *Pitture Murali in Alto Adige.* [Bozen?]: Cassa di Risparmio della Provincia di Bolzano, 1973.

——. "Runkelstein." *Tiroler Burgenbuch.* Ed. Oswald Trapp. Vol. 5. Bozen: Athesia, 1981. 109–76. 8 vols. to date. Bozen: Athesia; Innsbruck: Tyrolia, 1972-.

——. "Überraschende Funde." *Merian: Monatshefte der Städte und Landschaften: Südtirol* 26, 9 (1974): 48, 100.

Reallexikon zur deutschen Kunstgeschichte. 8 vols. and 4 additional fascicles to date. Stuttgart: Metzler; Stuttgart: Druckenmüller; München: Beck, 1937- .

Reau, Louis. *Iconographie de l'art chrétien.* 3 vols. Paris: Presses Universitaires de France, 1955–1958.

Redlich, Oswald, ed. *Die Traditionsbücher des Hochstifts Brixen vom 10. bis in das 14. Jahrhundert.* Acta Tirolensia: Urkundliche Quellen zur Geschichte Tirols. 1886. Aalen: Scientia, 1973.

Reinitzer, Heimo. "Über Beispielfiguren im *Erec.*" *Deutsche Vierteljahresschrift für Literaturwissenschaft und Geistesgeschichte* 50 (1976): 597–639.

Remnant, G. L. *A Catalogue of Misericords in Great Britain*. Oxford: Clarendon, 1969.

Restaurierte Kunstwerke in der Deutschen Demokratischen Republik: Ausstellung im Alten Museum, Staatliche Museen zu Berlin, April-Juni 1980. [Berlin:] Verband Bildender Künstler der DDR, 1979.

Richards, Raymond. *Old Cheshire Churches: A Survey of Their History, Fabric and Furniture with Records of the Older Monuments*. London: Batsford, 1947.

"Ring." *Handwörterbuch des deutschen Aberglaubens*. Ed. Hanns Bächtold-Stäubli. 10 vols. Berlin: de Gruyter, 1927–42.

Ringbom, Sixten. "Some Pictorial Conventions for the Recounting of Thoughts and Expressions in Late Medieval Art." In *Medieval Iconography and Narrative: A Symposium*. Proceedings of the Fourth International Symposium Organized by the Centre for the Study of Vernacular Literature in the Middle Ages held at Odense University on 19–20 November, 1979. Ed. Flemming G. Andersen et al. Odense: Odense University Press, 1980. 38–69.

Ringler, J. "Stocinger." *Allgemeines Lexikon der bildenden Künstler*. Ed. Hans Vollmer. Leipzig: Seemann, 1938.

Ritchie, R. L. Graeme, ed. *The Buik of Alexander: or the Buik of the Most Noble and Valiant Conqueror Alexander the Grit*. By John Barbour. 4 vols. Scottish Text Society 12, 17, 21, 25. Edinburgh: Blackwood, 1921–1929.

Robertson, D. W., Jr. *A Preface to Chaucer: Studies in Medieval Perspectives*. Princeton, NJ: Princeton University Press, 1962.

———. "Some Medieval Literary Terminology, with Special Reference to Chrétien de Troyes." *Studies in Philology* 48 (1951): 669–92. Rpt. in Robertson, *Essays in Medieval Culture*. Princeton, NJ: Princeton University Press, 1980. 51–72.

Roe, Fred. "More About Misericords." *Connoisseur* 77 (1927): 77–80.

Roethe, Gustav, ed. *Die Gedichte Reinmars von Zweter*. Leipzig, 1887.

Ross, D. J. A. "Methods of Book-Production in a XIVth-Century French Miscellany." *Scriptorium* 6 (1952): 63–75.

———. *Illustrated Medieval Alexander-Books in Germany and the Netherlands*. Publications of the Modern Humanities Research Association 3. Cambridge, Eng.: Modern Humanities Research Association, 1971.

Royal Commission on Historical Monuments in England: An Inventory of the Historical Monuments in the City of Oxford. London: HMSO, 1939.

Ruh, Kurt, ed. *Die deutsche Literatur des Mittelalters: Verfasserlexikon*. 2nd, rev. ed. 5 vols to date. Berlin: de Gruyter, 1977– .

Rushing, James A., Jr. "Adventures beyond the Text: Ywain in the Visual Arts." Diss. Princeton University, 1988.

———. "Iwein as Slave of Woman: The 'Maltererteppich' in Freiburg." *Zeitschrift für Kunstgeschichte* 61 (1992): 124–35.

———. "The Enville Ywain Misericord." *Bibliographical Bulletin of the International Arthurian Society* 38 (1986): 279–88.

Salmon, Paul. "The Wild Man in *Iwein* and Medieval Descriptive Technique." *Modern Language Review* 56 (1961): 520–28.

———. "'Âne zuht': Hartmann von Aue's Criticism of Iwein." *Modern Language Review* 69 (1974): 556–61.

Sandler, Lucy. "The Handclasp in the *Arnolfi Wedding*: A Manuscript Precedent." *Art Bulletin* 66 (1984): 488–91.

Sauer, Joseph. *Symbolik des Kirchengebäudes und seiner Ausstattung in der Auffassung des Mittelalters: Mit Berücksichtigung von Honorius Augustodunensis, Sicardus und Durandus*. 2nd ed. Freiburg, 1924. Münster: Mehren und Hobbeling, 1964.

Schapiro, Meyer. *Words and Pictures*. The Hague: Mouton, 1973.

Scheine, J. "Wilde Leute." Kirschbaum et al. 4: col. 531.

Scheuber, Joseph. *Die mittelalterlichen Chorgestühle in der Schweiz*. Straßburg: Heitz, 1910.

Schiller, Gertrud. *Ikonographie der christlichen Kunst*. 4 vols. Gütersloh: Gerd Mohn, 1968.

Schirok, Bernd. *Wolfram von Eschenbach "Parzival": Die Bilder der illustrierten Handschriften*. Litterae: Göppinger Beiträge zur Textgeschichte. Göppingen: Kümmerle, 1985.

[Schmidt, F.] "Der heutige Zustand der Burg Runkelstein." *Mittheilungen der k.k. Central-Commission zur Erforschung und Erhaltung der Kunst- und historischen Denkmale* ns 1 (1875): xxxv–xxxvi.

Schmidt-Pech, Heinrich. "Alte Hausmalereien in Konstanz." *Das Bodenseebuch* 27 (1940): 32–37.

Schmidt-Wiegand, Ruth. "Text und Bild in den Codices Picturati des 'Sachsenspiegels': Überlegungen zur Funktion der Illustration." *Text-Bild-Interpretation: Untersuchungen zu den Bilderhandschriften des Sachsenspiegels*. Ed. Ruth Schmidt-Wiegand. Vol. 1. Münstersche Mittelalter-Schriften 55. München: Fink, 1986. 11–31. 2 vols.

Schneider, Karin. *Gotische Schriften in deutscher Sprache*. Vol. 1. *Vom späten 12. Jahrhundert bis um 1300*. Wiesbaden: Reichert, 1987.

Schnell, Rüdiger. *Causa Amoris: Liebeskonzeption und Liebesdarstellung in der mittelalterlichen Literatur*. Bibliotheca Germanica 27. Bern: Francke, 1985.

Scholes, Robert. "Decoding Papa: 'A Very Short Story' as Work and Text." *Semiotics and Interpretation*. New Haven, CT: Yale University Press, 1982. 110–26.

Schönbach, Anton E. *Über Hartmann von Aue: Drei Bücher Untersuchungen*. Graz, 1894.

Schönherr, David von. "Das Schloß Runkelstein bei Bozen." *David von Schönherrs Gesammelte Schriften*. Vol. 1. *Kunstgeschichtliches*. Ed. Michael Mayr. Innsbruck: Wagner, 1900. 652–83. 2 vols.

———. "Urkunden und Regesten aus dem k.k. Statthalterei-Archiv in Innsbruck." *Jahrbuch der kunsthistorischen Sammlungen des allerhöchsten Kaisershauses* 2 (1884): i–clxxxviii.

Schroeder, Horst. "The Nine Worthies: A Supplement." *Archiv für das Studium der neueren Sprachen und Literaturen* 218 (1981): 330–40.

———. *Der Topos der Nine Worthies in Literatur und bildender Kunst*. Göttingen: Vandenhoeck und Ruprecht, 1971.

Schroth, Ingeborg. *Meisterwerke mittelalterlicher Kunst in Baden: Ausstellung im Augustinermuseum Juni–September 1946*. Freiburg: Urban, 1946.

Schuette, Marie and Sigrid Müller-Christensen. *Das Stickereiwerk*. Tübingen: Wasmuth, 1963.

Schultz, Alwin. *Das höfische Leben zur Zeit der Minnesänger*. 2nd ed. 2 vols. Leipzig, 1889.

Schultz, James A. *The Shape of the Round Table: Structures of Middle High German Arthurian Romance*. Toronto: University of Toronto Press, 1983.

Schupp, Volker. "Kritische Anmerkungen zur Rezeption des deutschen Artusromans anhand von Hartmanns 'Iwein': Theorie-Text-Bildmaterial." *Frühmittelalterliche Studien* 9 (1975): 405–42.

———. "'Scriptorialisches' zum Malterer-Teppich." *Vielfalt des Deutschen: Festschrift für Werner Besch*. Ed. Klaus J. Mattheier, et al. Frankfurt: Peter Lang, 1993. 149–59.

———. "Die Ywain-Erzählung von Schloss Rodenegg." *Literatur und bildende Kunst im Tiroler Mittelalter*. Ed. Egon Kühebacher. Innsbrucker Beiträge zur Kulturwissenschaft. Germanistische Reihe 15. Innsbruck: n.p., 1982. 1–27.

Schweikle, Günther. "Versuche wechselseitiger Erhellung mittelalterlicher Dichtung und Kunst." *Festschrift für Kurt Herbert Halbach*. Ed. Rose Beate Schäfer-Maulbetsch, Manfred Günter Scholz, and Günther Schweikle. Göppinger Arbeiten zur Germanistik 70. Göppingen: Alfred Kümmerle, 1972. 35–53.

Schweitzer, Hermann. "Die Bilderteppiche und Stickereien in der städtischen Altertümersammlung zu Freiburg im Breisgau." *Schau-ins-Land* 431 (1904): 35–64.

Scott, William. *Stourbridge and its Vicinity* Stourbridge, 1832.

Seelos, Ignaz, and Ignaz Vinzenz Zingerle. *Fresken-Cyklus des Schlosses Runkelstein bei Bozen*. Innsbruck, 1857.

Segre, Cesare, ed. *Li Bestiaires d'Amour di Maistre Richart de Fornival e li Response du Bestiaire*. By Richard de Fournival. Milano: Riccardi, 1957.

Shaw, Stebbing. *The History and Antiquities of Staffordshire* 2 vols. London, 1798.

Sidonius. *Poems and Letters*. Ed. and trans. W. B. Anderson. Vol 2. Loeb Classical Library. London: Heinemann, 1965. 2 vols.

Simson, Otto von. *Das Mittelalter II*. Propyläen Kunstgeschichte 6. Berlin: Propyläen, 1972.

Smeets, Jean-Robert. *La Chevalerie de Judas Macabé*. Assen: Van Gorcum, [1956?].

Smith, Susan Louise. "The Power of Women Topos on a Fourteenth-Century Embroidery." *Viator* 21 (1990): 203–28.

———. "'To Women's Wiles I Fell': The Power of Women *Topos* and the Development of Medieval Secular Art." Diss., University of Pennsylvania 1978. Ann Arbor: University Microfilms International, 1978.

Smits, Kathryn, ed. *Die frühmittelhochdeutsche Wiener Genesis: Kritische Ausgabe mit einem einleitenden Kommentar zur Überlieferung*. Philologische Studien und Quellen 59. Berlin: Schmidt, 1972.

Solterer, Helen. "Letter Writing and Picture Reading: Medieval Textuality and the *Bestiaire d'Amour*." *Word & Image* 5 (1989): 131–47.

Sommer, H. Oskar, ed. *The Vulgate Version of the Arthurian Romances, Edited from Manuscripts in the British Museum*. 7 vols. Washington, DC, 1908–16. New York: AMS, 1979.

Sparber, Anselm. "Brixen." *Lexikon für Theologie und Kirche*. 2nd ed. Ed. Josef Höfer and Karl Rahner. Freiburg: Herder, 1986. Cols. 699–700.

———. *Die Brixener Fürstbischöfe im Mittelalter: Ihr Leben und Wirken*. Bozen: Athesia, 1968.

———. "Der Brixener Bischofskatalog." *Mitteilungen des Instituts für österreichische Geschichtsforschung* 53 (1950): 373–85.

Spargo, John Webster. *Virgil the Necromancer: Studies in Virgilian Legends*. Harvard Studies in Comparative Literature 10. Cambridge, MA: Harvard University Press, 1934.

Stackmann, Karl and Karl Bertau, eds. *Leiche, Sangsprüche, Lieder*. By Frauenlob [Heinrich von Meissen]. Abhandlungen der Akademie der Wissenschaften in Göttingen, Philologisch-Historische Klasse 3rd ser. 119, 120. 2 vols. Göttingen: Vandenhoeck und Ruprecht, 1981.

Stammler, Wolfgang. "Aristoteles." *Reallexikon zur deutschen Kunstgeschichte*.

———. "Der Philosoph als Liebhaber." In Stammler, *Wort und Bild: Studien zu den Wechselbeziehungen zwischen Schrifttum und Bildkunst im Mittelalter*. Berlin: Schmidt, 1962. 12–44.

———. "Schrifttum und Bildkunst im deutschen Mittelalter." *Deutsche Philologie im Aufriss*. Ed. Wolfgang Stammler. Vol. 3. 2nd ed. Berlin: Erich Schmidt, 1962. 613–98. 3 vols. 1952–57.

Stammler, Wolfgang, and Karl Langosch, eds. *Die deutsche Literatur des Mittelalters: Verfasserlexikon*. 5 vols. Berlin: de Gruyter, 1933–55.

Steer, Francis W. *The Archives of New College, Oxford*. London: Phillimore, 1974.

———. *Misericords at New College, Oxford*. London: Phillimore, 1973.

Steinhoff, Hans-Hugo. "Herbort von Fritzlar." Ruh 3: cols. 1027–31.

Stock, Brian. *The Implications of Literacy: Written Language and Models of Interpretation in the Eleventh and Twelfth Centuries*. Princeton, NJ: Princeton University Press, 1983.

Stone, Lawrence. *Sculpture in Britain in the Middle Ages*. Pelican History of Art z9. Harmondsworth: Penguin, 1955.

Stones, Alison. "Arthurian Art Since Loomis." *Arturus Rex*. Ed. Willy Van Hoecke, Gilbert Tournoy, and Werner Verbeke. Mediaevalia Lovaniensia series 1, 17. Leuven: Leuven University Press, 1991. 21–78.

———. "The Illustrated Chrétien Manuscripts and Their Artistic Context." Busby et al. 1: 227–322.

———. "The Illustration of the French Prose *Lancelot* in Flanders, Belgium and Paris: 1250–1340." Diss. University of London, 1970.

Der Stricker. *Daniel von dem Blühenden Tal*. Ed. Michael Resler. Altdeutsche Textbibliothek 92. Tübingen: Niemeyer, 1981.

Strich, Fritz. "Der Lyrische Stil des Siebzehnten Jahrhunderts." *Abhandlungen zur deutschen Literaturgeschichte: Franz Muncker zum 60. Geburtstage*. München: Beck, 1916. 21–53.

Stülpnagel, W. "Grundherrschaften und Grundbesitzer." Statistisches Landesamt Baden-Württemberg. *Freiburg im Breisgau Stadt und Landkreis: Amtliche Kreisbeschreibung*. N.p.: Statistisches Landesamt Baden-Württemberg, 1965. Vol. 1, pt. 1: 267–311. 2 vols. in 4.

Swarzenski, Hanns. *Monuments of Romanesque Art: The Art of Church Treasures in North-Western Europe*. London: Faber and Faber, 1953.

Swoboda, Heinrich. "Neuaufbau des Domes." *Der Dom von Aquileia: Sein Bau und seine Geschichte*. Ed. Karl Graf Lanckoronski [-Brzezie]. Wien: Gerlach und Wiedling, 1906. 80–118.

Szklenar, Hans. "Iwein-Fresken auf Schloss Rodeneck in Südtirol." *Bibliographical Bulletin of the International Arthurian Society* 27 (1975): 172–80.

Tacitus. *The Histories and the Annals*. With trans. by Clifford H. Moore and John Jackson. 3 vols. Loeb Classical Library. London: Heinemann; New York: Putnam, 1931.

Thomas, Helmuth. *Untersuchungen zur Überlieferung der Spruchdichtung Frauenlobs*. Palaestra 217. Leipzig, 1939. New York: Johnson Reprint, 1970.

Thomasin von Zirclaria. *Der wälsche Gast*. Ed. Heinrich Rückert. Quedlinburg, 1852. Berlin: de Gruyter, 1965.

[Thompson, Henry Yates.] *Illustrations from One Hundred Illuminated Manuscripts in the Library of Henry Yates Thompson*. vol. 6. London: Chiswick, 1916. 7 vols. 1907–18.

Tobler, Adolf and Erhard Lommatzsch. *Altfranzösisches Wörterbuch*. Berlin: Weidmann, 1925–1976.

Töchterle, G. "Die Herren von Rodank und Schöneck." *Der Schlern* 12 (1931): 18–29, 93–100, 141–45.

Tractatus Statutorum Ordinis Cartusiensis pro Noviciis ejusdem Ordinis proficere in ipsus Observanciis consuetis cupientibus, valdé utilis (Cotton Nero A.III. fol.139). In *Monasticon Anglicanum: A History of the Abbies and other Monasteries* Ed. William Dugdale. Vol. 6. London, 1846. v–xii. 6 vols.

Tracy, Charles. *English Gothic Choir-Stalls 1200–1400*. Woodbridge, Suffolk: Boydell, 1987.

Tunison, J. S. *Master Virgil: The Author of the Aenied as he seemed in the Middle Ages*. Cincinnati, 1888.

Turner, Ralph V. "The *Miles Literatus* in Twelfth- and Thirteenth-Century England: How Rare a Phenomenon?" *American Historical Review* 83 (1978): 928–45.

Uitti, Karl D. "Le Chevalier au Lion (Yvain)." *The Romances of Chrétien de Troyes: A Symposium*. Ed. Douglas Kelly. Edward C. Armstrong Monographs on Medieval Literature 3. Lexington, KY: French Forum, 1985. 182–231.

Ulrich von Lichtenstein. *Ulrich von Lichtenstein*. Ed. Karl Lachmann. Berlin, 1841.

Van D'Elden, Stephanie Cain. "Specific and Generic Scenes: A Model for Analyzing Medieval Illustrated Texts Based on the Example of *Yvain/Iwein*." *Bibliographical Bulletin of the International Arthurian Society* 44 (1992): 255–69.

van Marle, Raimond. *The Development of the Italian Schools of Painting*. Vol. 7. The Hague: Martinus Nijhoff, 1926. 18 vols. 1923–1936.

———. *Iconographie de l'art profane au Moyen-Âge et à la Renaissance et la décoration des demeures*. 2 vols. La Haye: Nijhoff, 1931–32.

Vergilius Maro, P. *Aeneid*. *Virgil*. Ed. and trans. H. Rushton Fairclough. Loeb Classics. Rev. ed. 2 vols. Cambridge, MA: Harvard University Press, 1978.

Vintler, Hans. *Die pluemen der tugent*. Ed. Ignaz V. Zingerle. Ältere Tirolische Dichter 1. Innsbruck, 1874.

Visitations of the Archdeaconry of Staffordshire 1829–41. Ed. David Robinson. Col-

lections for a History of Staffordshire, 4th ser., vol. 10. London: HMSO, 1980.

Vitzthum, Georg Graf. *Die Pariser Miniaturmalerei von der Zeit des hl. Ludwig bis zu Philipp von Valois und ihr Verhältnis zur Malerei in Nordwesteuropa.* Leipzig: Quelle, Meyer, 1907.

von der Osten, Gert. "Beweinung Christi." *Reallexikon zur deutschen Kunstgeschichte.*

Walliczek, Wolfgang. "Die bibliographische Situation in der Erforschung der Bezüge zwischen höfischer Erzähldichtung und bildender Kunst des Mittelalters." *Bibliographische Probleme im Zeichen eines erweiterten Literaturbegriffs: Zweites Kolloquium zur bibliographischen Lage in der germanistischen Literaturwissenschaft, veranstaltet von der Deutschen Forschungsgemeinschaft an der Herzog August Bibliothek Wolfenbüttel, 23. bis 25. September, 1985.* Mitteilung IV der Kommission für Germanistische Forschung. Weinheim: VCH, Acta Humaniora, 1988. 143–58.

Walters, Lori. "The Creation of a 'Super Romance': Paris, Bibliothèque Nationale, fonds français, MS 1433." *Arthurian Yearbook* 1 (1991): 3–26.

Walther, Hans, ed. *Proverbia Sententiaeque Latinatis Medii Aevi*, Teil 1. Göttingen: Vandenhoeck und Ruprecht, 1963. 9 vols. 1963–86.

Walzel, Oskar. "Über Shakespeares dramatische Baukunst." *Jahrbuch der deutschen Shakespeare-Gesellschaft* 52 (1916): 3–35.

———. "Wechselseitige Erhellung der Künste: Ein Beitrag zur Würdigung kunstgeschichtlicher Begriffe." *Philosophische Vorträge* 15 (1917): 5–92.

Wapnewski, Peter. *Hartmann von Aue.* 2nd ed. Sammlung Metzler. Stuttgart: Metzler, 1964.

Weber, Paul. "Die Iweinbilder aus dem 13. Jahrhundert im Hessenhofe zu Schmalkalden." *Zeitschrift für bildende Kunst* ns 12 (1900–1901): 73–84, 113–20.

———. *Kreis Herrschaft Schmalkalden.* Marburg: Elwert, 1913. Vol. 5 of *Die Bau- und Kunstdenkmäler im Regierungsbezirk Cassel.* 8 vols. 1901–34.

Wehrhahn-Strauch, Liselotte. "Einhorn." *Reallexikon zur deutschen Kunstgeschichte.*

Wehrli, Max. "Iweins Erwachen." *Geschichte—Deutung—Kritik: Literaturwissenschaftliche Beiträge dargebracht zum 65. Geburtstag Werner Kohlschmidts.* Ed. Maria Bindschedler and Paul Zingli. Bern: Francke, 1969. 64–78.

Weingartner, Josef. *Die Kunstdenkmäler Südtirols.* 2nd ed. 3 vols. Innsbruck: Tyrolia, 1951–56.

———. "Die profane Wandmalerei Tirols im Mittelalter." *Münchner Jahrbuch der bildenden Kunst* ns 5 (1928): 1–63.

———. *Tiroler Burgenkunde: Geschichte, Bewohner, Anlage und Verfall der Burgen, Dorfburgen, Stadtbefestigungen, Klausen and Schanzen.* Innsbruck: Rohrer, 1950.

———. "Die Wandmalerei Deutschtirols am Ausgange des XIV. und zu Beginn des XV. Jahrhunderts." *Jahrbuch des kunsthistorischen Instituts der k.k. Zentral-Kommission für Denkmalpflege* 6 (1912): 1–60.

Weinhold, Karl. *Die deutschen Frauen in dem Mittelalter.* 2nd ed. 2 vols. in 1. 1882. Amsterdam: Rodopi, 1968.

Weitzmann, Kurt. *Illustrations in Roll and Codex: A Study of the Origin and Method*

of Text Illustration. 2nd ed. Studies in Manuscript Illumination 2. Princeton, NJ, 1947. Princeton, NJ: Princeton University Press, 1970.

———. "The Origin of the Threnos." *De Artibus Opuscula XL: Essays in Honor of Erwin Panofsky.* Ed. Millard Meiss. New York: New York University Press, 1961. 476–89.

Wells, David A. "Die Ikonographie von Daniel IV und der Wahnsinn des Löwen-ritters." *Interpretation und Edition deutscher Texte des Mittelalters: Festschrift für John Asher zum 60. Geburtstag.* Ed. Kathryn Smits et al. Berlin: Erich Schmidt, 1981. 39–57.

West, G. D. *An Index of Proper Names in French Arthurian Verse Romances 1150–1300.* University of Toronto Romance Series 15. Toronto: University of Toronto Press, 1969.

Whitaker, Muriel. *The Legends of King Arthur in Art.* Arthurian Studies 22. Cambridge: D. S. Brewer, 1990.

White, Hayden. "The Forms of Wildness: Archaeology of an Idea." *The Wild Man Within: An Image in Western Thought from the Renaissance to Romanticism.* Ed. Edward Dudley and Maximillian E. Novak. Pittsburgh: University of Pittsburgh Press, 1972. 3–38.

White, William. *History, Gazetteer and Directory of Norfolk, Including the City of Norwich* 4th ed. Sheffield and London, 1883.

Wickhoff, Franz. "Der Stil der Genesisbilder und die Geschichte seiner Entwick-lung." *Die Wiener Genesis.* Ed. Wilhelm Ritter von Hartel and Franz Wick-hoff. Separatausgabe der Beilage zum XV. und XVI. Bande des Jahrbuchs der kunsthistorischen Sammlungen des allerhöchsten Kaiserhauses. Vienna, 1895. 1–96.

Wickenden, [Joseph Frederic]. "The Choir Stalls of Lincoln Cathedral." *Associated Architectural Societies' Reports and Papers* 15, pt. 2 (1880): 179–97.

"Wilde." *Handwörterbuch des deutschen Aberglaubens.* Ed. Hanns Bächtold-Stäubli. 10 vols. Berlin: de Gruyter, 1927–1942.

Wisbey, Roy. "Wunder des Ostens in der 'Wiener Genesis' und in Wolframs 'Parzival.'" *Studien zur frühmittelhochdeutschen Literatur: Cambridger Collo-quium 1971.* Ed. L. P. Johnson, et al. Berlin: Schmidt, 1974. 180–214.

———. "Die Darstellung des Häßlichen im Hoch- und Spätmittelalter." *Deutsche Literatur des späten Mittelalters: Hamburger Colloquium 1973.* Ed. Wolfgang Harms and L. P. Johnson. Berlin: Schmidt, 1975. 9–34.

Wittkower, Rudolf. "Marvels of the East: A Study in the History of Monsters." *Journal of the Warburg and Courtauld Institutes* 5 (1942): 159–97.

Woledge, Brian. *Commentaire sur* Yvain (Le Chevalier au Lion) *de Chrétien de Troyes.* 2 vols. Geneva: Droz, 1986–88.

Wolff, Ludwig. "Handschriftenübersicht." Hartmann von Aue, *Iwein,* ed. Benecke, Lachmann, and Wolff. Vol. 1. 1–12.

Wolfgang, A[rthur]. "Misericords in Lancashire and Cheshire Churches." *Trans-actions of the Historic Society of Lancashire and Cheshire* 63 (1911): 79–87.

Wolfram von Eschenbach. *Parzifal.* In *Wolfram von Eschenbach.* Ed. Karl Lachmann. 6th ed. Berlin: de Gruyter, 1930.

———. *Willehalm.* In *Wolfram von Eschenbach.* Ed. Albert Leitzmann. vols. 4 and

5. Altdeutsche Textbibliothek 15 and 16. 5th ed. Tübingen: Niemeyer, 1963. 5 vols.

Wright, Thomas. "On the Carvings of the Stalls in Cathedral and Collegiate Churches." *Essays on Archaeological Subjects, and on Various Questions Connected with the History of Art, Science, and Literature in the Middle Ages.* Vol. 2. London, 1861. 111–28. 2 vols.

Wyss, Robert L. "Die neun Helden: Eine Ikonographische Studie." *Zeitschrift für schweizerische Archäologie und Kunstgeschichte* 17 (1957): 73–106.

Yates, Frances A. *The Art of Memory.* Chicago: University of Chicago Press, 1966.

Ywain and Gawain. Ed. A. B. Friedman and N. T. Harrington. EETS 254. London: Oxford University Press, 1964.

Zenker, Rudolf. *Forschungen zur Artusepik I: Ivainstudien.* Beihefte zur Zeitschrift für romanische Philologie 70. Halle: Niemeyer, 1921.

Zießler, Rudolf. *Die Iweinmalereien im Hessenhof zu Schmalkalden.* Schmalkalden: Fremdenverkehrsamt des Magistrates der Stadt Schmalkalden, nd.

Zießler, Rudolf et al. *Architekturführer DDR: Bezirk Suhl.* Berlin: VEB Verlag für Bauwesen, 1989.

Zimerman, Heinrich. "Urkunden und Regesten aus dem k.u.k. Haus-, Hof- und Staats-Archiv in Wien." *Jahrbuch der kunsthistorischen Sammlungen des allerhöchsten Kaiserhauses* 1 (1883): i–lxxviii.

Zimerman, Heinrich and Franz Kreyczi. "Urkunden und Regesten aus dem k.u.k. Reichs-Finanz-Archiv." *Jahrbuch der kunsthistorischen Sammlungen des allerhöchsten Kaiserhauses* 3 (1885): i–lxxxi.

Zingerle, Ignaz V. "Die Fresken im Schlosse Runkelstein." *Germania* 2 (1857): 467–69.

————. "Zu den Bildern von Runkelstein." *Germania* 23 (1878): 28–30.

Zingerle, Oswald von. "Hans Vintler." *Allgemeine deutsche Biographie.* 56 vols. 1875–1912. Berlin: Duncker und Humboldt, 1967–71.

Index

University of Pennsylvania Press
MIDDLE AGES SERIES
Ruth Mazo Karras and Edward Peters, General Editors

F. R. P. Akehurst, trans. *The* Coutumes de Beauvaisis *of Philippe de Beaumanoir.*
1992

Peter L. Allen. *The Art of Love: Amatory Fiction from Ovid to the* Romance of the
Rose. 1992

David Anderson. *Before the Knight's Tale: Imitation of Classical Epic in Boccaccio's*
Teseida. 1988

Benjamin Arnold. *Count and Bishop in Medieval Germany: A Study of Regional Power,*
1100–1350. 1991

Mark C. Bartusis. *The Late Byzantine Army: Arms and Society, 1204–1453.* 1992

Thomas N. Bisson, ed. *Cultures of Power: Lordship, Status, and Process in Twelfth-*
Century Europe. 1995

Uta-Renate Blumenthal. *The Investiture Controversy: Church and Monarchy from the*
Ninth to the Twelfth Century. 1988

Daniel Bornstein, trans. *Dino Compagni's* Chronicle *of Florence.* 1986

Maureen Boulton. *The Song in the Story: Lyric Insertions in French Narrative Fiction,*
1200–1400. 1993

Betsy Bowden. *Chaucer Aloud: The Varieties of Textual Interpretation.* 1987

Charles R. Bowlus. *Franks, Moravians, and Magyars: The Struggle for the Middle*
Danube, 788–907. 1995

James William Brodman. *Ransoming Captives in Crusader Spain: The Order of Merced*
on the Christian-Islamic Frontier. 1986

Kevin Brownlee and Sylvia Huot, eds. *Rethinking the* Romance of the Rose: *Text,*
Image, Reception. 1992

Matilda Tomaryn Bruckner. *Shaping Romance: Interpretation, Truth, and Closure in*
Twelfth-Century French Fictions. 1993

Otto Brunner (Howard Kaminsky and James Van Horn Melton, eds. and trans.).
Land and Lordship: Structures of Governance in Medieval Austria. 1992

Robert I. Burns, S.J., ed. *Emperor of Culture: Alfonso X the Learned of Castile and*
His Thirteenth-Century Renaissance. 1990

David Burr. *Olivi and Franciscan Poverty: The Origins of the* Usus Pauper *Controversy.*
1989

David Burr. *Olivi's Peaceable Kingdom: A Reading of the Apocalypse Commentary.* 1993

Thomas Cable. *The English Alliterative Tradition.* 1991

Anthony K. Cassell and Victoria Kirkham, eds. and trans. *Diana's Hunt/Caccia di*
Diana: Boccaccio's First Fiction. 1991

John C. Cavadini. *The Last Christology of the West: Adoptionism in Spain and Gaul, 785–820.* 1993

Brigitte Cazelles. *The Lady as Saint: A Collection of French Hagiographic Romances of the Thirteenth Century.* 1991

Karen Cherewatuk and Ulrike Wiethaus, eds. *Dear Sister: Medieval Women and the Epistolary Genre.* 1993

Anne L. Clark. *Elisabeth of Schönau: A Twelfth-Century Visionary.* 1992

Willene B. Clark and Meradith T. McMunn, eds. *Beasts and Birds of the Middle Ages: The Bestiary and Its Legacy.* 1989

Richard C. Dales. *The Scientific Achievement of the Middle Ages.* 1973

Charles T. Davis. *Dante's Italy and Other Essays.* 1984

William J. Dohar. *The Black Death and Pastoral Leadership: The Diocese of Hereford in the Fourteenth Century.* 1994

Katherine Fischer Drew, trans. *The Burgundian Code.* 1972

Katherine Fischer Drew, trans. *The Laws of the Salian Franks.* 1991

Katherine Fischer Drew, trans. *The Lombard Laws.* 1973

Nancy Edwards. *The Archaeology of Early Medieval Ireland.* 1990

Richard K. Emmerson and Ronald B. Herzman. *The Apocalyptic Imagination in Medieval Literature.* 1992

Theodore Evergates. *Feudal Society in Medieval France: Documents from the County of Champagne.* 1993

Felipe Fernández-Armesto. *Before Columbus: Exploration and Colonization from the Mediterranean to the Atlantic, 1229–1492.* 1987

Jerold C. Frakes. *Brides and Doom: Gender, Property, and Power in Medieval Women's Epic.* 1994

R. D. Fulk. *A History of Old English Meter.* 1992

Patrick J. Geary. *Aristocracy in Provence: The Rhône Basin at the Dawn of the Carolingian Age.* 1985

Peter Heath. *Allegory and Philosophy in Avicenna (Ibn Sînâ), with a Translation of the Book of the Prophet Muḥammad's Ascent to Heaven.* 1992

J. N. Hillgarth, ed. *Christianity and Paganism, 350–750: The Conversion of Western Europe.* 1986

Richard C. Hoffmann. *Land, Liberties, and Lordship in a Late Medieval Countryside: Agrarian Structures and Change in the Duchy of Wrocław.* 1990

Robert Hollander. *Boccaccio's Last Fiction: Il Corbaccio.* 1988

John Y. B. Hood. *Aquinas and the Jews.* 1995

Edward B. Irving, Jr. *Rereading* Beowulf. 1989

Richard A. Jackson, ed. Ordines Coronationis Franciae: *Texts and Ordines for the Coronation of Frankish and French Kings and Queens in the Middle Ages, Vol. I.* 1995

C. Stephen Jaeger. *The Envy of Angels: Cathedral Schools and Social Ideals in Medieval Europe, 950–1200.* 1994

C. Stephen Jaeger. *The Origins of Courtliness: Civilizing Trends and the Formation of Courtly Ideals, 939–1210.* 1985

Donald J. Kagay, trans. *The Usatges of Barcelona: The Fundamental Law of Catalonia.* 1994

Richard Kay. *Dante's Christian Astrology*. 1994

Ellen E. Kittell. *From* Ad Hoc *to Routine: A Case Study in Medieval Bureaucracy*. 1991

Alan C. Kors and Edward Peters, eds. *Witchcraft in Europe, 1100–1700: A Documentary History*. 1972

Barbara M. Kreutz. *Before the Normans: Southern Italy in the Ninth and Tenth Centuries*. 1992

Michael P. Kuczynski. *Prophetic Song: The Psalms as Moral Discourse in Late Medieval England*. 1995

E. Ann Matter. *The Voice of My Beloved: The Song of Songs in Western Medieval Christianity*. 1990

Shannon McSheffrey. *Gender and Heresy: Women and Men in Lollard Communities, 1420–1530*. 1995

A. J. Minnis. *Medieval Theory of Authorship*. 1988

Lawrence Nees. *A Tainted Mantle: Hercules and the Classical Tradition at the Carolingian Court*. 1991

Lynn H. Nelson, trans. *The Chronicle of San Juan de la Peña: A Fourteenth-Century Official History of the Crown of Aragon*. 1991

Barbara Newman. *From Virile Woman to WomanChrist: Studies in Medieval Religion and Literature*. 1995

Joseph F. O'Callaghan. *The Cortes of Castile-León, 1188–1350*. 1989

Joseph F. O'Callaghan. *The Learned King: The Reign of Alfonso X of Castile*. 1993

Odo of Tournai (Irven M. Resnick, trans.). *Two Theological Treatises:* On Original Sin *and* A Disputation with the Jew, Leo, Concerning the Advent of Christ, the Son of God. 1994

David M. Olster. *Roman Defeat, Christian Response, and the Literary Construction of the Jew*. 1994

William D. Paden, ed. *The Voice of the Trobairitz: Perspectives on the Women Troubadours*. 1989

Edward Peters. *The Magician, the Witch, and the Law*. 1982

Edward Peters, ed. *Christian Society and the Crusades, 1198–1229: Sources in Translation, including* The Capture of Damietta *by Oliver of Paderborn*. 1971

Edward Peters, ed. *The First Crusade: The* Chronicle of Fulcher of Chartres *and Other Source Materials*. 1971

Edward Peters, ed. *Heresy and Authority in Medieval Europe*. 1980

James M. Powell. *Albertanus of Brescia: The Pursuit of Happiness in the Early Thirteenth Century*. 1992

James M. Powell. *Anatomy of a Crusade, 1213–1221*. 1986

Susan A. Rabe. *Faith, Art, and Politics at Saint-Riquier: The Symbolic Vision of Angilbert*. 1995

Jean Renart (Patricia Terry and Nancy Vine Durling, trans.). *The Romance of the Rose or Guillaume de Dole*. 1993

Michael Resler, trans. Erec *by Hartmann von Aue*. 1987

Pierre Riché (Michael Idomir Allen, trans.). *The Carolingians: A Family Who Forged Europe*. 1993

Pierre Riché (Jo Ann McNamara, trans.). *Daily Life in the World of Charlemagne*. 1978

Jonathan Riley-Smith. *The First Crusade and the Idea of Crusading*. 1986

Joel T. Rosenthal. *Patriarchy and Families of Privilege in Fifteenth-Century England*. 1991

Teofilo F. Ruiz. *Crisis and Continuity: Land and Town in Late Medieval Castile*. 1994

James A. Rushing, Jr. *Images of Adventure: Ywain in the Visual Arts*. 1995

Steven D. Sargent, ed. and trans. *On the Threshold of Exact Science: Selected Writings of Anneliese Maier on Late Medieval Natural Philosophy*. 1982

James A. Schultz. *The Knowledge of Childhood in the German Middle Ages, 1100–1350*. 1995

Pamela Sheingorn, ed. and trans. *The Book of Sainte Foy*. 1995

Robin Chapman Stacey. *The Road to Judgment: From Custom to Court in Medieval Ireland and Wales*. 1994

Sarah Stanbury. *Seeing the* Gawain-*Poet: Description and the Act of Perception*. 1992

Robert D. Stevick. *The Earliest Irish and English Bookarts: Visual and Poetic Forms Before A.D. 1000*. 1994

Thomas C. Stillinger. *The Song of Troilus: Lyric Authority in the Medieval Book*. 1992

Susan Mosher Stuard. *A State of Deference: Ragusa/Dubrovnik in the Medieval Centuries*. 1992

Susan Mosher Stuard, ed. *Women in Medieval History and Historiography*. 1987

Susan Mosher Stuard, ed. *Women in Medieval Society*. 1976

Jonathan Sumption. *The Hundred Years War: Trial by Battle*. 1992

Ronald E. Surtz. *The Guitar of God: Gender, Power, and Authority in the Visionary World of Mother Juana de la Cruz (1481–1534)*. 1990

Ronald E. Surtz. *Writing Women in Late Medieval and Early Modern Spain: The Mothers of Saint Teresa of Avila*. 1995

Del Sweeney, ed. *Agriculture in the Middle Ages*. 1995

William H. TeBrake. *A Plague of Insurrection: Popular Politics and Peasant Revolt in Flanders, 1323–1328*. 1993

Patricia Terry, trans. *Poems of the Elder Edda*. 1990

Hugh M. Thomas. *Vassals, Heiresses, Crusaders, and Thugs: The Gentry of Angevin Yorkshire, 1154–1216*. 1993

Ralph V. Turner. *Men Raised from the Dust: Administrative Service and Upward Mobility in Angevin England*. 1988

Mary F. Wack. *Lovesickness in the Middle Ages: The* Viaticum *and Its Commentaries*. 1990

Benedicta Ward. *Miracles and the Medieval Mind: Theory, Record, and Event, 1000–1215*. 1982

Suzanne Fonay Wemple. *Women in Frankish Society: Marriage and the Cloister, 500–900*. 1981

Kenneth Baxter Wolf. *Making History: The Normans and Their Historians in Eleventh-Century Italy*. 1995

Jan M. Ziolkowski. *Talking Animals: Medieval Latin Beast Poetry 750–1150*. 1993

This book has been set in Linotron Galliard. Galliard was designed for Mergenthaler in 1978 by Matthew Carter. Galliard retains many of the features of a sixteenth-century typeface cut by Robert Granjon but has some modifications that give it a more contemporary look.

Printed on acid-free paper.